T. S. ELIOT'S ORCHESTRA

BORDER CROSSINGS
VOLUME 7
GARLAND REFERENCE LIBRARY OF THE HUMANITIES
VOLUME 2030

BORDER CROSSINGS

DANIEL ALBRIGHT, *Series Editor*
Richard L. Turner Professor in the Humanities
University of Rochester

T. S. Eliot's Orchestra
Critical Essays on Poetry and Music

Edited by
John Xiros Cooper

Garland Publishing, Inc.
A member of the Taylor & Francis Group
New York and London
2000

Published by
Garland Publishing Inc.
A Member of the Taylor & Francis Group
29 West 35th Street
New York, NY 10001

10 9 8 7 6 5 4 3 2 1

Library of Congress Cataloging-in-Publication Data
T. S. Eliot's orchestra : critical essays on poetry and music / edited by
John Xiros Cooper.
 p. cm.—(Garland reference library of the humanities ; v. 2030.
Border crossings ; v. 7)
 ISBN 0-8153-2577-0 (alk. paper)
 1. Eliot, T. S. (Thomas Stearns), 1888–1965—Knowledge—Music.
2. Music and literature—History—20th century. 3. Music in literature.
I. Cooper, John Xiros, 1944–. II. Garland reference library of the
humanities; vol. 2030. III. Garland reference library of the humanities.
Border crossings ; v. 7.
PS3509.L43 Z8734 2000
821'.912—dc21 00-021201

Cover: [caption, credit to come]

Printed on acid-free, 250-year-life paper.
Manufactured in the United States of America

Contents

Series Editor's Foreword

DANIEL ALBRIGHT

The Need for Comparison among the Arts

To study one artistic medium in isolation from others is to study an inadequacy. The twentieth century, so rich in literature, in music, and in the visual arts, has also been rich in criticism of these arts; but it is possible that some of the uglinesses and distortions in modern criticism has arisen from the consideration of each artistic medium as an autonomous field of development, fenced off from other media. It is hard for us to believe, but when, long ago, Horace said *Ut pictura poesis*—the poem should be like a picture—he meant it. Now that the twenty-first century has arrived, perhaps it will be possible to come near a total critique appropriate to the total artwork.

The twentieth century, perhaps more than any other age, has demanded a style of criticism in which, the arts are considered as a whole. This is partly because the artists themselves insisted again and again upon the inextricability of the arts. Ezra Pound, for one, believed that, in antiquity, "music and poetry had been in alliance . . . that the divorce of the two arts had been to the advantage of neither, and that melodic invention had declined simultaneously and progressively with their divergence. The rhythms of poetry grew stupider." He thought that it was the duty of the poet to learn music, and the duty of the musician to study poetry. But we must learn to challenge the boundaries among the arts not only because the artists we study demanded it, but because our philosophy demands it as well. The linguistics of Ferdinand de Saussure, the philosophy of Ludwig Wittgenstein and Jacques Derrida, tend to strip language

of denotation, to make language a game of arbitrary signifiers; and as words lose connection to the world of hard objects, they become more and more like musical notes, Wittgenstein claimed. "To say that a word has meaning does not imply that it *stands for* or *represents* a thing. . . . The sign plus the rules of grammar applying to it is all we need [to make a language]. We need nothing further to make the connection with reality. If we did we should need something to connect that with reality, which would lead to an infinite regress." And, for Wittgenstein, the consequence of this disconnection was clear: "Understanding a sentence is much more akin to understanding a theme in music than one may think." To Horace, reading is like looking at a picture; to Wittgenstein, reading is like listening to music. The arts seem endlessly interpermeable, a set of fluid systems of construing and reinterpreting, in which the quest for meaning engages all our senses at once. Thinking is itself looking, hearing, touching—even tasting, since such words as *savoir* are forms of the Latin *sapere,* to taste.

The Term *Modernism*

Modernism—like any unit of critical terminology—is a fiction, but an indispensable fiction. It is possible to argue (as Vladimir Nabokov did) that each work of art in the universe is unique and incommensurable, that there is no such thing as a school of artists, that an idea such as *influence* among artists arises from sheer intellectual laziness. This line of argument, however, contradicts our intuition that certain works of art look like one another; that, among many works of art produced at the same time or in the same place, there are family resemblances. Such terms as *modernism* need have no great prestige: they are simply critical indications convenient for describing certain family resemblances.

Furthermore, these terms denote not only kinship relations established by critics from outside, but also kinship relations determined by artists from within. The term *modernism* had tremendous potency for the modernists themselves: when Ezra Pound first read a poem by T. S. Eliot, he was thunderstruck that Eliot had managed to *modernize* his poetry all by himself, without any contact with other poets. Pound regarded modernism itself as a huge group project. To this extent, modernism is not just a label attached by students of a period, but a kind of tribal affiliation, one of thousands of examples of those arbitrary loyalty groups that bedevil the human race. Nearly every early twentieth-century artist felt the need to define himself or herself as a modernist or otherwise. When

Stravinsky at last met Rachmaninov in Hollywood, Stravinsky obviously greeted his colleague not simply as a fraternal fellow in the order of Prussian expatriate composers, but as a (self-sacrificing) modernist condescending to a (rich and successful) romantic. The label *modernist* shaped the interactions of artists themselves—sometimes as a help, sometimes as a hindrance.

Of course, it is the task of criticism of the present age to offer a better account of modernism than the modernists themselves could. Stravinsky's ideas about Rachmaninov were wrong in several ways; not just because Rachmaninov's royalties were not noticeably greater than Stravinsky's, but also because their music was somewhat more similar than Stravinsky would have liked to admit. For instance, compare the Easter finale from Rachmaninov's Suite for Two Pianos, op. 5, with the carillon evoked by the piano in Stravinsky's song "Spring," op. 6, no. 1: they inhabit the same aesthetic realm.

A theory of the modernist movement that might embrace both Rachmaninov and Stravinsky, or Picasso and Balthus, could be constructed along the following lines: modernism is a *testing of the limits of aesthetic construction.* According to this perspective, the modernists tried to find the ultimate bounds of certain artistic possibilities: volatility of emotion (expressionism); stability and inexpressiveness (the new objectivity); accuracy of representation (hyperrealism); absence of representation (abstractionism); purity of form (neoclassicism); formless energy (neobarbarism); cultivation of the technological present (futurism); cultivation of the prehistoric past (the mythic method). These extremes have, of course, been arranged in pairs because aesthetic heresies, like theological ones, come in binary sets: each limit-point presupposes an opposite limit-point, a counter-extreme toward which the artist can push. Much of the strangeness, the stridency, the exhilaration of modernist art can be explained by this strong thrust toward the verges of the aesthetic experience: after the nineteenth century had established a remarkably safe, intimate center where the artist and the audience could dwell, the twentieth century has reached out to the freakish circumferences of art. The extremes of the aesthetic experience tend to converge; in the modernist movement, the most barbaric art tends to be the most up-to-date and sophisticated. For example, when T. S. Eliot first heard *The Rite of Spring,* he wrote that the music seemed to "transform the rhythm of the steppes into the scream of the motor-horn, the rattle of machinery, the grind of wheels, the beating of iron and steel, the roar of the underground railway, and the other barbaric noises of modern life." *The Waste*

Land is itself written to the same recipe: the world of London, with its grime, boredom, and abortifacient drugs, overlays the antique world of primal rites for the rejuvenation of the land through the dismemberment of a god. In the modernist movement, things tend to coexist uncomfortably with their exact opposites.

Wallace Stevens referred to the story we tell ourselves about the world, about our presence in the world, and about how we attempt to configure pleasant lives for ourselves, as a Supreme Fiction; and similarly, critics live by various critical fictions, as they reconfigure the domain of similarities and differences in the arts. Modernism is just such a "high critical fiction."

The Span of the Modernist Age

The use of a term such as *modernism* usually entails a certain restriction to a period of time. Such a restriction is rarely easy and becomes immensely difficult for the interdisciplinary student: the romantic movement, for example, will invariably mean one age for a musicologist, another (perhaps scarcely overlapping) for a student of British poetry. One might say that the modernist age begins around 1907–9, because in those years Picasso painted *Les Demoiselles d'Avignon,* Schoenberg made his "atonal" breakthrough, and the international careers of Stravinsky, Pound, Stein, and Cocteau were just beginning or were not long to come. And one might choose 1951 for a terminus, since in that year Cage started using the I Ching to compose chance-determined music, and Samuel Beckett's trilogy and *Waiting for Godot* were soon to establish an artistic world that would have partly bewildered the early modernists. The modernists did not (as Cage did) abdicate their artistic responsibilities to a pair of dice; the modernists did not (as Beckett did) delight in artistic failure. Modernism was a movement associated with scrupulous choice of artistic materials, and with hard work in arranging them. Sometimes the modernists deflected the domain of artistic selection to unusual states of consciousness (trance, dream, etc.); but, except for a few Dadaist experiments, they did not abandon artistic selection entirely—and even Tristan Tzara, Kurt Schwitters, and the more radical Dadaists usually attempted a more impudent form of nonsense than aleatory procedures can generate. The modernists *intended* modernism—the movement did not come into existence randomly.

But the version of modernism outlined here—a triumphalist extension of the boundaries of the feasible in art—is only *one* version of modernism.

There exist many modernisms, and each version is likely to describe a period with different terminal dates. It is not hard to construct an argument showing that modernism began, say around 1886 (the year of the last painting exhibition organized by the Impressionists, at which Seurat made the first important show of his work). Nietzsche had privately published *Also Sprach Zarathustra* in 1885, and Mahler's first symphony would appear in 1889. And it is possible to construct arguments showing that modernism has only recently ended, since Beckett actualized certain potentialities in Joyce (concerning self-regarding language), and Cage followed closely after Schoenberg and Satie (Cage's *Cheap Imitation,* from 1969, is simply a note-by-note rewriting, with random pitch alterations, of the vocal line of Satie's 1918 *Socrate*).

And it is also possible that modernism has not ended at all: the term *postmodernism* may simply be erroneous. Much of the music of Philip Glass is a straightforward recasting of musical surface according to models derived from visual surface, following a formula stated in 1936 by an earlier American composer, George Antheil, who wrote of the "filling out of a certain time canvas with musical abstractions and sound material composed and contrasted against one another with the thought of time values rather than tonal values . . . I used time as Picasso might have used the blank spaces of his canvas. I did not hesitate, for instance, to repeat one measure one hundred times." Most of the attributes we ascribe to postmodernism can easily be found, latently or actually, with the modernist movement: for another example, Brecht in the 1930s made such deconstructionist declarations as "*Realist* means: laying bare society's causal network / showing up the dominant viewpoint as the viewpoint of the dominators." It is arguable that in the 1990s we are still trying to digest the meal that the modernist ate.

If modernism can be said to reach out beyond the present moment, it is also true that modernism can be said to extend backward almost indefinitely. Wagner, especially the Wagner of *Tristan und Isolde,* has been a continual presence in twentieth-century art: Brecht and Weill continually railed against Wagnerian narcosis and tried to construct a music theater exactly opposed to Wagner's; but Virgil Thomson found much to admire and imitate in Wagner—even though Thomson's operas sound, at first hearing, even less Wagnerian than Kurt Weill's. In some respects, the first modernist experiment in music theater might be said to be the Kotzebue-Beethoven *The Ruins of Athens* (1811), in which the goddess Minerva claps her hands over her ears at hearing the hideous music of the dervishes' chorus (blaring tritones, Turkish percussion): here is the

conscious sensory assault, sensory overload, of Schoenberg's first operas. Modernism is partly confined to the first half of the twentieth century, but it tends to spill into earlier and later ages. Modernism created its own precursors; it made the past new, as well as the present.

The Question of Boundaries

The revolution of the Information Age began when physicists discovered that silicon could be used either as a resistor or as a conductor of electricity. Modernist art is also a kind of circuit board, a pattern of yieldings and resistances, in which one art sometimes asserts its distinct, inviolable nature and sometimes yields itself, tries to imitate some foreign aesthetic. Sometimes music and poetry coexist in a state of extreme dissonance (as Brecht thought they should, in the operas that he wrote with Weill); but on other occasions music tries to *become* poetry, or poetry tries to *become* music. To change the metaphor, one might say that modernism investigates a kind of transvestism among the arts—what happens when one art stimulates itself by temporarily pretending to be another species of art altogether.

Modernist art has existed in an almost continual state of crisis concerning the boundaries between one art medium and another. Is a painting worth a thousand words, or is it impossible to find a verbal equivalent of an image, even if millions of words were used? Are music and literature two different things, or two aspects of the same thing? This is a question confronted by artists of every age, but the artists of the modernist period found a special urgency here. The literature of the period, with its dehydrated epics and other semantically supercharged texts, certainly resembles, at least to a degree, the music of the period, with its astonishing density of acoustic events. But some artists tried to erase the boundaries among music and literature and the visual arts, while other artists tried to build foot-thick walls.

Some of the modernists felt strongly that the purity of one artistic medium must not be compromised by the encroachment of styles or themes taken from other artistic media. Clement Greenberg, the great modernist critic, defended abstractionism on the grounds that an abstract painting is a pure painting: not subservient to literary themes, not enslaved to representations of the physical world, but a new autonomous object, not a copy of reality but an addition to reality. Such puritans among the modernists stressed the need for fidelity to the medium: the opacity and spectral precision of paint or the scarified, slippery feel of metal; the exact sonority

of the highest possible trombone note; the spondaic clumps in a poetic line with few unstressed syllables. As Greenberg wrote in 1940, "The history of avant-garde painting is that of a progressive surrender to the resistance of its medium; which resistance consists chiefly in the flat picture plane's denial of efforts to 'hole through' it for realistic perspectival space." To Greenberg, the medium has a message: canvas and paint have a recalcitrant will of their own, fight against the artists' attempts to pervert their function. He profoundly approved of the modernist art that learned to love paint for paint's sake, not for its capacity to create phantoms of solid objects.

But this puritan hatred of illusions, the appetite for an art that possesses the dignity of reality, is only part of the story of modernism. From another perspective, the hope that art can overcome its illusory character is itself an illusion: just because a sculpture is hacked out of rough granite does not mean that it is real in the same way that granite is real. The great musicologist Theodor Adorno was as much a puritan as Greenberg: Adorno hated what he called *pseudomorphism,* the confusion of one artistic medium with another. But Adorno, unlike Greenberg, thought that all art was dependent on illusion, that art could not attempt to compete with the real world. As he wrote in 1948, it is futile for composers to try to delete all ornament from music: "Since the work, after all, cannot be reality, the elimination of all illusory features accentuates all the more glaringly the illusory character of its existence."

But, while the puritans tried to isolate each medium from alien encroachment, other, more promiscuous modernists tried to create a kind of art in which the finite medium is almost irrelevant. For them, modernism was *about* the fluidity, the interchangeability, of artistic media themselves. Here we find single artists, each of whom often tried to become a whole artistic colony—we see, for example, a painter who wrote an opera libretto (Kokoschka), a poet who composed music (Pound), and a composer who painted pictures (Schoenberg). It is as if artistic talent were a kind of libido, an electricity that could discharge itself with equal success in a poem, a sonata, or a sculpture. Throughout the modernist movement, the major writers and composers both enforced and transgressed the boundaries among the various arts with unusual energy—almost savage at times.

It is important to respect both the instincts for division and distinction among the arts, and the instincts for cooperation and unity. In the eighteenth century, Gotthold Lessing (in *Laokoon*) divided the arts into two camps, which he called the *nacheinander* (the temporal arts, such as

poetry and music) and the *nebeneinander* (the spatial arts, such as paint-ing and sculpture). A modernist *Laocoön* might restate the division of the arts as follows: not as a tension between the temporal arts and the spatial—this distinction is often thoroughly flouted—but as a tension between arts that try to retain the propriety, the apartness, of their private media, and arts that try to lose themselves in some pan-aesthetic whole. On one hand, *nacheinander* and *nebeneinander* retain their distinctness; on the other hand, they collapse into a single spatiotemporal continuum, in which both duration and extension are arbitrary aspects. Photographs of pupillary movement have traced the patterns that the eye makes as it scans the parts of a picture trying to apprehend the whole—a picture not only may suggest motion, but also is constructed by the mind acting over time. Similarly, a piece of music may be heard so thoroughly that the whole thing coexists in the mind in an instant—as von Karajan claimed to know Beethoven's fifth symphony.

There are, then, two huge contrary movements in twentieth-century experiments in bringing art media together: consonance among the arts, and dissonance among the arts. Modernism carries each to astonishing extremes. The dissonances are challenging; perhaps the consonances are even more challenging.

In the present series of books, each volume will examine some facet of these intriguing problems in the arts of modernism—the dissemblings and resistings, the smooth cooperations and the prickly challenges when the arts come together.

Preface

JOHN XIROS COOPER

I really would like to understand music,
Not in order to be able to talk about it,
But . . . partly, to enjoy it . . . and because of what it stands for.
 —LUCASTA IN *THE CONFIDENTIAL CLERK,* ACT II

There is a lot of talk about music in this book, and most of it is about what music stands for in the imaginative and critical work of T. S. Eliot. There can be no doubt that for Eliot music "stands for" something important. Music is present in Eliot's work from beginning to end. Just about every critic and scholar who has written about him acknowledges this sustained interest in music, as theme, as metaphor, as form. One can hardly avoid this insight because the works themselves continuously point to music's informing proximity to poetry and drama in Eliot's mind, from J. Alfred Prufrock's "song" right through to *Four Quartets.* Eliot seems never to have lost sight of music as the source of his "poetics". "Song," "rhapsody," "prelude," "nocturne," "rag" (as in "O O O O that Shakespeherian Rag—"), *Tristan und Isolde* and *Parsifal* in *The Waste Land,* jazz, sonata form, quartet, the use of choral form in several of his plays, the 1942 essay "The Music of Poetry," and passages scattered in many other essays and talks suggest as much. In recent years the publication of the first volume of his letters reveals that Eliot's interest in and love of music began early in life, from his discussions with Jean Verdenal about the music of Wagner in his youth to his profession of a love for Bach and Mozart to Mary Hutchinson in 1919. And the musicologist Donald Mitchell has corroborated the published record with personal reminiscences during an interview with the editor on 4 February 1997 of Eliot's enduring love of music in his later years when Dr. Mitchell was involved editorially with Faber and Faber's music division. He also emphasized that Faber's musical publishing was actively supported and promoted by Eliot in the 1940s and 1950s, when the firm was first getting

into the music publishing business. Indeed, it was Eliot's presence at Faber that brought the distinguished composers Benjamin Britten and Igor Stravinsky to the firm.

There have been critical and scholarly attentions devoted to these musical matters in the past. But they tend to cluster around a couple of well-worn musical topics, namely Eliot's use of Beethoven and Wagner and his relationship to jazz in the 1920s. Very early in the critical response, Eliot's relationship to music was noted and explored in a summary way, most notably by Stephen Spender and Helen Gardner with respect to *Four Quartets*. Eliot's obvious appropriation of Beethoven and Wagner, his affinities with the French *symbolistes*, particularly the musical poetics of Mallarmé and Valéry, tended to limit attention to the whole extent of Eliot's interest in and use of music. The culmination of this critical tradition was the publication of Keith Alldritt's *Eliot's "Four Quartets": Poetry as Chamber Music* in 1978. But again it was sonata form, Beethoven, and the *Quartets* that took center stage. Indeed, as recently as 1992, John Holloway revisited the matter of *Four Quartets* and Beethoven yet again.

In London, the jazz age seems to have taken off with the arrival of the Original Dixieland Jazz Band at the Hammersmith Palais du Danse in August 1919. For three months West London jumped, and not only did everyone begin to take notice, but they also began to take sides, pro and con the new American phenomenon. The rage for jazz did not abate in England all through the interwar years. Eliot's relationship to jazz was first suggested in Clive Bell's sneering essay of 1921, "Plus de Jazz," an ugly salvo in the animated and often repulsively racist debate about the cultural influence of jazz in Europe in the 1920s. Luckily, the modern scholarly tradition has contributed a modest but more measured assessment of Eliot's relationship to jazz: the work of Morris Freedman and Carol H. Smith in the 1950s and 1960s comes immediately to mind, and Smith again more recently in her essay "Sweeney and the Jazz Age" in 1985. The opening essays here extend this line of inquiry significantly.

The volume not only adds to these two established areas of study but also remaps them and discovers new terrain to explore. The Eliot-jazz connection is resituated in its proper context in the first section of the book: Eliot and the popular musical culture of the turn of the century. Groundbreaking essays by David Chinitz, Kevin McNeilly, Jonna Mackin, and Jonathan Gill, open the field in impressive new ways. They bring important new research material and ideas to light. This is especially fruitful from another direction, namely the recent interest in Eliot

as an American writer, and these essays enrich our sense of Eliot's debts to his American roots by way of early twentieth-century American musical traditions.

Equally important is the new work presented here for the first time in the matter of Eliot's relationship to the classical music traditions. In addition to the reassessments of his use of Beethoven and Wagner, there are explorations of his affinities with important twentieth-century composers like Sir Michael Tippett, Charles Ives, and Benjamin Britten.

In the middle section of the book Eliot's musical poetics is explored in theory and practice. Brad Bucknell, in an impressive essay, teases out some of the implications for Eliot's affinity to music in his social and cultural criticism. Eliot's relationship to Walter Pater and French symbolism is reexamined by John Adames. The checklist of musical settings of Eliot's works, which concludes the volume, gathers together and brings up to date information that up until now could only be found scattered in various places.

Making sense of the way different musical traditions have influenced Eliot continues to be the principal aim of critical and scholarly notice. And to this task, these essays contribute a great deal of new material. But music represented something more than interdisciplinary influence in the making of poetry and drama. Music is, in some special sense, not only an artistic source and emotional stimulant but also a mode of active perception and cognition. Several of the essays begin this new discussion in a preliminary form. They point to a fruitful future direction in the study of Eliot's musical intelligence, not only in his poetry and poetics, where music is still seen as a modality of self-expression and self-recognition, but also in his cultural criticism.

In "Poetry and Drama" Eliot speaks of "a fringe of indefinite extent, of feeling which we can only detect, so to speak, out of the corner of the eye and can never completely focus . . . At such moments, we touch the border of those feelings which only music can express." His words here, as Geoffrey Hill has remarked in "Poetry As 'Menace' and 'Atonement,'" carry a conspicuous personal note, a double charge of meaning and affect. "In certain contexts the expansive, outward gesture towards the condition of music is a helpless gesture of surrender, oddly analogous to that stylish aesthetic of despair, that desire for the ultimate integrity of silence, to which so much eloquence has been so frequently and indefatigably devoted." There is no better summary judgment of the dilemma at the core of *Four Quartets* than this. But this aspect of Eliot's musicating intelligence, which sounds so well the ambivalences of Eliot's own

personal situation, both the longing for an inexpressible aesthetic deli-
cacy and the inevitable resulting despair, takes us out, beyond the per-
sonal, into the culture.

Musical experience and the "thinking" that accompanies it do not
happen at the level of concept and idea alone, if at all. Music penetrates
to that point in consciousness where formal cognitive activity can no
longer be strictly distinguished from sensation and feeling. It is in the
indeterminacies at this intersection of private and public worlds that
culture, in the anthropological sense, is produced. Rhythm, habit, and
resonance inscribe here what Eliot came to call in *The Idea of a Christ-
ian Society* (1939), the "substratum of collective temperament." Music
makes audible aspects of this "temperament" in a way that the concep-
tual idiom cannot adequately manage. It is what the populist or mes-
sianic political leader often intuits. The masses respond emotionally not
to the rationality and/or practicality of his ideas or even to what he says
but to the particular "music" of his voice.

Eliot recognized early on that certain musical forms, sounds, and
rhythms carry a potent charge of something like social and psychological
meaning that cannot be adequately put into a rational order of words.
In 1933 in *The Use of Poetry and the Use of Criticism* he called this feel-
ing for sound and rhythm the "auditory imagination." Three years later
he wrote in the *Listener* (25 November 1936) that he preferred poetry to
prose because poetry provides "a musical pattern" that strengthens our
"excitement . . . with feeling from a deeper and less articulate level"
("The Need for Poetic Drama" 994–95). And in 1942 he added in "The
Music of Poetry," when thinking of the poet's practice, and this may be
equally true for the reader or listener, "that a poem, or a passage of a
poem, may tend to realize itself first as a particular rhythm before it
reaches expression in words" or, in the case of the listener, as a para-
phrasable meaning. More work needs to be done in exploring this diffi-
cult area on the frontier between words and music, between speech and
song. This collection of essays opens a critical and scholarly discussion
that will lead eventually to a new appreciation of Eliot's place in that
largely undiscovered borderland between literature and music.

This volume would not have been possible without the help and
encouragement of numerous people. First I would like to thank all the
contributors for the work they have put into making this such an interest-
ing and, dare I say, important book. Also I would like to thank all those
who made proposals to me in the early going and for one reason or
another could not finally appear in the finished work. I would also like to

thank Daniel Albright, the series editor, who has helped me enormously whenever I have needed information and advice. His good humor, encyclopedic knowledge, and unerring taste and judgment have made my task easier.

The distinguished musicologist Donald Mitchell kindly made himself available for an interview at his flat in London. Listening to him remember working at Faber and Faber, his contacts with Eliot in the 1950s, and his knowledge of music and the situation of English music, in particular, will be one event associated with this book that will remain with me for a very long time. As an admirer of his writings about music ever since reading his marvelous *The Language of Modern Music* as an undergraduate, I found him as gracious and generous in person as his books are in style and content; *le style, c'est l'homme,* to be sure.

I would also like to thank Keith Alldritt for his help and guidance over the years. The untimely death of his wife, the author Joan Hardwick, in the summer of 1998 has shadowed the final months of work on the book. Keith's own book on *Four Quartets* was the major contribution to this topic in recent critical history. I hope that the current work, without, sadly, a new contribution on the subject from him, will take this topic a step or two further along the path he marked out so well in 1978.

My thanks go also to the staff of the Music and Koerner Libraries at the University of British Columbia, the British Library, then still in Bloomsbury, the Cambridge University Library, and the Library of the University of London. I want to thank Ms. Paula Marinescu, in the Arts Computing office at the University of British Columbia, for her expert help in sorting out some technical problems when the whole project was scattered over a dozen or more computer disks. In addition, the following colleagues have helped me in various ways: Andrew Busza, Ira Nadel, Grove Powell, Peter Quartermain, and Paul Stanwood. Finally, thanks must also go to Richard Wallis, initially, Soo Mee Kwon, her assistant, Gillian Rodger, and the editing staff at Garland for their help in making the book a concrete reality.

T. S. Eliot's Orchestra

Eliot and Popular Musical Culture

CHAPTER 1

A Jazz-Banjorine, Not a Lute
Eliot and Popular Music before *The Waste Land*

DAVID CHINITZ

STRONG WEATHER

Speaking in his native St. Louis in 1953, Eliot recounted the adventure of a certain American native who had survived the arduous voyage to Great Britain: "In October last occurred an event which, while not as spectacular as the descent of Col. Lindbergh at Le Bourget in 'The Spirit of St. Louis,' is equally remarkable in its kind. For the first time, apparently, an American robin, well named *turdus migratorius*, crossed the Atlantic under its own power, "favoured" according to the report, by 'a period of strong westerly weather'" (*To Criticize* 50). Eliot went on to identify this expatriate with the "American language," extending its influence eastward through the mass media, global capitalism, and the other phenomena of postindustrial modernity that seemed to emanate from the United States. Yet it is hard not to identify the robin with Eliot himself—and it is difficult to believe that Eliot himself did not do so, especially when he contrives (as if their parallel courses were not already obvious) to associate the bird's point of origin with St. Louis. Moreover, the "strong westerly weather" that had blown Eliot along his own passage to prominence was essentially the same force that was backing American English. During his rise to what Delmore Schwartz would call "literary dictatorship" (312), Eliot had been an American poet in England (it is not clear that he ever really ceased to be), and his ascendancy seemed related in some mysterious way to the other cultural developments blown over from America by the proverbial winds of change. The conviction that Eliot's work was, somehow, fundamentally connected

3

with jazz in particular has been held with assurance, even taken for granted, by critics since the earliest years of Eliot's career. This essay will show how that notion, though often vaguely apprehended, contains a genuine insight with a basis in both history and prosody.[1]

In his 1953 address Eliot proceeded to "speculate on the future" of the transatlantic robin. Would it soon be joined by a mate of its own species to populate England with American robins? Otherwise—what seems far more likely—"our lone pioneer must make the best of it, and breed with the English thrush, who is not *migratorius* but *musicus*. In the latter event, the English must look out for a new species of thrush, with a faint red spot on the male breast in springtime; a species which, being a blend of *migratorius* and *musicus*, should become known as the troubadour-bird, or organ-grinder" (*To Criticize* 50). Again, drawing a parallel with T. S. Eliot is irresistible. For Eliot was himself, as poet, just that combination of *migratorius* and *musicus*, an original blend of Yankee revolutionary and Great Traditionalist, peripatetic haranguing prophet and patron of the "music of poetry," exile and tribal bard. Eliot himself, to complete the analogy, was the "troubadour-bird," or else— and how much homelier it sounds!—the "organ-grinder." Of these two epithets, the early Eliot at least would have embraced the second. We will see presently how he chose to depict himself as a kind of literary organ-grinder: a rude musician, inelegant, impoverished, unrefined, an American migrant worker in the rich but overcultivated aesthetic fields of the Old World.

To play this role in the culturally conservative enclave of early twentieth-century London was, for Eliot, to present himself as something of a barbarian at the gates. His status as an outsider was enabling. Only by speaking as an American could Eliot write to Maxwell Bodenheim in 1921, "I have . . . a certain persistent curiosity about the English and a desire to see whether they can ever be roused to anything like intellectual activity" (*Letters* 431). This is Eliot at his most secure, certain that England needed him to rouse it. "This is not conceit," he assured Bodenheim, "merely a kind of pugnacity." By positioning himself as an American intruder, Eliot could critique British culture from a seemingly independent point of view.

Although Eliot found it useful in this endeavor to be an American, his pugnacity found no object in America. He showed little interest in attempting to establish "anything like intellectual activity" in the United States—considered this, in fact, an unlikely prospect.[2] The letter to Bodenheim explains the English difference: "Once there was a civilisation here,

I believe, that's a curious and exciting point" (*Letters* 431).[3] And this opposition of a once civilized England to an ever heathenish America gnawed at Eliot precisely because he *was* an American: he feared that his roots would forever snarl him in what he regarded as the morass of American nonculture.[4] In 1919 he spoke to his British friend Mary Hutchinson of his struggle to understand the national character: "But remember that I am a *metic*—a foreigner, and that I *want* to understand you, and all the background and tradition of you. I shall try to be frank— because the attempt is so very much worth while with you—it is very difficult with me—both by inheritance and because of my very suspicious and cowardly disposition. But I may simply prove to be a savage (318). Shortly after this letter, Eliot was writing "Tradition and the Individual Talent" and attempting to reassure himself that tradition "cannot be inherited, and if you want it you must obtain it by great labour" (*Selected* 4). If so, then being born, as Pound was to put it, "[i]n a half savage country" was no disqualification (61): *every*one had to labor to obtain "civilization," a term Eliot uses interchangeably with "tradition" in his letter to Hutchinson. But this idea could not dispel the anxious concern that Eliot, as an American, had simply missed out on the opportunity to be civilized. Civilization, he wrote to Hutchinson, "forms people unconsciously—I don't think two or half a dozen people can set out by themselves to be civilised" (*Letters* 317–18). Thus Eliot himself, for all his efforts, might "simply prove to be a savage." He would like to have been Henry James in Rome but dreaded that he might instead be Burbank, or even Bleistein, in Venice.[5]

Six months later Eliot was writing again to Mary Hutchinson in what appears to be the same tone of self-doubt: "I am glad to hear that you enjoyed yourself and didn't get tired, and that Lytton's life is so perfect. But it is a jazz-banjorine that I should bring, not a lute" (*Letters* 357). While it is impossible to reconstruct the full context of this enigmatic remark, it appears that Hutchinson, addressing Eliot as a troubadour (i.e., poet), had invited him and his "lute" to a social occasion.[6] Perhaps Eliot's lute was to balance Strachey's prose instrument. What is clear, at any rate, is the denial in Eliot's reply that he is the sort of poet who sings to the classic lute; it is rather the "jazz-banjorine" that suits him. Correcting his friend's contextualization of his poetry, Eliot bases himself in America rather than England, in the contemporary rather than the classical, and in the "jazz movement" of modernism rather than the Great Tradition.

Eliot's seizure of the "jazz-banjorine" is, on its face, self-abnegating. The banjo, popular in stage entertainment and parlor music, certainly

lacked the cultural cachet of the lute; in fact, it had a reputation as a crude
instrument with little expressive range: "With its African percussiveness
and short sustain on stopped strings, the banjo was ill-suited for the slow
legato melodies of much European music, and so seemed, by European
aesthetic standards, to be emotionally limited and incapable of musical
profundity" (Linn 2). And since the banjo was still best known as a fix-
ture in the minstrel show, Eliot's comment effectively cast him as a
blackface comic—or even as the "plantation darky" such a comic would
have played. By consigning his talent to the banjo, Eliot is foregoing any
claim to the bardic mantle that Mrs. Hutchinson's reference to the lute
would ascribe to him. He is no troubadour, but merely, as he described
himself to Herbert Read in 1928, a "southern boy with a nigger drawl"
(Read 15), merely a "savage."

Eliot's selection of the "banjorine" in particular only reinforces his
self-denigration. Variations on the banjo proliferated during its heyday:
there were mandolin-banjos, zither-banjos, banjolins, cello-banjos, tenor-
banjos, and so on.[7] Eliot's instrument of choice (often spelled *banjeau-
rine*) was a diminutive, high-pitched member of this family. In assigning
himself a jazz-banjorine, Eliot was making the humblest available selec-
tions in both genre and instrument.

Yet when Eliot offers to play his jazz-banjorine, there is a deeper
claim to power underlying his modesty. For seventy-five years, the banjo
had spearheaded the "Americanization" of Europe—the infiltration of
American mass culture into European life. The instrument seemed to have
been present at every turn. In 1843, when the minstrel show stormed into
England, the banjo (then a novelty) led the charge. By the 1880s it had
made its way into more "elevated" performance settings, becoming in the
process an acceptable musical study for respectable ladies and gentlemen.
By the 1890s it had become positively "a fixture in fashionable . . . par-
lors" (Winans and Kaufman 13). The fashion became a rage around the
turn of the century, when even the Prince of Wales began taking lessons.
As ragtime reached England, American banjo virtuosos were on the scene
again to facilitate its entry, so that in the early twentieth century the instru-
ment was commonly associated with ragtime (20–21). By the time Eliot
claimed to wield a "jazz-banjorine," the humble banjo had ushered in an
enduring taste for the "unofficial" artistic expression of American popular
culture. And so the banjo prepared the arrival of Eliot and his mod-
ernism—his own challenge to the official culture of England. For Eliot, to
play the "jazz-banjorine" was to be an agent of change.

There is another, related sense in which Eliot's banjorine signifies a kind of modernist bravado. As Michael North has shown, Eliot and Pound's assumption of African American "trickster" personae ("Old Possum" and "Brer Rabbit") in their correspondence, together with their appropriation of black dialect, functioned as a private code, a "sign of [their] collaboration against the London literary establishment and the literature it produced" (*Dialect* 77). By "blacking up" in their communications with each other, the two poets affirmed their mutual shame and pride in being American "savages" in exile. But in claiming to play the banjorine, in thus professing his abjection to Mary Hutchinson, Eliot is not only blacking up: he is also concealing his strength from his British correspondent while pretending to weakness. This is, of course, precisely the distinctive strategy of the trickster in African American folklore, and in the enormously popular semiauthentic tales of Uncle Remus that functioned as the sourcebook for Eliot and Pound in what North calls their "racial masquerade."[8] Meanwhile, by wearing blackface, Eliot again associates himself with the popular culture that was America's most important export—for the African American was always at the center of its creation and development.

"It is a jazz-banjorine that I should bring, not a lute": Brer Rabbit himself could not have framed a brag with warier calculation. Yet its anxious humility is genuine too. Eliot's deliberate association with popular culture, and with its largely African American roots, provided a way of laying claim to revolutionary cultural power while simultaneously acknowledging ambivalence about his relationship to it.

"AMURRICAN CULCHER"

In "Cousin Nancy," a poem of 1915, Eliot thematizes his anxiety over his own cultural identity. Nancy challenges the stale New England tradition of her aunts through her participation in the nascent culture of what we have since learned to call the jazz age:

> *Miss Nancy Ellicott*
> *Strode across the hills and broke them,*
> *Rode across the hills and broke them—*
> *The barren New England hills—*
> *Riding to hounds*
> *Over the cow-pasture.*

> *Miss Nancy Ellicott smoked*
> *And danced all the modern dances;*
> *And her aunts were not quite sure how they felt about it,*
> *But they knew that it was modern.* (*Complete* 17)

The second stanza historically situates the poem by alluding to the craze for "social dancing" that was sweeping across America (and blowing on to Europe) at just that time, an extension of the popularity of ragtime. Restaurants were laying dance floors and hiring dance bands in 1912; by the next year, theaters and ballrooms were beginning to sponsor dance contests and department stores were advertising *thés dansants* (Ewen 181–82). Nancy Ellicott's "modern dances" followed one another in rapid succession. And of course the establishment voiced its disapproval, continuously and strenuously.

Eliot was not about to range himself with that reflexive opposition and its expressions of alarm. His endorsement of Nancy's offensive against social authority is signaled by his comic portrayal of her aunts' befuddlement and by the parenthetical description of the matriarchal New England hills as "barren." But Nancy's unconventionality also makes Eliot sufficiently uncomfortable that he must parry it with irony, chiefly by making Nancy a romantic heroine of gargantuan dimensions. As a metaphor for her indulgence in tobacco and the tango, the image of Nancy bestriding and breaking the hills is simply out of proportion, an effect replicated when "Riding to hounds" is juxtaposed with "Over the cow-pasture." Nancy's rebellion is thus rendered nearly as absurd as her aunts' reaction.[9]

Yet in its original setting in *Prufrock and Other Observations*, "Cousin Nancy" appears among such other satires of high-bourgeois society as "The Boston Evening Transcript" and "Aunt Helen." In this context, Nancy's subversion, like that of Mr. Apollinax, remains admirable. The poem's final lines go so far as to align her with George Meredith's "Prince Lucifer" against the heavenly order of Victorian culture:

> *Upon the glazen shelves kept watch*
> *Matthew and Waldo, guardians of the faith,*
> *The army of unalterable law.* (*Complete* 18)

Although the association of Nancy with Lucifer continues to ironize her, this ending, as Ronald Bush points out, moves "beyond social satire" (24). By 1915 the cultural "law" of Arnold and Emerson is hardly "unalterable": Nancy's modern dances and the insurgent modernity they

represent are in the process of altering it beyond recognition, leaving Matthew and Waldo scowling from their glazen shelves. But the poem offers no clear point of view on this paradigm shift. It registers a certain enjoyment of Nancy's transgressions, the confusion of her aunts, the discomfiture of the two sages—and it qualifies this appreciation with an evident uneasiness with the new paradigm (and, doubtless, the "New Woman") that Nancy represents.

Eliot's mixed reaction to Nancy's audacity is symptomatic of his uneasy alliance with the American, the modern, and the popular. Truth to tell, he and Nancy were virtually kissing cousins. Privately he "confess[ed] to taking great pleasure in seeing women smoke"—so he told his real cousin Eleanor Hinkley around the same time he wrote the poem (*Letters* 96). Moreover, he liked the "emancipated Londoners" he was meeting in 1915; they were "charmingly sophisticated (even 'disillusioned') without being hardened," and "quite different from anything I have known at home or here" (96). Vivien Haigh-Wood, one of the "charmingly sophisticated" women mentioned in this letter, became Eliot's wife two months later. Vivien, incidentally, smoked and danced all the modern dances extremely well.

Eliot himself, as a matter of fact, danced all the modern dances— and fretted when he could not. In Oxford late in 1914 he had complained of his disconnection from American cultural developments: "I really feel quite as much *au courant* of [Boston] life as anyone can who has not yet learned the fox trot. . . . I expect when I return to put myself into the hands of Lily for a month of the strictest training" (*Letters* 70).[10] It was too bad: he had such "great fun" on his Atlantic crossing only four months earlier, dancing with various girls "to the sound of the captain's phonograph" (39). At least he was "able to make use of the fox trot"—or of his unfamiliarity with it—in a debate at Merton College on the topic, "Resolved that this society abhors the threatened Americanisation of Oxford": "I supported the negative: I pointed out to them frankly how much they owed to Amurrican culcher in the drayma (including the movies) in music, in the cocktail, and in the dance. And see, said I, what we the few Americans here are losing while we are bending our energies toward your uplift . . . ; we the outposts of progress are compelled to remain in ignorance of the fox trot" (70). Playing up his Americanness, even playing up his Missouri drawl ("Amurrican culcher in the drayma"), Eliot relishes his difference from the society that "abhors" the incursion of American popular culture. He is not altogether bluffing when he portrays Britain as practically an American colony, dependent on the New

World for cultural "uplift" by missionaries such as himself ("we the out-
posts of progress"). As for the fox trot, Eliot has perceived (as Terence
Hawkes explains), that "[t]he new style of ballroom dancing . . . is after
all one of the spearheads of the American cultural penetration of Europe"
(90). Apparently Eliot's audience also saw the point: his side "won the
debate by two votes" (*Letters* 70).

Hawkes points out that for Eliot, gauging English culture from a for-
eigner's perspective, stodgy British dancing reflected a deficient mod-
ernity that similarly vitiated British literary and intellectual life (91). If
English dancing was "very stiff and old fashioned" (*Letters* 97), English
letters was blighted by an analogous "critical Brahminism, destructive
and conservative in temper" (314). "Novelty," Eliot wrote John Quinn
in 1919, "is no more acceptable here than anywhere else, and the forces
of conservatism and obstruction are more intelligent, better educated,
and more formidable" (314–35). Or, as he declared in "Tradition and
the Individual Talent," if *tradition* signifies mere resistance to change,
to modernization, then "'tradition' should positively be discouraged,"
for "novelty is better than repetition" (*Selected* 4).[11] So Eliot was, and
allowed himself to be, a fox-trotting American in England, even if he
did "terrif[y] one poor girl . . . by starting to dip in my one-step" (*Letters*
97).[12] As a self-conscious poet of "Amurrican culcher," he brought the
potency of the popular to his art. It was here, as much as in his formal
innovations or in his urban imagery, that Eliot's modernism lay.

"TINK AND TANK AND TUNK-A-TUNK-TUNK"

Eliot's self-portrait as a performer on the jazz-banjorine stakes his claim
to authority and currency. For to have any truck with jazz at all around
1920 was not only to participate in a particular discourse but to take sides
in an ideological battle over the significance and value of modernity. To
unpack fully the meaning of Eliot's self-fashioning we must consider the
meaning of jazz itself.

Inevitably, Eliot's conception of jazz would have been less selective
than ours. As Howard Rye asserts, minstrelsy and what we have since
come to call *jazz* and *blues* formed a musical continuum in the 1920s
rather than a set of discrete genres (45). The "symphonic jazz" of the
era also belongs to this continuum, as do ragtime and certain genres of
"sheer Tin Pan Alley pop" (Douglas 352). Bernard Gendron has shown
that an "essentialist construction of 'authentic' jazz" was imposed on this
period by later criticism, creating an insupportable dichotomy between

the genuine and the "counterfeit" (13–14). For present purposes, there-
fore, it makes sense to use the term *jazz* in the comprehensive sense it
took on in 1920s discourse—a sense that includes the "classic" (or
"vaudeville") blues, ragtime, any sufficiently syncopated music of the
minstrel stage, the "sweet" jazz of orchestras such as Paul Whiteman's,
and jazz-inflected popular songs and dance music, as well as the New
Orleans style of "hot" jazz to which the term is now usually limited.

Ragtime, however, had an anterior life of its own, and the ragtime
phenomenon prefigured that of jazz. Ragtime had a considerable presence
in Europe, introducing millions there to African American musicianship,
dances like the "cake-walk," and the joys of continual syncopation. The
popularity of ragtime in the United States dated back to the 1890s, with
Britain not far behind; but the smash success of Irving Berlin's "Alex-
ander's Ragtime Band" in 1911 initiated a second wave that brought the
vogue of ragtime to a fever pitch across Europe. At this point a strong
sense developed that something permanent had changed in music and
entertainment—and that this change heralded or represented in its own
right a seismic shift in Western culture.

Its way prepared by ragtime, jazz was laden with extramusical
meanings from the moment the larger public began to hear of it. By 1922
the term *jazz* was often meant to encompass all that was considered char-
acteristic of the "modern condition." Despite its subtitle, for example,
Edmund Wilson's essay of that year, "The Esthetic Upheaval in France:
The Influence of Jazz in Paris and Americanization of French Liter-
ature and Art," barely mentions music: *jazz*, for Wilson, is essentially
synonymous with "American mass culture," represented mainly by the
skyscraper, the machine, and the motion picture. Because of its connec-
tion with nightlife, and because of its African American origins, which
allowed it to be figured as a "primitive" alternative to Western culture,
jazz also became shorthand for "modern," as opposed to "traditional"
values—for relaxed sexual mores, for informality, for leisure rather than
industry, for skepticism rather than faith, and, generally, for relativity in
moral and aesthetic matters (Leonard 70). Jazz was the emblem of an
age engaged in rejecting many of the principles, truths, and conventions
of its predecessor. Eliot's "Portrait of a Lady" invokes this symbology
when the "dull tom-tom" in the young narrator's brain reflexively ham-
mers out his own rebellion against the lady's romantic pretensions.[13]

For any poet to write *jazz* was inevitably to open a window on this
discourse, especially since artistic modernism itself was often associated
with jazz. As an editorialist in the *New York Times* sneered in 1924: "Jazz

is to real music exactly what most of the 'new poetry,' so-called, is to real poetry. Both are without the structure and form essential to music and poetry alike, and both are the products, not of innovators, but of incompetents" ("Topics"). And the American critic Robert Underwood Johnson complained that "The free verse of to-day disdains the lute, the harp, the oboe, and the 'cello and is content with the tom-tom, the triangle, and the banjo" (quoted in North 26)—a comment that further illuminates the context within which Eliot declined the lute for the banjorine.

Other poets willingly accepted and even pressed the same associations. In "A High-Toned Old Christian Woman," which dates, like *The Waste Land*, from 1922, Wallace Stevens taunts a member of the religious, moral, and aesthetic *ancien régime* while specifically linking the "New Poetry" with jazz. Modernity, which the old woman parses as "bawdiness," is "converted" by the poets "into palms, / Squiggling like saxophones" (59). Stevens's habitual figuration of the imagination as tropical coincides conveniently here with popular representations of "jungle jazz." Modern poems (Stevens's "novelties of the sublime") are verbal analogues to the quintessentially modern music identified with the saxophone and the banjo, whose staccato the poem imitates as "tink and tank and tunk-a-tunk-tunk." Stevens's "Of Modern Poetry" similarly defines the modernist timbre as the "twanging [of] a wiry string" (240). Jazz is the "skeptical music" of modern poetry that offers to supplant all preexisting systems of belief.

The most vociferous opposition to jazz came from religious, political, and community leaders, as well as self-appointed moralists (Stevens's "high-toned old Christian woman") who saw the enormous popularity of the new music as a threat to established values and social structures. Its proponents did not dispute this representation of jazz; rather, they treated its disruptive power as a positive force. Gilbert Seldes's defense is typical in this respect: "Jazz is roaring and stamping and vulgar, you may say; but you can not say that it is pale and polite and dying"—as opposed, that is, to "conventional pedantry . . . and a society corrupted by false ideas of politeness and gentility in the arts" ("Effort"). Edmund Wilson likewise contrasted American mass culture with the deathliness of a Europe strewn with "monuments of the dead": American "films and factories and marimbas [i.e., jazz] are at least of the living world" (100). Jazz, like electric signs, was one of those "triumphs and atrocities of the barbarous" that the New World offered a new age. By asserting an alliance with jazz—by offering to play his jazz-banjorine at Mary Hutchinson's soiree—Eliot depicts himself as a

similarly barbarous invader, confessing his atrocity ("I may simply prove to be a savage") but expecting, like jazz, to triumph.

Of course there were also a good many intellectuals, even in avant-garde circles, who wanted nothing to do with jazz. Clive Bell launched one of the ugliest attacks in a 1921 essay called "Plus de Jazz." For Bell, jazz is much less an ethnic music than an artistic movement, a subgenre of modernism, "a ripple" on a larger wave "which began at the end of the nineteenth century in a reaction against realism and a scientific paganism" (93). He wonders whether "the inventors of Jazz" (for African American musicians, to Bell, are merely pawns in an aesthetic contest beyond their scope) believed that nineteenth-century artists were overly dedicated to "beauty and intensity," and he asserts that the essence of the music is impudent rebellion against Nobility and Beauty. This impudence, motivated by a "childish" hatred of culture and intellect, finds its "technical equivalent" in syncopation (93).

When it comes to the work of artists he ascribes to the "jazz movement," Bell is somewhat more sensitive. Cubism was often identified outright with jazz, and Bell concedes that in their exploration of that generally unprofitable territory, Picasso and Braque have "produced works of the greatest beauty and significance" (95). In music—that is, "serious" music—Stravinsky has been "influenced much by nigger rhythms and nigger methods," and thus, Bell concludes, belongs to the jazz movement as much as any great artist can be said to belong to a movement (94). Jazz in literature, according to Bell, appears in syncopated rhythms and in distorted "sequences [of] grammar and logic." Its truest exemplars in poetry are Cocteau and Cendrars, who he says are worth, together, perhaps a half hour's attention. But Eliot, whom Bell calls "about the best of our living poets," is also a product of the jazz movement. In a bizarre conceit Bell figures jazz, Eliot's "black and grinning muse," as midwife to Eliot's "agonizing labors" of composition: "Apparently it is only by adopting a demurely irreverent attitude, by being primly insolent, and by playing the devil with the instrument of Shakespeare and Milton, that Mr. Eliot is able occasionally to deliver himself of one of those complicated and remarkable imaginings of his: apparently it is only in language, of an exquisite purity so far as material goes, but twisted and ragged out of easy recognition that these nurslings can be swathed" (94). I will be arguing presently that there is something to this. Certainly when Eliot published *The Waste Land* a year later, with its "Shakespeherian Rag" and its ragging of Shakespeare, Bell must have looked positively prophetic.[14]

More indicative than Bell's specific judgments, though, is his assumption that there was such a thing at all as a "jazz movement" in the arts; that its methods were in some way connected with the musical techniques of jazz; that its aesthetic goals were embodied in the "meaning" of jazz; that it was socially and culturally iconoclastic. Despite his respect for certain "jazz" artists, Bell is determined to range himself on the side of Beethoven, Beauty, and Nobility against an artistic faction that elevates popular culture over Art. It is a grievous mistake, he suggests, for artists to take seriously either waltzes or ragtime: the divide between popular and high art must not be violated (94). This is the sort of argument that is now often taken to characterize modernism's unalloyed horror of mass culture—usually in contrast with postmodernism's embrace. Yet Eliot's position (for one) is far more nuanced and less hysterical; and as Bell realized, Eliot's genius was thoroughly entangled with his "black and grinning muse." Indeed, Eliot had accepted his place in the jazz movement a long time before.

CONVERGENCE

Eliot's forgotten career in ballroom dance is matched by an overlooked disposition to crooning. Undeterred by vocal abilities considerably less than, say, Joyce's, he enjoyed unleashing a vaudeville tune or a "bawdy ballad" when his company would stand for it.[15] In the 1950s he sang to his friend and guardian Mary Trevelyan selections ranging from African American spirituals to pop (Gordon 212–14). Robert Giroux recollected Eliot's singing, in a single evening, "the verses of more [George M.] Cohan songs than I knew existed" (343). And Valerie Eliot later found her morning ritual of shaving her husband rendered "hazardous" by his spirited interpretations of comic music-hall numbers (T. Wilson 45). Popular song marked the stages of Eliot's life, as it does for others; his first visit to London, in 1910, for example, remained for him "always associated [with] the music of 'In the Shadows' by Herman Finck" (*Letters* 17). Perhaps Eliot could have erected internal barriers sufficient to keep such influences out of his work. But he did not.

 On the contrary, the poems in Eliot's early notebook (published in 1996 as *Inventions of the March Hare*) illustrate the importance of jazz-inflected popular song to the formation of his verse style. "Suite Clownesque" (1910), for example, includes a vaudeville-comic staging of Prufrock's urban wanderings done in a Tin Pan Alley pastiche:

> *If you're walking down the avenue,*
> *Five o'clock in the afternoon,*
> *I may meet you*
> *Very likely greet you*
> *Show you that I know you.* (35)

If such cadences were not recognizable enough, the persona soon makes their origins explicit ("It's Broadway after dark!"); he even alludes to "By the Light of the Silvery Moon," a familiar song hit of the previous year (171). A stage direction prescribing an accompaniment "on the sandboard and bones" introduces a minstrel element into the mix. The poem's diction, generally colloquial, is colored with Americanisms and other expressions of recent vintage ("get away with it," "cocktails," "I guess," "up to date," "very likely," "I'm all right").[16] In an unusually healthy juvenile twist, Eliot gives his comedian-hero an entourage of "girls" (enough to turn heads) and stands "looking them over" later on the beach. Through the mask of the clown, Eliot is able to project a side of his own character normally obscured by ambivalence and self-consciousness; for once he feels "Quite at home in the universe." Immersing himself in the strong popular rhythms that supply his prosodic medium, Eliot celebrates his young, American self as "First born child of the absolute / Neat, complete, / In the quintessential flannel suit" (35). The suit fits Prufrock, who also wears flannel on the beach, as well; but in "Suite Clownesque" the lullaby of Broadway has momentarily soothed the Prufrockian breast.

Eliot's harlequinade and his use of song rhythms both owe a great deal to Jules Laforgue, to whom Eliot had apprenticed himself early in 1909. In his "Complaintes," where the Pierrot figure makes his first appearances, Laforgue, too, experiments by incorporating popular song into his poetry; thus "Complainte de Lord Pierrot" begins by parodying "Au clair de la lune," and "Complainte de cette bonne lune," which Eliot quotes in "Rhapsody on a Windy Night," opens with an imitation of "Sur le pont d'Avignon." In these poems, as Anne Holmes argues, Laforgue rewrites familiar materials to "complicate and fuse worlds": the past, pastoral, romanticized realm evoked by the musical allusion and his own sophisticated, urban milieu (34). The technique clearly made an impression on Eliot, whose own allusions frequently perform a similar function. It may even suggest a Laforguean and popular prehistory for the "mythical method," whose purpose is likewise the complication and fusion of worlds.

The rhythmic model of popular song played a critical role in helping Laforgue break with the "formal Alexandrine" of traditional French prosody (Collie and L'Heureux 5), just as it may have helped Eliot reduce iambic pentameter to the "ghost of [a] meter" (*To Criticize* 187). At the same time, Laforgue's use of popular music in the "Complaintes" has certain limitations not present in the early Eliot. In particular, Laforgue's popular songs tend to be isolated within their host poems, their simple verse forms surpassed by the poems' own complex structures of rhyme and mutable line length (Holmes 81). It could be argued that these "intricately patterned stanzas" are themselves songlike, as in Donne's *Songs and Sonnets*;[17] but if so, their musical quality remains quite different from that of the songs they actually quote. It can hardly be said, for instance, that "Complainte de Lord Pierrot" as a whole is suffused with the cadences of "Au clair de la lune."

The more consequential Laforguean model for Eliot's musical prosody is his posthumous *Derniers Vers,* which helped establish *vers libre* in French. Eliot's early poems even show a prosodic development parallel to Laforgue's: "Spleen" and "Conversation Galante" borrow their versification from the "Complaintes," while the poems that follow work their way toward *Derniers Vers.* " 'Portrait of a Lady,' 'Prufrock' and 'La Figlia che Piange' are all in free verse of the kind toward which Laforgue's poetry evolved: irregular lines representing emotive ideas compose a stanza-sentence, with irregular rhyme and assonance lending firmness to fluid structure. . . . Through most of his first book Eliot exploits the instrument developed by Laforgue in his last" (Ramsey 202). Eliot must have been thinking of the *Derniers Vers* when he told Donald Hall in 1963: "My early *vers libre,* of course, was started under the endeavor to practice the same form as Laforgue," which required "rhyming lines of irregular length, with the rhymes coming in irregular places" (Hall 97).

One of the powers of this loose "form" is its ability to echo the "shifting play of emotions" expressed in the words (Holmes 129), a capacity that depends on a ductile, songlike patterning rich in unpredictable aural effects. Just as the words of a popular song follow a musical substructure that is hidden when the lyrics are printed, Laforgue's lines seem to take shape around a concealed framework:

> *Je fume, étalé face au ciel,*
> *Sur l'impériale de la diligence,*
> *Ma carcasse est cahotée, mon âme danse*
> *Comme un Ariel;*

> *Sans miel, sans fiel, ma belle âme danse,*
> *O routes, coteaux, ô fumées, ô vallons,*
> *Ma belle âme, ah! récapitulons.* (*Derniers* 213)

The manuscript of "L'Hiver qui vient," the first of Laforgue's late poems, shows Laforgue working backward from "long Whitmanesque lines" (he had recently been translating the American poet) toward a more "musical" effect produced by short, irregular lines saturated with repetition, rhyme, near rhyme, and internal rhyme (Holmes 119–20). It is really in these last poems, rather than in the "Complaintes," with their song quotations, that Laforgue earns his laurels as the "Watteau of the café-concert." For in the *Derniers Vers*, the songs of the French music hall have fully permeated the poetry: the use of song is no longer separable from the quality of the verse itself. This achievement is Laforgue's most significant gift to Eliot, surpassing even the better-noted attributes of urbanity and self-reflexive irony.[18]

Yet Eliot's poems also have a rhythmic suavity quite distinct from the ejaculatory style of *Derniers Vers*, with its jagged syntax and concentration of exclamation points; the later poet produces the effect of continual syncopation with considerably less strain. No doubt the difference derives in part from the linguistic gulf between French and English, but it also inheres in the two poets' underlying musical models, for Eliot's world of popular song is not Laforgue's. What the apprentice poems of *Inventions of the March Hare* now enable us to see is that the acknowledged influence of Laforgue was complemented by the nearly suppressed, yet indispensable, influence of American jazz. It was the *convergence* of these elements—or their chemical interaction in the presence of the poet's mental catalyst—that produced the masterpieces of the *Prufrock* period. Laforgue showed Eliot how to adapt his voice to the popular material around him, and jazz gave Eliot a way to bring Laforgue into contemporary English; that is, a way to incorporate the inflections of his own language in a form of verse derived from another.[19]

The crucial text, an untitled poem written in February 1911, makes the confluence of Laforgue's modernity with the experience of jazz all but explicit—enacts, in fact, the process by which Eliot put them together. The narrator of this poem sits in a Parisian cabaret, where he languishes among

> *The smoke that gathers blue and sinks*
> *The torpid smoke of rich cigars*
> *The torpid after-dinner drinks . . .* (*Inventions* 70)

The attitude of sophisticated ennui owes much to Laforgue as well as to Arthur Symons, who introduced Eliot to Laforgue. The torpid smoke, a fin-de-siècle cliché, echoes such poems as Symons's "At the Cavour," which is already derivative of, for instance, Laforgue's "La cigarette."[20] In the second stanza the speaker's drifting attention is finally caught by the live music around him, and Eliot's verse, heretofore as fatigued as Symons's, swerves abruptly into an entirely new form:

> *What, you want action?*
> *Some attraction?*
> *Now begins*
> *The piano and the flute and two violins*
> *Someone sings*
> *A lady of almost any age*
> *But chiefly breast and rings*
> "Throw your arms around me—Aint you glad you found me"
> *Still that's hardly strong enough—*
> *Here's a negro (teeth and smile)*
> *Has a dance that's quite worth while*
> *That's the stuff!*
> *(Here's your gin*
> *Now begin!) (70)*

And with that, presumably, the poet begins to fox trot. The stanza depicts protojazz performance and dance, quotes an actual lyric, includes appropriate slang ("action," "the stuff"), and strikingly imitates the angular rhythms and sudden rhymes of popular songs of the period, under the inspiration of ragtime. Ragtime, as Philip Furia explains, "licensed the vernacular as a lyrical idiom and forced the lyricist to construct a lyric out of short, juxtaposed phrases marked by internal rhymes and jagged syntactical breaks" (49). An ear for these qualities helped make Eliot, like the bandleader of Irving Berlin's "Alexander's Ragtime Band"—another composition of 1911—a "ragged meter man."

Eric Sigg has posed the question, "Is it too much to suppose that American popular music, whether from ragtime or Tin Pan Alley, helped to cultivate Eliot's ear for rhythm?" (21). The question need not be posed rhetorically: on the evidence of *Inventions of the March Hare* we can be sure that the influence of American popular music was indeed critical. It would be no exaggeration to call "The smoke that gathers blue and sinks" jazz poetry *avant la lettre*. Eliot's lines anticipate the musical techniques that would be exploited by Langston Hughes at the height of the jazz age.

Still, Eliot's precocity would be of only passing interest if he had merely experimented with such a verse form and then moved on. In reality, however, the explicit references to popular music in "Suite Clownesque" and "The smoke that gathers blue and sinks" foreground an element that is no less significant, only better assimilated, in the famous lines composed only a few months later. Compare

> *First born child of the absolute*
> *Neat, complete,*
> *In the quintessential flannel suit. ("Suite Clownesque")*

with

> *And indeed there will be time*
> *To wonder, "Do I dare," and, "Do I dare?"*
> *Time to turn back and descend the stair,*
> *With a bald spot in the middle of my hair. ("The Love Song*
> *of J. Alfred Prufrock")*

or

> *And I must borrow every changing shape*
> *To find expression . . . dance, dance*
> *Like a dancing bear,*
> *Cry like a parrot, chatter like an ape.*
> *Let us take the air, in a tobacco trance. ("Portrait of a Lady")*

Though these lines drape loosely over a skeleton of iambic pentameter, what gives them the particular character that one recognizes as Eliotic has no source in classical metrics. Nor is this inflection lost in *The Waste Land*, nor even years later in *Ash Wednesday*:

> *The new years walk, restoring*
> *Through a bright cloud of tears, the years, restoring*
> *With a new verse the ancient rhyme. Redeem*
> *The time. Redeem*
> *The unread vision in the higher dream. (Complete 64)*

Eliot's patented cadences—his characteristic rhythms, the ways he uses rhyme, the tonal contours of his lines—were discovered in the sounds of popular music circa 1911. It is, in fact, "Amurrican culcher . . . in music, in the cocktail, and in the dance" that gives Eliot's poetry its distinctive resonance.

NOTES

1. A few examples spanning seven decades: Clive Bell (1921) places Eliot within a larger "jazz movement" in the arts (94), but his conception of jazz—to which I will return in this essay—is significantly distorted. Stephen Spender (1935) finds Eliot "experimenting with jazz" in *Sweeney Agonistes* but does not elaborate (187). Morris Freedman (1952) does not distinguish jazz from operetta or even from nursery rhymes; thus any sharp rhythms in Eliot's poetry are immediately declared to be "jazz." Carol H. Smith (1985) discusses Eliot's "jazz rhythms" intelligently, though with reference only to *Sweeney Agonistes* (51–61). Marshall McLuhan (1985) comments perceptively on the relation of Eliot's art to his American background; however, his assertion that Eliot "said a great deal about jazz and blues, both in his prose and in his poetry" seems hyperbolic, and the connection he makes between Eliot and jazz remains an inspired hunch (122). Robert Fleissner (1990) alludes nebulously to "some jazz or music-hall-revue syncopation in Eliot's early poetry" (1).

2. Eliot's attitude may be gauged from his December 1917 comment to his brother: "Somehow I have not felt since last March that I ever wanted to see America again. Certainly at the present time I think I should feel like an adult among children" (*Letters* 216). By 1919 he was "depressed by my awareness of having lost contact with Americans and their ways, and by the hopelessness of ever making them understand so many things" (307).

3. Unfortunately, English civilization was currently in abeyance. As Eliot wrote in 1915, "I do not think that I should ever come to like England—a people which is satisfied with such disgusting food *is not* civilised" (*Letters* 88).

4. Apparently Eliot's acquaintances in England remained always conscious of his Americanness. In 1918, for example, during a period of British curiosity about baseball, Eliot found himself "constantly called upon to explain terms" (*Letters* 237). And even after his death, his friend Hope Mirrlees was commenting on the "indestructible American strain" in Eliot, which she claimed he acknowledged. "He wasn't a bit like an Englishman," she remarked ("Out of the Air").

5. In his memoir, Joseph Chiari records the feeling that he and Eliot, even in his later years, shared: that "seen within the context of the highly evolved and complex English society to which we were both deeply attached, we nevertheless were two kinds of primitives, he from Missouri and I from Corsica" (12).

6. In the paragraph that follows, Eliot twice expresses regret at having to turn down an invitation for the following Sunday.

7. Linn 83–84; Winans and Kaufman 14–15.

8. Here, for example, is Eliot in 1934, aping Pound aping Uncle Remus: "Now, Mr. Orage, Sir, I am going to set round the chimbly and have a chaw terbacker with

Miss Meadows and the gals; and then I am going away for a 4tnight where that old Rabbit can't reach me with his letters nor even with his post cards." The letter to the *New English Weekly* that this passage concludes is signed, "I am, dear Sir, Your outraged POSSUM" (" 'Use' ").

9. The gender issues raised by "Cousin Nancy" are certainly worth considering as well, and though I do not discuss them here, I have treated them elsewhere (Chinitz 323–24).

10. Valerie Eliot's note identifies the instructor mentioned here as Lily Jones of Cambridge, who, "with her sister Pauline, taught dancing and was involved in local theatricals" (*Letters* 70).

11. Clearly Eliot is working out the ideas presented in "Tradition and the Individual Talent" in both the letter to John Quinn just quoted and the letter to Eleanor Hinkley quoted earlier. The letters were written only two days apart (9 and 11 July 1919) and the essay published a few months later in the *Egoist*.

12. Eliot's letters show dance to be an ongoing activity in his life, at least in the earlier and happier days of his marriage to Vivien, and before the business of editing the *Criterion* caught up with him. He was as eager to know "all the modern dances" in 1919 as he had been five years earlier (*Letters* 275), and he and Vivien often passed a Sunday afternoon dancing to the gramophone in their apartment or at a Queensway dance hall (Matthews 53–54). Eliot even regretted the end of his dancing days. Many years later, his troubles finally assuaged by his second marriage, Eliot told the *Daily Express*, "I am thinking of taking up dancing lessons again, as I have not danced at all for some years" (Ackroyd 321). For the earliest image of a dancing Eliot, see the narrative of Margaret Shapleigh quoted in Soldo, which gives us young "Tom" as a St. Louis school boy, costumed as a farmer in "blue jeans, plaid shirt & straw hat" (27). Soldo also notes Eliot's participation in the Brattle and Buckingham Hall social dances at Harvard (57).

13. In 1920s discourse the tom-tom, like the saxophone, quite often stands synecdochically for jazz. It appears that this association was valid a decade earlier for the Eliot of "Portrait."

14. Eliot himself apparently considered Bell an intellectual lightweight: "Bell is a most agreeable person, if you don't take him seriously, but a great waster of time if you do, or if you expect to get any profound knowledge or original thought out of him" (*Letters* 450).

15. This seems to have occurred with some regularity. For examples see Richards 6, Read 15, and Duncan 278. At a party celebrating his receipt of the Nobel Prize in 1948, for example, Eliot treated the assembled well-wishers to a rendition of "Under the Bamboo Tree" (Ackroyd 290), a tune he had learned more than forty years earlier and that he had meanwhile parodied in *Sweeney Agonistes*.

16. The first three phrases are specifically identified by the *Oxford English Dictionary* (*OED*) as originating in the United States. Eliot's usage of "get away with it" predates by two years the first citation in the *OED* (under "get," 61c); "I guess," meaning "I am pretty sure," is historically rooted in Yankee understatement (see "guess," 6). "Likely," in the sense of "probably, in all probability," has largely been replaced by "most likely" and Eliot's "very likely," which dates from the late 1800s (B. *adv.*, 2).

17. The connection Eliot makes between Donne and Laforgue in "The Metaphysical Poets" is based on both poets' ability to integrate thought and complexity of feeling in their verse (*Selected* 248–49). In a 1931 essay called "Donne in Our Time," Eliot extends this point about Donne in a way that strongly suggests the technical resemblance to Laforgue to which I have alluded here: "Donne . . . first made it possible to think in lyric verse, and in a variety of rhythms and stanza schemes which forms an inexhaustible subject of study; and at the same time retained a quality of song and the suggestion of the instrumental accompaniment of the earlier lyric" (16–17).

18. Eliot is also beholden to Laforgue's frank portrayal of the cityscape, but here his debt to Baudelaire is at least as great. And Laforgue himself took this page from Baudelaire.

19. Several critics have remarked on the disparity between English and French verse; Annie Finch, following the lead of C. K. Stead, has even argued that Eliot's success in negotiating this difference produces his unique prosody (87). I suggest that Eliot's adoption of American jazz to fill the role that the music of the *café-concert* had played for Laforgue is what made this difficult feat practicable.

20. Symons: "The blue-grey smoke of cigarettes / Curls from the lessening ends that glow" (33). Laforgue: "Moi, le méandre bleu qui vers le ciel se tord / Me plonge en une extase infinie et m'endort / Comme aux parfums mourants de mille cassolettes" (*Oeuvres* 443).

WORKS CITED

Ackroyd, Peter. *T. S. Eliot: A Life.* New York: Simon & Schuster, 1984.

Bell, Clive. "Plus de Jazz." *New Republic* 21 Sept. 1921: 92–96.

Bush, Ronald. *T. S. Eliot: A Study in Character and Style.* New York: Oxford University Press, 1983.

Chiari, Joseph. *T. S. Eliot: A Memoir.* London: Enitharmon, 1982.

Chinitz, David. "'Dance, Little Lady': Poets, Flappers, and the Gendering of Jazz." *Modernism, Gender, and Culture: A Cultural Studies Approach.* Ed. Lisa Rado. New York: Garland, 1997.

Collie, Michael, and J. M. L'Heureux. Introduction. Laforgue, *Derniers* 3–16.

Douglas, Ann. *Terrible Honesty: Mongrel Manhattan in the 1920s.* New York: Farrar, Strauss, 1995.

Duncan, Ronald. *How to Make Enemies.* London: Hart-Davis, 1968. "The Effort to Take Jazz Seriously." *Literary Digest* Apr. 1924: 29–30.

Eliot, T. S. *The Complete Poems and Plays 1909–1950.* New York: Harcourt, 1971.

———. "Donne in Our Time." *A Garland for John Donne: 1631–1931.* Ed. Theodore Spencer. Cambridge: Harvard University Press, 1931, 1–19.

———. *Inventions of the March Hare: Poems 1909–1917.* Ed. Christopher Ricks. New York: Harcourt, 1996.

———. *The Letters of T. S. Eliot, Vol. 1: 1898–1922.* Ed. Valerie Eliot. San Diego: Harcourt, 1988.

———. *Selected Essays.* New ed. New York: Harcourt, 1960.

———. *To Criticize the Critic.* New York: Octagon, 1965.

———. "The Use of Poetry." Letter. *New English Weekly* 14 June 1934: 215.

Ewen, David. *The Life and Death of Tin Pan Alley.* New York: Funk, 1964.

Finch, Annie. *The Ghost of Meter: Culture and Prosody in American Free Verse.* Ann Arbor: University of Michigan Press, 1993.

Fleissner, R. F. "Eliot's Appropriation of Black Culture: A Dialogical Analysis." Special session on "T. S. Eliot and Ethnicity," MLA Convention, Chicago, 28? Dec. 1990.

Freedman, Morris. "Jazz Rhythms and T. S. Eliot." *South Atlantic Quarterly* 51 (1952): 419–35.

Furia, Philip. *The Poets of Tin Pan Alley: A History of America's Greatest Lyrics.* New York: Oxford University Press, 1990.

Gendron, Bernard. "Jamming at Le Boeuf: Jazz and the Paris Avant-Garde." *Discourse* 12 (1989- 90): 3–27.

Giroux, Robert. "A Personal Memoir." Tate 337–44.

Gordon, Lyndall. *Eliot's New Life.* Oxford: Oxford University Press, 1988.

Hall, Donald. Interview with T. S. Eliot. *Writers at Work.* 2nd Series. Ed. Van Wyck Brooks. New York: Viking, 1963, 89–110.

Hawkes, Terence. *Meaning by Shakespeare.* London: Routledge, 1992.

Holmes, Anne. *Jules Laforgue and Poetic Innovation.* Oxford: Clarendon, 1993.

Laforgue, Jules. *Derniers Vers.* Ed. Michael Collie and J. M. L'Heureux. [Toronto]: University of Toronto Press, 1965.

———. *Oeuvres Complètes.* Lausanne: Editions L'Age d'Homme, 1986.

Leonard, Neil. *Jazz and the White Americans.* Chicago: University of Chicago Press, 1962.

Linn, Karen. *That Half-Barbaric Twang: The Banjo in American Popular Culture.* Urbana: University of Illinois Press, 1991.

Matthews, T. S. *Great Tom: Notes towards the Definition of T. S. Eliot.* New York: Harper, 1974.

McLuhan, Marshall. "Mr. Eliot and the St. Louis Blues." *Antigonish Review* 62–63 (1985): 121–24.

North, Michael. *The Dialect of Modernism: Race, Language, and Twentieth-Century Literature.* New York: Oxford University Press, 1994.

"Out of the Air: Eliot's Life." *Listener* 14 Jan. 1971: 50.

Pound, Ezra. *Selected Poems of Ezra Pound.* New York: New Directions, 1957.

Ramsey, Warren. *Jules Laforgue and the Ironic Inheritance.* New York: Oxford University Press, 1953.

Read, Herbert. "T.S.E.—A Memoir." Tate 11–37.

Richards, I. A. "On TSE." Tate 1–10.

Rye, Howard. "Fearsome Means of Discord: Early Encounters with Black Jazz." *Black Music in Britain.* Ed. Paul Oliver. Philadelphia: Open University Press, 1990, 45–57.

Schwartz, Delmore. *Selected Essays of Delmore Schwartz.* Ed. Donald A. Dike and David H. Zucker. Chicago: University of Chicago Press, 1970.

Sigg, Eric. "Eliot As a Product of America." *The Cambridge Companion to T. S. Eliot.* Ed. A. David Moody. Cambridge: Cambridge University Press, 1994, 14–30.

Simpson, J. A., and E. S. C. Weiner, eds. *The Oxford English Dictionary.* 2nd ed. Oxford: Clarendon, 1989.

Smith, Carol H. "Sweeney and the Jazz Age." *Critical Essays on T. S. Eliot: The Sweeney Motif.* Ed. Kinley E. Roby. Boston: G. K. Hall, 1985, 87–99.

Soldo, John J. *The Tempering of T. S. Eliot.* Ann Arbor: UMI Research Press, 1983.

Spender, Stephen. *The Destructive Element.* London: Jonathan Cape, 1935.

Stevens, Wallace. *The Collected Poems of Wallace Stevens.* New York: Vintage, 1954.

Symons, Arthur. *Selected Writings.* Ed. R. V. Holdsworth. Cheadle: Carcanet, 1974.

Tate, Allen, ed. *T. S. Eliot: The Man and His Work.* New York: Dell, 1966.

"Topics of the Times: Before Long They Will Protest." *New York Times* 8 Oct. 1924: 18.

Wilson, Edmund. "The Aesthetic Upheaval in France: The Influence of Jazz in Paris and Americanization of French Literature and Art." *Vanity Fair* Feb. 1922: 49+.

Wilson, T. "Wife of the Father of *The Waste Land.*" *Esquire* May 1972: 44–46.

Winans, Robert B., and Elias J. Kaufman. "Minstrel and Classic Banjo: American and English Connections." *American Music* 12 (1994): 1–30.

Culture, Race, Rhythm
Sweeney Agonistes and the Live Jazz Break

KEVIN McNEILLY

INTERROGATING CULTURE:
"I GOTTA USE WORDS WHEN I TALK TO YOU"

In *Sweeney Agonistes*, T. S. Eliot achieves a radical form of cultural critique through a complex juxtaposition of high and low culture, elegance and violence, classicism and vulgarity. The fragmented discourse, because it cannot be made simply to resolve into particular styles or conventions, calls into question the structure and origin of those very categories. "[P]erhaps you're alive," the final chorus intones in speculative parataxis, "And perhaps you're dead"—the status of listener or reader absolute only in its uncertainty (*Collected Poems* 136). Numerous readers have noted the poem's racy, Americanized or "jazz" idiom (see Ellis 34, 206n), but few have pursued with any rigor the critical consequences of this hybridity for the cultural framing Eliot undertakes in this text. The "jazz" of *Sweeney Agonistes* engenders certain layers of indeterminacy, concentric strata that the poem itself, as it moves forward through its vestigial "plot," digs through and peels back in an apparent effort to make meaning, to exceed its fragments. But such a struggle for resolution is necessarily frustrated by the indeterminacy at the core of the text itself; the onomatopoeic "KNOCK" with which the second part closes in effect reduces that struggle for meaning ("What's that mean?" Doris asks repeatedly in the prologue [*Collected Poems* 125]) not to meaningless frustration so much as to the presemantic rhythmic components of language. Those fundamental beats invoke an inarticulable, unstable violence as they pound out, and are, as verbal performatives, essentially the only

action of the text. Echoing the knocking in the Prologue, they not only create a rhythmic backdrop for *Sweeney Agonistes* but also return readers to the senseless syllabary ("Hoo ha ha," "KNOCK KNOCK KNOCK") upon which sense, form, and even culture want here to be founded. The text's jazz draws its readers through interrogations of national culture (in the tensions between English and American or "home" and foreignness in the Prologue), racial discourse (in the appropriation of minstrel song and burnt-cork vaudeville), and rhythm (distending fixed meters with improvisatory excesses), in order to dissect the generative contradictions of utterance, of making sense with words. When Sweeney slurs, "I gotta use words when I talk to you," he foregrounds the paradox born of the insufficiency of speech and the compulsion to speak.

Published serially in two fragments in *Criterion* (October 1926 and January 1927), *Sweeney Agonistes* appeared in its current form in 1932. It can be read as an extension of the techniques used in *The Waste Land* of 1922, fulfilling the promise made in the earlier poem's third section that the "sound of horns and motors . . . shall bring / Sweeney to Mrs. Porter in the spring" (*Collected Poems* 70). Eliot's interest in music-hall performance, which appears to have inspired the "Shakespeherian Rag" of *The Waste Land*'s "A Game of Chess," is expanded to the reworking of popular song and vaudevillian antics throughout *Sweeney Agonistes*. The fragmentation of European culture diagnosed in the former text is reenacted in the later work and in Eliot's critical writing of the period.

In *The Use of Poetry and the Use of Criticism* (1933), Eliot accommodates what he calls the "demands" of the current "age," arguing that the task of such writing is the "lifting of the burden of anxiety and fear which presses upon our daily life so steadily that we are unaware of it" (141, 144). Poetry's critical task is cultural: to engender a defamiliarization, "the breaking down of strong habitual barriers" (144). The diagnoses contained within *The Waste Land* and *Sweeney Agonistes* also call for an epistemic shift, a coming to social and cultural awareness; neither mystical nor escapist, poetry and critical discourse are "used" by both poet and reader to "cut across all the present stratifications of public taste—stratifications which are perhaps a sign of social disintegration" (152) and foster a refocusing of attention, a contemporary rethinking of social and cultural relationships (150). Poetry attends, for Eliot, to its social formations and analyzes self-consciously the cultural forces that produce the stratifications and conventions in language.

Eliot's conception of "culture" nevertheless appears at first more conservative than radical. In *The Use of Poetry and the Use of Criticism*,

he asserts the need for a "sound theology" as a basis for the poet's social interrogations (150). In his *Notes towards the Definition of Culture*, he seeks to reassemble the cultural remains of postwar Europe, arguing that the "dominant force in creating a common culture between peoples each of which has its distinct culture is religion," specifically Christianity, which offers "the common tradition, . . . the common cultural elements and the common ideals" to remake a "unity" out of disintegrated and defeated nations and to reinscribe the hegemony of "the Western world" (122–23). The fragments that the poet shores against his ruins in *The Waste Land*, a work predicated on unresolvable crisis, seem in this more recent work to have given way to the comforting fixities of orthodoxy.

But Eliot's sense of tradition, even as far back as "Tradition and the Individual Talent" (1917), is not based simply in reaction or retreat. He repeatedly approves a differential process of cultural formation, what he calls "the ecology of cultures" (*Notes* 58). Examining differences in region, class, and language both within and among nations, he argues for a kind of kinetic tension among both individuals and groups, stressing "the vital importance for a society of *friction* between its parts" (58). Culture is thus founded on both internal and external animosities, on the sense of an "enemy," but an enemy whose antagonistic presence—as irritant, as difference—subtends an ongoing challenge to the staid fixities of cultural orthodoxy:

> I do not approve the extermination of the enemy: the policy of exterminating or, as is barbarously said, liquidating enemies, is one of the most alarming developments of modern war and peace, from the point of view of those who desire the survival of culture. One needs the enemy. So, within limits, the friction, not only between individuals but between groups, seems to me quite necessary for civilization. The universality of irritation is the best assurance of peace. A country within which the divisions have gone too far is a danger to itself: a country which is too well united—whether by nature or by device, by honest purpose or by fraud and oppression—is a menace to others. (59)

Eliot writes in the wake of the defeat of totalitarian regimes, and one can hear in his text hints of nationalist protectionism. But against that strain Eliot also offers a model of peace through the dynamic balancing of opposed "forces" (61), a mutual strengthening of local and global, of citizen and stranger, across the national and cultural borders that they draw for themselves. Culture, as the process of constructing such boundaries,

must constantly encounter the Others that exist at its edges, in order to maintain its own viability as a locus of societal bonding.

Difficulties arise in this paradigm, especially a propensity for xenophobia. (The equation between an "ideal" and "Christendom" declares a Eurocentric ethos [82].) The argument for retaining certain strata of class and region is also based, paradoxically, on a dilution of the aggressive energies Eliot saw as necessary to cultural vitality: "Numerous cross-divisions favour peace within a nation, by dispersing and confusing animosities; they favour peace between nations, by giving every man enough antagonism at home to exercise all his aggressiveness. The majority of men commonly dislike foreigners, and are easily inflamed against them; and it is not possible for the majority to know much about foreign peoples" (60). Eliot's aim is to pacify the masses so that they are more easily managed by the ruling class, and a blind dislike of the foreign is fostered more to cement cultural bonds under that elite leadership than to encourage the awareness of difference or the dynamic remaking of cultural frames of reference. Eliot condescendingly notes the epistemic failure of "the majority" to attain any sort of thorough self-consciousness.

An encounter with the foreigner, as both tourist and cultural invader, shapes the "Fragment of a Prologue" from *Sweeney Agonistes*. Steve Ellis points out the "racy American idiom" of the poem, a "trans-Atlantic" tension between the gentlemanly propriety of English speech and the "vulgar" and "crude" textures of American slang (Ellis 34; Williamson 195). Eliot prefaces that encounter, however, with a brief examination of English convention, here figured as the proper way to address a lady, the *politesse* through which improprieties are kept unmentionable. The text traces a hypocrisy within Englishness against which a non-English presence can manifest itself, commencing with an exchange between the two ladies of the poem, Dusty and Doris, over the relative merits of their friend Sam Wauchope and the untrustworthy Pereira. They inquire into the nature of a gentleman, with Dusty providing the defining point: a gentlemen, she says, can always be trusted. Sam, then, is a gentleman, but Pereira is not (*Collected Poems* 123).

"Pereira" (named for Bishop Henry Horace Pereira, 1845–1926, Honourary Chaplain to Queen Victoria and leader of the English temperance movement [Roby 104]), represents manners without substance, hollow hypocrisy. His name suggests position and prestige, but its meaning remains lacunal and unclear: the fragments of the text never identify him or clarify his role. Conversely, a gentleman such as Wauchope is trustworthy, a "nice boy" who lives up to the expectations of

polite role-playing, maintaining the "urbanity" and "civility" of social conventions—terms that Eliot uses to define the "refinement of manners" of a particular "social class" and "the superior individual as representative of the best of that class" (*Notes* 22).

Wauchope and Pereira are opposed tendencies contained within the category of Englishness; the concept of the gentleman comes under scrutiny in the poem only with the entrance of two Americans, with the intrusion of the foreign into the contrived domestic harmony of Doris Dorrance's "home." Sam Wauchope and Captain Horsfall enter with, as Wauchope says, "two friends of ours, / American gentlemen here on business" (*Collected Poems* 127). But the resonance of "gentleman" has shifted away from proper conduct to an identification with the foreign "gentlemen" from abroad; it becomes a marker of "business" interest, potential paying customers for the ladies. The style of Klip and Krum is a contrived informality, and the set of conventions that designates them as "gentlemen" separates them from English manners (represented, ironically, by a Canadian and thus exposed as a contrivance of place and discourse rather than as any genetic or national disposition) (128).

Their grammatically improper colloquialisms—"me and the cap," "as you folks say"—signal cultural difference, at odds with the mannered propriety of Sam and all "nice" English boys. These phrases are the first inklings of the patter that the Agon develops into a key stylistic marker of Sweeney, who has up to now emerged only peripherally as a "very queer" presence read in the cards (125). Klip and Krum also have pronounced American accents, rendering lieutenant as "lootenant," or "the Loot," instead of "leftenant," after the proper British (or standard Canadian) manner, although they attempt after their own fashion to be proper and polite, to say the right things ("I should say . . ."). Again, they designate themselves as "foreign," their slang closely tied to vaudevillian rhyme, when Klip lilts that "we got the Hun on the run" (128).

Philip Larkin, characterizing the subculture of "the generations that came to adolescence between the wars," his own generation, remembers that certain catchphrases from black American jazz tunes acted as shibboleths for his Oxford circle: "For us, jazz became part of the private joke of existence, rather than a public expertise: expressions such as 'combined pimp and lover' and 'eating the cheaper cuts of pork' (both from a glossary on 'Yellow Dog Blues') flecked our conversations cryptically" (17). Larkin and friends inhabited the same stylizations that mark *Sweeney Agonistes*, borrowing from records or from quasi-ethnographic sources. Jazz, for Larkin, embodied "that unique private excitement that

youth seems to demand. In another age it might have been drink or drugs, religion or poetry. . . . In the thirties it was a fugitive minority interest, a record heard by chance from a foreign station, a chorus between two vocals, one man in an otherwise dull band. No one you knew liked it" (15). Jazz was foreign, anti-British, rebellious, exotic, and private. But Larkin also takes pains to distinguish what he calls jazz of the period from popular British song and dance-band culture. Jazz is not the music of the masses, but something that mass consciousness, at least in England, habitually misses. In his obituary essay on entertainer "Marie Lloyd" from 1922, Eliot enthuses that in the comedian's "tone of voice" and "smallest gestures," she was able to represent and express "that part of the English nation which has the greatest vitality and interest," which is, for Eliot, the "dignity" of class-consciousness, particularly the life of the "lower classes," which he sees as rapidly disappearing (*Selected Prose* 173–74). The quasi-Vaudevillian theatrics of Marie Lloyd oppose the jazz language of *Sweeney Agonistes*, inasmuch as her popular numbers create a nationalistic sympathy with her audiences, while jazz is the music of cultural enemies; jazz talk, in Eliot's fragments, constitutes a verbal form of the "enemy" that he sees as necessary for the fruition of culture, an opposition against which Englishness can consolidate itself and keep "the Hun on the run."

This rhetoric of contention and displacement continues in the gentlemen's next exchange with Dusty and Doris. At stake is the foreigner's ability to place himself, to "know London well" (*Collected Poems* 128). Klip and Krum's overstated politeness, flattering their hosts with pat phrases, wears thin, undone by the impropriety of their Americanisms (128). Forgetting their questioner's name—they have, after all, only just been introduced—throws the hypocrisy of their enthusiasm into relief and becomes boorish to their hostesses; with mocking snideness, Dusty demands that if they like London so well, as they have overprofessed, "Why don't you come and live here then?" The offer to make themselves "at home," however, causes Klip and Krum to backpedal, as politely as they can, preferring to remain temporary, tourists. Their mock cosmopolitanism is subsumed by a pose of moral restraint, squeamish about any potential coarseness (a secularized version of Pereiran behavior, no doubt), and the vitality they so "like" in London becomes too much (128). They evoke the idea of a homeland, of being at home, which was coded into the original title for *Sweeney Agonistes* in *New Criterion* (January 1927): "Wanna Go Home, Baby?" (74). The need to go home, coupled with the inability to do so, the "want" of a home in Eliot's "wanna,"

sets up a distension within the text itself, as acculturation, learning to "like" London and to find your way around, is set against the irresolute cosmopolitanism of the American foreigner. If the writer's task is to forge a "unity" for the Western world from postwar wreckage, then by setting up "home" both through and against the "enemy" Americanized language, Eliot problematizes the possibility of ever arriving home again, dramatizing the futility of any such poetic effort.

That tension, far from defeating, enables the difficult activity of articulate utterance. Eliot's poetic, emerging from his sense of cultural displacement as a young American "foreigner" in London, discovers its energies not in coming home, but in the refusal to settle, in both its cosmopolitan brashness and its alienated fear. In a letter to his brother Henry from London (8 September 1914), Eliot complains about the city's urban mess: "The noise hereabouts is like hell turned upside down. Hot weather, all windows open, many babies, pianos, street piano accordions, singers, hummers, whistlers" (*Letters* 55). Street life, mass culture, is place specific, and the antagonisms of life in London depend on his being a "cultured" American abroad. "You are unfortunate," he writes to Henry in July 1919,

> in having a consciousness—though not a clear one—of how barbarous life in America is. If you had, like all other Americans, no consciousness at all, you would be happier.
>
> Don't think that I find it easy to live over here. It is damned hard work to live with a foreign nation and cope with them—one is always coming up against difference of feeling that make one feel humiliated and lonely. One remains always a foreigner—only the lower classes can assimilate. (310)

Eliot has become his own cultural "enemy," embodying a sense of difference from himself against which he must continually be measured as foreign.

But the trans-Atlantic shift from America to England is not accomplished merely by formalities, and the tension continues within Eliot's discourse (see Ellis 145). In a letter to Mary Hutchinson (possibly 11 July 1919), Eliot tries to define culture by offering a short, chaotic list, including the music of "Mozart, Bach, etc." and attempting to orient his own tastes toward European excellence (317); his claim, however, comes with a proviso, recognizing his own artificiality: "remember that I am a *metic*—a foreigner, and that I *want* to understand you, and all the

background and tradition of you. . . . But I may simply prove to be a savage" (318). His savagery, a theme to be taken up in *Sweeney Agonistes* through Sweeney himself, is voiced here as the American topos of individual freedom, set against the strictly coded proprieties of British civilization. In a letter to Eliot that same month, his mentor Charles W. Eliot expresses confusion over the young poet's rejection of American life: "[I]t is, nevertheless, quite unintelligible to me how you or any other young American scholar can forego the privilege of living in the genuine American atmosphere—a bright atmosphere of freedom and hope. I have never lived long in England—about six months in all—but I have never got used to the manners and customs of any class in English society, high, middle, or low" (323). It is precisely in that rejection of freedom and hope, however, coupled with his own inability to "get used" to English life, that the poet problematizes the very processes of cultural making that constitute the poetic act.

NEGOTIATING RACE: "YOU'LL BE THE CANNIBAL!"

In his *Reader's Guide to T. S. Eliot* (originally published in 1955), George Williamson notes the "shocking incongruity" of "the union of Aristophanes and music-hall verse" in *Sweeney Agonistes*, but maintains that the literary framework of the poem is "sufficiently ironic to lift a music-hall libretto into a disturbing atmosphere" (191, 192). Beginning with the subtitle of the collected version of the text ("Fragments of an Aristophanic Melodrama") and the epigraph from the *Choephoroi*, Williamson wants the poem to foray into popular culture but to maintain its highbrow cachet; he suggests that its vestigial classical structure—the generic delineation of "Prologue" and "Agon," for instance—elevates what otherwise threatens to become melodramatic trash. The shock value of the poem depends on a rather condescending dilettantism, since in Williamson's reading the poet lowers himself into the cultural underside to take hold of a degraded language emblematizing the fragmentation of the world and the ruin of literary expression. Such condescension is at odds with Eliot's reading of Marie Lloyd, for whom he expresses not contempt but envy, asserting that she achieved a "collaboration" with her audiences "which is necessary in all art" (*Selected Prose* 174). The music hall does not need to be "lifted" to the level of literature; instead, poetry needs to return to its mass roots. *Sweeney Agonistes*, from this perspective, aims not to shock so much as to revitalize, by reconnecting formal discourse with the popular sphere.

Carol Smith, writing on "Sweeney and the Jazz Age," takes up the incongruities of musical forms in an attempt to rethink the poem's cultural context: "In order to understand [the] unlikely juxtapositions of theme, setting and hero [in *Sweeney Agonistes*] it is necessary to understand something about Eliot's interest in jazz and the English music-hall in the 1920s and the connections he saw between jazz rhythms and the origins of classical drama" (87). The problem with such a reading is that Eliot appears to have no substantial interest in jazz in the period, rarely mentioning the music by name in his letters, although he does refer to urban noise and popular theater. Smith's reading, blurring "jazz" and "music-hall" performances, takes for granted a continuity that in the late 1920s was highly debatable. A blurring of jazz and popular music did occur at the time, but these categories were always contentious, reflecting the cultural demographics of the urban United States. Kathy Ogren notes that there was substantial confusion about jazz, and the term named everything from a profligate lifestyle to popular records, including black folk music and white art music, as well as hybrids (11–22). To address Eliot's text with any rigor, critics must be as precise as possible about the nature of the hybrid he attempts to create, and not conflate "jazz," "rag," and "music-hall" performances into a vaguely coherent vulgar activity, particularly in the trans-Atlantic context of contemporary England.

The demand to contextualize artistic and critical production comes from Eliot himself. In "A Commentary" (the lead editorial for *New Criterion* in January 1927, where the "Fragment of an Agon" was first published), Eliot wants the writer culturally engaged, "[t]o be perpetually in change and development, to alter with the alterations of living minds associated with it and with the phases of the contemporary world for which and in which it lives" (1). The Shakespearean echo here suggests a departure for Eliot from a sacrosanct traditionalism—Shakespeare's love, after all, does *not* alter when it alteration finds—and an engagement with the particularities of a mutable and elastic expression, a critical direction noted six years later in *The Use of Poetry and the Use of Criticism*: "Each age demands different things from poetry. . . . So our criticism . . . will reflect the things that the age demands. . . . Our contemporary critics, like their predecessors, are making particular responses to particular situations" (141). The "sympathy" and communion with the popular (though "educated") audience, which Eliot praises in Marie Lloyd and in the music hall in general, is transferred here, wishfully, to the critical and poetic realms.

This engagement with a living world, however, does not wholly maintain its particularity or fluidity, and the desire to commune with that world in a vital poetic form prompts Eliot to seek a primal continuity, a basis upon which the sympathy he craves can be sustained. This universal principle is rhythmic: "Poetry begins . . . with a savage beating a drum in a jungle, and it retains that essential of percussion and rhythm" (155). Eliot's evocation of the "jungle" and his insistence on the savage drum links his work with a form of primitivism current in the 1920s and associates it explicitly with black American jazz. The "jungle" sound was, in the late 1920s, a well-traveled epithet for music emerging from New York's cabaret scene, particularly the Chick Webb Jungle Band of 1927–29 and the Cotton Club orchestra of Duke Ellington (Schuller 47, 293). The Cotton Club itself, as Kathy Ogren discovers, was decorated with "graphics patterned after African sculpture or interspersed with palm trees and bongo drums" (76). Ogren notes that this high-energy music was directed specifically toward black audiences, citing an ad for Vocalion Dance Records from the mid-1920s that proclaims that "Vocalion band leaders . . . [including] Duke Ellington and others need no introduction to the Race. Their music always sparkles with life, pep and originality—just what you want when you feel like dancing" (99–100). Gunther Schuller describes the Harlem "Battles of the Bands" in the late 1920s and early 1930s as having "something of the African tribal game-rivalries," expressing "the same competitive spirit and need to excel one finds (or used to find) in African village rituals and games" (292). The drum-saturated jungle sound that Eliot wants to recover in such texts as *Sweeney Agonistes* emerges directly from the nostalgic Afrocentrism of so-called race music in the Harlem Renaissance. The drumbeats behind Sweeney's text are displaced versions of the "low beating of the tom-toms" that "stirs" the poet's blood in Langston Hughes's "Danse Africaine," evoking the imagined "depths of my Africa" (Hughes, *Selected Poems* 7, 8).

But that displacement is not to be taken for granted, nor are Eliot's appropriated jungle sounds as immediately accessible to him as they might appear. Eliot's jungle, given both his racial and national contexts, is not quite the Africa imagined by Hughes, though both are nostalgic for a living presence represented by the exotic primitive. Even Hughes and others associated with the Harlem Renaissance, while revaluing jazz as "part of the cult of primitivism," as Kathy Ogren notes, were suspicious of the potentially negative racial stereotypes it embodied; historian Nathan Huggins argues that there was a certain "myopia" among the

leaders of the Harlem Renaissance consisting of a mixture of "wistfulness and criticism" (Ogren 116–17). Black American music offers Eliot the promise of visceral contact with origins, while maintaining a somewhat uncomfortable sense of distance and difference, its vitality dependent on an exoticism that, once appropriated, loses its essential value as "living" rhythm; to be poetically useful, rhythmically life-giving, jazz cannot be parodied but must be reembodied, dramatized, in the present tense. But to do so means incorporating into the text racial types that cannot sustain that energy, as little better than reductive racist fictions themselves.

Race, rather than national culture, becomes the issue in the second of the poem's fragments. When the Agon of *Sweeney Agonistes* begins with a deadly invitation to Sweeney's cannibal isle, it replicates primitivist stereotypes running back through centuries, such as those accounts of "cannibals" that mark the realization of European imperialism; the "cannibal" is at once the delightful primitive in touch with an essential nature and the threatening savage, "a thing most brutish," who will murder the hapless conqueror in his sleep. Doris, in the text, seems enchanted with exotic possibilities. The role playing—the melodramatic bathos evident in Doris's coy protestations—constitutes the only direct mention of race in the text. Coupling the erotic allure of the "cannibal," who will carry off the "nice" white girl, with a threat of death and dismemberment, the poem foregrounds a racialized voyeurism, combining gore and saccharine sentimentality (*Collected Poems* 130). Any real revulsion is aestheticized, distanced into a verbal sex game, although within a few pages the threat becomes more real as Sweeney insinuates that "any man might do a girl in" (134). If the missionary's task is to civilize the pagan primitive, to "convert" the Other to European values and customs, then here that task—a job analogous to the social "use" to which the poet needs to address himself, revitalizing the "common ideals" of culture and civilization—is undone by the "living" violence that the primitive embodies; the very energy that the staid formalities of "civilization" appear to need in order to sustain themselves will consume those forms and structures. But this threat is contained by the discursively regulated lines of the poem: the exchange between Sweeney and Doris, formalized to the point of silliness, tames the undoing, reducing it to parodically sweet "little" fragments.

Missionary zeal, with its insistence on voyeuristic distance, characterizes white jazz culture in Europe in the 1920s. French surrealist-anthropologist Michel Leiris, looking back in his 1939 memoir *L'Âge d'homme*, locates his fascination with jazz in the 1920s within a tension

between revulsion and desire. His aim is "to perceive the mechanism of my constant oscillation between disgust and nostalgia" (*Manhood* 106). Leiris, like Eliot, diagnoses his youthful ruin as symptomatic of cultural collapse and discovers himself only as a problem, a quandary: "always wanting to be elsewhere and to attach myself to things and people in their most individual, alien, disturbing aspects and then immediately to withdraw; scorning the involvement which is ultimately reduced to no more than a certain taste for the picturesque, a dilettante's attraction to the exotic, to unknown countries, alien ideas" (106–7). Jazz, Leiris immediately notes, appears "about a year before the end of the war" and catches his attention largely because of his alienated state, as a seductive, frenzied, and foreign music, "each performance . . . dominated almost from beginning to end by the deafening drums" (108–9):

> In the period of great license that followed the hostilities, jazz was a sign of allegiance, an orgiastic tribute to the colours of the moment. It functioned magically, and its means of influence can be compared to a kind of possession. It was the element that gave these celebrations their true meaning: a *religious* meaning, with communion by dance, latent or manifest eroticism, and drunks, and the most effective means of bridging the gap that separates individuals from each other at any kind of gathering. (109)

But for Leiris, jazz is not simply an aestheticized savagery into which he can let himself go, but carries within it, in tension with that "primitive" frenzy, the vestigial trappings of civilized form:

> Swept along by violent bursts of topical energy, jazz still had enough of a "dying civilization" about it . . . to express quite completely the state of mind of at least some of that generation: a more or less conscious demoralization born of the war, a naïve fascination with the comfort and the latest inventions of progress, a predilection for a contemporary setting whose inanity we nonetheless vaguely anticipated, an abandonment to the animal joy of experiencing the influence of a modern rhythm, an underlying aspiration to a new life in which more room would be made for the impassioned frankness we inarticulately longed for. (109)

Balachandra Rajan praises this quality in the "stanzas of athletic animality" of *Sweeney Agonistes*, locking the poems' reader into a malaise

like that described by Leiris in his jazz experience: "The pulsation of things must be felt in its inescapability and Sweeney's cannibal isle may be the place in which to feel it, particularly when one is relieved of the distractions of the world's best books" (38). But Rajan allows for an impassioned frankness in Eliot, an unimpeded casting off of the distraction of civilization and "tradition," while maintaining the protective veneer, the barrier window, of the voyeur; Eliot's cannibal isle, in this reading, is a safe escape, a deserted sanctuary without any threat of devouring savages. Leiris, too, hears in jazz the myth of an African paradise, a myth that was later to drive his anthropological work, *L'Afrique fantôme*, and to lead back to the self-analysis of his autobiographies: "In jazz, too, came the first public appearance of *Negroes*, the manifestation and the myth of black Edens which were to lead me to Africa and, beyond Africa, to ethnography" (*Manhood* 109). The African myth informing American jungle music creates for the white listener and reader a safe haven, a dream of primitive redemption that can be digested, "used," and reincorporated into poetic and cultural work.

But the ethnographic assimilations charted by Leiris throughout his early career, and the playful voyeuristic safety of *Sweeney Agonistes*, make contemporary readers conscious of failure and appetite rather than success or closure; Eliot composes, after all, poetic fragments, which cannot resolve into a coherent drama, just as Leiris's anthropological data begin to come unglued as he realizes that his own inadequacies as an observer, a scholar, are his real object of study (see Clifford 165–74). Africa remains intangible, a phantom, while *Sweeney Agonistes* turns away from its games about island getaways to cannibalize itself, recognizing the impossibility of getting beyond the "civilized" edges of its own forms. Missionary and cannibal, in this sense, consume each other, the one ingesting exotic life even as its Other chews it to pieces.

This duplicity within the discourse of race—the desire to take hold of the primitive and the recognition that satisfaction can only be realized within the bounds of "civilized" understanding—shapes the context of *Sweeney Agonistes* at its first publication. Eliot's *Criterion* of June 1927 offers an unsigned review of Carl van Vechten's *Nigger Heaven*, a sensationalist American novel that was becoming notorious for its primitivist set dressing; *Nigger Heaven* is dismissed as belonging "to a particular type of contemporary American fiction: a more or less documented narrative exposing the hideousness of some corner or stratum of American life" (364). Noting the "snatches of modern negro lyrics . . . written for the book by Mr. Langston Hughes," the reviewer nonetheless condemns

the novel for mixing "its types," unsuccessfully concatenating colloquial dialect and "priggish" intellectual commentary (364). This same critical pressure can be brought to bear on *Sweeney Agonistes*, which obviously mixes "its types" in extensive stylistic juxtapositions. What Carol Smith takes to be verbal signs of "jazz"—its "primitive rhythm," "stylized" surface, and syncopation touching "the human heart" (98)—need to be rethought in terms of the structure of that mix. If *Sweeney*'s cannibalizing jungle music were able to cut to the rhythmic essence of the human, to provide insight into the source of a universal culture, how can it account for the dynamic of difference, of discursive instability, epitomized by its racially inflected speech, that appears to suspend any mixing at all and merely to turn inward on its own parodic emptiness?

This question is best approached by turning to Eliot's reworking in the Agon of "Under the Bamboo Tree," a song closely tied to the popular "colored" revues and minstrel shows in the first decades of the century. The original tune, by Bob Cole and J. Rosamond Johnson (the brother of James Weldon Johnson, with whom he also composed songs), is derived by syncopating the spiritual "Nobody Knows de Trouble I See" and is thus explicitly tied to American racial history, though as something of a popular hybrid (cf. Boni 68). It was first performed around 1902 and continued to be associated with novelty music and so-called black exotica well into the 1950s, appearing complete with palm trees and faux Zulu illustrations in the 1952 compilation *The Fireside Book of Favorite American Songs* (see Nesnow 112). Even when *Sweeney Agonistes* was being composed in the late 1920s, the text had come to represent a saccharine, quaint Americana and was well entrenched in the popular American psyche.

The tune was often used in blackface shows and burnt-cork revues. Eliot is clearly conscious of this tradition of white performers darkening their faces with shoeblack or burnt cork and mimicking "coloured" speech, as the reassignment of hackneyed "darky" names to the performers: "SWARTS AS TAMBO. SNOW AS BONES" (*Collected Poems* 131). Again, as with Sweeney's cannibal isle, the transgression of racial barriers is diffused by staginess, by aesthetic game playing. (Swarts and Snow, as their names suggest, were in early drafts of the text labeled "Black" and "White," making the racial dichotomy obvious.) The original Cole and Johnson song is not a highbrow foray into Afrocentric primitivism (like work by Langston Hughes) but indulges in a deplorable set of negative "jungle" stereotypes catering to largely white audiences:

Down in the jungles lived a maid, Of royal blood though dusky shade,
A marked impression she once made Upon a Zulu from Matabooloo
And every morning he would be Down underneath a bamboo tree,
A-waiting there his love to see And then to her he's sing:
 If you lak-a-me, lak I lak-a-you And we lak-a both the same
 lak-a say, this very day I lak-a change your name;
 'Cause I love-a-you and love-a-you true And if you-a love-a me,
 One live as two, two live as one Under the bamboo tree. (Boni 68–71)

The audience is intended to find the familiar in the exotic, a sense of story-book royalty in spite of the "dusky shade" of the objects here; place-names like "Matabooloo," contrived obviously from a non-European language base, are juxtaposed with seemingly proper, elevated English, as in the phrase "marked impression," allowing audiences the thrill of an imaginative foray into the darkness of the jungle without losing any of the familiar trappings of civilized American life.[1]

 Eliot's modifications to the Cole, Johnson, and Johnson song carry even further its removal from any contact with the "jungle" it purports to represent, foregrounding the artificiality of the blackface masks the characters don. The opening of Eliot's version takes up the famous "Under the bamboo" chorus, fragmenting and rearranging it (*Collected Poems* 131–32). A single trace of vernacular remains in the poem, the agreement slip in the fifth line, "One live as two." Even there, this sort of error has been marked off in the text as American (in the speech of Krumpacker and Klipstein) rather than as particularly racial. The text self-consciously indicates its awareness of stylization as poetic effect rather than as contact with any living "animality" from the primeval jungle. The song's third verse makes this self-awareness explicit, framing a retreat to distant islands in terms of European high art, the stylized exotica of Gauguin (132). To escape under the bamboo tree is to replicate imaginative reconstructions of the primitive that inform Western Orientalist discourses, without any necessary recourse to the actual contact with other cultures, other races. The "natives" dress and act as the singers dream they should; the song is, after all, a flirty pastoral fiction ("Do you want to flirt with me?") that will not bear too much reality.

 When the song closes by affirming that "Any old isle is just my style," it confirms that the appropriation of other cultures, the crossing into "enemy" territories, is by and large a fiction of the cultural dominant voiced in the text, and that no real transgression ever takes place; the

poem generates its own fictions of Otherness within its safe aesthetic confines, the limits of its own knowability and familiarity as text, and then proceeds to assimilate those styles and forms from within itself, cannibalizing its own imaginative and cultural matter. The particularities and tangibilities of Otherness become immaterial, interchangeable, "just my style." By winnowing out the song's dialect, Eliot foregrounds the contrivance of his own nostalgia for the "primitive" and begins the work of dismantling, a symptom of his own cultural unease. Writing through Cole, Johnson, and Johnson's "black exotica," Eliot intensifies the hollowness of cultural signification, the detachment of language from the living "fresh and plastic" contexts of its production. That detachment echoes the nothingness that these fragments confront. But, more significantly, it reenacts the seizure and appropriation of the exotic, the transgression of cultural boundaries, and the attempt to reanimate the dead through the processes outlined in Eliot's *Notes towards the Definition of Culture*.

CRITICAL RHYTHM: THE LIVE JAZZ BREAK

The "drama of the impossible," which Carol Smith contends that Eliot attempts in *Sweeney Agonistes*, is rhythmic in a primeval sense; if Eliot's text problematizes its cultural and racial status, it attempts to work through its own aporia, the irresolution brought on by facing these inherently confounding categories, through the agency of a distilled rhythm: to return to the idealized "jungle" by breaking apart the fixed vessels of cultural and social value that are inevitably carried along in words. Eliot's text offers its readers, through its fragmenting drives, a form of utterance that has pulverized articulation and reduced language back to a thudding pulse.

In the late 1960s, the English painter Francis Bacon completed a triptych inspired by *Sweeney Agonistes*. Claiming to have "considered and *seen* the abyss of himself and his age," Bacon was "haunted," according to his biographer, by Eliot's poetry, and was drawn to the Sweeney fragments in particular by "that world of drifting and drinking, casual acquaintances that might lead to crime, bought sexual favours and incursions into the night" that the poems depict (Sinclair 93, 208–9). The paintings themselves, like much of Bacon's work, depict bodies in torsion, violently distended by the painter's eye, and set against a background of abstract emptiness: color and form alienated from location, meaning, self. Echoing the murderous violence described

in the "Fragment of an Agon," Bacon's paintings play out what Michel Leiris—to whom the painter himself has paid homage (see *L'Ire des vents* 139)—calls a "jazz break," a way of energetically disrupting the "undifferentiated neutrality of the abyss," and that bodies forth what Leiris calls a "dazzling nakedness of the very moment," an ephemeral, temporalized point of contact between the perceiving consciousness and the "lived fact of existence" (*Francis Bacon* 24). Jazz offers Leiris a trope of primal urgency, a "writhing" that gives rise to disillusionment, a clarified vision of the "brilliant and pointless ecstasies" of modernist art. Through the rhythmic jazz of *Sweeney Agonistes*, framed by Bacon's violent canvases, this meaningless (that is, unmeaning, existing prior to the social and cultural loadings of language) life energy bursts forth, "incandescent."

Leiris defines "breaks" as "solos grafted onto the beat of the basic rhythm—i.e., in more classical terms, frenzied or Dionysiac parts contrasting with calm Apollonian parts," suggesting an ametrical tug within the text or canvas at the strictures of aesthetic control (24). Jazz critic Barry Kernfeld understands the "break" in decidedly less metaphorical terms, tying it directly to the evolution of the improvised "solo" in early jazz:

> **Break**. A brief solo passage occurring during an interruption in the accompaniment, usually lasting one or two bars and maintaining the underlying rhythm and harmony of the piece. . . . The break probably formed an evolutionary link between brass-band music and improvised jazz, at a stage when soloists were capable of creating short stretches of new material but not complete choruses: the first coherent, extended solos may have evolved from chains of breaks. (148)

If Eliot's poem, like Bacon's canvases, can be characterized as informed by "jazz" rhythms, its rhythmic basis can be sought in the break, at once freeing the voice from metrical stricture and playing through the basic pulse beat of the text's melopoeia. The "break" is not simply a release from the limiting fixities of Apollonian form into Dionysian ecstasy, but a tensioning from within, a rhythmic assembling of the centripetal and centrifugal forces of meaning and sound.

Like much early jazz, *Sweeney Agonistes* is structured with a pattern of call and response. A phrase is thrown out into the text, setting up a basic form for the ensuing dialogue; that phrase is then answered, thematically and rhythmically. The basic "meter" of the poem, for instance,

is a four-beat line: Eliot departs from the quasi-free accentual-syllabic scansion of his earlier texts and opts for an elastic accentual form, allowing for temporal stretching and songlike looseness. Even as it establishes itself as a meter, the poem's basic pattern of beats is constantly modified, pulled at through anacrusis and distributed stress (*Collected Poems* 126).

One exchange between Doris and Dusty, drawn from the first fragment, is built using the stichomachia characteristic of most of the text. The characters are "trading fours" like jazz musicians, bouncing thematic and rhythmic ideas back and forth as they play (in this case, with language). Words, phrases, and textures are picked up by alternate speakers and expanded, contracted, inflected, or filtered, as the speaker adds or deletes certain words: "a lót" becomes "an áwful lót," or "what you wánt to ásk them" becomes "what you wánt to knów," picking up the verb from the previous phrase. The spondaic thickening of Dusty's "dráw córt cárds" is rebalanced in Doris's "píck thèm úp," the central distributed stress now polarized and reduced to a tenuous thesis between the rocking ends of each arsis. Furthermore, the general lack of punctuation in the text—end-stops, for example—suggests clearly that Eliot relies on the listener's (and the performer's) ear to mark distinctions between phrases and periods: rhythm expresses punctuation. The open-endedness of each line reinforces the interdependence of phrases, as one line leads into its mate, its response. Sound answers sound; idea answers idea. As conversation, this exchange appears rather banal (although, arguably, it explores certain epistemic circles, "knowing" what "you want to know"), but in terms of its texture, what is enacted is precisely a conversation before meaning, a form of response that takes place through language operating on a presemantic level, a traded verbal music.

The agon of the second fragment, its crucial struggle, is not obvious thematically; given that the poem is fragmentary, and its action uncertain at best, it is difficult to determine exactly what the conflict consists in here. But what can be understood as agonistic, as agonized, is the rhythm. Sweeney, the antagonist (or perhaps the protagonist), the primary agent of dramatic agony, pulls the beat to its breaking point. Snow insists that Sweeney "continue his story," and Swarts's interventions keep the narrative going (*Collected Poems* 134). Here again the four-stress line predominates in the traded phrases. But Sweeney and the others break their lines into two-beat hemistiches, displaced as units between speakers, sometimes held in suspension across several intervening lines; Swarts's "What did he do?" remains unanswered until Sweeney's "That don't

apply," hanging a phrase in hiatus and testing the viscosity of a single line. What is "done" here, immediately within the ear of the listener, is a plasticizing of "all that time"; time itself, kept by the recurrence of the seemingly stable pulse of each four-beat unit, begins to come unglued.

It is this deliberate torsion of the poetic phrase that constitutes what Leiris characterizes as a jazz break. Sweeney's tug-of-war with his own words—the opening of his last long speech—becomes even more violent and tense as the fragment works to its finish (135). Sweeney's call-and-response turns back on itself, as he repeats and rearranges his basic material (turning on tautological the two-as-one, one-as-two suggested by "Under the Bamboo Tree"); his only way out of the self-consuming trap is to introduce new material (like milkman and rent-collector) in counterpoint, breaking the constricting cycle, and pressuring the lines to accept a greater density of stress (as in "the rent-collector wasn't," where three stresses crowd out two). The lines become hypermetric, as four additional hemistiches are tacked on to the circling lines at the speech's center (a strategy that will be expanded in the subsequent full chorus, where eight-beat lines are used, compounding two lines into one). The rhythmic density increases in the subsequent "short" lines in the passage, the repeated "There wasn't any joint," which operate as musical triplets, figures where three distinct notes are set into the metrical space reserved for two. Sweeney improvises rhythmically against the meter, introducing additional verbal matter that cannot be assimilated into a rigid structure of beats, but works in counterpoint with it, as tension, as "break." It is not that he abandons the form altogether—he has, after all, "gotta use words"—but that those words are pushed to the verge of sense, hammered through repetition and rhythmic torsion to the edge of any meaning at all.

Sweeney Agonistes does not abandon meaning but tests meaning's possibility. Rhythm signals a kind of critique, a jarring of habit or stable form and a forced recognition of the unstable primeval mess on which all acts of meaning rest. But is such a recognition necessarily the outcome of the poem's jazz rhythms? In an essay on jazz, commodification, and mass culture in his collection *Prisms* (originally published in 1967), Theodor Adorno characterizes jazz by the two essential elements we have seen in *Sweeney Agonistes*: a rhythmic syncopation and a basis in popular song. But, while Eliot's jazz appears to touch on critical energy, Adorno is disparaging: "Jazz is music which fuses the most rudimentary melodic, harmonic, metric and formal structure with the ostensibly disruptive principle of syncopation, yet without ever really disturbing the

crude unity of the basic rhythm, the identically sustained metre, the quarter-note" (121). What appears to be a disruptive and contrary music only reinforces the rudimentary strictures of rhythm and the tyranny of tonality, and consists not in newness, or in what Whitney Bailliet has called "the sound of surprise," but in familiar formulas and a repetitive beat. Jazz epitomizes, for Adorno, both a false security and a misguided sense of freedom, pretending to encourage nonconformity and contrariety while reinforcing a mass homogeneity, as the listening public become less and less themselves, absorbed in a common mold while believing in their uniqueness (125–26). By this view, jazz pretends to be disruptive and expressive, but merely reifies an insidious identitarianism, catering to the closed-minded expectations of its listeners by deluding them into believing themselves open-minded. The primeval, rhythmic characteristic that Eliot takes over from jazz, its vital commonality, its universal pulse, is precisely that which Adorno identifies with mass culture, with propaganda and, finally, with a pervasive, hegemonic "musical dictatorship." Jazz, Adorno asserts, does not threaten the institutions and orders that have subdued human vitality; instead, it integrates, musically, "stumbling and coming-too-soon into the collective march-step" (128). Jazz presents a facade of liberation (of "getting into trouble and out again"), while insidiously reinforcing conformity, "an emphatic street-drill rhythm" (see *The Stars Down to Earth* 55).

Adorno, however, neglects the self-conscious gestures of such a music, the possibility that improvisation can actually take place; rather than simply reiterating tired clichés and memorized figures (as Adorno claims the "amateur" jazz pianist habitually does [*Prisms* 123]), the improvised break can also lead to a form of playing against the harmonic and metrical strictures of a given context. The language of *Sweeney Agonistes* is overladen with clichés and dead, replicated style, but in reworking that material against itself, Eliot offers a critique on the level of diegesis, of telling. Certainly the poet, like Sweeney, cannot escape the identitarian social and cultural loading of his language—he's still "gotta use words"—but from within that loaded context Eliot can take up the matter of language itself, caught at its own moment of temporal formation, and can formulate a kind of differential resistance to the "march-step" of meaning and identity that Adorno fears.

The inarticulate close of the poem's agon, the apparent lapse of the whole chorus into onomatopoeia and nonsense syllables—"Hoo ha ha / Hoo ha ha / Hoo / Hoo / Hoo / KNOCK KNOCK KNOCK / KNOCK KNOCK KNOCK / KNOCK / KNOCK / KNOCK"—is not so much a

shedding of meaning as it is a reduction of meaning to a state in which verbalization and action correspond as closely as possible to each other, prior to the intrusion even of representation into the sound, the beat, of the syllable. When "you've got the hoo-ha's coming to you," as the chorus intones, you are faced with the basis of song, of singing meaning into being, and thus engaged in a critique, a process of differentiation and self-conscious making, at the fundamental level of the oral, of the plastic matter of culture itself. The "enemy" presence that Eliot understands as necessary to the formation of culture has been imbedded, in this poem, in the conflictual textures of its beat. Eliot's *Sweeney Agonistes*, by playing in and out of a series of imitated "jazz breaks," at once recognizes the same falsity that Adorno pessimistically acknowledges, the identitarian drive of meaning in language and received form to close itself off from life, from the vital energy of that primeval beat, but also exposes to full view, roughly, nakedly, the violent unknitting of his visionary apparatus. Eliot's poem offers a kind of doubled poetic "movement" at once "brilliant and pointless," as Leiris says, an unmitigated and broken approach to his own lyric theological contrivances and to the ultimately word-bound failure of the mystical formulas that were to emerge a decade later in *Four Quartets*. *Sweeney Agonistes* presents a negative prophecy, a vision of the end of the visionary enterprise, and a poetry that, even as it presupposes a relief from the deadening weight of habit and mechanistic culture, plays itself out in flubbed choruses and meandering parodies, breaking at last into a primal, heavy knock.

NOTE

1. The song retains little "dialect," compared with other music used in blackface revues. Only the kitschy "lak-a" of the chorus marks the text as black vernacular. One might compare the texts of songs and readings issued in the 1920s by such publishers as Chicago's T. S. Denison, for instance, under titles like *Bundle of Burnt-Cork Comedy*, which included not only parodies of southern black speech patterns but also dialect poems by Paul Laurence Dunbar and other black American writers; Denison issued Dunbar's "Speak Up, Ike, An' 'Spress Yo'se'f'" in 1922, for instance, in which a young black woman chastises her taciturn suitor: "Laffin' at you ain't no harm—Go 'way dahky, wha's yo' arm?—Hug me closer—dah, dat's right!" Such songs, widely used in amateur and professional minstrel shows, often overcooked their style to the point of ridiculousness, their comedic effect (unintentionally, perhaps, in the case of Dunbar) hinging on the quaint oddity of "dahky" talk. James Weldon Johnson, brother and sometime collaborator

with Rosamond, decries this abuse of dialect because of what he sees as market demand, and laments the loss of the linguistic and poetic power behind its style, citing Dunbar as his test case; in his autobiography, *Along This Way*, Johnson describes Dunbar's co-optation by songwriters in white communities, epitomized by the burnt-cork comedies of Denison and other publishers, and separates this style from real "Negro life," arguing it had become a form of white speech, constructed by audience expectations and stereotypes created independently of any contact with real Negro lives (158–59). Even if the words themselves have been composed by a black writer such as Dunbar, they lose their ability to signify his racial experience:

> I could see that the poet writing in the conventionalized dialect, no matter how sincere he might be, was dominated by his audience; that his audience was a section of the white American reading public; that when he wrote he was expressing what often bore little relation, sometimes no relation at all, to actual Negro life; that he was really expressing only certain conceptions about Negro life that his audience was willing to accept and ready to enjoy; that, in fact, he wrote mainly for the delectation of an audience that was an outside group. (159)

Like with Sweeney's cannibal text, "Under the Bamboo Tree"—given the marginality of its dialect and the overwriting of "Zulu" and "black" discourse with a homely whitened speech—is a fiction of white expectations, the "nice little" civilized players of the text.

WORKS CITED

Adorno, Theodor. *Prisms*. Tr. Samuel and Shierry Weber. Cambridge: MIT Press, 1981.

———. *The Stars Down to Earth and Other Essays on the Irrational in Culture.* Ed. Stephen Crook. London: Routledge, 1994.

Bacon, Francis. "Mieux que personne Michel Leiris. . . ." *Autour de Michel Leiris. L'Ire desvents* 3–4 (Spring 1981): 139.

Boni, Margaret Bradford, ed. *The Fireside Book of Favorite American Songs.* New York: Simon & Schuster, 1952.

Clifford, James. *The Predicament of Culture*. Cambridge: Harvard University Press, 1988.

Denison's Musical Readings. "Speak Up, Ike, An' 'Spress Yo'se'f (Encouragement). Words by Paul Laurence Dunbar. Music by Henry S. Sawyer." Chicago–Minneapolis: Denison, 1922.

Eliot, T. S. "A Commentary." *New Criterion* 5.1 (Jan. 1927): 1–8.

———. "Fragment of an Agon (from *Wanna Go Home, Baby?*)." *New Criterion* 5.1 (Jan. 1927): 74–80.

———. "Fragment of a Prologue." *New Criterion* 4.4 (Oct. 1926): 713–18.

———. *Notes towards the Definition of Culture.* London: Faber, 1962.

———. *Selected Prose.* Ed. Frank Kermode. London: Faber, 1975.

———. *Collected Poems 1909–1962.* London: Faber, 1963.

———. "Shorter Notices." *New Criterion* 5.3 (June 1927): 364–65.

———. *The Use of Poetry and the Use of Criticism.* London: Faber, 1933.

Eliot, Valerie, ed. *The Letters of T. S. Eliot, Vol. 1: 1898–1922.* New York: Harcourt Brace Jovanovich, 1988.

Ellis, Steve. *The English Eliot: Design, Language and Landscape in "Four Quartets."* London: Routledge, 1991.

Hughes, Langston. *Selected Poems.* New York: Random House, 1959.

Johnson, James Weldon. *Along This Way: The Autobiography of James Weldon Johnson.* New York: Viking Penguin, 1990.

Kernfeld, Barry. "Break." *The New Grove Dictionary of Jazz.* Ed. Barry Kernfeld. New York: St. Martin's Press, 1994, 148.

Larkin, Philip. *All What Jazz.* London: Faber, 1985.

Leiris, Michel. *Francis Bacon: Full Face and in Profile.* Tr. John Weightman. New York: Rizzoli, 1983.

———. *Manhood.* Tr. Richard Howard. San Francisco: North Point, 1984.

Nesnow, Adrienne. *John Rosamond Johnson Papers.* New Haven: Yale University Music Library, 1980.

Ogren, Kathy J. *The Jazz Revolution: Twenties America and the Meaning of Jazz.* Oxford: Oxford University Press, 1989.

Rajan, Balachandra. *The Overwhelming Question.* Toronto: University of Toronto Press, 1976.

Roby, Kinley E., ed. *Critical Essays on T. S. Eliot: The Sweeney Motif.* Boston: G. K. Hall, 1985.

Schuller, Gunther. *The Swing Era: The Development of Jazz 1930–1945.* New York: Oxford University Press, 1989.

Sinclair, Andrew. *Francis Bacon: His Life and Violent Times.* London: Sinclair-Stevenson, 1993.

Smith, Carol H. "Sweeney and the Jazz Age." Roby, 87–99.

Williamson, George. *A Reader's Guide to T. S. Eliot.* New York: Noonday, 1966.

Raising Life to a Kind of Art
Eliot and Music Hall

JONNA MACKIN

> *Various critics have done me the honour to*
> *interpret the poem in terms of criticism of*
> *the contemporary world, have considered it,*
> *indeed, as an important bit of social criticism.*
> *To me it was only the relief of a personal and*
> *wholly insignificant grouse against life; it is*
> *just a piece of rhythmical grumbling.*
> —T. S. ELIOT ON *THE WASTE LAND*

> *There may be personal causes which make it*
> *impossible for a poet to express himself in any*
> *but an obscure way.*
> —T. S. ELIOT, *THE USE OF POETRY*
> *AND THE USE OF CRITICISM*

WORM'S-EYE VIEW

When the famous music hall artist Marie Lloyd was called before the London County Council on charges of moral intemperance, she defended her work by showing how innocent were the words to her songs and by demonstrating how lewd Tennyson"s "Come into the Garden, Maud" could be if delivered with (im)proper tone and gesture. On another occasion she was called to respond to complaints about the questionable propriety of her song "I Asked Johnny Jones, So I Know Now," which she performed dressed as a schoolgirl, inquiring in several encounters with her parents and a schoolboy, "What's that for, eh?" (Pennybacker 131). As one of the most successful music-hall performers of all time, Lloyd was adored for her enjoyment of risqué material and her legendary talent for innuendo. It is said that one cannot appreciate Marie Lloyd's songs by reading their lyrics; we must imagine her drawing out and manipulating her audiences' responses with gestures that they knew only too well

how to read. With those "innocent" lyrics she stimulated multiple private imaginings.

Audiences also loved her feistiness. She was a leading figure in the music-hall artists' strike in 1907. And when "given the bird" by a Sheffield audience, she waited patiently until the noise died down and then responded, "So this is Sheffield; this is where you make your knives and forks. Well, you know what you can do with them, don't you. And your circular saws as well!" (Lee 111).

Yet in his idolizing tribute to Marie Lloyd written shortly after her death, T. S. Eliot claims that Marie Lloyd was never subjected to "this kind of hostility" and that "no objector would have dared to lift his voice" (*Selected Essays* 406). Reading this essay, we find some puzzling dislocations between the Marie Lloyd Eliot portrays and the Lloyd described by cultural historians. How can Eliot be so rapturous in praising "the perfect expressiveness of her small gestures" without acknowledging in any way what those gestures so often suggested in the way of sexuality? For Eliot, the song in which Lloyd depicts herself as "One of the Ruins that Cromwell Knocked abaht a Bit" portrays "a middle-aged woman of the charwoman class" lovingly sorting through her bag; yet one can imagine that in Lloyd's rendering, the Cromwellian knocking about suggested some thoroughly indecent activities. A mere glance at the well-known illustration of Marie Lloyd, looking at us with a provocative smile and cherries dangling from her mouth, suggests what this experienced theatrical diva could promise in the way of innuendo.

Eliot's essay on Marie Lloyd and other comments about music hall in his early criticism, as well as the publication of *The Waste Land* facsimile and its fragments of music-hall song, have resulted in new attention to his interest in popular forms.[1] Though Eliot is hardly famous as an obscene poet, he had his bawdy side and was known among his friends for what Ronald Schuchard calls "the lusty characters who peopled his bawdy ballads and limericks" ("Savage Comedian" 27).[2] Thus, it is unlikely that he was unresponsive to the sexual aspect of Lloyd's appeal. But his crudest and more risqué material was usually edited out. It found its way into the poetry in veiled and elusive ways. The appearance of *Sweeney* provides us with Eliot's own version of sexual innuendo, yet more overt explorations are either in another language, as in "Dans le Restaurant," or canceled, as in "Ode" or "The Death of Saint Narcissus," or circulated privately among friends, like the 1939 pamphlet entitled *Noctes Binanianae.*[3]

With the advent of cultural studies, popular forms of entertainment, like music hall, are receiving increased scholarly attention. As more historically accurate versions of the history of the halls become available, Eliot's descriptions are revealed to be more romanticized than realistic. I would like to suggest that we must look closely at the inaccuracies in Eliotic representations of music hall and question why his tribute to Marie Lloyd is so coy about her sexual appeal. If we compare Eliot's ideas with current research on the business and performance traditions of the halls, we can come to a deeper understanding of what attracted Eliot to them. His failure to address directly the psychosexual dimension of music-hall songs and performance suggests that as Eliot was inventing a modern poetic voice, he was struggling with the problem of sexual representation. With the decline of Victorian moral codes, more explicit representations became available. Yet there were always vestiges of these codes in Eliot's conception of art. The comic ambiguity about sexual matters explored from "a worm's-eye view" in music-hall songs provided him a working model of the distance he wanted from emotional raw material. Songs and comic turns could be appropriated for his own poetry as an expression of private emotion in a form that was suitably objective. He most certainly enjoyed the sexual subtext of music hall, but in his critical voice he sublimated this enjoyment into the creation of a cultural myth about art and the role of the working class.

CONVERGENCE IN THE HALL

Eliot's interest in music hall is relatively easy to document since he obliged us with a series of remarks about his addiction to this popular form of comedy. What is not so clear is the significance of his attachment. In a groundbreaking article in *PMLA*, David Chinitz considers the role of music hall and jazz in helping Eliot to build a continuum between the primitive, the popular, and high culture. Eliot's aesthetic, suggests Chinitz, was informed by a desire to "recombine the stratified levels of culture" (240). The Chinitz article provides valuable insight into Eliot's views on various forms of popular culture. However, in accepting Eliotic representations of music halls uncritically, Chinitz's analysis repeats their inaccurate portrayal of cultural production as embodying a kind of polarization of high and low. If we as critics repeat Eliot's misrepresentations of music hall as a pure working-class phenomenon, our analysis of what

music hall meant to him will be based on a false idea of the cultural product that was actually affecting him.

The article on Marie Lloyd presents us with quite an inaccurate portrayal of music hall. Eliot represents the halls as legitimate drama of the working class, a class that he says engendered a Marie Lloyd to express its virtues and excoriate its vices.[4] Where the middle class is morally bankrupt and soon to be absorbed by a defunct aristocracy, the working-class audience of the music hall is, according to Eliot, to be admired for its genuine "moral superiority" as indicated by its engagement with the music-hall performer. Cultural historian Peter Bailey refutes what he terms this "folk or idealist interpretation of music hall history" (xiv). It is now generally accepted that the middle classes were represented in music hall audiences from an early date. In specifically rejecting Eliot's interpretation of music hall in the Marie Lloyd article, where music hall is portrayed as an unselfconscious expression of the popular voice, Bailey points out that such a designation is a kind of "reverse Whiggery in which the past becomes authentic, and the present embattled with the hybrid, the artificial and the alien" (xiv). By contrast, one recent study of music-hall songs identifies the halls after a certain point as more typically petit bourgeois than working class (Bratton 67).

Eliot's romanticizing of music hall as the voice of the common man fails to recognize that the halls themselves were sites of cultural contestation. Whatever sense of community existed in the halls was not a result of preexisting unity but a product of constant parody of any and every contemporary discourse of authority, from the police to the bureaucrat, from the clergyman to the mother-in-law. The performer directed and celebrated social forces awash in the halls.

> In their relationship to the performance on stage the music hall audience has too often been represented as an undifferentiated lump with a simple reflex role in chorus-singing and banter, whereas the interaction was more complex . . . a running drama of inclusion and exclusion as songs and acts celebrated or satirized particular types or groups, sometimes doing both at the same time, drawing their targets from inside as much as outside the audience, inviting identification or discrimination simultaneously . . . [A]s an audience they constituted a different and more volatile collectivity, dissolving and recomposing as members of other groups by nationality, age, gender and stratum as invoked in performance. (Bailey xvii)

The power the comic artist had over the audience was engendered by an ability to awaken individual forces of imagination and bind them into a collectivity. The moral voice that Eliot so desired is derived from the ability to play with the audience members' private emotions, and by establishing a sympathy with the audience, to sway those ambiguous energies toward a resolution of contradictions. "It was the particular concentration of such ambiguities within the marginal culture of the lower middle class that gave music hall's comic realism some of its richest material and most plausibly qualifies it as more petit bourgeois than proletarian in its sensibilities" (Bailey xviii). The availability of sexual material attracted large audiences to the halls. Once inside, class antagonisms were negotiated within the raucous comic framework.

Owners of the halls sought to appeal to middle-class audiences to promote the success of their enterprise. They introduced changes in the mode of the entertainment to gain approval from the regulatory councils. As the new style of the halls moved away from the old tavern atmosphere, advertisements for them represented music hall as "healthy" entertainment suitable for women and families. Language emphasizing themes important to the middle class helped to break down resistance to the halls. The imperatives of capitalism and the growing respectability of the halls meant that the performances Eliot witnessed were often already infiltrated with middle-class values. Thus, when Amy Koritz states that what Eliot feared was the merging of the lower class with the middle class, "and his attempts to appropriate music hall for high art can be read as a rearguard action against this cultural alliance" (151), she fails to note that such an alliance had in many ways already taken place. That the halls largely succeeded in their quest for respectability is indicated by the royal command performance staged in 1917 (a performance to which Marie Lloyd was not invited; she staged her own show, to overflow crowds).

It has been said about music hall that it was both a public and a private space, where the multiple intimacies of the crowd paradoxically afforded a kind of privacy. The music of music hall also exhibited this kind of public-private duality. In her study of the Victorian popular ballad, Jacky Bratton points out that sexual relations had been the main area of subject matter from the first. The comic ballad specialized in personal relationships, particularly marriage, and usually viewed the subject from a physical, earth-bound perspective. The relationship between the performer and the audience was especially close during the singing, for it was important for the audience to identify *as well as* to laugh at the

performer, and by laughing to simultaneously critique and affirm the way of life that was being represented. Bratton points out that these songs turned a sardonically earthy glance on airy notions of romance and wedded bliss, deflating particularly by means of the physical practical joke. If critics are correct that much of Eliot's early poetry is expressive of sexual anxieties and his anguish over his disastrous marriage to Vivien Haigh-Wood,[5] it is not hard to imagine that he found this "worm's-eye view" of the sexual stresses of the marital bed particularly funny and cathartic.

Marie Lloyd was especially adept at sexual farce. In her 1899 song "Hulloa! Hulloa!! Hulloa!!!" Bratton suggests that innuendo "leaps and twists round the situation described in a genuinely inventive way" (196).

> *Whenever at a big hotel down by the sea I stay,*
> *I like to watch the couples who arrive from day to day;*
> *Invariably I scan the book to see what they put down*
> *And I clearly recollect a Mr. and Mrs. Brown—*
> > *From town.*

Chorus:

> *They make a point of squabbling*
> *In public, it appears,*
> *To give one the impression*
> *That they've been spliced for years.*
> *At breakfast, though, next morning*
> *I heard her ask him "Joe*
> *Do you take milk and sugar?" Hulloa! Hulloa! Hulloa!!!*

Sexuality is celebrated in the song, and "we are expected to enjoy the contemplation of it and to find common cause with the experienced in mocking—and initiating—the innocents, who are all eagerness to learn" (198). Notice how the communal singing is described by Bratton as a rite of initiation, as well as an act of ridicule and acceptance. This act of instruction and acceptance constitutes the moral voice that Eliot celebrates in Marie Lloyd; it is the capacity to orchestrate the energies in a charged social space and to create a collective sense through the shared activity of identification and laughter. We should also note the elusive sexual subtext within the public/private configuration of the audience's mental space. By *not* being explicit and *not* being overt, Lloyd provokes

the private imaginings of each audience member without being crude or expressly erotic.

The constant policing of the halls by the London County Council had resulted in some reforms that made them more commensurate with middle-class ideas of respectability. But as Susan Pennybacker points out, the basic sexual material of the halls never changed from what it had been from the earliest beginnings; it merely went slightly underground.

> Perhaps, then, the most salient fact about audience participation was the persistent display of sympathy for allusions to sexual impropriety and the satirical portrayal of public and private life in performance . . . [In the policing of the halls] Masses of people do seem to have been subjected to a general moderation of certain kinds of lyrics, nudity and outright suggestiveness on stage, at least when someone in authority was looking. The entertainment, however, seems to have remained in many ways similar in thrust to what it "traditionally" had been, but with a greater reliance on gesture or style of speech—insinuation rather than the words themselves. (137)

Marie Lloyd's famous talent for innuendo can be seen as collaborating with the middle-class project of cleaning up the halls. And when Eliot describes her as "moral . . . elevating crude material to the level of art," he is, in effect, expressing sympathy with that project. By preserving the relatively free expression of sexual material for artistic performance, this project of accommodating middle-class respectability also, ironically, became a way of making sexual impropriety accessible to a wider audience. "It is worth considering too how, in a more general sense, music hall's particular mode of conceit, parody and innuendo constituted a second language *for all classes*, whose penetrations had a powerful integrative force in English society" (Bailey xviii). Eliot's twentieth-century audience wanted more than just good clean fun; they wanted racy material that was acceptable because it was artistic.[6]

INNOCENT LYRICS

Eliot's theory about working-class art seems, on the surface at least, in conflict with his theory of artistic production. On the one hand, he contextualized working-class culture; on the other, he desired a classless, timeless art that was to take its place in the "tradition." Another paradox

is an apparent discrepancy between Eliot's valorization of the performer
in music hall and his statement that the performer in poetic drama is to be
subordinated to the text. While music-hall artists such as Marie Lloyd
embody all that is praiseworthy in popular drama, Eliot says that in
poetic drama "we must take into account the instability of any art—the
drama, music, dancing—which depends upon representation by per-
formers . . . [T]he performer is interested not in form but in oppor-
tunities for virtuosity or in the communication of his 'personality.'"
(*Selected Essays* 69).[7] Yet another paradox is Eliot's claim that in observ-
ing poetic drama " it is essential that we should preserve our position of
spectators, and observe always from the outside though with complete
understanding" (82). For, as we shall see, the integral collaboration be-
tween audience and performer in music hall is one of the attributes he
most prizes and desires for his own poetic drama.

As he does so often, Eliot invokes Elizabethan drama as a standard:
"The Elizabethan drama was aimed at a public which wanted *entertain-
ment* of a crude sort, but would *stand* a good deal of poetry; our problem
should be to take a form of entertainment, and subject it to the process
which would leave it a form of art. Perhaps the music-hall comedian is
the best material" (*Sacred Wood* 70). The fact that Eliot was attracted to
the entertainment value of the halls is a tacit acknowledgment of the role
of the public in validating the performance. It was important enough to
him that it defined the social usefulness of poetry:

> Every poet would like, I fancy, to be able to think that he had some
> direct social utility. . . . He would like to be something of a popular
> entertainer, and be able to think his own thoughts behind a tragic or a
> comic mask . . . There might, one fancies, be some fulfilment in excit-
> ing this communal pleasure, to give an immediate compensation for
> the pains of turning blood into ink. . . . All the better, then, if he could
> have at least the satisfaction of having a part to play in society as wor-
> thy as that of the music-hall comedian. (*Selected Prose* 95)

The performance traditions of Elizabethan drama that Eliot invokes were
greatly influenced by the material conditions of the theater itself, condi-
tions that music hall originally shared to some extent.

In his article on "Bifold Authority in Shakespeare's Theater" Robert
Weimann discusses the sharing of authority between audience and per-
formers that results from the use of the Renaissance platform stage. His
description suggests a way of seeing music hall as a legitimate sibling to

Shakespearean theater. Weimann considers two kinds of representational space: that of the locus, located at the rear and privileging who or what was represented, and that of the *platea*, which "tended to privilege the authority of what and who was *representing* that world" (409). The *platea* is located at the front of the stage, where the performer walks forward and engages with the audience. The authority of the Renaissance stage, because it was derived from its provision of pleasure, needed to be validated by the audience. Such validation, as Weimann points out, was unlikely to result without the cooperative effort of the audience's "imaginary forces." For example, the very limitations of the scaffold stage required the audience to supply the imagination to "deck our kings," transversing the space between the imagined loci of the dramatic action and the real conditions of performance inside theaters. One can imagine that when music hall first began in Elizabethan inns and pubs, representational locus was in short supply. Hence the tradition that in brightly lit music halls, performers work in *platea* space. When combined with what Weimann calls the "mingle-mangle conditions" of audience behavior and indecorous conventions of clowning and topsyturvydom, *platea*-directed performance could invite impertinence and subversiveness on the part of the audience's imaginings to be included in the performance. Eliot acknowledged the importance of this relationship in his essay on Marie Lloyd: "The working-man who went to the music-hall and saw Marie Lloyd and joined in the chorus was himself performing part of the work of acting; he was engaged in that collaboration of the audience with the artist which is necessary in all art and most obviously in dramatic art" (*Selected Essays* 407). When Eliot claims that Lloyd "succeeded so well in giving expression to the life of that audience, in raising it to a kind of art" (406), what he is describing is this relationship between the music-hall artist, working on the *platea* stage in a brightly lit hall, interacting with the public and authorizing their multiple imaginings as part of the performance. By giving up strict representational authority, the performer's power becomes that of unleashing the libidinal energies of the public and directing them within the force of the performance. Thus, the effect is not merely one of personality—though the power of personality is efficacious in directing this shared imagining. It is also an effect of form.

Though Eliot's critical writings on music hall may be misdirected as critiques of class culture, the real litmus test of its importance to him would be his poetry. We know now, thanks to *The Waste Land* facsimile, that Eliot's original title was "He do the police in different voices," and

that music-hall songs were to be a larger part of the poem. What would
we have thought of a poem that began with these lines?

> *First we had a couple of feelers down at Tom's place,*
> *There was old Tom, boiled to the eyes, blind,*
> *(Don't you remember that time after a dance,*
> *Top hats and all, we and Silk Hat Harry,*
> *And old Tom took us behind, brought out a bottle of fizz,*
> *With old Jane, Tom's wife; and we got Joe to sing*
> *"I'm proud of all the Irish blood that's in me,*
> *There's not a man can say a word agin me." (1–8)*

Silk Hat Harry and old Tom are clearly characters out of music hall; dele-
tion of these lines pushes music hall to the background and gives the poem
a more elevated tone. Despite the change, however, the poem retains in its
"different voices," the quick shifts in scenes and voices that reflect music-
hall style. F. J. Gould, commenting in the *Leicester Pioneer* on a per-
formance at the Palace Theater in 1910, found the fragmented nature of the
material similar to what he considered the alienated nature of "modern"
life": "we live in bits—our work, our play, our religion, are partitioned and
divided . . . [T]housands of people prefer the scattered items of a music
hall to the connected thought of an epic or the sustained intent of the classi-
cal drama" (Crump 67). It requires the same act of imagination on the part
of the "audience" to authorize Eliot's "unreal city" as it does to unify the
fragments in Marie Lloyd's song. The audience shares authority with the
artist over what is imagined. Thus Eliot can say, "what a poem means is
as much what it means to others as what it means to the author" (*Selected
Prose* 88) Another way of reading *The Waste Land* is to respond as a
music-hall audience would, letting the various "scenes" and vignettes
create a world that is both ours and something we view as spectators. Like
Marie Lloyd's fans, we recognize the implied sexual subtext and supply
an imaginary world implied by the poet. In "A Game of Chess" (*Waste
Land* II), Eliot assembles the collagelike fragments of a dramatic en-
counter between a man and his wife. As the sumptuous description gradu-
ally changes tone, it points toward the bitter undercurrents of fear and
frustration between the man and the semihysterical woman:

> *In vials of ivory and coloured glass*
> *Unstoppered, lurked her strange synthetic perfumes,*
> *Unguent, powdered, or liquid-troubled, confused,*
> *And drowned the sense in odours; stirred by the air (86–89)*

The scene proceeds to bits of dialogue between her frightened, insistent voice and his inward grumbling:

> *"What is that noise?"*
> *The wind under the door.*
> *"What is that noise now? What is the wind doing?"*
> *Nothing again nothing.*
> *"Do*
> *"You know nothing? Do you see nothing? Do you remember*
> *"Nothing?"* (117–23)

We imagine a relationship full of sexual frustration and longing, where she demands and he cannot respond. The nature of this relationship is portrayed more explicitly in "The Death of the Duchess," a canceled poem from *The Waste Land* manuscript. In the tense bedroom scene, "the game of chess" represents their painful, blunted desire, resulting in mechanical sex where "ivory men make company," bloodless pieces on a predestined board, markers of the sterility of their lovemaking as they wait for a maid's "knock upon the door." And when the knock comes, it is cause for fear, for "If it is terrible alone, it is sordid with one more."

Whatever explicitness we find in the canceled "Death of the Duchess," it has become strictly innuendo in "The Game of Chess." Yet we can supply the erotic subtext in our own imaginations. But in this case it is not sexual lust that is celebrated; the scene portrays a *lack* of erotic passion. Nonetheless, if we read *The Waste Land* looking as much for what is left out as for what remains (which the footnotes certainly teach us to do), we see that a major part of the breathless sterility in the wasted land is derived from its inarticulate and mechanical sex. The poem celebrates erotic ecstasy by decrying its lack. But by not describing sexual acts directly, the poem eludes censorship. The promise that the thunder signals is that erotic pleasure will return with fertility and fecundity to a people temporarily deprived of its satisfying presence. Eliot's characteristic manner of representing this sexual material is to invoke minimal images and manipulate bits of fragmentary scenes; in short, to suggest in the scantiest of ways the sexual performance that he does not mention directly. Prostitutes washing their feet point toward Mary Magdalene, washing Christ's feet, but also obliquely to the practice of prostitutes washing their vaginas with soda water to prevent venereal disease. Sexual perversion, desire, impotence, hysteria—Eliot alludes to them all without being explicitly clear about any. Thus, he would be able to say, with Marie Lloyd, that his lyrics are "innocent," merely a heap of

personal grumbles. In *Sweeney Agonistes*, another "innocent" text, Eliot has Sweeney acknowledge that there are those who "understand" and those who "don't" (*Collected Poems* 135), but that the difference means "nothing."

Eliot did write verse that was crude and explicit but circulated it only privately, and this impulse was more than just the product of an adolescent sensibility. Schuchard notes with interest "that the bawdy element not only survived his twenty-fifth year but, with the appearance of Sweeney in 1918, became one of the most 'serious' and 'personal' elements of his art" ("Savage Comedian" 27).[8] *Noctes Binanianae* appeared as late as 1939. Comparing some of these sexual caricatures with poetry initially intended for publication provides an example of what Eliot meant when he characterized making art as a process of "refinement."

Compare one of the Columbo verses:

> On Sunday morning after prayers
> They took their recreation
> The crew assembled on the deck
> And practiced masturbation.

with lines from the canceled "The Death of Saint Narcissus" (from *The Waste Land* manuscript):

> Then he knew that he had been a fish
> With slippery white belly held tight in his own fingers,
> Writhing in his own clutch, his ancient beauty
> Caught fast in the pink tips of his new beauty.

The Narcissus poem, already a step toward the ambiguity that characterized refinement, was evidently still considered too explicit for publication in *The Waste Land*.

Schuchard points out in his forthcoming book (*Eliot's Dark Angel*) the influence of music hall and dance on Eliot's criticism and poetry, stating that Eliot was inspired by artists like Lloyd, who, for years "had fueled his creative imagination and had unknowingly served as a collaborator for his theory of art. She had achieved as a popular performer what he wished to achieve as an artist in search of popular forms—the elevation of crude material to the level of art" (ms. p. 16). "Elevation" meant bringing explicit material about sexual relationships into a process of refinement and sublimation. To "recombine the stratified levels of culture" meant importing what was available in music hall—public expression about private sexual relationships—into respectable poetry. What Marie

Lloyd makes available is explicit sexual enjoyment in a form that is presentable to a middle-class audience. A master at inspiring audience collaboration, she gained access to private psychosexual material that she then bound into a collective experience. Innuendo allowed her to avoid the censors but still satisfy the desire for provocation. Eliot appropriated her technique for his poetry. Far from being a "high" artist and a "low" stage performer, Eliot and Lloyd were key players in an essentially middle-class project of making sexual representation more explicit and more widely available but also more respectably "artistic."

NOTES

1. For further information see Peter Burger, *Theory of the Avant-Garde*, trans. Michael Shaw, Minneapolis: University of Minnesota Press, 1984; Bernard Gendron, "Jamming at Le Boeuf: Jazz and the Paris Avant-Garde," *Discourse* 12.1 (1989–90): 3–27; Andreas Huyssen, *After the Great Divide: Modernism, Mass Culture, Postmodernism*, Bloomington: Indiana University Press, 1986; Gregory S. Jay, "Postmodernism in *The Waste Land:* Women, Mass Culture and Others," and Lawrence W. Levine, *Highbrow/Lowbrow: The Emergence of Cultural Hierarchy in America*, Cambridge: Harvard University Press, 1988.

2. Some of these characters have recently become available to the public with the publication of *Inventions of the March Hare: Poems 1909–1917.*

3. Ronald Schuchard indicates, "The pretentious Latin title, according to my colleague William Arrowsmith, translates, appropriately, 'Buggery Nights.' . . . The Latinate construction originated from the gathering place of the authors: John Hayward's London flat, at 22 Bina Gardens." In "The Savage Comedian and the Sweeney Myth," 42.

4. Eliot was not alone in this view. Virginia Woolf called it the "real thing, as in Athens one might have felt that poetry was." She also considered music-hall humor to be "natural to the race." And Richard Hoggart in *Uses of Literacy* (Harmondsworth, Eng.: Penguin, 1958) points out that "Even a writer as stringent and seemingly unromantic as [George] Orwell never quite lost the habit of seeing the working classes through the cosy fug of an Edwardian music hall" (15).

5. See Vicki Mahaffey, "'The Death of Saint Narcissus' and 'Ode': Two Suppressed Poems by T. S. Eliot" and Ronald Schuchard, "T. S. Eliot: The Savage Comedian and the Sweeney Myth." Both critics read Eliot's poetry as growing out of what Schuchard calls "a deeply wounded sensibility" and consider the voices and images that he adopts to transcend his personal pathos. Schuchard finds in the savage humor of the "Sweeney" character a mask for Eliot's anger at Vivien's affair with Bertrand Russell. Mahaffey reads "Ode" as an anguished

reflection on the Eliots' disastrous honeymoon and considers whether Eliot suppressed the poetry because it was too clearly personal.

6. The contemporary critical reception did not raise any objections to what might have been considered "crude" material. Sweeney's contortions on the bed were thoroughly enjoyed. Criticism seems to have focused on the "obvious" nature of the parodies of popular song (D. G. Bridson, Review, *New English Weekly* 2 [12 Jan. 1933]: 304). The same critic found the humor "feeble." *The Waste Land* was criticized for its lack of passion rather than any abundance of vulgar emotions. Edmund Wilson in "The Poetry of Drouth" (*Dial* 73 [Dec. 1922]: 611–16) refers to criticism that Eliot received elsewhere, charging him with emotions that "belong essentially to a delayed adolescence . . . At bottom, it is sure to be said, Mr. Eliot is timid and prosaic like Mr. Prufrock; he has no capacity for life." Wilson excuses Eliot for his "constricted experience" and for drawing "rather heavily on books for the heat he could not derive from life."

7. In her chapter on "Disappearing Acts" Amy Koritz is also concerned with the contradiction in Eliot's views on performers. However, Koritz feels that Eliot's criticism is particularly reserved for female performers and that male stars do not receive the same treatment.

8. Note also Eliot's comments about music-hall comedian Ernie Lotinga in "A Dialogue on Dramatic Poetry": "Take the humour of our great English comedian, Ernie Lotinga. It is (if you like) bawdy. But such bawdiness is a tribute to, an acknowledgement of, conventional British morality" (*Selected Essays* 37).

WORKS CITED

Bailey, Peter. Introduction. *Music Hall: The Business of Pleasure*. Philadelphia: Open University Press, 1986.

Bratton, J. S. *Music Hall Performance and Style*. Philadelphia: Open University Press, 1986.

———. *The Victorian Popular Ballad*. Totowa, NJ: Rowman & Littlefield, 1975.

Chinitz, David. "T. S. Eliot and the Cultural Divide." *PMLA* 110.2 (Mar. 1995): 236–47.

Crump, Jeremy. "Provincial Music Hall: Promoters and Public in Leicester, 1863–1929." *Music Hall: The Business of Pleasure*. Ed. Peter Bailey. Philadelphia: Open University Press, 1986, 53–72.

Eliot, T. S. *Collected Poems 1909–1962*. San Diego: Harcourt Brace Jovanovich, 1963.

———. *Inventions of the March Hare: Poems 1909–1917*. Ed. Christopher Ricks. New York: Harcourt Brace, 1996.

————. *The Sacred Wood: Essays on Poetry and Criticism*. London: Methuen, 1950.

————. *Selected Essays*. New York: Harcourt Brace, 1950.

————. *Selected Prose of T. S. Eliot*. Ed. Frank Kermode. New York: Harcourt Brace Jovanovich,1975.

————. *"The Waste Land:"A Facsimile and Transcript of the Original Drafts including the Annotations of Ezra Pound*. Ed. Valerie Eliot. New York: Harcourt,1971.

Grant, Michael, ed. *T. S. Eliot: The Critical Heritage*. Vol. 1. London: Routledge, 1982.

Koritz, Amy. *Gendering Bodies/Performing Art: Dance and Literature in Early Twentieth-Century British Culture*. Ann Arbor: University of Michigan Press, 1995.

Lee, Edward. *Folksong and Music Hall*. London and Boston: Routledge & Kegan Paul, 1982.

Mahaffey, Vicki. " 'The Death of Saint Narcissus' and 'Ode': Two Suppressed Poems by T. S. Eliot." *American Literature* 50 (Jan. 1979): 604–12.

Pennybacker, Susan. " 'It was not what she said, but the way in which she said it': The London County Council and the Music Halls." *Music Hall: The Business of Pleasure*. Ed. Peter Bailey. Philadelphia: Open University Press,1986.

Schuchard, Ronald. " T. S. Eliot: The Savage Comedian and the Sweeney Myth." *The Placing of T. S.Eliot*. Ed. Jewel Spears Brooker. Columbia: University of Missouri Press, 1991, 27–42.

————. *Eliot's Dark Angel* (forthcoming).

Weimann, Robert. "Bifold Authority in Shakespeare's Theatre." *Shakespeare Quarterly*. 39.4 (Winter 1988): 401–17.

Protective Coloring
Modernism and Blackface Minstrelsy
in the Bolo Poems

JONATHAN GILL

> *Anyway it's interesting to cut yourself to pieces*
> *once in a while, and wait to see if the fragments*
> *will sprout.*
>
> —T. S. ELIOT, 1914

CREATURES OF MIXED BLOOD

According to legend, upon hearing that T. S. Eliot had won the 1948 Nobel Prize and the British Order of Merit, a group of students from Harvard, Eliot's alma mater, sent him a telegram reading: "You've Come a Long Way from St. Louis" (Sanders 26). In fact, as he grew older, Eliot seemed to grow increasingly closer to St. Louis, revisiting in poems, essays, letters, and interviews the place of his birth, and reminiscing publicly about his happy boyhood beside the Mississippi River, which defines the city's eastern limit. Yet Eliot always seemed to overlook the fact that two great rivers define the borders of St. Louis, with the Missouri meandering west of the city and meeting the Mississippi just to the north. So too, the scholarship surrounding Eliot has almost invariably emphasized his British and European heritage, ignoring a second mighty stream of influence: African American culture, and blackface minstrelsy in particular. It was in blackface minstrelsy, that typically American form of nineteenth-century popular musical theater, that Eliot recognized, in both overt and covert ways, an important model for his own poetry: a discontinuous, fragmented genre marked by the mixing of high and low styles and subjects, and an overriding concern with sexual impotence, homosexuality, violence, hysteria, and the loss of faith that the faith in technology instigated in the modern world. If the sprouting fragments that Eliot mentioned to his friend Conrad Aiken in 1914 (*Letters* 59) may be seen as the issue of a racial cross-fertilization, then modernism itself must be understood as a creature of mixed blood, counting Tambo and Bones alongside Dante and Shakespeare as ancestors.

To be sure, explicit references to blackface minstrelsy and even out-right theft of its conventions occur in Eliot's better-known works. As of 1926, part of *Sweeney Agonistes* bore the subtitle "Fragment of a Comic Minstrelsy" (North 87), while in the related "Fragment of an Agon" (1927) two characters drawn directly from blackface minstrelsy, the "endmen" Tambo and Bones, sing about two people living as one, one as two, "Under the bamboo tree" (*Complete Poems* 81). This passage is lifted from "Under the Bamboo Tree," a widely popular 1902 minstrel song by Bob Cole, James Rosamond Johnson, and James Weldon John-son that includes the refrain "One live as two, two live as one, / Under the bamboo tree" (quoted in Levy 90). The original manuscript version of *The Waste Land* also contains lines drawn directly from minstrelsy. Eliot at one point cuts "I'm proud of all the Irish blood that's in me, / 'There's not a man can say a word agin' me" (5), adapted from the song "Harri-gan," from George M. Cohan's 1907 musical *Fifty Miles From Boston*, in favor of the lines "Meet me in the shadow of the watermelon vine / Eva Iva Uva Emmaline," adapted from Thomas S. Allen's 1907 minstrel song "By the Watermelon Vine."[1] As the manuscript indicates, the Allen refer-ence was in turn to be replaced by "Tease, Squeeze lovin & wooin / Say Kid what're y' doin" (5), drawn from Mae Anwerda Sloane's 1901 min-strel tune "My Evaline" (125).

BLACKING UP

Eliot's debt to blackface minstrelsy is most significant, if not as immedi-ately visible, in the series of lyrics—"unpublished and unpublishable," as he later called them (Reid 540)—that he wrote, starting in his college years, about the irreverent and even obscene adventures of a fictional King Bolo and his Big Black Bastard Queen. Discovered by Christopher Columbus and brought back to Europe, the couple's comic lack of in-hibition scandalizes the upholders of Western civilization. The queen in the passage takes us in the company of "Cardinal Bessarion" to Golders Green (*Letters* 125).[2]

As this relatively mild example shows, the Bolo poems struggle with the very same tensions that dominate Eliot's published output—Old World versus New, high culture versus low, order versus chaos, tradition versus innovation, the dead versus the living—yet all within the formal conventions of the nineteenth-century African American minstrel song, and with a surprising racial, even racist, focus. The sudden availability of

the Bolo lyrics (a small selection first became available in 1988, in the first volume of Eliot's letters, and others were included in the 1996 collection of unpublished early poetry known as *Inventions of the March Hare*, although dozens more appear in unpublished letters to Pound) threatens, as it should, Eliot's position as the avatar of the values, literary and otherwise, of European high culture. Far from Anthony Lane's claim that these lyrics are "negligible as poetry; there is nothing to it except the sneer" (90), the Bolo poems are enormously revealing, suggesting the extent to which the African American tradition, and blackface minstrelsy in particular, "colors" the founding texts of modernism.

Critics have, of course, always linked Eliot with the culture of the jazz age. As early as 1921, Clive Bell's landmark discussion of jazz and modern poetry was calling Eliot "as much a product of the Jazz movement as so good an artist can be of any" (94), and since Charles Sanders suggested in 1980 that "conventions common to minstrel shows and music-hall entertainment . . . inform the context, structural techniques, and the conceptual scheme" (25) of *The Waste Land*, a whole new scholarly approach has devoted itself to teasing out the connections between Eliot and popular culture as a way to understand the relationship between the highest of high modernists and the lowest of low cultures. Yet to say, as Sanders does, that the great British vaudevillian Marie Lloyd, whose death Eliot famously mourned in a 1932 essay, is "as present in Eliot's bones as Virgil, Dante, or Shakespeare" (25) is to ignore the question of race. Although Bell attributed some of Eliot's most successful early work to the "ministrations of a black and grinning muse" (94), Sanders and his successors have sought to diminish the extent to which African American culture and blackface representations of African American culture—they are not, most assuredly, the same thing—help generate Eliot's sense of popular, and therefore for him, primitive, art. Scholars like Carol H. Smith and David Chinitz notice the "jazz rhythms" of Eliot's poems, and Leo Hamalian goes so far as to call *Sweeney Agonistes* a "jazz operetta" (3), but rarely does race enter the picture. Sanders, for example, transforms what Eliot himself once called his own "nigger drawl" (quoted in Tate 15) into the more palatable "Southern drawl" (29).

Eliot's unfinished mock drama from 1914, *Effie the Waif*, stars "Rev. Hammond Aigs," a "comic negro minister of the 'come breddern' type" who is given to "gin, chicken stealing and prayer" (*Letters* 77),[3] but Eliot also tended to leave race out of the relationship between popular culture

and high modernism, which is the "cultural divide" that Chinitz addresses. In his 1920 essay "The Possibility of a Poetic Drama," Eliot was proposing to "take a form of entertainment, and subject it to the process which would leave it as a form of art," and suggested "the music-hall comedian" (70) as a possible starting place, a gesture that carefully elides the fact that his primary interest in popular theater was focused even as an adolescent on American blackface minstrelsy, not on the typically British venue of the music hall, which he encountered only as an adult, after moving to England. Many of Eliot's essays on poetry and drama during the 1920s look to the "primitive" arts as a model for a revitalized theater, but he never betrays that African ritual music and drama, and its descendant, blackface minstrelsy, more than Greek tragedy, serves as a model. The reader who is attentive to the intellectual lexicon of the jazz age, with its racial coding of terms like *vitality* and *rhythm*, knows better when Eliot uses such language.[4]

Even if "the greatest debts are not always the most evident," as Eliot told the Italian Institute of London on 4 July 1950 (*To Criticize the Critic* 126)—not coincidentally, American Independence Day—it takes some effort to convince readers of Eliot's prose paeans to the classics that blackface culture was also in his blood. Most middle- or upper-class children in late nineteenth-century America learned to read with the help of Joel Chandler Harris's best-selling Uncle Remus tales; when Pound and Eliot "blacked up" in their correspondence, it was under the names of the Harris characters Brer Rabbit, Possum, and Tar Baby. Moreover, Eliot lived until the age of sixteen in a southern city that had only recently ended its dependence on the plantation system, a city that had become a mecca of black—and blackface—culture. Herbert Howarth offers a useful history of St. Louis and its influence on Eliot in *Notes on Some Figures behind T. S. Eliot*, but spares barely a word for the city's African American heritage, while in fact ever since its founding in 1764, St. Louis has always had one of the nation's proportionally largest black populations. In 1772 one-third of the city's 517 inhabitants were slaves (Gerlach 11), and by 1850 more than six thousand slaves lived at the meeting point of the Mississippi and Missouri Rivers (Gerlach 23). By the time of Eliot's birth, at least twenty thousand blacks lived in St. Louis, which was by then the fourth-largest city in the nation and host to three black newspapers. As for African American culture, St. Louis was a regional center for black musical theater, from vaudeville to opera. The ragtime composer Scott Joplin lived in St. Louis during Eliot's childhood,

and his opera *A Guest of Honor* premiered there to wide publicity in 1900. In 1904 St. Louis dominated the nation's musical interests when it hosted the National Ragtime Contest. As for blackface minstrelsy proper, the city had, since the rise of the genre, regularly sponsored some of the nation's most prominent troupes. The St. Louis Museum brought in the Birch, Bowers, and Fox's Minstrels as early as 1857, Johnny Allen's Minstrels performed in St. Louis in 1864, and the famed Georgia Minstrels appeared there in 1871, while the well-known minstrel Sam Lucas entertained audiences in St. Louis in 1886, two years before Eliot's birth. In 1896 one of the most famous blackface minstrel shows of all, *Darkest America*, garnered a lengthy review in the *St. Louis Post Dispatch* (Toll 199).

Eliot grew up in well-to-do white circles, and many of the Bolo lyrics originally appeared in a notebook entitled *Inventions of the March Hare*, an allusion to Lewis Carroll's *Through the Looking Glass*, in which the characters take great pains to emphasize that the song that the White Knight sings is not his own; indeed, Eliot later noted that "a good poet will usually borrow from authors remote in time, or alien in language, or diverse in interest" (*Selected Essays* 206). Nonetheless, Eliot must have had contact with local African Americans and African American culture during his childhood. While much of the white population of St. Louis was moving to the suburbs in the 1890s, fleeing an influx of African Americans from the rural South, the Eliots remained at the family home on Locust Street, which Eliot noted several times later in his life was no longer a proper neighborhood for a family of the Eliots' station in life. In a 1960 article called "The Influence of the Landscape upon the Poet," for example, Eliot remembered how "we lived on in a neighborhood which had become shabby to a degree approaching slumminess" (421); then, as now, the word *slum* carried with it unmistakable racial overtones.

Clearly there was an element of coyness in such reminiscence, since Eliot, the slum dweller with a "nigger drawl," could not resist doing some slumming of a different sort while a Harvard undergraduate. According to Aiken, in the early years of the century the two young poets fell under the spell of popular comic strips like *Krazy Kat*—drawn by the black cartoonist George Herriman—and enjoyed speaking about, and speaking in, black slang: "How delighted we were with the word 'dinge' for negro!" (March and Tambimuttu 21).[5] No wonder, then, that when Eliot returned to St. Louis in 1953 to lecture on "American Literature and the American Language" he announced: "perhaps I am unconsciously bilingual"

(*To Criticize the Critic* 46). The reference was surely as much in reference to black and white speech as to British and American English.

DIALECT OF THE TRIBE

For the adolescent Eliot, this interest in black culture, an interest bordering on identification, culminated, as Aiken recalled, in the "hilariously naughty parerga which was devoted spasmodically to that singular and sterling character known as King Bolo, not to mention Bolo's Queen" (March and Tambimuttu 22).[6] Hilariously naughty seems an understatement, especially the phallic allusions in the "Fried Hyenas" poem (*Letters* 42). Eliot's work in this vein strives for a tone of formal spontaneity appropriate to what he termed in a 1921 letter to James Joyce "coon transformations" (*Letters* 455), but his typography clearly admits, even emphasizes, the extent to which these poems were carefully planned and revised. In "l(oader)" and "p(enis)" remain the vestiges of blank spaces in parentheses, pending finalization of the rhyme scheme; but why take the trouble to wait for the perfect rhyme, and then in both cases chose an imperfect rhyme? The answer lies not in resolving the rhetorical paradox but in acknowledging the extent to which the Bolo lyrics imitate the paradoxical rhetoric of blackface minstrelsy.

At first glance, the formal characteristics of the Bolo poems suggest an affiliation with songs found in any number of popular anthologies of Negro song that were published and in many cases not only transcribed but written by white writers in late nineteenth-century America. Both types of verse feature phonetic spelling, improper syntax, and highly charged and malleable rhythms. In fact, Eliot's Bolo lyrics—they are clearly verse of the type Eliot called "suitable for singing," since he at one point suggested musical accompaniment (quoted in *Inventions* xix) and at another called them an "epic ballad" (*Letters* 455)—employ the specific formal and thematic conventions of blackface minstrel songs, with their daringly self-conscious violations of the accepted rules and practices of standard English. It is not merely affective but essential to their very nature that the Bolo poems are written badly, epitomizing the "eccentric vocabulary, full of bad grammar, faulty pronunciation and bombastic ignorance" (Wittke 142) that characterize blackface minstrel lyrics. The Bolo poems are not written, in the manner of the nineteenth-century anthologies, in Black English, which supposedly replicates the authentic patterns of African American speech, but in the highly

self-conscious literary language that I would call blackface English, which shows off a carefully contrived spontaneity, a pompous naïveté, a naturalness achieved only by the most painstaking of artifice—"pure manure," as one of the rhymes suggests. Eliot's 1926 introduction to one of his mother's works claimed that "the recognized forms of speech-verse are not as efficient as they should be; probably a new form will be devised out of colloquial speech" (xi), but something more heretical than efficient is at work in what Eliot understood as "Bolovian" phonetics.

As in blackface minstrelsy, the misspellings, mispronunciations, and ungrammatical usages of the Bolo poems evince a self-consciously illiterate literariness. In a letter to Aiken on 10 January 1916, Eliot includes four verses that play with a variety of "klassic" errors by the unlettered (*Letters* 125). The reader is meant to link phonetic spelling, particularly the substitution of a "k" for all "/k/" sounds, with the simpleminded, illiterate heroine, who cannot spell but who knows obscenity when she sees it. Such errors are only erudition masquerading as error, however; a carefully calculated gesture toward ignorance that recalls not only Herriman's *Krazy Kat,* but the "komical koons" ubiquitous in minstrel show advertisements from Eliot's childhood; indeed, the magazine that Eliot produced as a child, *The Fireside*, featured a "Kook's Korner."[7]

It takes a sublime sensibility to find obscenity revolting and a keen attention to spelling to get all the mistakes right. As such, the Bolo lyrics exude the double tone characteristic of the classic blackface minstrel song, which are at once comedies "of the grotesque and unacceptable," as Ralph Ellison put it (48), and tragedies of the proper and legal. Just as the queen with a weak stomach and a dirty mouth is besmirched by excrement, so too is the lyric itself both official and illegitimate, classic and obscene, learned and ignorant. For every "unlettered" rhyme in the Bolo poems—"soda" and "loader" (*Letters* 42) or "breezes" and "Jesus" (206)—is a witty one: "sink'd her" and "sphincter" (59), or "hyenas" and "penis" (42). For every instance in which the orthography, vocabulary, or syntax of the Bolo poems replicates the speech patterns of black English—"one" is spelled "un" (125) and "awfully" appears twice as "awf'ly" (125–26)—there are virtuosic, multisyllabic displays of blackface poetic skill, often within the same lyric, as in the rhyming of "& elastic one" with "fantastikon" (568). Beyond the imagination, vocabulary, and technical ingenuity required to pull off such a rhyme, it

is worth noting that *phantastikon*, the ancient Greek for "imaginative faculty," was a concept much in vogue with the modernists; Ezra Pound, who refers to the *phantastikon* in his 1910 collection of essays, *The Spirit of Romance*, in his 1913 poem, "The Condolence," and in the 1917 version of "Canto I," calls the *phantastikon* the type of mind that passively mirrors externals, as opposed to the "germinal" consciousness that creates and imposes its own world on the outside world. This is no mere idle reference to literary salon talk for Eliot, though; if King Bolo's Big Black Queen is to enjoy her own *phantastikon*, the performed outer image by which she, and all black people, are to be recognized, she must also possess an inner, germinal mind that can create and perceive such an image. Eliot has smuggled a model of blackface esthetics into a poem that masquerades, like King Bolo's Big Black Queen, as a frisky and trifling joke.

The distorted, even grotesque "body" of the Bolo poems—their spelling, syntax, diction, and meter—match the distorted and grotesque bodies of their chief protagonists. Bolo, his queen, and their subjects are always very big and very black and unable to control the excessive appetites and desires that are not surprisingly appropriate, in these poems, to characters of their skin color. The King's thirty-three followers are childlike, dirty, climb trees, and defecate at will (*Inventions* 316). Such outrageous activities as shitting on the naked body of one's monarch, and the unruly poems that portray these events, are all the more amusing because of their pretensions to elegance, a gesture Eliot confirmed in a drawing he included in a 1914 letter to Aiken (*Letters* 43). Here we have a bald black man with an obscenely wide smile, an impossibly broad nose, and a huge, polka-dotted tie playing the English gentleman, or at least the American idea of what such a character should be, complete with top hat, cigar, and monocle. This image matches precisely the classic stage presence of the typical blackface minstrel that Mark Twain, for example, saw in "nigger shows" in Missouri in the 1840s: such characters wore clothing with buttons "as big as a blacking box" and had mouths that "resembled slices cut in a ripe watermelon" (*Autobiography* 59). Twain's autobiographical account is confirmed by the historian Robert Toll, who describes the typical blackface performer as a "flat-nosed, big-lipped, 'dancing darky' with the ear to ear grin [with] huge eyes and gaping mouth . . . dressed in ill-fitting, patchwork clothes" (37), and seconded by Wittke, who depicts "the Negro type" as "always distinguished by an unusually large mouth and a peculiar kind of broad grin; he dressed in gaudy colors and in a flashy style" (8).

King Bolo looks like the blackface minstrel characters that Eliot encountered in St. Louis and at Harvard, and he acts like them too. Among the most popular scenarios in blackface minstrelsy was one concerning "just how ridiculous Negroes could be when they tried to live like 'gentlemen'" (Toll 68). In these plots, rustic ex-slaves are forever unsuccessfully imitating and therefore disrupting the polite, civilized, white upper classes; they are inevitably befuddled by and therefore challenging modern technology, fashion, or manners. The result when these unruly primitives meet their civilized counterparts is shock and embarrassment on all sides, a scenario Eliot borrows over and over again in his minstrel lyrics, but with a twist. King Bolo and his Big Black Queen are forever being brought back from the New World by Christopher Columbus to the Old World, where their uncivilized tastes, grotesque behavior, and obscene bodies appall the guardians of civilization. In addition to leading a public dance with a medieval cardinal among the staid housewives and clerks in Golders Green, a fashionable Jewish suburb in northwest London, King Bolo's "sweet and pure" Big Black Queen cannot contain her religious sensibilities in church:

> *King Bolo's big black bassturd kween* ˉ
> > *Was awf'ly sweet and pure*
> *She interrupted prayers one day*
> > *With a shout of Pig's Manure. (Letters 125)*

How appropriate for a monarch whose illegitimacy is somehow excremental—this bastard is also a "turd"—to disrupt the most formal, spiritual, and holy use of language with an explosion of linguistic waste. Excessive and unruly in every way, Queen Bolo seems to have a thing or two to teach the church even when it comes to sexual purity:

> *K. B. b. b. b. k.*
> > *Was awf'ly sweet and pure*
> *She said "I don't know what you mean!"*
> > *When the chaplain whistled to her. (Letters 126)*

Here the relentlessly sexual black savage, the product of an unlawful sexual union, is so disruptive that she even rejects the sexual advances of the clergy, allowing Eliot to display some uncharacteristic spleen toward the church. Of course, it is in the nature of the New World and its inhabitants, and their poetic equivalents, to inspire Europeans to uncivilized behavior; the rhetorical environment of the Bolo poems offers a

space for transgression, encouraging the chaplain to make a pass at a congregant, and inviting Columbus to serve penis for lunch.

For Eliot, King Bolo's Big Black Queen becomes a particularly important locus for sexual, and therefore, in the logic of the genre, poetic, transgression:

> *One day Columbo and his men*
> *They took and went ashore*
> *Columbo sniffed around the air*
> *And muttered "I smell whore"*
> *And ere they'd taken twenty steps*
> *Among the Cuban jungles*
> *They found King Bolo & his queen*
> *A-sitting on their bungholes.* (*Inventions* 317)

As always in Bolo lyrics, the representatives of European decency, order, and civilization meets the dangerously sexual savage; Bolo's Queen is a "tart" who excretes an odor of sexual indecency even while sitting with her monarch on what passes for a throne in the wilds of the New World. King Bolo's Big Black Queen further obliges civilization's appetite for the indecent by transgressing the boundaries of gender; this she is so "plastic" and "elastic" that she may not be a she at all. She is big and hairy, and therefore masculine, but she is also an "airy fairy"—that is, a masculine female playing a male homosexual. Such play was, of course, standard fare in blackface minstrelsy, where sexual impersonation and cross-dressing were often matters of necessity. Although some companies included women in the nineteenth century, the majority were male; companies made the most of this necessity, adding the thrill of sexual masking—"the homosexual content of blackface transvestism" (Lott 27)—to that of class and race.

Pound called the Bolo poems "Chancons ithyphallique" (Gallup item 69), and although Pound's metrics are not quite accurate—ithyphallic meter is technically trochaic dimeter brachycatalectic, meaning a line of two trochees that are often lacking a foot or two other syllables—the link he made between these songs and sexuality is correct. *Ithyphallic* literally means "erect penis," and ithyphallic meter is in fact proper to Bacchic hymns, chanted to accompany processions of holy phallic symbols in ancient Greece.

So too, the Bolo poems re-rehearse the obsession with African American sexuality that blackface minstrelsy always acts out. Yet where "authentic" blackface minstrelsy refrains from explicit treatments of

sexuality, instead reveling in indirection and double entendre, Eliot seems incapable of suppressing his overt interest in the type of unbridled sexual activity with which his chosen literary medium by intention and necessity only flirts. Take, for example, the famous 1827 minstrel song "Long Tail Blue," which operates successfully and completely in two separate universes, the sexual and the sartorial:

> *If you want to win the Ladies hearts,*
> *I'll tell you what to do;*
> *Go to a tip top Tailor's shop,*
> *And buy a long tail blue.* (quoted in Lott 25)

Here the implicit meaning not only coexists with the explicit meaning but depends on it. Any challenge that blackface minstrelsy makes to the racial, literary, or political status quo thrives on the restrictions of skin color, the constraints of poetic and musical form, and the limits of subject matter. In comparison, Eliot's project has a different approach to the unacceptable.

> *King Bolo's swarthy bodyguards*
> *Were called the Jersey Lilies*
> *A wild and hardy set of blacks*
> *Undaunted by syphilis.*
> *They wore the national uniform*
> *Of a garland of verbenas*
> *And a pari of great big hairy balls*
> *And a big black knotty penis.* (*Inventions* 316)

Bolo's men are unafraid of the physical or moral consequences of sexual overactivity, not to mention contact with Europeans bearing venereal diseases. So too does Eliot's poem roll on in its ideological and rhetorical overactivity. The rhyme, meter, and imagery are so grossly indecent, yet so innocently displayed. If Bolo's men pose no danger to society because their dark sexuality is open for all to see, then this Bolo lyric short-circuits the shock of the unacceptable by wearing its art on its sleeve. Although Lane notes that the Bolo poems show "what happens when vers becomes to libre for its own good" (89), it is clear that freedom imposes certain restrictions on Eliot's imagination—when he loses his creativity and allows himself to write anything and everything not permissible in proper verse, he gravitates toward a mode of literary creation whose lawlessness is so predictable as to become almost rule-bound,

whose transgression was required. The Bolo lyrics are ritualized, even stylized, chaos."

CONTRIVED DISORDER

The Bolo poems came, of course, at a crucial moment in Eliot's career as a poet, when he had decided to forsake America for England and become a writer with a particular interest in voices. Eliot wrote a letter while crossing the Atlantic in July 1914—literally in-between the two states, and the two states of mind—reproducing a variety of accents, black and white, southern and northeastern, American and English:

> *When I look at the water, heven, it 'eaves my*
> *stomach 'orrible . . . My but you do have grand*
> *thoughts! . . . why arn't you dancing? . . . Very pleased*
> *to meet you . . . My name's Calkins, Michigan 1914*
> *. . . Aw I wish I'd known what was good for me and*
> *staid in Detroit, Michigan, it's a long swim to*
> *the Irish coast . . . If I ever get to Liverpool I'm going*
> *to join the church . . . Ah no sir they don't make no*
> *trouble for me, they just lays where I put 'em and*
> *honly wants to be left quiet . . . Try the tripe and*
> *onions, its just lovely . . . Yes this genlmn knows*
> *I'm speakin gospel truth (pointing at me) he's*
> *connected with the building trade hisself. (Letters 39)*

These "brilliants," as he called them, became a regular feature of his letters to his cousin Eleanor Hinkley in 1914 and 1915, and mimicking voices, particularly in the vernacular, remained a crucial element of Eliot's poetic technique; eventually, of course, he gave up verse altogether for the drama of pure voice. What, then, are we to make of Eliot's decision to begin his career as a writer in England, but not in the English—as opposed to American—language? England was, to be sure, the proper place for a white southerner with a "nigger drawl" to purge himself of the taint of the American language. Recall that when Eliot moved to England, he entered an intellectual climate that was already attempting to preserve, regulate, and promulgate a distinctly class-bound national language. No wonder, then, struggling to master British English, that Eliot wrote to Aiken from Oxford in 1914 of a resolution: "I must learn to talk English" (*Letters* 58). Half a decade later, the same year as the founding of the Society for Pure English, Eliot lamented: "I may simply prove to be a savage" (318).

Nonetheless, the Bolo lyrics, written in the very voice of which Eliot was seeking to purge himself at the start of his career as a poet, ought to be taken seriously—Eliot himself certainly did. Far from writing them exclusively "for the private entertainment of male friends," as one scholar has it (Pinion 13), Eliot offered the Bolo poems for publication along with his most serious and accomplished works. In early 1915 Eliot was simultaneously seeking to publish "Prufrock," "Portrait of a Lady," and a group of occasional verses including the Bolo poems[8]; he remarked in a 2 February letter to Pound that Wyndham Lewis's "puritanical principles" stood in the way of the Bolo poems appearing in *BLAST*:

> *I fear that King Bolo and his Big Black Kween will*
> *never burst into print. I understand that Priapism,*
> *Narcisissim [sic] etc. are not approved of, and even so*
> *innocent a rhyme as*
> *. . . pulled her stockings off*
> *With a frightful cry of "Hauptbahnhof!!"*
> *is considered decadent. (Letters 86)*

Six years later, Eliot was still hoping to see the Bolo poems in print, even as he prepared *The Waste Land* for publication. Eliot wrote to James Joyce of his desire to "bring out a limited edition of my epic ballad on the life of Christopher Columbus and his friend King Bolo" (*Letters* 455). He sent some of the verses to Pound as part of their more general correspondence surrounding the editing of *The Waste Land* in late 1921 and early 1922. Pound responded "you can forward the 'Bolo' to Joyce if you think it won't unhinge his somewhat sabbatarian mind" (*Pound Selected Letters* 171).[9] In September 1922, a month before the appearance of *The Waste Land* in the *Criterion*, Eliot offered both the manuscript of *The Waste Land* and the notebooks in which some Bolo poems appear to John Quinn but with an ironic proviso: "I beg you fervently to keep them to yourself and see that they never are printed" (*Letters* 572). Why preserve and even distribute texts so emphatically unworthy of preservation and distribution if not to secure a place for them, as small and marginal as that might be? For the rest of his life Eliot continued to waver over the value of his minstrel songs, enthusiastically explaining all about the "Bolovians" to Bonamy Dobrée in the late 1920s (see *Inventions* 321), but making it clear to others that he wished the Bolo lyrics to remain unread. Pound recalled the Bolo poems in a 1935 letter to Arnold Gingrich recommending that he print "a couple of bawdy songs

from father Eliot . . . or of course 'Bolo,' which I am afraid his religion
won't now let him print" (*Pound Selected Letters* 266), yet in 1941 Eliot
was again writing about the Bolo poems, this time to Clive Bell, the critic
who originally linked Eliot with black culture. By 1963 Eliot was calling
the notebook in which some of the Bolo poems appear "unpublishable,"
and the next year he again found them "not worth publishing" (Wood-
ward 268).

While Bolo lyrics themselves remained suppressed, the impulse
toward the disruptive masking of blackface minstrelsy conventions that
they exemplified could not help but manifest itself in Eliot's most seri-
ous works—and here we ought to keep in mind that Eliot himself often
failed to distinguish his more occasional, or even, as we have seen, ob-
scene verse from his more respectable literary productions. As Sanders
has suggested, *The Waste Land* mimes the structure of a nineteenth-
century American blackface minstrel show. Indeed, the poem seems to
adhere almost rigidly to the classic three-act form of minstrelsy. In "The
Burial of the Dead" we can see the minstrel show's opening section, in
which an "interlocutor"—we will know him as Tiresias—seems to intro-
duce the characters of the show. "A Game of Chess," "The Fire Sermon,"
and "Death by Water" function as the "olio," or middle section, a variety
of "folklore, dance, jokes, songs, instrumental tunes, skits, mock oratory,
satire, racial and gender cross-dressing or impersonation" (Lott 13).
Finally, in "What the Thunder Said" we have a finale, consisting of a full
dramatic scene that provides resolution and closure.[10] However, Eliot
seemed less interested in the structure of the minstrel show as a model
for his own poetry than in minstrelsy's more general approach to ques-
tions of identity and language, in which self-consciously masked voices
allow for a safe, even guaranteed transgression; the modernist-style
poetic fragmentation and formal discursiveness that Eliot appreciated
in minstrelsy also extended to fragmentary and discursive identities. If
"Who's there" is the first line and central question of Eliot's beloved
Hamlet, the unasked but nonetheless "overwhelming question" of "The
Love Song of J. Alfred Prufrock" finally appears at the center of *The
Waste Land*: "what shall we do?" The masking poetics of blackface min-
strelsy helped Eliot promulgate performative, rather than essential, aspects
of racial, not to mention sexual, class, and national, identities.[11] Old Pos-
sum, as Eliot called himself in his correspondence with Pound, after the
character in Harris's Uncle Remus tales—he might also have been iden-
tifying with the classic minstrel song "Opossum Up a Gum Tree"—
might play dead, but he could not escape what Ralph Ellison calls "the

old American problem of identity" (53). Hence blackface minstrelsy's obsession with masking—blacks in blackface playing whites, whites in blackface playing Germans, black women in blackface playing slaves playing Irish immigrants—offered a tool for radical performance, an endless, indeterminate play with racial, economic, gender, ethnic, and national identities. The American identity, minstrels told audiences, was an improvisation.

Ultimately, of course, Eliot's greatest blackface performance was his own life: "T. S. Eliot" served as the interlocutor, as it were, between northerner and southerner, banker, publisher, and poet, between American and Englishman, between Unitarian and Anglican, between "Thomas Stearns Eliot," "Tom Eliot," "Thomas S. Eliot," "Thomas Eliot," and "T. Stearns Eliot"—such is the variety with which he signed his letters. Moreover, by happy coincidence, and one with which he was no doubt familiar, Eliot bore one of the most common and colorless first names in English, which made it popular in blackface minstrelsy, as the roster of performers who used the name attests: Black Tom, Blind Tom, Japanese Tommy, Tom Thumb, Tom Fletcher, Tom McIntosh, and Tom Brown. Eliot once even offered to play Uncle Tom to Pound's Little Eva (*Letters* 350).

If Eliot blacked up for the Bolo poems, and even wore green powder on his face "to look cadaverous" (Gordon 5) at social occasions, might we not also see him whiting up at times as well, capitalizing on the ambiguities that discursive identities admit and even encourage? Like Bolo, who is both African and native American, Eliot found in an African American musical form a way to exploit and harmonize the curious pitches of race and the English language.

Unfortunately, the publication of the Bolo lyrics seems destined to secure Eliot's reputation as a tin-eared racist, in addition to being a snob, a misogynist, and an anti-Semite. The Bolo lyrics are racist, to be sure, but are they only racist? Or in them do we see that, as Ralph Ellison has argued, "the motives hidden behind the mask are as numerous as the ambiguities the mask conceals" (55)? The Bolo verses are certainly much more than merely "part of the story of the poet's transition from the Laforguean velleities of 1917 to the Corbièresque bluntness, such as 'Sweeney Erect,' of 1920," as Ricks suggests (*Inventions* xvi). Rather, they form a legitimate stage in Eliot's career, and it is because of, rather than in spite of, their lawless, comic irreverence that we ought to take these lyrics in earnest. Eliot's route back to the artistic experience of primitive culture, and therefore to a redemption of modern life, was through

blackface minstrelsy. After all, do not the Bolo poems, where Columbus is forever discovering King Bolo and his Big Black Queen, obsessively reenact the encounter between Europe and America, the Old World and the New, the modern and the primitive, tradition and innovation, the devouring binary at the very heart of Eliot's project? The contrived formal disorder of the Bolo poems reflects the larger disorder with which King Bolo and his Big Black Queen threaten Columbus's world, both on the ship and back home in Europe. Like minstrelsy, which makes "an intentional comic assault on Standard English and the values cherished by those who spoke it" (Mahar 262), the very existence of Bolo and his Big Black Queen, like the literary form in which they appear, is obscene, sullying the pretensions of proper poetry, and challenging the legitimacy of the culture that it represents and the supposed distance between the two. Eliot wrote to Aiken in 1914 that "the thing is to be able to look at one's life as if it were somebody else's" (*Letters* 59), already aware that his black voice and his white voice were not merely relative, but related; so, too, minstrelsy was for almost a century the preferred cultural site for an entire nation to attack, defend, or simply examine the esthetic and racial relationship between the popular and the genteel, the low and the high. In the end, blacking up by using African American musical forms to portray African Americans made Eliot not simply more white, but more American, in the logic of blackface, which operated according to what Lott calls "a peculiarly American structure of racial feeling" (18). If the "brown god" of the Mississippi River called up in "The Dry Salvages" is not quite completely forgotten, perhaps it is because "the problem" (130) has not been solved. North understands blackface English as an effort of "rebellion and escape by means of racial cross-identification" (9), but might we not also understand Eliot's use of the conventions of blackface minstrelsy as a return to a native tradition, and the Bolo poems as less a kind of poetic dross than a poetic compensation? Far from standing "in insurrectionary opposition to the known and familiar in language," as North puts it (1), blackface was the known and familiar for Eliot, indeed to all of the modernists, all of whom must be seen as what Lott calls "raced" subjects (4), all of whom might be seen as possessing double consciences, if not double consciousnesses. If the mirroring fictions and counterfictions make the Bolo poems a kind of blackface minstrel ventriloquism, it is thankfully never made clear who is sitting on whose lap, who is making who sing.

NOTES

1. Michael North's *The Dialect of Modernism* contains the definitive discussion of the dating of this song (223), as well as useful background on many of the popular songs that inform *The Waste Land.*

2. Eliot misspells "Bessarion" and mistakenly adds an apostrophe to Golders Green. The latter, incidentally, was the site of the popular Hippodrome Theater, which opened in 1913, although there is no record of Eliot having seen any shows there. Eliot also mentions Golders Green in his poem "A Cooking Egg" as a place from which "red-eyed scavengers are creeping" (*Complete Poems* 27). Perhaps its inhabitants had the last laugh: the final resting place for Eliot's own body after his death in 1965 was the Golders Green Crematorium.

3. The part was to be played by Eliot's cousin, the eminently respectable Rev. Frederick Eliot, soon to become the head of the American Unitarian Association.

4. Of course, blackface minstrelsy was itself never purely a product of black culture, nor was it solely a product of white culture's response to black culture, as Eric Lott suggests. After all, though whites formed the majority of minstrel companies in the nineteenth century, blacks played in blackface from the very beginning; such a troupe appeared in Eliot's hometown at least before the Civil War.

5. Aiken seems to think that the two young poets had happened upon a novelty, but the disparaging term had been in common use for decades in both the United States and Great Britain. The *Dictionary of American Regional English* and the *Oxford English Dictionary* both list the earliest usage as 1848.

6. A number of sources seem to have contributed to Bolo's name. The most likely seems to have been the Haitian General Rosalvo Bobo, a Paris-trained doctor turned politician and dandy—Bobo tended to cover red hair with a high silk hat and kept his hand tucked, in the style of Napoleon, inside a Prince Albert coat (Heinl 412). Bobo's name was much in the news in 1914 and 1915 for a flamboyant military campaign against American occupation and his own government. Eliot's 1914 imitation of the "BLAST" and "BLESS" lists in the periodical *BLAST* contains the name "BOLO" (*Letters* 40), and in a similar list Eliot wrote the next year, Bolo's name is replaced by "GEN. BOBO" and "GEN. BLOT," another Haitian military leader (*Letters* 111). Ricks, who seems unaware of this possible source, offers as another possibility the *Bab Ballards* of W. S. Gilbert, in particular "King Burria" (*Inventions* 321). Ricks seems to be referring to "King Borria Bungalee Boo," a linked set of twenty-one five-line stanzas, first published in 1866, about "a man-eating African swell" (90) and his attempts to capture a queen. B. C. Southam claims that Bolo refers to King Shamba Bolongongo, a seventeenth-century Kuba leader about whom Eliot might have learned

in the British Museum, which showed a statue of Bolongongo starting in the summer of 1909; Southam also notes that Eliot might have encountered Bolongongo's story in Emil Torday's *Notes ethnographiques,* which was published in 1911 (Southam 103). Eliot may also have borrowed his hero's name from that of Paul Bolo, a World War I–era French pacifist and adventurer eventually executed for his German sympathies.

7. It is worth noting that *The Fireside* functions precisely like a textual minstrel show, integrating seemingly unrelated fragments of drama, news, and literature into a larger whole.

8. Wyndham Lewis declined to print these "excellent bits of scholarly ribaldry" because, he wrote to Pound, of his determination to have no "Words Ending in -Uck, -Unt, and -Ugger" (*Pound/Lewis* 8). The other poems were "The Triumph of Bullshit" and "Ballade pour la grosse Lulu" (Ackroyd 61). Lewis did eventually include "Preludes" and "Rhapsody on a Windy Night" in the July issue of *BLAST.*

9. The prospect of showing the Bolo poems to Joyce seems to have inspired in Pound a whole chain of thought on matters African American: "The antelynch law (postlude of mediaeval right to scortum ante mortem) has I see been passed to the great glee of the negro spectators in the congressional art gallery. Dere z also de stoory ob de poker game, if you hab forgotten it" (*Letters* 505). The references remain obscure.

10. Of course, blackface minstrelsy has no single claim on the origin of modernist-style discursiveness. As Henry Louis Gates Jr. and others have noted, blackface minstrelsy derives in part from Renaissance harlequin plays in Europe, which are nonetheless themselves concerned with representations of blackness. Moreover, while I have focused on Eliot's connections with minstrelsy in America, and its influence on his major poems, Eliot may have seen minstrel shows in England. Margate Sands, which is mentioned in *The Waste Land,* was famed for its blackface minstrel troupes in the early decades of the century. See George Rehin's "Blackface Street Minstrels in Victorian London and Its Resorts," *Journal of Popular Culture* (Summer 1981): 19–38.

11. It is also worth noting that a well-known blackface minstrelsy version of *Hamlet* performed at the African Grove Theater in New York in the years before the Civil War had the hero famously soliloquizing: "and by opossum end 'em."

WORKS CITED

Ackroyd, Peter. *T. S. Eliot.* London: Abacus, 1984.

Bell, Clive. "Plus de Jazz." *New Republic* 28 (21 Sept. 1921): 94–95.

Chinitz, David. "T. S. Eliot and the Cultural Divide." *PMLA* 110/2 (Mar. 1995):
 236–47.

Dobrée, Bonamy. "T. S. Eliot: A Personal Reminiscence." *T. S. Eliot: The Man and His Work.* Ed. Allen Tate. New York: Delacorte Press, 1966, 65–88.

Eliot, T. S. *The Complete Poems and Plays 1909–1950.* New York: Harcourt Brace Jovanovich, 1971.

———. "From a Distinguished Former St. Louisan." *St. Louis Post-Dispatch* (5 Oct. 1930).

———. "The Influence of Landscape upon the Poet." *Daedalus* 89/2 (Spring 1960): 420–22.

———. Introduction. *Savonarola: A Dramatic Poem by Charlotte Eliot.* London: R. Cobden-Sanderson, 1926, vii–xii.

———. *Inventions of the March Hare: Poems 1909–1917.* Ed. Christopher Ricks. London: Faber & Faber, 1996.

———. *The Letters of T. S. Eliot, Vol. 1.* Valerie Eliot. New York: Harcourt Brace Jovanovich, 1988.

———. "Marie Lloyd." *Selected Essays.* London: Faber & Faber, 1932, 369–72.

———. "The Possibility of a Poetic Drama." *Dial* LXIX/5 (Nov. 1920): 441–47; repr. in *The Sacred Wood: Essays on Poetry and Criticism.* London: Methuen, 1920.

———. *Selected Essays.* London: Faber & Faber, 1932.

———. *To Criticize the Critic and Other Writings.* London: Faber & Faber, 1965.

———. *The Waste Land: A Facsimile and Transcript of the Original Drafts including the Annotations of Ezra Pound.* Ed. Valerie Eliot. New York: Harcourt Brace Jovanovich, 1971.

Ellison, Ralph. *Shadow and Act.* New York: Vintage, 1964.

Gallup, Donald. "Ezra Pound (1885–1972): The Catalogue of an Exhibition in the Beinecke Library, 30 October–31 December 1975, Commemorating His Ninetieth Birthday." *Yale Library Gazette* 50/3 (1976): 135–63.

Gates, Henry Louis, Jr. *Figures in Black.* New York: Oxford University Press, 1987.

Gerlach, Russell L. *Settlement Patterns in Missouri.* Columbia: University of Missouri Press, 1986.

Gilbert, W. S. *The Bab Ballads.* Ed. James Ellis. Cambridge: Harvard University Press, 1970.

Gordon, Lyndall. *Eliot's Early Years.* New York: Oxford University Press, 1977.

Hamalian, Leo. "The Voice of This Calling: A Study in the Plays of T. S. Eliot." Ph.D. diss., Columbia University, 1955.

Heinl, Robert Debs, and Nancy Gordon Heinl. *Written in Blood: The Story of the Haitian People, 1492–1971.* Boston: Houghton Mifflin, 1978.

Howarth, Herbert. *Notes on Some Figures behind T. S. Eliot.* Boston: Houghton Mifflin, 1964.

Lane, Anthony. "Writing Wrongs: What Do the Early, Unknown Poems of T. S. Eliot Reveal?" *New Yorker* (10 Mar. 1997): 86–92.

Levy, Eugene. *James Weldon Johnson: Black Leader, Black Voice*. Chicago: University of Chicago Press, 1973.

Lott, Eric. *Love and Theft: Blackface Minstrelsy and the American Working Class*. New York: Oxford University Press, 1993.

Mahar, William. "Black English in Early Blackface Minstrelsy." *American Quarterly* 37/2 (1985): 260–85.

March, Richard, and Tambimuttu, eds. *T. S. Eliot: A Symposium*. London: Editions Poetry, 1948.

North, Michael. *The Dialect of Modernism: Race, Language, and Twentieth-Century Literature*. New York: Oxford University Press, 1994.

Pinion, F. B. *A T. S. Eliot Companion*. London: Macmillan, 1986.

Pound, Ezra. *Pound/Lewis: The Letters of Ezra Pound and Wyndham Lewis*. Ed. Timothy Materer. New York: New Directions, 1985.

———. *Selected Letters of Ezra Pound*. New York: New Directions, 1950.

Reid, B. L. *The Man from New York: John Quinn and His Friends*. New York: Oxford University Press, 1968.

Sampson, Henry. *Blacks in Blackface: A Sourcebook on Early Black Musical Sources*. Metuchen, NJ: Scarecrow Press, 1980.

Sanders, Charles. "*The Waste Land*": The Last Minstrel Show?" *Journal of Modern Literature* 8 (1980): 23–38.

Smith, Carol H. "Sweeney and the Jazz Age." *Critical Essays on T. S. Eliot: The Sweeney Motif*. Ed. Kinley E. Roby. Boston: G. K. Hall, 1985, 87–99.

Southam, B. C. *A Student's Guide to the Selected Poems of T. S. Eliot*. London: Faber & Faber, 1968.

Tate, Allen, ed. *T. S. Eliot: The Man and His Work*. New York: Delacorte, 1966.

Toll, Robert. *Blacking Up: The Minstrel Show in Nineteenth-Century America*. New York: Oxford University Press, 1974.

Twain, Mark. *The Autobiography of Mark Twain*. New York: Harper, 1924; repr. New York: Harper & Row, 1959.

Wittke, Carl. *Tambo and Bones: A History of the American Minstrel Stage*. Durham, NC: Duke University Press, 1930.

Woodward, Daniel H. "Notes on the Publishing History and Text of *The Waste Land*." *Papers of the Bibliographical Society of America* lviii (July–Sept. 1964): 252–69.

Thinking with Your Ears
Rhapsody, Prelude, Song in Eliot's Early Lyrics

JOHN XIROS COOPER

Music is the art of thinking in sounds.
—JULES CAMBARIEU, 1910

THE COMING CLATTER

In May 1921 Vienna was a deflated and bankrupt city. The European war had brought the defeat of the Imperial armies, the abolition of the monarchy, the dismemberment of the Empire, and the mad scramble by new (and sometimes ferociously violent) political forces to seize control of the remnants in the resulting power vacuum. The economic situation for all classes of society had become increasingly uncertain. The old regime and the old forms of life by which it breathed and lived had vanished in the practicalities of a bleak day-to-day existence.

Yet, everywhere around the city, memories of the Empire persisted, in the great public and private buildings, in the magnificent gardens and parks, and in the public sculptures that stood frozen in the opulent gestures of a heroic but dead time. All of this past splendor had become grimly ironic after 1918. By 1921 Vienna was a city of rich memories but of rather sparse prospects. The splendid spectacle of the Hapsburg dynasty, which, from the podium of the aristocracy, gave to Imperial history a sonorous authority, had given way to new harmonies come to earth in the all-too-real world of a minor Central European capital that had seen better days. The sound of history from the streets had become little more than a dissonant clatter. Yet for the Viennese, the old order could not be that easily forgotten; it persisted, primarily in their heads, as memories and as fragments of memories.

Vienna in its heyday always prided itself on its cultural life and that, too, after the deluge, had been diminished (Stuckenschmidt 255). The

pursuit of cultural activities in this kind of environment was no doubt dif-
ficult, if not entirely impossible. Yet it persisted nonetheless, truncated
and trimmed, but still limping along at the institutions that had survived
the debacle.

The time also required new forms and institutions, not only for the
preservation of the past but for its enlargement and development and,
more important, for making the new. One such new institution was the
Verein für musikalische Privataufführungen, founded by Arnold Schoen-
berg in November 1918 as a private performing society, which not only
set itself the task of reviving the musical life of Vienna but took on the
duty of fostering modern music. This important artistic community drew
most of its members and performers from Schoenberg's own circle of
students and friends. It gave weekly concerts concentrating on new
works by the younger generation of composers whose creative lives lay
in the future, not in the past. From 1918 to 1922, when the *Verein* itself
disappeared, its audiences had had an opportunity to listen to new works
by Bartók, Berg, Busoni, Debussy, Kodály, Korngold, Milhaud, Ravel,
Reger, Satie, Scriabin, Stravinsky, Webern, Zemlinsky, and many of their
contemporaries.

But like all such societies, the *Verein* was always in need of funds to
continue its work. And on 27 May 1921, in order to raise money from a
wider audience, the society, in a mood of jovial homage dipped in Krau-
sian irony, organized a "merry evening" of waltzes by, of all people,
Johann Strauss, one of the musical icons of the dead Empire.[1] The queer-
ness of a militantly "ultra-modern" musical society offering an evening
of the waltz king to a Vienna that was a shadow of its old Imperial self
could hardly have escaped anyone at the time.

The waltzes were specially arranged by Alban Berg, Anton Webern,
and Schoenberg, all of whom took part in performing them (Schoenberg
on violin), along with Eduard Steuermann, Rudolf Kolisch, Karl Rankl,
and Othmar Steinbauer. For the concert Schoenberg arranged Strauss's
"Rosen aus dem Süden" and the "Lagunenwalzer" for piano, harmonium,
and string quartet. The satiric send-up, of course, is audible in every
phrase, but if one listens carefully, it quickly gives way to something else,
something more serious.

In his arrangement Schoenberg uncovers a strangely modern Strauss.
In the sumptuous harmonies he finds an inner structure of dissonances
that his arrangements make vibrantly audible and that, on the night in
question, must have captured the mood of a Vienna that could not forget
the past, yet needed to hear the brave new tone-world of the future as

well. Schoenberg discovers in the luscious melodies the coming clatter of modernity; it is as if the grandiose Vienna of the past already contained within it the noise of its own final, fizzling deflation. If one listens attentively enough, one can hear the sound of the future in embryo, but muted in Strauss's originals by the ravishing sonority of Empire. Only the arrival of the proper external conditions could bring the unborn to life. Schoenberg is, to quote Hugh Kenner's shrewd name for T. S. Eliot, the "invisible poet" of these waltzes. He merely "arranges" the given musical artifact to show that it contains—that *it must* contain—the ghastly colorings of its photographic negative image.

We would need to return to that merry May evening in 1921 to hear precisely the bawling Strauss that the audience heard for the first time. For one thing, the meager musical forces (exactly six musicians) deployed by Schoenberg to perform works that had previously been heard in large would no doubt have made for a sadly comic contrast.[2] Perhaps the more youthful listeners would have smiled sardonically to hear Strauss, the emblem of a bloated and fleshy time, stripped down to a flayed skeleton. And the older ones would have perhaps seen the humor in the rendering but would have also felt the loss more keenly. Perhaps the most intense response might have occurred at the moment when the music was experienced not as a satirical exposé of the gay banalities of a ridiculous time but as serious musical criticism. Schoenberg makes us hear something that is *in* Strauss, something like a structural paradox, a contradiction, that needs to be sounded, something that needs to be properly understood. Three years later Schoenberg revisited the waltz form in one of his own dodecaphonic compositions, the little "tipsy waltz-tune that emerges in the first movement of the Op. 29 Suite for seven instruments" (MacDonald 84).

Perhaps Strauss, captive of his own time, understood precisely the very thing Schoenberg was able to make him say but was himself unable to speak. Perhaps he buried in the music a time capsule that would need not the alien but the alienated visitor from other times, other planets. Perhaps Strauss did this unconsciously, in spite of himself; perhaps it was his secret joke, the great musical genius waving to the future from the prisonhouse of his own lush harmonies and the life-world that expected them. Whatever the case, Schoenberg has given us a critical lesson that is more widely applicable. By making audible a silenced modernity in Strauss, he has made us think through to the modern with our ears.

I believe that T. S. Eliot has done something rather similar in his early lyrics, lyrics that look back to a profuse tradition that had reached

its bloated excess in the late nineteenth century and needed exploding, not by one more romantic gesture of rejection and exile but by a sidling and sly undoing from within. To discover the dissonance at the heart of an old, taken-for-granted harmony unravels not only certain lyric forms and the narcissistic effusiveness that had come to be associated with them, but, for a budding anthropologist, the bad faith at the heart of a whole way of life, of a whole culture. To paraphrase one of a series of arresting formulations in Eliot's notable essay "The Music of Poetry," it is only at certain moments that a sound (Eliot writes "a word") can be made to "insinuate the whole history of a language and a civilization" (*On Poetry and Poets* 33).

GRATING HARMONIES

The Boston of Eliot's early years was no Vienna, but the forms of life were no less elaborate, self-consciously artificial, and conventionalized. Unlike Catholic Vienna, the puritan tradition of New England valued visible sobriety in manners and morals; the inhabitants meanwhile indulged themselves in that most satisfying intoxicant of the righteous, the inner vanities of an unhampered smugness. Eliot could not help but see, from a very young age, the "satisfied procession / Of definite Sunday faces" ("Spleen," *Complete Poems and Plays* 603, hereafter *CPP*). Certainly a good deal of "laughter tinkled among the teacups" ("Mr Apollinax," *CPP* 31) in both Boston and Vienna, but in Boston the manifest composure was vexed, for clever, attentive (and fragile) young men, by the priapic gape of the intrusive centaur. The consciousness that could compose "Nocturne ('Romeo, *grand sérieux*')" as a teenager and see past his hero's smile ("in my best mode oblique"—*CPP* 601) while realizing that the appropriate tune for such a scene was, at best, "Banal," would not have any trouble seeing right through Professor Cheetah's whingeing envy. Nor would he who had seen "Mouth twisted to the latest tune" ("Humouresque," *CPP* 602) have any trouble seeing past the artifices of conventionalized artistic productions.

This is also a young man who was not about to be intimidated by the pretentious occasions of high culture, either.

> We have been, let us say, to hear the latest Pole
> Transmit the Preludes, through his hair and finger-tips.
> ("Portrait of a Lady," *CPP* 18)

Such witheringly accurate observations of the performing practices of the time, the cult of the soulful romantic artist, might be put down as the

observations of a clever comic satirist. Such figures were already the stuff of satire in the popular culture, as in John Tenniel's famous comic cartoon in *Punch* in the 1880s called "Perils of Piano Playing." A long-haired maestro, clearly based on a composite caricature of Chopin, Liszt, Paderewski, and Rubinstein, is pounding the piano so violently and with so much cyclonic force that a vortex of rushing objects—hats, gloves, sheet music, umbrellas, women's bonnets—spins about the room, while the piano stool, tilting precariously in the squall, is anchored to the ground by a chain. By the turn of the century this sort of satire of the bohemian transports of the "romantic" artist was common currency.

Eliot's "Pole" in "Portrait of a Lady" is already worn coin in 1917. But to call it satire and leave it at that would miss the more important point—namely, that here we have the beginnings of that same critical acuity that allowed Schoenberg to hear the stifled dissonance that lay at the core of Strauss's waltzes. It was certainly as necessary for Schoenberg to satirize the bloated Strauss, to make his listeners hear the schmaltz as schmaltz and not another thing, so that they could begin to hear Strauss's other temper, "a kind of grating harmony which becomes in time very pleasing" (*Varieties of Metaphysical Poetry* 145), as it was for Eliot to hear the one false note "Among the windings of the violins" (*CPP* 19) and to position against it the "dull tom- tom . . . Absurdly hammering a prelude of its own" inside our brains. That he was following French poets, like Jules Laforgue, in this endeavor does not blunt the point.

That many forms of art inherited from the nineteenth century had arrived in the new century exhausted, worn down by use, was one of modernism's starting points in its critique of the past. This consciousness of the exhaustion of past forms, not only of art but of life itself, informed the work of the younger generation in every area and discipline, from John Maynard Keynes's evocation in Paris, 1919, of the "the forces of the nineteeth century" that "have run their course and are exhausted" in his *Economic Consequences of the Peace* (254) to Martin Heidegger's plaintive declaration that even "language in general is worn out and used up" in "The Fundamental Question of Metaphysics" (*Introduction to Metaphysics* 42). It was a necessary, preparatory recognition in the coming task of construction. Eliot's early poetry is permeated by this awareness in every word and phrase, in every rhythm and pause. Discerning this exhaustion in general informs a good deal of his early poetry and prose; but *hearing* it in the performance norms that had come to circumscribe certain musical forms provides a particular and highly evocative manifestation of the general condition.

Eliot was specially attuned to the corruption of those solo forms in the nineteenth century that allowed the performer to display his or her virtuosity. Technical brilliance was often enlivened, for paying audiences, by animated performance practices. The soulful transport entertained, as it still does, by providing not only a musical experience but also a theatrical one. The uncritical listener—increasingly hungry for intense emotional experiences as well as music—was often led to speculate, from certain kinds of lushly spirited performances, about the nature of a particular performer's personality and to assume from that the general existence of a specialized artistic temperament.[3] In 1919 Eliot's "Tradition and the Individual Talent" set down his disgust explicitly; in his early lyrics, the repugnance was implied, but it was no less judicious. The musical forms that brought this sort of attention to the performer were the smaller, more intimate ones for solo recitalist: the nocturne, the prelude, the song, or the rhapsody for a single instrument.

In "Conversation Galante," Eliot already understood how the economy of self-display worked and where it stood on the scale of things. I have in mind the second stanza in particular.

> *And I then: "Someone frames upon the keys*
> *That exquisite nocturne, with which we explain*
> *The night and moonshine; music which we seize*
> *To body forth our own vacuity."*
> > *She then: "Does this refer to me?"*
> > *"Oh no, it is I who am inane."*
> (*CPP* 33)

Eliot's grasp of the tainted relationship between player and listener already anticipates the sort of "sociology of music" that characterizes Adorno's cultural criticism decades later. The "nocturne" is not just music, but a language for bringing into the human scale of things the "night and moonshine" as mere effects of the occasion, effects "framed" by the player. Further, the music acts to "body forth" not a musical order but a psychological condition in the listener, a condition he calls "our vacuity." The slipperiness of the possessive ("our") makes audible for a moment the inclusion of the listener's companion in the general condition, which the speaker seems to dispel in the closing line. Of course, the irony only underlines the actual companion's inclusion in the condition, while giving her a verbal escape route. Finally, the irony with which the stanza closes retrospectively encompasses the "Someone" at the start whose "exquisite nocturne" is framed upon the keys. It is as if the music

inescapably participates in the bad faith, and we hear as a result, faintly to be sure, but clearly enough, the dissonance of the brittle cliché in the word *exquisite.*

Eliot was not the only one in his day who experienced the sound world of the late nineteenth and early twentieth centuries as a regressive state of conventionalized sensations and a parallel sclerosis of musical thought. Indeed, there were many contemporary critiques of precisely what is made audible in "Conversation Galante."

Katherine Ruth Heyman, the concert pianist and early companion of Ezra Pound, writing in 1921, comments again and again about the wearisomeness of "machine-made" compositions or the "stencilled copies of nineteenth-century patterns" in a book that argues that only by a rediscovery of the archaic in music will the modern composer be able to pull the musical republic out of the mud (80; cf. *The Use of Poetry and the Use of Criticism* 118–19).

More penetrating than Heyman and anticipating general points later made by Theodor Adorno, the musicologist Edward Dent in his absorbing early book, *Terpander, or Music and the Future,* condemns the cheapening of the musical idiom by "romantic" clichés. The audience will recognize, he writes,

how "picturesqueness" is achieved by the exploitation of conventional idioms: how these idioms evoke associations not merely with things outside music, but far more widely with the recollection of music of past generations as familiar to them as it was to the composer who exploits it. They will recognize conventions of sound without sense— strings of notes, that perhaps once had musical value but have now become mere formulae, rushing winds and roaring waves.

And like all the modernists of the first decades of this century, he adds an optimistic note, that the listener in the future will learn "to mistrust the composers who delude their audiences, perhaps delude themselves too, with a shimmering veil of indeterminate harmonies, and to mistrust no less those who with an aggressive air of sincerity and directness assume the solemn pose of mystery and chivalry" (65–66). His most illuminating insight here is the recognition that the "conventional idioms" do not merely "evoke associations with things outside music," but with music itself, and that commercialization has produced the frequent repetition of the "classics." The inertial drag of familiarity leaves the "casual listener" in a state where he or she learns to consume not music as such but the

familiar. The listener, Dent writes, comes to love the "dear familiar strain" (66) in the way memorably described by Adorno in 1938: "The familiarity of the piece is a surrogate for the quality ascribed to it. To like it is almost the same thing as to recognize it" ("On the Fetish Character in Music and the Regression of Listening" 26).

To hear under these conditions, one must learn to unhear the familiar. "I should almost be inclined to say," the modernist composer Cyril Scott wrote in 1917, "that the man of genius is invariably a greater hand at unlearning than at learning; nay, some geniuses have hardly learnt at all in the usually accepted sense of the word; they have been unlearners from their cradles" (25). Eliot's early lyrics, like Laforgue's before him, fall into this category; they are exercises in unlearning the received lyric tradition. In the same way, Schoenberg's arrangements of Strauss are the accomplishment in negative of a "man of genius" in Scott's sense. This process of unlearning was particularly difficult for Eliot because he was such a good pupil, such a good learner. It is the exemplary student's practice of attention and obedience that is sometimes the most serious barrier to creative progress. "We are . . . slaves," Scott writes, "to our good habits as much as we are to our bad habits" (25).

DISSONANCES

Eliot's use of music as a principal point of reference in his critique of late Victorian culture was an inspired choice. First of all, it cast a sardonic light on the late nineteenth-century aestheticist obsession with music in the titles of countless poems, paintings, and wallpapers. Walter Pater's famous sentence about the inevitable tendency of the arts to aspire to the condition of music in the "School of Giorgione" had had its fatal fallout. For every Whistler and Wilde, whose "symphonies" and "nocturnes" were possibly worthy pieces of work, there were others whose instincts were rather more attuned to the current chic than to significant artistic creation. For many writers and painters of the fin de siècle, references to music were little more than code for curious cognitive states, or for a kind of abstract emotional intensity, or for an artistic ethos struggling to get out from underneath Victorian moralism. These habits originated in the poetry of some of the romantics. The "School of Giorgione" simply gave them persuasive formulation. Eliot's early lyrics work in this context, not in the attitude of a reformer, aiming to get back to the authentic sublime, but sounding the contradictions at the heart of all such professions.

Eliot's use of music was inspired for another reason. Notwithstanding his hostile attitude to the musicating tendencies of a decadent aestheticism, he was nonetheless deeply attached to a musical aesthetics. It would not take an explicitly positive form until *Four Quartets*, when the work of demolition, of unlearning, was concluded. In his early lyrics, it was necessary to vacate the musical habitus of decadence at any cost. It was accomplished not by gestures of defiance but by quietly sounding in the midst of its most characteristic expressions the dissonance of the modern.

"Rhapsody on a Windy Night" is a case in point. To what does the word *Rhapsody* in the title actually refer? In what musical sense, if any, is the poem a "rhapsody"? Grover Smith proposes that a reader of the poem might pick any number of possible meanings for the word *rhapsody* but that the "the musical one" might be the most appropriate. On the question of what is so appropriate about that, Smith is conspicuously nebulous. The poem enacts a dream state, a work of free association rather than logic; as a result, Smith asserts that the musical meaning of *rhapsody* implies "irregularity and diversity" (24). And, as far as music is concerned, that is it.

John Paul Riquelme identifies the title as Eliot's negative evocation of a romantic commonplace—that is, poems that announce their status as a musical form ("usually an ode") and then their subject (urn, nightingale, skylark, and so forth) (53). Eliot's evocation of the "rhapsody" in his title is then read as a witty "joke on the Romantic heritage," by which he means the literary heritage. Riquelme goes on to demonstrate Eliot's play with a whole series of romantic literary effects. His extended commentary scores off the worn coinage of romanticism—wind, lamp, flower, the child—that the poem twists into a series of disfigurations of the standard tropes (54–55). This is no doubt true. Where does this leave the musical analogy? For Riquelme, not very far. It seems to do little more than satirical work—namely, reversing the polarities of certain literary clichés and creating, as a result, a species of semantic dissonance. His culminating observation that these reversals—these twists and turns of rhetoric—add up to a wholly new set of meanings seems in the end a little strained (57–59).

Smith's mention of free association is perhaps the better tack. The rhapsody was one of a number of free forms of music that became increasingly popular in the nineteenth century and in which the display of a performer's emotional intensity, and, therefore, a revelation of personality, was as much the purpose of the musical occasion as the making of music for its own sake. These forms prospered because they were easily

adapted to the aesthetic principle that art is primarily a form of self-expression. Other pieces that belong to the same category include the prelude, fantasy, impromptu, capriccio, étude, nocturne, and so forth. The toccata in the eighteenth century had already anticipated the development of these forms, but the focus there was on the technical virtuosity of the performer, not the revelation of the depths of character.

Mastery of technique and of the medium was not the inspired musician's first order of business. In this respect Robert Schumann is the musical type of the artist of inwardness, of *Innerlichkeit*. His music was thought to emanate from the deepest resources of character rather than from the exercise of a craft discipline. His wayward grasp of technique was, in the new spirit of the age, enthusiastically endorsed as a sign of authenticity rather than of incompetence. His influence on the evolution of European music in the later nineteenth century is immense. Many composers did not escape what Hugo Leichentritt calls the "Schumannesque melodic line" (214). For them, Schumann was a liberating figure for the most part, but in the popular imagination the Schumann type became fixed as the musician as such and has more or less remained so to this day.[4] This type won the status of a social icon in mid-nineteenth-century bourgeois societies, which found in romanticism a kind of decommunalized culture suited to the new cult of privacy and the new authority of personal candor.

The later romantic composers favored short pieces in one movement, and this becomes "a very striking and characteristic feature" of their work. "They are not interested in complicated design but in inspiration, poetic ecstasy, . . . The interest is centered on creating not a cyclical work of powerful construction but a short piece or a loose bundle of short pieces, flaring up in inspiration for as long or as short a time as the flame may burn" (Leichentritt 214–15). The signature of romantic art is *Stimmungsmusik*, music of the pointedly characteristic mood. And the mood, it goes without saying, is the outward projection of the great individual soul, the boundless personality of the inspired genius.

It also goes without saying that by the time this musical tradition had descended to Eliot, it had become somewhat corrupt. Great character was seen to be as much a matter of artful theatrics as it was an essential aspect of soulful inspiration. The magician was an illusionist in every way, including the wily self-fashioning of the myth of his own mysterious uniqueness. A careful reading of the Browning monologues, which deal with powerful personalities—Abt Vogler, for example, or Charles Avison—will reveal, if nothing else, the importance of getting right the

optics of the self. In the hands of the charlatan or the self-deluded ama-
teur (and the difference between the two is not as great as one might
assume), art became the occasion for self-display, warranted by the aes-
thetic of self-expression.

If we read "Rhapsody on a Windy Night" in this context, we see that
the central issue that the text raises is the matter of the speaker, of the
poem's "I" and its negotiations with things, with others, and with itself.
Riquelme touches on this but does not press the issue. The paradoxical
evocation and denial of the rhapsodist makes it difficult to locate the
source of the poem's *Stimmungsmusik* in a singular, unified subject. The
personality of the speaker never comes to a focus in the piece. We do not
have a "person" whole; even memory, as a source of past selves, dis-
solves. Fragments of an "I" appear in grammatical traces, in the faint and
fragmentary psychodrama of the pronouns, but nowhere do we have a
center of consciousness that functions as the source of meaning. It would
be just as easy to assign the fragments of the person circulating in the
poem to the pronoun "one" rather than to an "I" at all. But that sort of
shift of pronominal force would result in a real loss. The poem would lose
both the keenness of the pain that suffuses its exhausted circulation of "I,"
"you," and "she," and the disquiet of voided possessiveness in the play
of "her," and "your." This is a poem in which the speaking subject has
broken up into bits but has not yet given up sifting through the rubble.

So, in what sense is this a "rhapsody," with all its connotations of the
ecstatic transport of the rhapsodist and of the expected effusiveness of a
uniquely great soul? The rhapsody as a free form of self-expression, as
an occasion for the display of personality, spreads a sympathetic coloring
across objective existence, or, if one prefers, the bleakness of a fallen
world. This, like the last line of "Prufrock," is what the second-to-last
line in the poem seems to suggest: "sleep, prepare for life" (*CPP* 26).
The "life" of everyday is presumably the domain of "sleep." And the rhap-
sodic in its degenerate state at century's end is part of the dreamy irrele-
vance of a culture of sleepwalkers.

But Eliot's rhapsody is of a different kind. It is wide awake. The dis-
integrated subject has annulled the psychological structures that keep us
dozing within the settled mental world of everday existence. In his doc-
toral thesis Eliot had dismissed psychology as being epistemologically
regressive, dealing only with "half-objects. . . . There is, in this sense,
nothing mental," he wrote (*Knowledge and Experience* 83).[5] Only sci-
ence, which deals in objects—lamps, geraniums, skeletons—and meta-
physics, which deals with "the subject, or point of view," could produce

knowledge of the real. Music and poetry in the nineteenth century had
abandoned themselves to their own rhapsodic voodoo and abandoned,
as a result, both object and point of view.[6] Eliot's rhapsody attunes us to
what the poem offers as the new counterpoint of objective reality and dis-
tinct points of view beyond the grasp of the rhapsodist's psychology.
Clock time, for example, as a unit of objective measurement imper-
turbably resists his sympathetic magic. This, perhaps more than anything
else, attests to Eliot's final disillusion with the fashionable Bergsonian-
ism of the period (cf. Smith 24–25). The denial of the philosophical effi-
cacy of psychology itself, which Eliot had asserted in his doctoral thesis
(82–83), is asserted again in the poem: "I could see nothing behind that
child's eye" (*CPP* 25). The memory, too, as the foundation of the self and
of its sense of its own continuity, is not Wordsworth's consoling sanc-
tuary but another alien province littered with broken things, "Hard and
curled and ready to snap" (*CPP* 25). There is a point of view, but it is
empty of psychological significance, the self having been dismantled. It
simply registers things and the mood of things without bothering to
weigh up and judge; "the border of her dress" is no more significant in
psychological terms than "An old crab with barnacles on his back," or the
stuttering of the lamp (which sputters, mutters, and hums), or the short
suite of smells in the fifth strophe. Meanings are not constellated around
a psychologically constructed subjectivity but are like the chords and
notes of a musical composition that has no key center, no chromatic for-
mula of completion.

By invoking the rhapsody, Eliot accomplishes something like Schoen-
berg's rehearing of Strauss. "Rhapsody on a Windy Night" does not bring
the rhapsodist to the fore (he remains a kind of disembodied eye) but the
objective reality that the rhapsodic glamour conventionally effaces. This
is not strictly speaking a satirical project, although satire is involved; it is
a critical, and even a philosophical, task.[7] The rhapsody as a form is not
denounced or parodied in the poem as a gesture of romantic defiance and
rejection; the poem simply makes audible the dissonance, which is always
already there, at the core of an old harmony. It does not try to convince
the reader of anything, but it sounds and resounds what Eliot believed
already exists in the "substratum of collective temperament" (*Idea of a
Christian Society* 18). Its rhythms and resonances, like Schoenberg's
waltzes, disturb the familiar not in the name of the unfamiliar and the
strange but in the name of the inevitable, in the name of what we do not
know that we already know.

The poem certainly evokes a mood, but it is mood in a new sense, no longer a matter of giving the world a subjective coloration or submerging its existence in the sympathetic glamour of private states of mind. Indeed, "private states of mind," which depend on the presence of a psychologically constructed human subject, are systematically extinguished in the poem. It is not toward Bergson that the poem looks; if anything it looks ahead to the Heidegger of *Being and Time*, specifically to the pages on mood as an existential constituent of the "There," a primordiality that is prior to the psychology of personal moods (172–79). Heidegger's notion of mood "makes manifest 'how one is, and how one is faring' [*wie einem ist und wird*]. In this 'how one is,' having a mood brings Being to its 'there'" (173). "Having a mood" brings us closer to *Existenz*. What remains is not a subjective mood that we can confidently assign to any particular "one" but a general, objective condition; the world, the poem tells us, has given up "The secret of its skeleton." Eliot's rhapsodist, like Siegfried when he hears the truth of Mime's speech, even when Mime is lying, cannot help but disclose "how one is." The poem is a rhapsody inside out, incapable of not revealing what it can no longer hide.

CLANG

And so, as Ezra Pound wrote in *Pavannes and Divisions* (1918), "we have come to the pianola" (146). Poems like "Rhapsody on a Windy Night" or "Preludes" invoked literary traditions in their time that raised music to the level of the rarest of the arts. "Poetry is a composition of words set to music," Pound wrote in 1918 (151). And, he added a few lines later, "Poetry must be read as music and not as oratory." The prestige of music in the nineteenth century cannot be overestimated.

Music and the making of music played a far more important role in the culture, both high and low, than can be imagined today. The making of music, especially in the home, was a widespread activity that required everyone's participation both as performer and listener. The Schumanesque cult of art as inspired self-expression not only permeated the concert hall, it infected the domestic sphere as well, bringing to bear a whole new set of tensions and anxieties on the amateur player. "Countless millions hum the melody of [Chopin's] Polonaise in A Flat Major," Adorno remarks sardonically, "and when they strike that pose of the chosen one at the piano to tinkle out some of the less demanding Preludes or Nocturnes, we may assume that they are vaguely counting themselves with

the elite" (*Introduction to the Sociology of Music* 61). How could one possibly match in one's drawing room the podium styles of a Schumann or a Chopin or a Liszt?

The truth of the matter is that one could not, without some help, and a consumer-sensitive capitalism was, as always, quick to respond with the appropriate mechanical appliances to feed the new demand for soulfulness: "The great value of the Pianola lies in the power it gives to anyone, whether a trained pianist or not, to play any composition—a Chopin Ballade, a Liszt Rhapsody, the latest comic opera—with equal facility, and to impress it with whatever individuality one's own innate musical sense permits" (from an advertisement in Munro 45). The pianola was developed at the turn of the century along with a whole series of player pianos and other mechanical musical devices to ease the burden of music making in the average household. The advertisement quoted above goes on to describe the operation of the pianola in some detail. The instrument is a substitute for human fingers, for, like them, it performs the key striking part of piano playing. The pianola is placed in position so its padded "fingers" rest over the piano keys; the roll of music then takes care of the mechanical matter of striking the right notes as the performer pumps two foot pedals. Little levers allow the performer "to govern light and shade, instantaneous changes of time, every degree of touch (from the most delicate to the most tremendous) and accent, both light and heavy" (45). In this way, the amateur of limited technical facility could set aside the elementary problem of merely getting the notes right and concentrate instead on the real musical display, proclaiming the fineness of his or her own sensibility.

It was a pretty remarkable device because it gave the player the opportunity to emote at the keyboard without knowing how to play the piano. In a culture increasingly driven by the ideology of the market, the mechanical manipulation of the egotistical sublime, of *Innerlichkeit*, was a perfectly "natural" development. It extended the franchise in the matter of creative self-expression, and this fit in nicely with the democratic temper of the time. The pianola was dispensed with when democracy achieved one of its more perfected cultural embodiments, the invention of the gramophone, which eliminated the need for doing anything altogether and turned the listener into a passive consumer of soulfulness.

The pianola is a small episode in the history of musical instruments, but it is a significant one for our purposes. It makes visible, puts in a material form, the evolution of the nineteenth-century cult of character. And it gives sharper point to the exertions of the modernists to both disparage

and exploit the particular cultural forms that evolved to meet new psychological and aesthetic needs. By 1922 the "typist" and the "young man carbuncular" in *The Waste Land* will have already graduated to the gramophone. But in his early poetry Eliot was not about to turn his back on or reject the culture of the pianola.[8]

Eliot's strategy was to adopt a kind of aggressive wariness; it combined a disgusted cynicism at how things were going with an alert responsiveness to the expressive possibilities of the new situation of modernity. If that meant shrewdly pedaling and levering the "rhapsody" or "song" for all they were worth in order to bring the disaster more fully to light, then he was ready to do it. He knew all too well the cultural stagflation that lay behind the words of the "Lady" in "Portrait of a Lady."

> *"So intimate, this Chopin, that I think his soul*
> *Should be resurrected only among friends*
> *Some two or three, who will touch the bloom*
> *That is rubbed and questioned in the concert room."* (*CPP* 18)

But he also knew that her words and the modernity in which they did their work sounded, whether one liked it or not, a new kind of music, discordant, out of key, a music that could only be got at through the received forms and usages, not outside them. The literal meaning of her words did not matter as much as what her performance of her meaning conveyed. Wolfgang Iser's claim that "literary texts initiate 'performances' of meaning rather than actually formulating meanings themselves" (27) is relevant here but misrecognizes a specific early modernist artistic procedure for a more general condition. This was very much the unintended "meaning," if that is the right way of putting it, of the pianola's place in the emerging culture of simulation. And it was the more deliberate, intended meaning of Schoenberg's deadpan confiscation of the Strauss waltzes. It is also the "meaning" of a poem like "Preludes."

"The prelude," Aaron Copland writes, "is a very loose term for a large variety of pieces, generally written for piano." He continues: "As a title, it may mean almost anything from a quiet, melancholy piece to a long and showy, virtuoso piece. But as a form it will generally be found to belong to the 'free' category. Prelude is a generic name for any piece of not too specific formal structure" (201).

What Copland does not say is that the word had accumulated a heavy cargo of meanings in literary contexts. It connoted a kind of small poetry of portentous indefiniteness, a coy but fuzzy impressionism, in which images were made to do the work of conveying tantalizingly vague

feelings. One might argue that this was merely a mistaken impression of what the prelude *in music* was all about. And so it was. But there were enough examples of the same freighted inconsequence in music to make Eliot's critique convincing. As discussed above, the cultural situation of the rhapsody is very similar, and Eliot's "Preludes" works across some of the same terrain: for example, the play of the pronouns in conveying the filmy presence of characters without names or qualities, or the preoccupation with clock time, or the steady undermining of the psychological as a satisfactory modality of seeing and knowing. "Thinking" is reduced to an elementary recording of things and actions: "One thinks of all the hands / That are raising dingy shades / In a thousand furnished rooms" (*CPP* 22), but we are not given any clues about what "one" is thinking or what "one" feels about such thoughts or such events.

If we are looking for a musical analogy here, we do not have to look much further than Schoenberg's notion of composition without a key center. "Preludes" is working toward the status of what is sometimes misleadingly called "atonality" (total tonality might be the better term). The lyric subjectivity that might give the text the poetic analog of a key center is dispersed among the pronouns and the indefinite points of view: "The morning comes to consciousness." The morning? In the fourth "prelude" the thematic subject, "His soul," is dispersed among "short square fingers stuffing pipes," bodiless "eyes," and "a blackened street" that is enigmatically said to have a "conscience" (*CPP* 22–23). As I have argued elsewhere, it was Ezra Pound in the *Cantos* who took the modernist poetic toward the literary analog of the Schoenbergian tone row, rows of images variously juxtaposed without the unnecessary reaching after the dominant. The early Eliot started down that path but by *Ash Wednesday* had chosen the other fork, namely the well-travelled road toward the neoclassicism of a Stravinsky.

The performance norm of a prelude by Chopin predicated a lyricizing subjectivity that Eliot carefully reduces to nullity. The ominous pause in the first strophe that precedes "the lighting of the lamps" has the effect of effacement, as does the hand "across your mouth" in the fourth. In the second, consciousness is assigned to morning, and the speaker deflects any accumulating personal interest by recourse to the anonymity of the indefinite pronoun. In the third, the accumulation of little bits of experience that culminate in a vision of the street is immediately annulled by the fact that it cannot to be understood. Yet, Eliot is not simply sending up the prelude as one more piece of bloated romanticism. The poem's bleakness and its discordant effects are as much a part of the prelude idea

as the shimmering transports of a Chopin. Chopin's emotionally moti-
vated pacing, the sudden contrasts and flights, even the dissonances,
are held together musically by the inevitable return of the dominant
and, psychologically, by the embrace of a "great soul." Eliot's poem is
the antitype, the negative transparency in which the healthy fleshiness
of the photograph is rendered skeletal and monochrome. Eliot's pre-
ludes, in effect his antipreludes, like Schoenberg's waltzes, sound the
modern in the very core of the "dear familiar strain."

UNPLEASANT WHINING

Eliot's "The Love Song of J. Alfred Prufrock" accomplishes something
similar in the domain of song. "Prufrock" is the third of this group of early
lyrics that Eliot first set down in the 1910–11 period. As a dramatic mono-
logue, it makes the status of the monologuist a more obvious feature of
the text. At least in this "song" the singer has a name and a voice. And he
has a point of view. There are more traces in the poem of the presence of a
possible psychology. It may not amount to much, but at the end of the day,
a kind of dire mood in a minor key, not entirely unrelated to the tragic,
seems to prevail. An evaluative hierarchy has been provisionally advanced:
for example, the speaker is conscious of the difference between the bear-
ing of a Prince Hamlet and the meticulous cringe of Polonius. He also
seems to know that he is paralyzed by extreme self-consciousness and dis-
mally conveys his unhappiness about that fact. This is more than we find
in the previous two poems. But then, this is a song, that is, music for
voice, not an instrumental piece. Inevitably, the fact of a singer will bring
the matter of the presence of the human subject more fully to view. And
because of that the song is rich in self-references. "J. Alfred Prufrock"
does not bowl us over with his passion, lyricism, or strength, but there is
at least the remnants of a psychology at work here, not a nullity as in "Pre-
ludes" and "Rhapsody on a Windy Night."

By the turn of the nineteenth century, the singer, rather than the
music, had become the heart and soul of the song in both the high cul-
tural and popular spheres. Indeed, a strong and charismatic singer could
make even the most banal tunes bewitching to an audience. Most, if not
all, of the popular music of today still operates on the same principle.
The most authoritative book on singing published before World War I
Harry Plunket Greene's *Interpretation in Song* (1912) emphasized the
centrality of the singer in its very title. It is difficult to imagine, by way of
contrast, how one might *interpret* a Gregorian chant. This emphasis had

come about because of two developments in the history of the song in the nineteenth century. The gradually increasing popularity of the German lied for audiences growing accustomed to the aesthetic ideas of the romantics helped to create a serious vocal tradition. I have in mind the lieder of Schubert, Schumann, Brahms, and Wolf. At the other end of the culture industry, the enormous output of what were commonly called royalty ballads, shop ballads, or drawing-room songs flooded the popular market with, in Plunket Greene's mordant words, "cheap" songs from the "cheap-jack composer" (199). To make the products of this "miasmatic swamp" (x) marketable, the singer did not need a classically trained voice as much as he or she needed a catchy tune, a conspicuous personality, and a signature vibrato or tremolo to juice up the emotion. The system of the "hit" song, which still persists today, resulted from the industrial production of tunes, lyrics, and stars. And it was this system of production, beginning to infect the music halls of Britain and America at the turn of the century, that Eliot lamented in his homage to Marie Lloyd in 1923.

As in the case of instrumental music, especially in music for the piano, the interest in song was not restricted to the concert or music hall. It invaded the domestic sphere as well, for the high sales figures of the type of song in question could never have been reached by the patronage of the relatively few public singers. And, indeed, the whole object of the paying of royalties to well-known public performers and composers was the ultimate promotion of large private sales (Scholes 293). The trade in tunes stimulated a trade in "lyrics," huge quantities of verse, "tender, sad, or arch." Many authors made a good living providing what came to be known as "lyrics," in the specialized sense used in the music business to this day. The name of one of the more popular "lyric authors" on the title page of a song greatly helped its sales (294).

"The Love Song of J. Alfred Prufrock" engages with this state of affairs in a number of ways and not simply as an exorcism of his own "conflicted energies" through the "violence of satire" (Bush 10). First of all, the "love song" insists on its own status as "song" by drawing on some familiar effects. The refrains and repetitions, for instance; "In the room the women come and go" is the most famous example. But the changes rung on phrases and words such as "Let us go," "Do I dare," "revisions," "decisions," "how should I presume," "That is not what I meant at all," "I have seen," and "I grow old" create a sound texture made coherent for the ear by echo and reverberation. Repetition of sounds is reinforced by the rhythmical effects of syntactic parallels and variations:

"For I have known them all already, known them all— / Have known the evenings, . . ." and so on.

More specifically, the poem follows the tradition of the art song by its looser approach to form in contrast to the shop ballad with its more mechanical deployment of musical resources. The singer's emotional surges mark out strophes of various length. The variable pacing creates a kind of rubato effect. The expressive, rather than strict, use of end rhyme and other rhyming patterns makes for more complex sound effects. And the diminuendo, or dying fall, of the closing lines suggests a feeling-state that had become a standard for art songs on certain themes and was not unknown even in the popular songs of the day.

As with the prelude and the rhapsody, Eliot takes the received culture of the musical analogue, the romantic art song in this case, and turns it inside out. The singer may make use of all the resources of the art song, but the whole effect clashes with what was intended by the convention. Instead of the performance thrusting forward the singer's personality, Eliot's acts to diminish the salience of the singer's presence. Each possibility of self-assertion is raised, then withdrawn. In the end, the disconsolate singer rattles around an artistic framework that is palpably larger than he is; it requires a more substantial egotist to drive it forward toward that romantic version of sublimity in which the individual psyche begins to overlap with and then replace the universe. Prufrock's efforts in this direction are risible. The crucial image in this respect occurs early in the poem when Prufrock seems to dangle like a hanged man in his "morning coat," "collar," and "necktie," items of attire that are too stiff and too large for him.

The nineteenth-century song is all about the singer, and Prufrock, predictably, begins in the key of assertion, a dominant that has vanished by the close—the assertive "go" is the third word of the text, the dying "drown" the last. The poem begins with the drama of singular persons, "you and I," but ends with the bathetic anonymity of the collective "we." The lied is meant to go in the opposite direction, from the type to the unique individual to the egotistical sublime. In the art song, the unrequited lover, for example, is unrequited because of some formidable obstacle to love—another man, fate, family, the death of the beloved—that leads to some vision of self in a universal or cosmic setting, often straining for a tragic effect. The impossible desire for some experience beyond the reach of mere human expression is well illustrated by Shelley's "A Dirge," where he speaks of a grief so profound that it is "too sad for song." One does not have to look very far in the poetry and song of

European romanticism for a thousand other illustrations of the same paradoxical sentiment or for the conventional effect of soulful ardor that it stimulates in readers and listeners. Eliot was unable not to hear the jangling contradiction in the warm bath of feeling. So, in "Prufrock," the props of the German lied, and the romantic art song of the nineteenth century in general, are all there in the last lines of the poem, the sea, the wind, fabulous sea creatures, humanity, the dramatic pauses, desire, all the stuff of the transcendant finale. But, instead, Eliot puts it all in the service of a bad case of nerves. Yet, and this is the crucial point, it is *still* song, but it sounds an unresolvable discord; it sounds the noise that modernity is beginning to make.

In "The Love Song of J. Alfred Prufrock" the particular noise that Eliot makes us hear is the sound of the clapped-out self breaking into myriad anonymous bits. If anyone were to set Prufrock to music, it would have to be to the accompaniment of shattering glass. At the end of the day, the song, like the prelude and the rhapsody—and let us not forget Schoenberg's waltzes—is like the pianola—a mechanical device that simply reminds us of the "dear, familiar strain," inside of which the poet hears, and makes us hear, the din to come.

NOTES

1. My knowledge of this event comes from three sources: Stuckenschmidt's biography of Schoenberg (272–73); Malcolm MacDonald's *Schoenberg,* in the Master Musicians series (34ˉand 34n); and the sleeve notes from the Deutsche Grammophon vinyl album of the waltzes released in 1979 (*Johan Strauss Walzer*), now, sadly, dropped from the catalog.

2. In Strauss's time smaller combinations had performed his music on occasion for different functions. But the approach was always keyed to keeping feet a-tapping, even as the patrons were engaged in other activities, like dancing or chatting or simply eyeing one another's clothes.

3. Listeners were encouraged in this way of thinking by the popular music criticism at the time. See in particular the writings of middlebrow critics like R. W. S. Mendl and W. J. Turner. Mendl, for example, devotes eight pages to the necessity of personality in musical composition in his *From a Music Lover's Armchair* (160–68). This was the standard view, and we do well to remember that this was the context in which Eliot first published his famous views about the impersonal in literature.

4. The degree to which this was the case is well illustrated by the opening of Oscar Wilde's *The Importance of Being Earnest*. Algernon is playing the piano in

the next room as Lane, his manservant, is arranging afternoon tea. The music stops and Algy enters.

ALGERNON: Did you hear what I was playing, Lane?

LANE: I didn't think it was polite to listen, sir.

ALGERNON: I'm sorry for that, for your sake. I don't play accurately—anyone can play accurately—but I play with wonderful expression. As far as the piano is concerned, sentiment is my forte. I keep science for Life.

5. Some years later, in the Clark Lectures (1926), published as *The Varieties of Metaphysical Poetry* (1993), Eliot would return to this point (83), what he calls the "general law of the supersession of ontology by psychology" in European culture (90).

6. By century's end, the subjective view of art had acquired the status of an orthodoxy. "It has been said that music was applied to the translation of the inward life, that it had no grasp of material objects, and that, as it was deprived of any resources of depiction, it was obliged to reduce everything to vocalization—that is to say, to psychological expression—by transforming what was objective into the subjective" (Cambarieu 169). The indirect form of address quietly conveys Cambarieu's skepticism.

7. In his Clark Lectures, Eliot makes some very interesting comments on satire as a form and as a mood and the qualities that go into the "formation of the satiric poet" (*Varieties of Metaphysical Poetry* 140–45). He certainly does not think of the "satiric spirit" as "simple." Its complexity is compounded of an "active ratiocinative intellect" and a "keen eye for common observation" (142).

8. The pianola also interested serious composers as well. Those tuned to the mechanical soul of modern times were especially alert to the possibilities offered by the device. Stravinsky's *Etude for Pianola,* the pianola versions of his ballets, and George Antheil's *Ballet mécanique* are well-known examples.

WORKS CITED

Adorno, Theodor W. *Introduction to the Sociology of Music.* Trans. E. B. Ashton. New York: Continuum, 1989.

———. "On the Fetish Character in Music and the Regression of Listening." In *The Culture Industry: Selected Essays on Mass Culture.* Trans. J. M. Bernstein. London: Routledge, 1991, 26–52.

Bush, Ronald. *T. S. Eliot: A Study in Character and Style.* New York: Oxford University Press, 1983.

Cambarieu, Jules. *Music: Its Laws and Evolution.* London: Kegan Paul, Trench, Trubner, 1910.

Copland, Aaron. *What to Listen for in Music*. New York: New American Library, 1953.

Dent, Edward J. *Terpander, or Music and the Future*. London: Kegan Paul, Trench, Trubner, [1926].

Eliot, T. S. *Complete Poems and Plays*. London: Faber, 1969.

———. *The Idea of a Christian Society*. London: Faber, 1939.

———. *Knowledge and Experience in the Philosophy of F. H. Bradley*. London: Faber, 1964.

———. *On Poetry and Poets*. London: Faber, 1969.

———. *The Use of Poetry and the Use of Criticism: Studies in the Relation of Criticism to Poetry in England*. London: Faber, 1933.

———. *The Varieties of Metaphysical Poetry*. The Clark Lectures, 1926. Ed. and intro. Ronald Schuchard. London: Faber, 1993.

Greene, Harry Plunket. *Interpretation in Song*. London: Macmillan, 1912.

Heidegger, Martin. *Being and Time*. Trans. John Macquarrie and Edward Robinson. San Francisco: HarperCollins, 1962.

———. *Introduction to Metaphysics*. Trans. Ralph Mannheim. Garden City, NJ: Anchor Books, 1961.

Heyman, Kaherine Ruth. *The Relation of Ultramodern to Archaic Music*. Boston: Small, Maynard, 1921.

Iser, Wolfgang. *The Act of Reading: A Theory of Aesthetic Response*. Baltimore: Johns Hopkins University Press, 1978.

Johan Strauss Walzer: Transkriptionen von Schönberg, Berg, Webern. Boston Symphony Chamber Players, 1979. Deutsche Grammophon Stereo 2530 977.

Keynes, John Maynard. *The Economic Consequences of the Peace*. New York: Harcourt, Brace and Howe, 1920.

Leichentritt, Hugo. *Music, History, and Ideas*. Cambridge: Harvard University Press, 1944.

MacDonald, Malcolm. *Schoenberg*. Master Musicians Series. London: Dent, 1976.

Mendl, R. W. S. *From a Music Lover's Armchair*. London: Philip Allan, 1926.

Munro, Hector H. ("Saki"). *The Westminster Alice*. Illus. F. Carruthers Gould. Westminster Popular No. 18, [1903]. Reprinted from *The Westminster Gazette*.

Pound, Ezra. *Pavannes and Divisions*. New York: Knopf, 1918.

Riquelme, John Paul. *Harmony of Dissonances: T. S. Eliot, Romanticism, and Imagination*. Baltimore: Johns Hopkins University Press, 1991.

Scholes, Percy A. *The Mirror of Music, 1844–1944: A Century of Musical Life in Britain As Reflected in the Pages of the "Musical Times."* Vol. 1. London: Novello and Oxford University Press, 1947.

Scott, Cyril. *The Philosophy of Modernism (in Its Connection with Music).* London: Kegan Paul, Trench, Trubner, 1917.

Smith, Grover. *T. S. Eliot's Poetry and Plays: A Study in Sources and Meanings.* 2nd ed. Chicago: University of Chicago Press, 1974.

Stuckenschmidt, H. H. *Schoenberg: His Life, World and Work.* Trans. Humphrey Searle. London: John Calder, 1977.

Turner, W. J. *Facing the Music: Reflections of a Music Critic.* London: G. Bell, 1933.

PART II
You Are the Music

CHAPTER 6

Eliot's Impossible Music

BRAD BUCKNELL

MUSIC AND CULTURE

I will not be addressing the putative, or even the possible, analogies between Eliot's poetry and music here—at least in any strictly formal way. I am not seeking a formal analogy between the "way" music means, and the "way" Eliot's poetry means. Much has been said on this subject already, especially in regard to the *Four Quartets*, and there will likely be more to come. What concerns me here is the notion of music itself as a cultural signifier, one with a varied and complex history. When I refer to music, I mean, of course, the music of the Western European tradition, the same intellectual and aesthetic tradition about which Eliot himself was so concerned. In the often impressionistic (though sometimes credible) use of music as an analogy for the structure and meaning of, say, the *Four Quartets*, music appears as a kind of vague, if loosely applied, model for structural and thematic variations.[1] Often, too, these analyses culminate at some point with a direct or indirect sense of some transcendent meaning that is meant to connect the poem to the *way* in which music is supposed to mean. Such a sense of the meaning of music is not unknown in Eliot's own analyses. One often-quoted passage from F. O. Matthiessen's *The Achievement of T. S. Eliot* records a selection from an unpublished lecture of Eliot's called "English Letter Writers" (1933). Here, Eliot states that poetry must try to "get beyond language, just as the late Beethoven quartets try to get beyond music" (Matthiessen 90). Eliot also expresses his own desire to write a "poetry standing naked in its bare bones, or poetry so transparent that we should not see the poetry" (90).[2]

However, in something like "The Music of Poetry" (1942) we notice that music is talked about in somewhat different terms. Here, the language of poetry is removed (could we say, saved?) from any Paterian or postsymbolist reach. The music of poetry must be intelligible; it must be a part of what circumscribes the poem and allows it to create and express an ordered whole. Indeed, it is interesting to discover that in "The Social Function of Poetry" (1943), written a year later, Eliot will claim that what is most important about the poetry of a given people is its ability to express the *feelings and emotions* of that people as the other arts—painting or music—cannot do (18–19). It is almost as though he is trying to win expressiveness back from music—not as Mallarmé might have done with Wagner in reclaiming the fundamental *mystery* of the poetic Book—but through a claim for the necessity of intelligibility and order, though it sounds as though he is speaking only of expression here. The tension between music as transcendent *and* as something that must be controlled echoes a similar sense of the necessary ordering of things that can be found in Eliot's cultural writings, especially *Notes towards the Definition of Culture*. There, too, we can see the same regard for the proportionate distribution of cultural elements, with the overall thrust being in the direction of hierarchy, circumscription, and the avoidance of miscegenation in the realms of both culture and art—not that these terms are for Eliot by any means separate. However, it is the manner in which these terms are linked, especially in regard to music, that interests me here.

I want to connect various references and allusions to music that Eliot makes to the larger cultural project he establishes in *Notes towards a Definition of Culture*. Clearly, Eliot has an interest in music as a cultural signifier, though he rarely mentions exactly what kind of music he means, in the *Four Quartets* for instance, though Wagner is cited in *The Waste Land*, and the "low" art of the "Shakespeherian Rag" seems to threaten the "high" in that same poem. But also in *The Waste Land*, there is the image of a music of reconciliation, "the pleasant whining of a mandolin" of community, apparently emerging from the "lower" public house in some ideally stratified England. Eliot mentions the fact that he *listened* to the late Beethoven quartets while composing his own *Four Quartets* (see Howarth 277–78): Beethoven's pieces and his own "quartets" both assume a five-part structure. There is little else, perhaps, to make an analogy on. However, the conjuring up of "Beethoven" may have its purpose.

It is important to remember that Eliot is not only the prototypical New Critical poet and critic, though the early statements of such pieces as "Tradition and the Individual Talent" (1919) may still ring in our ears,

with their imperatives of the sacrifice of the poet's self and the suggestion of an "ideal order" of "existing [literary] monuments" ("Tradition" 50). For many contemporary scholars after almost twenty years of fierce and necessary debate about the notion of any "ideal" canon, Eliot's words cannot help but sound not only old-fashioned, but, considering their enormous influence, perhaps still too influential. But maybe it is our own critical failing that we see Eliot only as the poet of poetry before all else. As John Xiros Cooper has pointed out, "there was never a time (except perhaps in *The Elder Statesman* period) when he [Eliot] did not maintain a keen interest in the external social world, and, further, maintain himself as a commentator, spokesman and impresario of certain social and cultural values which he promoted, increasingly publicly, after 1930" (6)— in other words, after his religious conversion. In the 1928 preface to *The Sacred Wood*, Eliot could propound a familiar division of labor within the poem, "that its parts form something quite different from a body of neatly ordered biographical data; that the feeling, or emotion, or vision, resulting from the poem is something different from the feeling or emotion or vision in the mind of the poet" (x). But he could also maintain in the next breath that "poetry certainly has something to do with morals, and with religion, and even with politics perhaps, *though we cannot say what*" (x, my emphasis).

However, the consideration of what art and poetry generally might have to do with a larger cultural nexus did indeed interest Eliot, especially as time went on and he himself had an increasingly vested interest in "culture" of a more established variety. His later statements on culture, and especially the post–World War II *Notes towards the Definition of Culture,* will probably not redeem Eliot in the eyes of most contemporary scholars. But they supply a great deal of evidence of Eliot's interest in realms beyond poetry. Indeed, it is likely impossible to separate anymore Eliot's seemingly innocuous comments, say on music and literature in his "The Music of Poetry," from his larger cultural and aesthetic project. And even some, perhaps suspect, notion of historical relativism cannot save Eliot from his apparent modernist sins: his conservatism, his "flirtation" with fascism by association with Charles Maurras, his anti-Semitism, his social elitism, his fear of miscegenation and perhaps much else. One might then expect me to proceed merely to condemn Eliot as some kind of proto-fascist, anti-Semitic, High Church conservative, afraid of losing, or seeing crumble, the very things he had hoped to become part of as he changed his allegiances from America to England—and to see this turn as being evident in his poetry from first to last. All this is, to one

degree or another, true of Eliot, and it will indeed affect my reading here. But instead of merely showing the ideological continuity between his critical remarks and his poetry—or showing this only—I would like to read Eliot's cultural/musical statements in the light of a problem of history and knowledge as it appears within the larger context of the general nostalgia of his conservatism. I want first to focus on a certain tension or even division that exists within Eliot's thought and that is expressed in his own statements in regard to poetry and music in "The Music of Poetry" essay. I will then briefly relate my discussion there to the cultural project of *Notes towards the Definition of Culture*, and finally, I will take up the concept of culture Eliot proffers in *Notes* in relation to the repetitious practice of the *Four Quartets*. For ultimately, it will be by repetition and insistence that Eliot will figure his problematic poetics of music.

UNSPEAKABLE MEANINGS

It is striking that in what is Eliot's most explicit discussion of the relations between poetry and music, "The Music of Poetry" (1942), it is the anti-Paterian tone that implicitly—and still, very clearly—pervades. It is obvious in his other pieces on Pater that Eliot does not perceive the writer of *The Renaissance* to be among the first order of critic. He disparages both Arnold's and Pater's tendency, as Eliot sees it, to diminish the importance of religion to the point where it is merely one aspect of human experience among others ("Arnold and Pater" 437). Thus, for Eliot, "The degradation of philosophy and religion, skilfully initiated by Arnold, is competently continued by Pater" (437). Pater merely marks a moment in the "dissolution of thought" (442) in the nineteenth century, an age where "Religion became morals, religion became art, religion became science of philosophy; [and] various blundering attempts were made at alliances between various branches of thought" (442–43). Still, despite this disparagement of Pater's critical project, Eliot seems determined to take Pater on in the "Music of Poetry" essay.

This may not at first seem apparent. However, Eliot's claims regarding "musical" poetry, especially in regard to the problem of meaning, are clearly meant to be more precise than anything offered under the aegis of Pater's musical ideal: "My purpose here is to insist that a 'musical poem' is a poem which has a musical pattern of sound and a musical pattern of the secondary meanings of the words which compose it, and that these two patterns are indissoluble and one. . . . The sound of a poem is as much an abstraction from the poem as is the sense" ("Music" 33). This

seems a long way from Pater's dictum that "All art constantly aspires towards the condition of music" (Pater 86). Eliot's apparently precise combination of patterns made of sound and associational linguistic meaning remains interlocked. Pater, on the other hand, seems to wax far too poetical (especially for Eliot) when, in *The Renaissance*, in the chapter on the School of Giorgione, he claims that "Art, then, is thus always striving to be independent of the mere intelligence, to become a matter of pure perception, to get rid of its responsibilities to its subject or material; the ideal examples of poetry and painting being those in which the constituent elements of the composition are so welded together, that the material or subject no longer strikes the intellect only; nor the form, the eye or the ear only; but form and matter, in their union, or identity" (88). All the talk of unity may give this statement an air of similarity to Eliot's; but of course they are not similar at all. Eliot is talking only about what he considers "musical" in terms of the composition of poetry; Pater is making a claim for "music" as the ideal to which any composition, poetic or otherwise, must strive. Moreover, the notion of "meaning" in these passages is very different. Though Pater seems to say that form *and* matter are to be "welded" together under the musical ideal, it is obvious that as form gets "rid of its responsibilities to its subject or material" and becomes a matter of "pure perception," the subject or material becomes quite secondary. Eliot, while allowing for a variance in interpretations ("Music" 30–31), will not suffer mere formal properties, especially those of sound, to take the reader wholly away from an intelligible reward: "We can be deeply stirred by hearing the recitation of a poem in a language of which we understand no word; but if we are then told that the poem is gibberish and has no meaning, we shall consider ourselves deluded—this was no poem, it was merely an imitation of instrumental music" (30). Though some might find such an imitation of great interest, and perhaps even full of "meaning," Eliot will not allow this. The "music" of poetry remains the counterpoint of sound and secondary meaning.

But is this all that precise a demand? For what exactly *is* a "musical pattern of secondary meanings"? And indeed, can they be as tightly corralled as Eliot would like them to be? He wishes us to think so, since he seems much concerned to counter Pater's more nebulous pronouncements on the musical ideal of art. However, Eliot has made a rather dramatic and perhaps nebulous shift here himself in the move from the relatively concrete statement on the rhythmic properties of words to the very metaphorical notion of the patterning of their secondary meanings. For Eliot, the musicality of the word is created at the site of its

synchronic and diachronic conjunction: "The music of a word is, so to speak, at a point of intersection: it arises from its relation first to the words immediately preceding and following it, and indefinitely to the rest of its context; and from another relation, that of its immediate meaning in that context to all the other meanings which it has had in other contexts, to its greater or less wealth of association" (32–33). The complex nexus of the word is made even richer if we remember that Eliot also maintains that "[t]he music of poetry . . . must be a music latent in the common speech of its time" (31) and place. Eliot means to be exacting here, and to a degree he is, especially in contrast to Pater. Eliot is attempting to move into the very un-Paterian territory of history and social practice.[3] He is in his way admitting the temporal and historical specificity of the making of poetry and is thus delimiting the context of the "musical" word (the musical "material" of the poet) in both its immediate and its historical contexts.

Or so it seems. Eliot is in fact making another attempt to reconcile the timeless with the timebound, history with the ideal, a project that very much resembles that set out so early in the "Tradition" essay. But there are difficulties. Yeats, whom Eliot mentions in the "Music" essay, is a fine reader of *Irish* poetry and especially of his own verse (31–32); however, Yeats is an "astonishing" rather than a "satisfying" reader of Blake (32). The voice of Irish speech does very well on its own turf (or bog), but less well even with its visionary English precursor. No doubt, a white male teacher (like me) would prefer to have Langston Hughes, or Gwendolyn Brooks, or, indeed, Yeats or Eliot read their own poetry to his students. There are sounds and tones in the language that are best left to the voice of the maker. But on those occasions where this is impossible and I myself must do the job, even without "doing" the poem in any given voice (Irish, British English, "black"), must we consider the "music" to be completely gone? I cannot think so, even being the poor reader I am, for this would mean then that there is no translation, no way to hear the music of poetry at all across the barriers of class, race, gender, time, or even in the verbal transformation of the written word in silent reading. For as temporally and spatially specific as Eliot is trying to be here, one feels that what is really going on is that the "ideal order" of the "Tradition" essay lurks somewhere in the background. Whose ear is it that is offended when Yeats reads Blake? What *is* so astonishing about the transposition of Yeats's voice over Blake's words? We have to infer that Eliot is in part perhaps making a kind of inside joke that he and his original audience at Glasgow University must share—though here

too, one would think that the notion of a standard sounding *way* to read Blake might have given some in the audience pause. But, more important, if the associational qualities of the words themselves must form a "musical" secondary pattern in the poem, then these cannot rest *only* within the actual voice of a given reader.

Eliot has inadvertently opened the tension within the very nature of time, place, and sound as voice, even while seeking to circumscribe the very allusive possibilities he is trying to acknowledge. He claims not to wish for a standard BBC English (31), and insofar as this pertains to mere undifferentiated sounding speech, we can believe him. However, I believe he does wish for a standard of associational possibilities, even as these apply to sound. The voice, Yeats's voice, seems somehow to endanger the secondary pattern of meaning. This is because it opens *another field of associations*, another set of "secondary meanings" that are drawn both from the culture from which a given voice comes *and* from the very particularity of the speaker's voice.[4] There is no single "Irish" voice that could do simple justice to Yeats and disservice to Blake—at least not in the same way as Yeats's own voice. No two sounds of Irishness or blackness or Britishness are alike, nor is any one voice *the* sound of black, Irish, or British. Once the specificity of the voice is, so to speak, let out, it bears the traces of its individual and cultural histories, and within the vast parameters of both cultural and individual variation, any secondary pattern of associations is indeed hard to control.

Two levels of association are in fact let loose here, and Eliot, if pressed, would find it difficult to constrain them. There is no way necessarily to include or exclude the allusiveness that any voice uttering the words of a poem may produce; and, just as the vocal variations of utterance are manifold, so too must be the variations of the lexical possibilities of the words in their own unuttered right. Eliot *is*, I believe, trying to be flexible, to be reasonable, to allow for a fluidity of language within what are to him acceptable boundaries. The boundaries will not remain in place, however, and it is his own raising of the image of Yeats as reader that undoes him. More significant here, he is trying, I think, to have his music of poetry two ways at once. It seems in fact that he wishes to contain the nonlexical properties of music, the very power of its presence without words, to found the properties of a poetic language.

In the romantic tradition of music aesthetics, a tradition that Pater came late to, music took over the literary trope of "unspeakability" (see Dahlhaus, *The Idea of Absolute Music* 63); it then acquired the property of being able to *speak* the unspeakable, to represent the unrepresentable.

This sublime lexicality seems to stem precisely from the fact that music lacks lexicality: since it does not "refer" to anything, it seems to be able to refer to *all* things. But its associational capacities, as we know, are rich, and a good deal can stand in for the "sublime"—even, of course, music itself. Such a sense of the sublime requires a social infrastructure in order to maintain it, a dialectic of priests and consumers, to use Susan McClary's terms, wherein "the priesthood prattles on in its jargon that adds a metaphysical component to the essence of music and abdicates responsibility for its [own] power; and listeners react as though mystically—not wanting to attribute to mere mortals the power to move them so" (McClary 17).[5] Partly then, music enters history and the realm of the social by virtue of its apparent *need* for explanation, as a consequence of its power to move without lexicality. Thus, "music" becomes a sign of recondite "high" culture itself: it signifies the past of Mozart, Hayden, Beethoven, Puccini, and Wagner; and perhaps even more important, especially for Eliot, is that such a past also signifies an order. It offers an intelligibility where it might otherwise be threatened.

This is partly what Eliot himself is trying to do with poetry in the "Music" essay and elsewhere: to explain poetry, or at least its necessary and continued existence in the modern world.[6] However, at the same time as Eliot gives a very compelling and accurate musical-literary explanation of the synchronic/diachronic nature of the poetic word, he is also creating a space of social explanation wherein the more abstract dimensions of both poetry and music can be brought under control. The plausibility and insight of his remarks on the musical poetic word tend to obscure the less secure statements regarding voice and secondary associations. The difficulty is, then, that Eliot inadvertently acknowledges, if not the well-known "sublime" nature of music, then certainly the power of its nonlexical nature, and yet he wishes to corral it for the purposes of hierarchy and order. This musical past, while itself a varied, complex, and, as is the case with all social/historical events or developments, partly unrecoverable set of social, cultural, and aesthetic circumstances, can offer its representatives (Beethoven, for instance) as signs in themselves of the sublime, of an art of music that can speak the unspeakable, and therefore can reconcile elements of experience (personal, social, cultural) that might otherwise remain unreconcilable. Music, then, in Eliot's terms, can be seen as another facet of his attempt to shore his fragments, not only against his own ruin, but that of his culture's as well.

A SINGULAR ORDER

For Eliot *is* very much interested in culture, at least his version of it; the post–World War II volume *Notes towards the Definition of Culture* amply shows this. And here too the call is for hierarchy and order: the explanation of the necessity, indeed, the inevitability and necessity of elites (chapter 2); the resistance to the idea of "equal opportunity" education— very much an issue in postwar Britain (chapter 6); and even his honest attempt, I believe, to speak to the question of colonization and the post-colonial world Britain was facing (chapter 3) seem now at best paternalistic.[7] The implied readership here is clearly those who saw their cultural power threatened at war's end with the ruin of Europe and the immediate rise of Labour at war's end. This is after all a volume written very much amid the debris of the war. The orthodoxy of the ideal here might be mitigated somewhat by this fact. But as John Xiros Cooper has suggested, regarding the *Four Quartets*, *Notes* is also concerned with quieting the fears of the postwar cultural "mandarinate" (Cooper 134; and chapter 5). As such, it is very much yet another of Eliot's documents concerned with order, and time, and the attempt to reconcile the two. This is clear in the way in which religion is described as primary to Eliot's version of culture.

For Eliot, it is imperative to see the connection between culture and religion as not merely a "relation" but as "different aspects of the same thing" (*Notes* 28). "Culture," which for Eliot encompasses "Derby Day, Henley Regatta, Cowes, the twelfth of August, a cup final, the dog races . . . boiled cabbage cut into sections (!)" and much else in the realm of the English day-to-day, cannot be separated from religion in the sense that all this is part of "our *lived* religion" (30, Eliot's emphasis). In Eliot's view, "behaviour is belief" (30), even though this may be a disquieting vision for some. What this social dimension of the religious-cultural means for the production of art is that "[ae]sthetic sensibility must be extended into spiritual perception, and spiritual perception must be extended into aesthetic sensibility and disciplined taste before we are qualified to pass judgement upon decadence or diabolism or nihilism in art" (29). Now religion here does not exactly stand in for the musical sublime that I spoke of earlier; but what is clear is that the reins of religion as a transcendental signified are quite clearly applied to the social and aesthetic realms. There is, moreover, in this view more than a little nostalgia, a sentiment not unknown in many conservative quarters from Eliot's time down to the present. This nostalgia includes a longing for an

England of quieter and more established times,[8] as is clear in the chapter on education (chapter 6), in which Eliot gives space to Dr. C. E. M. Joad's encomium on pre–World War I Oxford, a place and time not created, as Eliot points out, by "equality of opportunity" (105).[9] More serious, though, is Eliot's conservative nostalgia for a Christian Europe. This is not a simple utopian dream; Eliot does not seek heaven on earth. He maintains rather that "Christendom should be one: the form of organization and the locus of powers in that unity are questions upon which we cannot pronounce. But within that unity there should be an endless conflict between ideas—for it is only by the struggle against constantly appearing false ideas that the truth is enlarged and clarified, and in the conflict with heresy that orthodoxy is developed to meet the needs of the times" (83). Christianity so conceived will indeed remain a still point, and though the world may change as time and history decide, there will always be a point of reference crossing all ages. Again, history can be reconciled to an order outside itself, and though vicissitudes occur, they can ostensibly be accommodated.

Or can it? Eliot maintains, and with some truth, that in the West, "we must recognize that the main cultural tradition has been that corresponding to the Church of Rome . . . and anyone with a sense of center and periphery must admit that the western tradition has been Latin, and Latin means Rome" (74). This is not a point upon which Eliot seems willing to be debated; no questions regarding violence, conflict, or countercultural influence seem to impinge on Eliot's line of argument. Thus, Eliot's is a history of vast omissions, and there is one in particular that is all the more astonishing, and even reprehensible, given the historical moment just after World War II in which Eliot writes: I refer, of course, to the decided absence of any Jewish influence. There is no arguing with the Christian domination (and this word should play here in all its unhappy senses) of Europe that Eliot notes. But at the same time there is no way around acknowledging the influence of Jewish tradition on this culture either— even as a presence variously despised, appropriated, persecuted, indeed, annihilated, or nearly so. No way, unless, as Eliot does here, one simply avoids it altogether. To do so is also to overlook not only the Old Testament and its Jewish origins, but also (for example) to exclude from memory, and semiutopian cultural divination, the expulsion of the Jews from Spain—in the same year that the Arabs also lost power there, and Columbus "discovered" America. Eliot entertains no notion that colonial expansion and Jewish and Arabic expulsion might be less savory dimensions of a Christian-Latin inheritance. Worse still may be the fact that Eliot excludes

the tradition of Christian Europe's anti-Semitism, which had its most recent culmination during World War II, just a few years before Eliot writes. Perhaps Eliot is trying to avoid the egregiousness of the kind of clearly anti-Semitic claims he had made in *After Strange Gods* (1934), where he held that no society would last long with an unwanted number of "free-thinking Jews" (19–20). As Anthony Julius points out, "liberalism" and "free-thinking Jews" were joined in Eliot's mind, and both, separately and together, were anathema to him, at least clearly so in the 1930s (Julius 155–159). Even though *Notes* avoids any explicitly anti-Semitic remarks, there is, however, one footnote in chapter 4 where Eliot speaks of the diaspora of the Jews among Christians allowing for "culture-contact" only in the "neutral zones of culture in which religion could be ignored" (*Notes* 70, n2). This unfortunate contact leads only to the illusion that "there can be culture without religion" (70).[10] Eliot still seems to be quietly suffering a hangover from the silliness of *After Strange Gods*; the illusions of cultural-religious homogeneity unfortunately still take precedence over historical fact—both early and recent. *Notes*'s fantasy history of Europe also suggests a concomitantly narrow and unrealistic notion of the uniformity of "culture" itself. The work of religion in relation to culture is that of Christianity alone, and this religious cultural concept extends into proposals for the future. The future, in Eliot's terms, will be as exclusively Christian as was the past.

This rather exorcized sense of history clearly displays the nostalgic conservatism of Eliot's sense of culture; moreover, this is a repetition of the call to an order outside of time, even if now, "tradition" has been replaced by "orthodoxy" (Julius 151). For my purposes, it does not really matter which term Eliot uses, though he himself will make distinctions about these terms (*Gods* 21). More important is the sense that the necessary interrelation of all cultural endeavors is rooted in an erroneous and unconsciously (so it seems) exclusive historicism, a historicism that is justified fundamentally by Eliot's hierarchical Christianity. Eliot's orthodoxy/tradition signals a *desire* for hierarchy, and indeed, the redemption of temporal and historical "disorder" by reference to an order that is founded outside of time. Such a desire, or belief, is of course a fundamental theme of *Four Quartets*.

NOSTALGIA AS REPETITION

I see very little in these poems upon which to base a musical analogy in any formal sense, though as I noted at the outset, many have tried. My

contention is that especially in these late poems, it is the *idea* of music that signifies, and I mean "music" as an aesthetic signifier that is part of Eliot's overall cultural project. When I speak of Eliot's desire for hierarchy, then, I mean to include his sense of a sort of controlled transcendence that is so clear in the essay on "The Music of Poetry" and that is also apparent in his theorizing about culture. The formal project of the poems is linked to the cultural theorizing, and, most important, to the conservative nostalgia that plagues that theorizing.

Crucial, then, to Eliot's poetic music of redemption is the technique of repetition upon which the *Quartets* are based. Jewel Spears Brooker has noted that one of the most significant changes in Eliot's poetic technique from *The Waste Land* to the *Quartets* is that of the shift from citation and mythological collage, or, as she puts it, the "juxtaposition of fragments which can be (re)collected and organized by reference to a privileged myth" (90) to repetition, where "the pattern is both the main subject and major principle of form" (94). The contrast is an accurate one, and the use of repetition is obvious enough in the *Quartets*: the five-part structure of each poem; the recurrence of thematic material—especially that of the relationship of time and the timeless—often in corresponding sections of the poems (most obvious in the first sections of each poem); the technical similarities between sections (usually the fourth section of each poem is shorter, and often, though not always, of a more strict poetic form); and there is, of course, Eliot's own claim for the presence of repetition as not only a quality of the poetic voice but also as its necessity: "You say I am repeating / Something I have said before. I shall say it again. / Shall I say it again?" ("East Coker" 201). Eliot does indeed say "it" again, the "it" being the presentation of paradoxes and aporias: "And what you do not know is the only thing you know / And what you own is what you do not own / And where you are is where you are not" (201). Such paradoxes repeat and continue those from Heraclitus that preface the entire set of poems.[11]

I think that this constant attempt on the poem's part to tease us out of reason is perhaps where we see Eliot's most consistent effort at musical analogy; for repetition and variation of theme—even as weighty and difficult a theme as time—do not of themselves require or necessitate a musical analogy, though one *might* be used. Instead, Eliot is forcing and *en*forcing an analogy with music by means of these mystical paradoxes, pushing at the limits of what he calls, in the "Music" essay, the "frontiers of consciousness beyond which words fail, though meaning still exists" (30). Here, Eliot comes to the true crux of both musical meaning and

mystical, symbolic exchange: for how can we tell that such "frontiers" exist except as the poem or the piece of music operates *within time*? The security of any other realm beyond the image or word or musical passage is ultimately tied to the passage itself, to history, or time, and the cultural-subjective interpretive moment that, like the word or music, is always constrained by time. The meaning beyond the concrete physical manifestation of word or music can only be asserted as "true" by the very insistence of the word or music itself. This is not to say that we cannot find meaning in poetry or music, but rather that we can never be sure of the "sublime" nature of music, or the salvation of Heaven to secure the defeat of time. What stands in instead of proof is insistence, repetition. Why else would Eliot be concerned with a bare-bones poetry analogous, so he believed, to the late Beethoven quartets, which were, according to Eliot, an attempt to "get beyond" music? Why else, unless one must posit the very possibility of the disappearance of the artifact, the music, the poem, which in any case can only palely point toward this more significant and *un*representable realm. But the poetry or the music will not go away; they can only repeat themselves.[12]

Eliot's insistence amounts to a kind of repetition (somewhat) in the Lacanian sense. At least one dimension of Lacan's discussion of Freud and repetition echoes for me Eliot's kind of insistence and repetition concerning order and hierarchy—whether as tradition, orthodoxy, or indeed, the poetic appeal to the timeless realm of God. Lacan himself insists, in reinterpreting Freud, that "repetition is not reproduction" (*Concepts* 50). This is to say that the repetition is not the re-creation of some trauma that the subject then attempts to master through repetitious behavior. As Lacan puts it, "who masters, where is the master here to be mastered? Why speak so hastily when we do not know precisely where to situate the agency that would undertake this operation of mastery?" (51). Repetition is its own event. It "first appears in a form which is not clear, that is not self-evident, like a reproduction, or a making present, *in act* (50, Lacan's emphasis). Later, Lacan discusses the dream Freud describes in *The Interpretation of Dreams* concerning the father who dreams that his dead child is burning in the next room. The father's dream proves true, and Lacan asks, "Is not the dream essentially, one might say, an act of homage to the missed reality—the reality that can no longer produce itself except by repeating itself endlessly in some never attained awakening?" (58). This "homage" to the missed reality is in a sense more real than the fire next door. Similarly, Eliot's poetic "music," interimplicated as it is with his cultural-religious sensibility, is part of the endless

repetition, the homage, to the absent (if not "missed") reality of his con-
servative Christianity.

In the *Quartets* themselves, it is the image of music as an aesthetic
object that Eliot uses as the model for the artistic, cultural, and spiritual
overcoming of time. It is meant to collect the problems of time (as a con-
tinual passing that offers little evidence in our ordinary experience of any
order beyond it), memory, art, and, indeed, spiritual experience into one
succinct image. Part V of "Little Gidding" provides the classic formula-
tion beginning with the familiar "Words move, music moves" (194).
Words and music are here joined in the spatializing metaphor that is made
concrete in the image of the Chinese jar. Still, and moving, aesthetic
form overcomes the problem of the "enchainment of past and future"
("Burnt Norton" 192), defeating mere succession and placing the other-
wise random points of experience (musical, poetic, "ordinary") into co-
herent order. But "music" here is also the sign not only of the return to
intelligibility that Pater sought to sidestep, but also for the organization
of the lost temporality that always escapes history or historiography.
Indeed, it is the sign of the organization of time itself in the outlines of
the jar, always present past any particularity. Moreover, it signals the
time that escapes art and the writing of history—an "in between time"
that cannot be recorded or known other than in its particularity; is "true"
in some sense, always "there now, there" but also unrecoverable. Jewel
Spears Brooker also points out, though for different reasons, that Eliot is
always pointing to what is not there, to what is ungraspable by ordinary
means; indeed, for her, Eliot's work with oppositions and paradoxes is
part of the means of overcoming them (99). As she puts it, "[t]his insis-
tence on absence is a part of the pattern of oppositions, for it is simulta-
neously an insistence on presence" (99).

This is so; but I do not think I hear this music the same way as
Brooker does. The aesthetic becomes for Eliot a model for the spiritual,
and vice versa; moreover, the historical-cultural-religious nexus that
underpins this music is fraught with its own dissonances, its errors and
omissions. Eliot worried that in shaping the *Quartets*, he might turn
repetition into mere redundancy.[13] Insofar as the insistence on hierar-
chy remains and shapes the poetry, I believe he has, unfortunately, done
precisely this. I do not say that we present-day critics and thinkers have
overcome the problems of hierarchy—for all our talk of difference, not
yet, and maybe Eliot has more than a little to show us about the practical
problems of working out a new order, be it aesthetic and/or social, a bet-
ter and more inclusive one. But the lines of the *Quartets* do not sing to

me as they once did, however beautiful they still may be. They repeat themselves now, in tones too exclusive or rarified, too insistent on a set of social interpretive structures that, as broadly as these themes mean to stretch, still seem too narrow.

NOTES

1. See, for example, Helen Gardner's "The Music of *Four Quartets*" where, though she warns that the musical analogy must not be taken too literally (120), she nevertheless adopts it at times rather freely, as when discussing the third movement of "East Coker": "The repetitive circling passage in *East Coker*, in particular, where we seem to be standing still, waiting for something to happen, for a rhythm to break out, reminds one of the bridge passages between two movements which Beethoven loved. The effect of suspense here is comparable to the sensation with which we listen to the second movement of a Beethoven Violin Concerto finding its way towards the rhythm of the Rondo" (123). Most of the readings mentioned in the next footnote have similar passages. One notable exception to this impressionism in regard to the musical analogy of the *Quartets* is Brian Hatton's "Musical Form in Poetry: *Four Quartets* and Beethoven," which attempts a more rigorous analogy based on the way Eliot uses "[a] *logic* [of concepts] the way a musician uses harmony" (5). Hatton produces a compelling anti-impressionistic, antitranscendent reading of the poem. But, while Beethoven and Eliot are saved from unnecessary emotionalism, they both seem to become master aesthetic logicians here, a position perhaps no less exalted than artists who offer immense emotional (if impressionistic) rewards.

2. References to Mathiessen's recovered Eliot lecture are pervasive. See for instance, Herbert Howarth, *Notes on Some Figures behind T. S. Eliot*, 277–89; Elizabeth Schneider, *T. S. Eliot: The Pattern in the Carpet*, 169; Stanley M. Wiersma, "'My Words Echo Thus in Your Mind': T. S. Eliot's *Four Quartets* and Beethoven; and John Holloway, "Eliot's *Four Quartets* and Beethoven's Last Quartets."

3. But for a different discussion of Pater, music, and history, see my "Re-Reading Pater: The Musical Aesthetics of Temporality."

4. Mark E. Blanchard discusses the paradox of the voice as presented in Elias Canetti's *The Voices of Marrakesh:* "Words belong to everyone, the voice, one voice only to someone" (Blanchard 130). One thinks too, here, of Barthes's 'idea of the distinctive "grain" of the voice, the mark of the body in words.

5. McClary points out, in reference to the real complexities of musical comprehension, that a given pitch signifies only "by appearing in a highly structured, ordered context—a context dependent on norms, rules, and those apparently self-contained, abstract principles known explicitly only by initiated practitioners"

(16). The resonances with Eliot's description of the poetic word should be evident here.

6. This is not so far from what we ourselves do at academic institutions—all of us, of any political persuasion. It is just that we cannot be certain anymore—and for good reason—just what any canonical "ideal order" might look like.

7. Eliot does indeed seem to understand some of the problems that occur when a "*higher* foreign culture has been imposed, often by force, upon a *lower*" (*Notes* 63, my emphasis). But more than a little of the original imperialist justification remains in the language here. And by the time he begins speaking of the problem of colonization as the problem of "migration" (63–64), he loses all credibility. The historical blindness is great indeed here.

8. See John Xiros Cooper's discussion of Eliot's strong connection to the pastoral version of English history as presented by historians such as Keith Feiling. As Cooper notes, Eliot's attraction to the Tory historians resides in their, and Eliot's, belief in "loyalty to, obedience and trust in the paternalistic authoritarianism which a governing elite practices in the context of a scrupulously divided and ranked hierarchical society" (13).

9. In this regard, Eliot cannot understand Dr. Joad's acquiescence to R. H. Tawney's idea that "the public schools should be taken over by the State and used as boarding schools to accommodate for two or three years the intellectually abler secondary school boys from the ages of sixteen to eighteen" (*Notes* 105).

10. See Julius on this passage, 164–65.

11. These are given in Greek, and as Brooker translates them, they are: "Though there is but one Centre, most people live in centres of their own" and "The way up and the way down are one and the same" (91).

12. I also believe that Eliot saw this problem very clearly. Cleo McNelly Kearns remarks, paraphrasing Eliot's view as presented in his seminar with Josiah Royce, that "Eliot insisted that an insider's account of [religious] phenomena would be blind in one way; an outsider's in another, and no certain third point of view could be established to adjudicate their claims" (85).

13. Brooker notes this and cites a letter of Eliot's to John Hayward as proof (90–91).

WORKS CITED

Barthes, Roland. "The Grain of the Voice." *The Responsibility of Forms: Critical Essays on Music, Art, and Representation*. Trans. Richard Howard. New York: Hill and Wang, 1985, 267–77.

Blanchard, Marc E. "The Sound of Songs: The Voice in the Text." *Hermeneutics and Deconstruction*. Ed. Hugh J. Silverman and Don Ihde. Albany: State University of New York Press, 1985.

Brooker, Jewel Spears. "From *The Waste Land* to *Four Quartets*: Evolution of a Method." *Words in Time: New Essays on Eliot's "Four Quartets."* Ed. Edward Lobb. Ann Arbor: The University of Michigan Press, 1993, 84–106.

Bucknell, Brad. "Re-Reading Pater: The Musical Aesthetics of Temporality." *Modern Fiction Studies* 38.3 (Autumn 1992): 597–614.

Cooper, John Xiros. *T. S. Eliot and the Ideology of "Four Quartets."* Cambridge: Cambridge University Press, 1995.

Dahlhaus, Carl. *The Idea of Absolute Music.* Trans. Roger Lustig. Chicago: University of Chicago Press, 1989.

Eliot, T. S. After Strange Gods. London: Faber & Faber, 1934.

———. "Arnold and Pater." *Selected Essays.* London: Faber & Faber, 1961, 431–43.

———. *Four Quartets. Collected Poems: 1909–1962.* London: Faber & Faber, 1963, 187–223.

———. *The Idea of a Christian Society.* London: Faber & Faber, 1939.

———. "The Music of Poetry." *On Poetry and Poets.* London: Faber & Faber, 1979, 26–38.

———. *Notes toward the Definition of Culture.* New York: Harcourt, Brace, 1949.

———. Preface to the 1928 edition. *The Sacred Wood: Essays on Poetry and Criticism.* London: University Paperback, 1979, vii–x.

———. "The Social Function of Poetry." *On Poetry and Poets.* London: Faber & Faber, 1979, 15–25.

———. "Tradition and the Individual Talent." *The Sacred Wood: Essays on Poetry and Criticism.* London: University Paperback, 1979, 47–59.

Gardner, Helen. "The Music of *Four Quartets.*" T. S. Eliot: *"Four Quartets." A Casebook.* London: Macmillan, 1969, 119–137.

Hatton, Brian. "Musical Form in Poetry: *Four Quartets* and Beethoven." *Yeats-Eliot Review* 6.2 (1979): 3–14.

Holloway, John. "Eliot's *Four Quartets* and Beethoven's Last Quartets." *The Fire and the Rose:New Essays on T. S. Eliot.* Ed. Vinod Sena and Rajiva Verma. Delhi: Oxford University Press, 1992, 145–59.

Howarth, Herbert. *Notes on Some Figures behind T. S. Eliot.* Boston: Houghton Mifflin, 1964.

Julius, Anthony. *T. S. Eliot, Anti-Semitism, and Literary Form.* Cambridge: Cambridge University Press, 1996.

Kearns, Cleo McNelly. "Religion, Literature, and Society in the Work of T. S. Eliot." *The Cambridge Companion to T. S. Eliot.* Ed. A. David Moody. Cambridge: Cambridge University Press, 1994, 77–93.

Lacan, Jacques. *The Four Fundamental Concepts of Psycho-Analysis.* Trans. Alan Sheridan. New York: W. W. Norton, 1981.

Matthiessen, F. O. *The Achievement of T. S. Eliot: An Essay on the Nature of Poetry.* 3rd. ed., revised and enlarged, with an additional chapter by C. L. Barber. New York: Oxford University Press, 1959.

McClary, Susan. "The Blasphemy of Talking Politics during Bach Year." *Music and Society: The Politics of Composition, Performance and Reception.* Ed. Richard Leppert and Susan McClary. Cambridge: Cambridge University Press, 1990.

Pater, Walter. *The Renaissance: Studies in Art and Poetry.* 4th ed. Ed. and intro. Adam Phillips. Oxford: Oxford University Press, 1986 [1893].

Schneider, Elizabeth. *T. S. Eliot: The Pattern in the Carpet.* Berkeley: University of California Press, 1975.

Scott, Peter. "The Social Critic and His Discontents." *The Cambridge Companion to T. S. Eliot.* Ed. A. David Moody. Cambridge: Cambridge University Press, 1994, 60–76.

Wiersma, Stanley M. "'My Words Echo Thus in Your Mind': T. S. Eliot's *Four Quartets* and Beethoven." *Concerning Poetry* 13.1 (Spring 1980): 3–19.

Eliot's *Ars Musica Poetica*
Sources in French Symbolism

JOHN ADAMES

> *And every phrase*
> *And sentence that is right.*
> —"LITTLE GIDDING" V

THE CONDITION OF MUSIC

True to the reach of her own etymological history, Eliot's muse, knowing she is the source of both music and poetry, inspires him accordingly. Evidence for this inspiration is Eliot's intuitive understanding of the properties of music that suggested several analogs for the practice of his art. This artistic hybridity is evident throughout his development as both literary critic and poet, as music becomes an indispensable unifying force behind his aesthetic and spiritual vision. "[Y]ou are the music / While the music lasts" ("The Dry Salvages," *Complete Poems and Plays* 190, hereafter *CPP*), he says, suggesting, moreover, that we might even read our whole lives as a musical score.

When considering the place that music occupies in Eliot's poetics, it is useful to begin with Walter Pater's well-known dictum: "All art constantly aspires towards the condition of music" (Pater 156). For not only did Pater have a strong literary influence on poets such as W. B. Yeats and Arthur Symons, whose early works were important precursors of the high modernist revolution that encompassed Eliot, but such a statement provides a useful touchstone against which we can begin to assess Eliot's view of the relationship between music and poetry. Moreover, Paterian poetics in 1890s British aestheticism are gradually subsumed by symbolist ones that quintessentially influence Eliot's formative years as a poet. Consequently, my discussion will then turn to how French symbolist poets' preoccupations with music—particularly those of Baudelaire and Mallarmé—are an essential part of literary history that provided essential

precedents for Eliot's use of music in his own poetry. Finally, the integral role of music in the symbolist poetics of Baudelaire and Mallarmé has noticeable affinities with the metaphorical role of music in Eliot's Christian logocentric vision, which reaches its most complete and compelling expression in *Four Quartets*.

Pater's assertive claim that music represents the inevitable destination of all art rests primarily on the inveterate proposition—one whose earliest roots may date to Aristotle's argument in the *Poetics* for organic form[1]—that good art achieves a seamless blending of form and content: "It is the art of music which most completely realises this artistic ideal, this perfect identification of matter and form. In its consummate moments, the end is not distinct from the means, the form from the matter, the subject from the expression; they inhere in and completely saturate each other; and to it, therefore, to the condition of its perfect moments, all the arts may be supposed constantly to tend and aspire" (Pater 158).[2] Each art has "its own peculiar and untranslatable sensuous charm, has its own special mode of reaching the imagination, its own special responsibilities to its material" (153), and the degree to which these "responsibilities" are fulfilled determines the quality of the art. In short, the subject is nothing by itself; what matters most is the indivisible interfusion of subject with the formal properties of a particular medium: "That the mere matter of a poem, for instance, its subject, namely, its given incidents or situation—that the mere matter of a picture, the actual circumstances of an event, the actual topography of a landscape—should be nothing without the form, the spirit, of the handling, that this form, this mode of handling, should become an end in itself, should penetrate every part of the matter: this is what all art constantly strives after, and achieves in different degrees" (156). In addition, the work of art achieving this complete interpenetration of form and subject will not appeal strictly to the senses or to the intellect but to a combination of the two; consequently, the work is "always striving to be independent of the mere intelligence, to become a matter of pure perception . . . present[ing] one single effect to the 'imaginative reason,' that complex faculty for which every thought and feeling is twinborn with its sensible analogue or symbol" (158).

The "condition of music" provides the best analog for the achievement of "pure perception" and in Pater's aesthetic framework becomes a metaphor for the possibilities of artistic perfection. A Venetian landscape painting attains such perfection when its topographic details are so completely subsumed by a pictorial sensuousness that they become "the notes of a music which duly accompanies the presence of their men and women,

presenting us with the spirit or essence only of a certain sort of land-scape—a country of the pure reason or half-imaginative memory" (157). Lyric poetry reaches a similar perfection when it "appears to depend, in part, on a certain suppression or vagueness of mere subject, so that the meaning reaches us through ways not distinctly traceable by the under-standing as in . . . Shakespeare's songs [where] the kindling force and poetry of the whole play seems to pass for a moment into an actual strain of music" (157).

Like Pater, Eliot looks to music to help him articulate his vision of an ideal poetry. In his essay on Matthew Arnold, whom he faults for not being "highly sensitive to the musical qualities of verse . . . this virtue of poetic style, this *fundamental*" (my emphasis), Eliot introduces his oft-quoted concept of the "auditory imagination" (*Use of Poetry* 118):

> What I call the "auditory imagination" is the feeling for syllable and rhythm, penetrating far below the conscious levels of thought and feel-ing, invigorating every word; sinking to the most primitive and forgot-ten, returning to the origin and bringing something back, seeking the beginning and the end. It works through meanings, certainly, or not without meanings in the ordinary sense, and fuses the old and obliter-ated and the trite, the current, and the new and surprising, the most ancient and the most civilized mentality. (118–19)

Eliot's "auditory imagination" comprehends the totality of a poem's sound and sense and has affinities with Pater's "imaginative reason," which also seeks to account for a poem's multiplicity of resonance. In short, both conceptions allow for a poem's combined appeal to the senses and the intellect, and both suggest that poetry reaches toward the condition of music. Yet Eliot's "auditory imagination" has wider implications, espe-cially for his own poetry. It implies a timeless fusion of past, present, and future, which looks forward to *Four Quartets*, and also acknowl-edges the place of a poem's "meanings in the ordinary sense." This latter emphasis on literal meaning signals a significant divergence from Pater's aesthetic and is repeatedly stressed in Eliot's other critical writing on music and poetry.

Eliot refuses to accept a pyrotechnical display of prosodic effects as a substitute for meaning. Nor would he celebrate the highest achieve-ments of lyric poetry as those that seem "to pass for a moment into an actual strain of music" (Pater 157). Or as Harvey Gross has argued, Eliot "is not approaching the condition of music because he wishes to lose his

ideas in his form, or to create mere patterns of pleasing sounds" (278). Eliot himself insists that "the music of poetry is not something which exists apart from the meaning. Otherwise, we could have poetry of great musical beauty which made no sense, and I have never come across such poetry" (*Selected Prose* 110, hereafter *SP*).[3] Similarly, in "Ezra Pound: His Metric and Poetry," he alludes to Pater and makes the following claim: "For poetry to approach the condition of music (Pound quotes approvingly the dictum of Pater) it is not necessary that poetry should be destitute of meaning" (*To Criticize the Critic* 170). Admitting no exceptions to this view, Eliot argues that "in even the most purely incantatory poem, the dictionary meaning of words cannot be disregarded with impunity" (32).

Yet in his essay on Dante, Eliot does admit "that genuine poetry can communicate before it is understood," that there exists an "objective 'poetic emotion'" (*SP* 206). But by making such a concession, he is not suggesting that we ignore the poem's meaning. Rather, deep, passionate responses to poetry that one does not understand should precipitate only a stronger desire to seek out the full range of its literal and figurative meanings. Thus he also argues "That in good allegory, like Dante's, it is not necessary to understand the meaning first to enjoy the poetry, but that our enjoyment of the poetry makes us want to understand the meaning" (230). Moreover, if we are moved by a reading of a poem whose language is unfamiliar to us and then told that the poem is nonsensical, Eliot claims: "we shall consider that we have been deluded—this was no poem, it was merely an imitation of instrumental music" (111).

To appreciate fully Eliot's insistence that meaning not be neglected in favor of music, it is helpful to consider his inclusive vision of what constitutes the music of poetry. To begin with, he obviously includes sound clusters such as alliteration, assonance, and consonance, but at the same time reminds us that melody is but one aspect of a poem's music, and that "there are many other things to be spoken of besides the murmur of innumerable bees or the moan of doves in immemorial elms" (*SP* 112). "Dissonance, even cacophony, must have its place," he argues, and any poem of substantial length must include transitional sections between its high and low levels of diction in order to accommodate the different levels of emotional intensity that contribute to the total musical structure (112). Indeed, Eliot claims provocatively that "no poet can write a poem of amplitude unless he is a master of the prosaic" (113). A poem's amplitude also includes the literary history of its words, and this kind of allusiveness is, of course, for Eliot, a supreme aspect of the music

of poetry. He elaborates that "a 'musical' poem is a poem which has a musical pattern of sound and a musical pattern of the secondary meanings of the words which compose it, and that these two patterns are indissoluble and one" (113).[4] These attributes notwithstanding, Eliot believes "that the properties in which music concerns the poet most nearly, are the sense of rhythm and the sense of structure" (114). First, rhythm is the poet's most direct link with music because it is directly transferable from one medium to the other and not construed by analogy. Second, the structure of music provides several useful analogies for the poet's repetition and modulation of theme, phrase, and imagery:

> The use of recurrent themes is as natural to poetry as to music. There are possibilities for verse which bear some analogy to the development of a theme by different groups of instruments; there are possibilities of transitions in a poem comparable to the different movements of a symphony or a quartet; there are possibilities of contrapuntal arrangement of subject-matter. It is in the concert room, rather than in the opera house, that the germ of a poem may be quickened. (114)

These analogies reconfirm Eliot's equal preoccupation with both meaning and sound, and his view that melody is not the primary aspect of the music of poetry. What is more important is how the structure of music provides analogies that help to facilitate the expression of ideas: a poem's figurative and literal meanings. Susan Langer puts the matter well in a passage that Eliot could not help but approve: "The tension which music achieves through dissonance, and the reorientation in each new resolution to harmony, find their equivalents in the suspensions and periodic decisions of propositional sense in poetry. Literal sense, not euphony, is the 'harmonic structure' of poetry; word-melody in literature is more akin to tone-color in music" (261).

GARLIC AND SAPPHIRES

Since the melodic quality of words is not primary for Eliot, he would find Verlaine's well-known doctrine, "De la musique, avant toute chose," an egregious preference for sound over sense. In other words, euphony can never be a substitute for ideas. Yet Eliot's thoughts on the analogies music provides for the structure of poetry recall the theories of another school of symbolist poets, namely, Baudelaire and Mallarmé, who, in some ways, oppose the school of Verlaine and his successors. Baudelaire

and Mallarmé were "not after the *sounds* of music but wanted to recapture the *form* of music. . . . Verlaine, though, comprehended the musical parallel only in a very limited way: he thought of this music in terms of syllables and rhymes" (Balakian 85).

In "Richard Wagner and *Tannhauser* in Paris," Hyslop and Hyslop record how certain memorable musical passages from *Tannhauser* and *Lohengrin* suggested analogies for Baudelaire's own poetic art. He begins by noting how Wagner's music implies synaesthetic relationships much like the ones in his own famous sonnet "Correspondences." Sound suggests color, which in turn suggests melody, and together sound and color can serve as a vehicle for ideas. Consequently, he concludes that "things always [have] been expressed by a reciprocal analogy since the day when God created the world as a complex and indivisible whole" (199). Baudelaire also admires Wagner's repetition of melodic motifs. In particular, he observes that his "melodies are, in a sense, *personifications of ideas*," and that "important situations and characters are all described musically by a melody which becomes their constant symbol" (218). These insights lead him to conclude that "without poetry, Wagner's music would still be a poetic work, endowed as it is with all the qualities that constitute well made poetry; self-explanatory in that all of its elements are so well combined, united, adapted to one another, and . . . scrupulously concatenated" (218–19). Here Baudelaire's conception of Wagner's music as a "poetic work," and the obvious musical-poetic analogies that this implies, anticipates Eliot's appreciation of similar analogies in "The Music of Poetry," where he speaks of music's "use of recurrent themes . . . the development of a theme by different instruments . . . [and the] possibilities of transitions in a poem comparable to the different movements of a symphony or a quartet" (*SP* 114.) Baudelaire's perception that musical sound can set off a chain of synaesthetic associations in the auditor's imagination also implies that "words may be able to assume the same function as structured musical notes, creating beyond the description of a sensation the sensation itself, and even that complexity of sensations which we call a 'mood' " (Balakian 50). That Eliot would approve of this analogy seems clear from his remark that Baudelaire fashions imagery of the "*first intensity*—presenting it as it is, and yet making it represent something much more than itself" (*Selected Essays* 377, hereafter *SE*).

Like Baudelaire, Mallarmé was also a devotee of Wagner.[1] Indeed, Arthur Symons has argued: "Carry the theories of Mallarmé to a practical conclusion, multiply his powers in a direct ratio, and you have Wagner.

It is his failure not to be Wagner" (62). Should we doubt, however, the veracity of such a claim, we need only turn to the elevated closing of Mallarmé's own essay on Wagner, in which he all but apotheosizes the composer's achievement:

> Oh Genius . . . I suffer and reproach myself, in moments branded with weariness, because I am not among those who leave the universal pain and find lasting salvation by going directly to the house of your Art. . . . For them it is not merely the greatest journey ever conducted under the aegis of man and your leadership; it is the end of man's journey to the Ideal. May I at least have my share in this delight? And half-way up the saintly mountain may I take my rest in your Temple, Whose dome trumpets abroad the most extensive dawning of truths ever known. (78)

Wagner, who proclaims that the "most complete work of the poet should be that which in its final realization would be perfect music" (quoted in Hyslop & Hyslop 207), appears to be the chief catalyst for Mallarmé's preoccupation with music. In a letter to Paul Valéry, Mallarmé follows Wagner's lead—and here we must also recall Pater—when he says that the "perfect poem we dream of can be suggested by Music itself"- (Mallarmé 102–3). Music is thus a supreme source of inspiration, and its predominating influence in the articulation of Mallarmé's poetics engenders a complex philosophy of aesthetics—one that also extends the literary theories of Baudelaire.

Baudelaire's observation that all good art, especially "eloquent" music, is "an inexhaustible source of suggestions" (Hyslop and Hyslop 190, 197) clearly looks forward to Mallarmé's unwavering belief that the poet must always evoke but never describe. "It is not *description* which can unveil the efficacy and beauty of monuments, seas, or the human face in all their maturity and native state, but rather *evocation, allusion, suggestion*." (Mallarmé 45). The multiplicity of resonance in the symbolist image gathered through evocation allies it with the abstract suggestions of music. Accordingly, in Mallarmé's poetics, "verbalization renders vision as abstract as musical notation which makes heard sounds abstract. The purity of poetry then, is like the purity of music, in that in the successful composition the natural objects disappear into their verbal generalizations" (Balakian 88). Of course, music is an obvious model for such analogies because its syntax is not governed by stable external referents in any kind of denotative sense. That is to say, "music has all the earmarks of a true symbolism, except one: the existence of an *assigned*

connotation. It is a form that is capable of connotation, and the meanings to which it is amenable are articulations of emotive, vital, sentient experiences. But its import is never fixed" (Langer 240).

Baudelaire and Mallarmé provide Eliot with significant precedents for considering how the suggestive range of theme and mood in a musical composition suggests analogies for creating a similar range of suggestiveness in a poem. As we have seen, Eliot does think of the multiple connotations of a poem's syntax and diction as having affinities with musical sound and form. Moreover, like any good poet, he would in most instances favor evocation over mere description, but not to the extent to which Mallarmé often wishes to thwart all interpretation, or to the extent that many of Mallarmé's poems, even after decades of scholarship, are now famous for their impenetrability. Let us recall Eliot's statement that "in even the most purely incantatory poem, the dictionary meaning of words cannot be disregarded with impunity" (*To Criticize the Critic* 32). Furthermore, Eliot's poetry is concerned with ideas—seemingly polymathic in their scope—in a way that would be anathema to Mallarmé, who says: "It isn't with ideas but with words that one makes a poem" (Balakian 87). To be fair, Eliot is a poet, not a philosopher, historian, psychologist, or theologian; consequently, words will certainly take precedence over ideas, but not to the point where submerged denotative reference would create what he himself has called "the mossiness of Mallarmé" (*To Criticize the Critic* 170).

Other affinities linking Mallarmé's and Eliot's views of music and poetry need less qualification. In order to accommodate experiments with free verse and a loosening up of the alexandrine, whose dominance in French poetry is the equal of the pentameter in English poetry, Mallarmé develops an inclusive conception of verse by thinking of its various forms in terms of music. In "Crisis in Poetry," after citing several of his contemporaries' "breaking up of official verse," he enthusiastically proclaims:

> But the truly remarkable fact is this: for the first time in the literary history of any nation, along with the general and traditional great organ of orthodox verse which finds its ecstasy on an ever-ready keyboard, any poet with an individual technique and ear can build his own instrument, so long as his fluting, bowing, or drumming are accomplished— play that instrument and dedicate it, along with others, to Language. . . . Each soul is a melody; its strands must be bound up. Each poet has his flute or viol, with which to do so. (37)

This passage forms part of the immediate literary ancestry that is passed down and carried on in many of Eliot's assertions about music and verse. In spite of his well-known reservations about free verse, Eliot gives priority to the soul's individual music over any prescribed prosodic formula: "no prosodic system ever invented can teach anyone to write good English verse. It is, as Mr. Pound has so often remarked, the musical phrase that matters" (*Use of Poetry* 38). Or consider Eliot's criticism in "Reflections on *Vers Libre*" of the "erudite complexities of Swinburnian metre," and his subsequent observation that "one ceases to look for what one does not find in Swinburne; the inexplicable line with the music which can never be recaptured in other words" (*SP* 33). Moreover, it is interesting to note that Eliot pinpoints the steady increase in the use of blank verse after the romantics and Victorians as due somewhat to the English ear, which "is or (was) more sensitive to the music of the verse and less dependent upon the recurrence of identical sounds in this metre than in any other" (36).

Eliot and Mallarmé both insist that the music of poetry is not meant to be a self-indulgent ecstasy of elegant, mellifluous sounds but must chiefly derive from the lexicon of the poet's quotidian milieu. Mallarmé's claim that the poet must eschew "all virtuosity and bravado, must project his vision of the world and use the languages of the school, home, and market place which seem most fitting to that purpose" (55) is echoed by Eliot's assertion that "The music of poetry, then, must be a music latent in the common speech of its time" (*SP* 112).[6] In what seems a paradox, but one Eliot may well have agreed with, Mallarmé argues further that poetic diction grounded in the everyday world can result in rapturous flights of song: "The poetry will be lifted to some frightening, wavering, ecstatic pitch—like an orchestral wing spread wide in flight, but with its talons still rooted deep within your earth" (55).

According to Mallarmé, this "orchestral wing" of poetry must also seek to recover, or more precisely, to enact an instance of what he perceives as the unifying music of the cosmos. "For what is the magic charm of art, if not this: that, beyond the book itself, beyond the very text, it delivers up that volatile scattering which we call the Spirit, Who cares for nothing save universal musicality" (55). Here the implications of Mallarmé's reference to "Spirit" and "universal musicality" suggest some significant parallels with the musical-logocentric vision that dominates Eliot's *Four Quartets*. Before examining such parallels, however, we first need to consider how Mallarmé's symbolist poetics implies a Logos.

Mallarmé believes that poetry must seek to enact correspondences between the earthly and the divine, the latter being characterized pervasively in his writings by words such as "Idea," "Ideal," "Spirit," "Comprehension," "Truth," "Mystery," and "Word." His hieratic stance as a poet is predicated on the possibilities of creating symbols that through their multiplicity of evocation capture the essence of the "great symphony" of cosmological forces (102):

> What, then, will the work itself be? I answer: a hymn, all harmony and joy; an immaculate grouping of universal relationships come together for some miraculous and glittering occasion. Man's duty is to observe with the eyes of the divinity; for if this connection with that divinity is to be made clear, it can be expressed only by the pages of the open book in front of him. (25)

By creating such a harmonious universal hymn through "the mystery of the word, which may evoke the Word—the Logos, the poet seeks to commune with and to reveal the invisible, the infinite or the unknown" (Brée 3). In another of many effusive passages proclaiming the possibilities of achieving such an ultimate communion of the physical and the metaphysical, Mallarmé declares:

> Yes, for me the miracle occurs when, in a dream of fiction, we seize the ideal which is absent here below, yet explosively present up above, and hurl it to some forbidden, thunderbolt height of heaven. . . . I am convinced that the constant grasp and realization of this ideal constitutes our obligation to Him Who once unleashed Infinity—Whose rhythm (as our fingers longingly seek it out among the keys of our verbal instrument) can be rendered by the fitting words of our daily tongue. . . . For in truth, what is Literature if not our mind's ambition (in the form of language) to define things; to prove to the satisfaction of our soul that a natural phenomenon corresponds to our imaginative understanding of it. (Mallarmé 49–50)

Of course, the model for this expansive vision is music, which "has a similar though unexpressed ambition" (Mallarmé 49). Yet Mallarmé always reminds us that literature must be foremost, for "nothing will endure if it remains unspoken"; consequently, the poet's chief task "is to find a way of transposing the symphony to the book" (42). More important, the origins of all music can be traced to the word, whose combined

power of sound and sense can recreate the music of the spheres: "the true source of Music must not be the elemental sound of brasses, strings, or wood winds, but the intellectual and written word in all its glory—Music of perfect fullness and clarity, the totality of universal relationships" (42).

WHILE THE MUSIC LASTS

This ultimate verbal music, which becomes a metaphor for the Logos, "the totality of universal relationships," is also the music of Eliot's *Four Quartets*, albeit within a Christological teleology. All of his insights into the music of poetry we have examined thus far culminate in this work, which produces in many of its sections a profound paradoxical, logocentric vision of music and silence. Evidence of a preoccupation with a Christian Logos appears in early poems such as "Gerontion"—"The word within a word, unable to speak a word" (*CPP* 37)—and first becomes conflated with ideas of music most noticeably in *Ash-Wednesday*. In *Ash-Wednesday* III, for example, the speaker is tempted by an earthly sensuality that is made more pronounced by the music of the garden god's flute—"Distraction, music of the flute, stops and steps of the mind over the third stair"—and pauses in his climb to reiterate his unworthiness: "Lord, I am not worthy / but to speak the word only" (93). Yet toward the end of Part IV, the flute of the "garden god . . . is breathless," signifying a temporary silence of the sensual attractions of earthly life— a silence wherein we hear the redemptive song of a bird whose music is a sign of the Word, the Logos:

> But the fountain sprang up and the bird sang down
> Redeem the time, redeem the dream,
> The token of the word unheard, unspoken. (95)

The bird's song, as noted, is only a sign of the Logos, which, for the speaker at the beginning of Part V, is wrapped up in a series of elusive but increasingly familiar paradoxes and puns rung on the meanings of "word" and "Word," heard and unheard songs, light and dark, "world" and "whirled," and so on (96). The Logos is eternal, but the requisite silence and stillness—qualities informing Eliot's key references to music in *Four Quartets*—that allow us to feel its redeeming force are rarely experienced.

In the first part of "Burnt Norton," a bird's song, once again, signifies the potential for humanity's redemption that is implicit in the Logos.

In a fleeting vision that suggests aspects of our prelapsarian existence, we are told that "the bird called, in response to / The unheard music hidden in the shrubbery" (*CPP* 172). The "unheard music" echoes the "word unheard" in *Ash-Wednesday*, which is also the Word that, because of earthly preoccupations, we have so much difficulty communing with. Yet the Word is eternal, and, as the Incarnation of Christ, makes possible our redemption from time, which Eliot at this point only hints at. The hopelessness implied by the proposition "If all time is eternally present / All time is unredeemable" is subtly mitigated by the lines that closely follow: "What might have been and what has been / Point to one end, which is always present" (171).

The music of bird song as metaphor for various states of the human soul is further modulated in the third part of this poem, where it suggests the "twittering," quotidian world of distraction, a world where we are redeemed by "Neither plenitude nor vacancy" (*CPP* 174). That is, we experience neither an abundance of the divine light of love nor an abstention from earthly attachments that would leave us in "darkness to purify the soul" (173). Such salvation, particularly by way of the *via negativa*, is too often precluded by the constant, tremulous chatter of humanity (174).

This "twittering" world can, however, reach a point of stillness through art, and in the concluding section of "Burnt Norton," Eliot meditatively suggests the possibilities (*CPP* 175). Words and music move in time, but through artistic patterning both achieve the "co-existence" of motion and stillness. This paradoxical coexistence of contraries is necessary because "only through time time is conquered." When the motion of music and words constitutes a pattern, the pattern becomes in a sense immutable and so effects a victory over time. For even though a poem or symphony is performed in time and has a beginning and an end, it retains its pattern and can be performed repeatedly at will (Blamires 36). Just "as a Chinese jar still / Moves perpetually in its stillness" (*CPP* 175), the poem or musical composition then exists both in and out of time, and when not being performed exists in silence. The "co-existence" (175) of the contraries of motion and stillness is also a coexistence of the temporal and eternal, an intersection pointing to the Logos, where the word becomes the Word and all time is eternally present: "And all is always now" (175). In the lines immediately following, however, Eliot admits how difficult a task he has set for the artist. Words too often collapse "under the burden," and the Logos, "The Word in the desert / Is most attacked by voices of temptation" (175). Yet Eliot can never relinquish

this task, for, as Grover Smith reminds us, "The Word is the perfection moving the poem and the poet, too, in his own empty desert" (267). And, of course, the words of the poem are also its music, which, as in *Ash-Wednesday,* reaches into the silence, where "Still is the unspoken word, the Word unheard" (*CPP* 96).

The connection between silence and the Logos is further illuminated through music, which in "The Dry Salvages" V becomes a sweeping metaphor for the entirety of human existence and the possibility of redemption from time by Christ's Incarnation. Leading up to this vision of redemption, furthermore, is another pattern of musical imagery, namely, the sounds of different bells marking different stages of calamity and salvation. In Part I, "the ground swell, that is and was from the beginning, / Clangs / The bell" (*CPP* 185). This sound is older than human time, "Older than the time of chronometers" (185). It is the sound of time immemorial and symbolizes the vast chaotic, temporal framework of our lives, especially as it is joined in chorus by "The sea howl / And the sea yelp" (185). In Part II, there is no end to "the drifting wreckage" of our lives, and the "Clamour of the bell of the last annunciation" rings out our death (185–86). Only the "Prayer of the one Annunciation" (186), signaling the birth of Christ, offers hope beyond a seemingly endless procession of mutability and death. This movement from the annunciation of death to the annunciation of life finally culminates in a prayer to the Virgin, followed by the redemptive sound of "the sea bell's / Perpetual angelus" (189), which subsumes and silences the previous clanging notes of our calamitous lives.

The music of this "Perpetual angelus" commemorating the Annunciation anticipates the "intersection of the timeless / With time" in Part V (*CPP* 189–90). We manage, however, only the briefest distracted glimpses of such an intersection, which is properly "an occupation for the saint" (190). These moments are both in and out of time; the "wild thyme" is seen and not seen; music heard and not heard, or "heard so deeply" that it overruns and subdues personal being. In these lines, silence and the Logos are further conjoined through music. In short, music is a metaphor for both word ("heard") and Word ("not heard").

To hear music "so deeply / That it is not heard at all" signals an apprehension of the Logos, the Word expressed through Christ's Incarnation, which, of course, cannot actually be heard but only experienced in heightened states of consciousness. Moreover, for most of civilization these heightened moments are "only hints and guesses" as to the intersection of time and timelessness represented by the Incarnation. Here a

fusion of modalities of existence, which is otherwise "impossible," becomes "actual," conquering and reconciling "the past and future" (*CPP* 190). This connection between silence and the Logos appears to extend in a Christian context symbolist ideas that Mallarmé had already forged in his essay "Music and Literature." Having taken great pains to evoke the abstracted essence of an object, the poet, according to Mallarmé, may find that "the melodic line has given way to silence" wherein is revealed the true music of being, the "very logic and substance of our soul" (Mallarmé 49). He then adds that this poetic process is an immense labor, which never quite reaches the logocentric threshold: "the omnipresent line which runs infinitely from point to point in Its creation of idea—creation unseen by man, mysterious, like some Harmony of perfect purity" (49). Nevertheless, he does remind us that "the constant grasp and realization of this ideal constitutes our Obligation to Him who once unleashed Infinity—Whose rhythm (as our fingers longingly seek it out among the keys of our verbal instrument) can be rendered by the fitting words of our daily tongue" (49). Mallarmé's association of silence with a "Harmony of perfect purity" brings to mind the music of the spheres—a music too perfect to be audible to human ears, and one that is akin to Eliot's conception of unheard music as superior. Keith Alldritt has argued:

> In "Dry Salvages" as in "Burnt Norton" full consciousness is defined as a musical condition. . . . The related concepts of language as music and of music as something which is truly unheard are both hallmarks of symbolism and of the metaphysical tradition from which it derives. 'Mallarmé, who could have subscribed to Plato's aphorism, repeated by Pater that "all art aspires to the condition of music" rediscovers for himself the Platonic and Pythagorean conception that the universe is musically constructed, and the human soul, which is similarly formed, cannot hear through the sensorial apparatus of the body the celestial music of its source. Therefore heard music is inferior to unheard music which is the true wisdom of Plato.' (120–21)[7]

Eliot's unheard music in "The Dry Salvages" also has numerous implications for the process of art. First, music heard at the deepest level is unheard because the auditor and the music are one. This is the ultimate absorption wherein the auditor is no longer aware of listening but has become a conduit for sound, which is now unheard because it is inseparable

from being. In other words, lacking any separation between auditor and sound, music is part of our ontology and can no longer be heard as something outside of ourselves. Neither can it be heard as something within, for this would require a consciousness of hearing that is only possible if music and auditor are not perfectly conjoined. Moments like this are extremely rare, even for the professional musician. They are attained only when performers, having reached the peak of their abilities, are no longer aware of trying to make music because the music, as it were, is playing them.[8] While it lasts, music becomes an inclusive metaphor for the human horizon. Consequently, in terms of art, all of our vocables, all soundings of ourselves in whatever patterns they coalesce, are kinds of music. And the oneness, the stillness, the silence—which are made possible through artistic form—are equally available not just to the maker but also to the listener, reader, and observer.

In "Little Gidding," this stillness—the moment in and out of time—is presented as a dance. This is the final modulation of Eliot's use of music as metaphor presented within the self-reflexive context of the artistic process. The ghost of Dante tells the speaker-poet that the "gifts reserved for age / To set a crown upon your lifetime's effort" (*CPP* 194) bring nothing but spiritual exasperation, unless cleansed from wrong by measured movement ("like a dancer") in purgatorial fire (195). To move in measure implies both progression in musical time and expression of one's thoughts in verse, the patterning of which is then compared to the movements of a dancer. Moreover, as words and music move in patterns reaching toward silence and stillness, so do the movements of the dancer in the refining fire. For example, behind this vision we feel the contextual pressure of earlier meditations on the dance as an emblem of motion and stillness in "East Coker" and in "Burnt Norton." In "East Coker" III, the speaker proclaims "So the darkness shall be the light, and the stillness the dancing" (180); and in "Burnt Norton" II, we are told that "At the still point of the turning world . . . there the dance is" (173). The related concepts of music, words, and dance are integrated in a final modulation in the last section of "Little Gidding," where Eliot envisions the best words in the best order as the "complete consort dancing together" (197).

Here we are plunged back into the realm of aesthetics, where Eliot offers a more elaborate vision of Mallarmé's call "To purify the dialect of the tribe" (*CPP* 194). This emphasis is entirely appropriate, for it reminds us that through the perfection of the aesthetic, the word becomes the Word, the music in and out of time. The way up is the way down, and

we must take our cues from what is before us, must make our art out of the world in which we live. And now "the complete consort" gathers in its culminating rhythms Eliot's ruminations on poetry and music. It implies the aesthetic affinities shared with Pater, Baudelaire, and Mallarmé, and the appropriation of them to his own poetics. The music of poetry as a dance is thus a signature metaphor incorporating motion and pattern, the paradoxical simultaneity of movement and stillness, beginning and end.

NOTES

1. Aristotle, *Poetics,* trans. S. H. Butcher; *Criticism: The Four Major Texts*, ed. W. J. Bate, 25, argues that "the plot, being the imitation of an action, must imitate one action and that a whole, the structural union of the parts being such that, if any one of them is displaced or removed, the whole will be disjointed and disturbed. For a thing whose presence or absence makes no visible difference, is not an organic part of the whole."

2. Here, though, we should recall, as other critics have done, that Peter is not implying the superiority of musical art, but arguing that music easily collapses the boundaries of form and content because its form is not burdened with denotative reference. For example, Susanne Langer states that Pater's view of music as a model for other art forms "does not mean, however, that music achieves the aim of artistic expression more fully than other arts. An ideal condition is its asset, not a supreme attainment. . . . Its artistic mission is more visible because it is not obscured by meanings belonging to the represented object rather than to the form that is made in its image. But the artistic *import* of a musical composition is not therefore greater or more perfectly formulated than that of a picture, a poem, or any other work that approaches perfection as closely after its kind" (257).

3. In this passage, Eliot further supports this assertion by noting that "The apparent exceptions only show a difference of degree; there are poems in which we are moved by the music and take the sense for granted, just as there are poems in which we attend to the sense and are moved by the music without noticing it" (110).

4. We should note that this indivisible patterning recalls Pater's seamless match of form and content that makes music the most desirable model to which all arts aspire.

5. It is well documented that despite his great interest in Wagner, Mallarmé "had never seen a Wagnerian performance, as had Baudelaire, whose enthusiasm he accepted as a legacy" (Balakian 87).

6. Here we must also acknowledge the influence of Laforgue, who Eliot says "was the first to teach me how to speak, to teach me the poetic possibilities of my own idiom of speech" (*To Criticize the Critic* 126).

7. Alldritt quotes from Joseph Chiari's *Symbolism.*

8. This interpretation is partly based on my own practice as a professional musician for twenty-five years. What I have said about absorption to the point where performer is played by the music is actually a commonplace idea confirmed by countless comparisons of other musicians' experiences of rare musical moments.

WORKS CITED

Alldritt, Keith. *Eliot's "Four Quartets": Poetry As Chamber Music.* London: Woburn Press, 1978.

Balakian, Anna. *The Symbolist Movement: A Critical Appraisal.* New York: New York University Press, 1977.

Bate, W. J., ed. *Criticism: The Four Major Texts.* New York: Harcourt, Brace, Jovanovich, 1970.

Blamires, Harry. *Word Unheard: A Guide through Eliot's "Four Quartets."* London: Methuen, 1969.

Brée, Germaine. Preface. *Four French Symbolist Poets: Baudelaire, Rimbaud, Verlaine, Mallarmé.* Trans. Enid Rhodes Peschel. Athens, OH:: Ohio University Press, 1981.

Eliot, T. S. *The Complete Poems and Plays.* 1969. London: Faber & Faber, 1985.

———. *Selected Essays.* New York: Harcourt, Brace & World, 1950.

———. *Selected Prose of T. S. Eliot.* Ed. Frank Kermode. London: Faber & Faber, 1975.

———. *To Criticize the Critic.* New York: Farrar, Straus, & Giroux, 1965.

———. *The Use of Poetry and the Use of Criticism.* 1933. London: Faber & Faber, 1987.

Frye, Northrop. *T. S. Eliot: An Introduction.* Chicago: University of Chicago Press, 1981.

Gross, Harvey. "Music and the Analogue of Feeling: Notes on Eliot and Beethoven." *The Centennial Review* 3 (1959): 269–88.

Hyslop, Lois Boe, and Francis E. Hyslop Jr., eds. and trans. *Baudelaire: As a Literary Critic.* Pennsylvania: University of Pennsylvania Press, 1964.

Langer, Susan. *Philosophy in a New Key: A Study in the Symbolism of Reason, Rite, and Art.* Cambridge: Harvard University Press, 1969.

Mallarmé, Stéphane. *Selected Prose Poems, Essays, and Letters*. Trans. Bradford Cook. Baltimore: Johns Hopkins University Press, 1956.

Pater, Walter. *Walter Pater: Three Major Texts*. Ed. William E. Buckler. New York: New York University Press, 1986.

Smith, Grover. *T. S. Eliot's Poetry and Plays: A Study in Sources and Meaning*. Chicago: University of Chicago Press, 1956.

Symons, Arthur. *The Symbolist Movement in Literature*. New York: Dutton, 1958.

Eliot and the Composers

The Pattern from the Palimpsest
Convergences of Eliot, Tippett, and Shakespeare

SUZANNE ROBINSON

> *Enter Ariel, invisible, playing solemn music.*
> —*THE TEMPEST,* II, i

ELIOT, TIPPETT, AND SHAKESPEARE

On several occasions the English composer Michael Tippett (1905–98) has provided an account of the circumstances of his first meeting with T. S. Eliot.[1] To the best of his memory it took place some time between 1936 and 1938, but one of those who facilitated the introduction recalls it more precisely as the summer of 1935. In that year Tippett was aged thirty, and although he had not yet published a work, several of his early compositions had been performed in amateur forums. Subscribing to left-wing political views, he read Marx and Trotsky and temporarily enlisted with the British Communist Party. At some point in the early 1930s, through the agency of his friend David Ayerst, he met the precocious, young Wystan Auden. Tippett was interested in poetry, while one of Auden's passions was playing Bach's preludes and fugues on the piano. Their meeting took place shortly before the inception of the Group Theatre, for which Auden wrote several avant-garde verse dramas. His first, *The Dance of Death* (1933), required music, and Auden proposed that his new discovery and protégé, Tippett, become the group's composer. The proposal was rejected (Tippett was found to be too "grave"), and although no bitterness was harbored on either side, the rejection forestalled any further collaboration between them.[2]

In 1935, however, Auden volunteered Tippett to teach piano to the son of Frank Morley, one of the directors of Faber.[3] Eliot was at this time an employee of Faber and friend of the Morley family. He frequently stayed at the Morleys' country house, a retreat from troubles associated

with the dissolution of his first marriage. On one of his piano-teaching visits Tippett remembers glimpsing Eliot "mooching" among the currant bushes.[4] Introductions were inevitably effected. Discussions about art took place in the Morley household over games of Monopoly, and subsequently adjourned to Eliot's London office.[5] There Tippett took tea proffered in the ritualistic manner described by other young acolytes.[6] Tippett recalls that these meetings continued throughout the war, but that they rarely met after 1945.[7] He comments in his autobiography: "I knew Eliot very well, and knew him particularly at the time he was writing the plays. I met him first just as he was about to do 'Murder in the Cathedral,' saw all of them as they came out, and talked to him at great length about the problems of mixed art—which of course opera is. He helped me an enormous amount to see how music upon music must be the absolute centre of the opera."[8] As Tippett indicates, the date of their initial meeting coincided with the commencement of Eliot's career as a verse dramatist.

Eliot's first verse drama, *Sweeney Agonistes*, was produced by the Group Theatre in 1934 and 1935, while his first popular success, *Murder in the Cathedral*, was first performed in June 1935. In his essay "John Marston" (1934), Eliot adumbrated a method for verse drama that would be distinguished by "a kind of doubleness in the action, as if it took place on two planes at once."[9] He followed this comment with a number of essays on the nexus of poetry and drama, including "The Need for Poetic Drama" (1936) and two lectures on "The Development of Shakespeare's Verse," presented in 1937. Alongside these activities, in 1934 he visited the garden at Burnt Norton which inspired the first of *Four Quartets* (1935), a poem that includes more references to music than any other.[10]

As mentor and oracle to young modernist poets Eliot assessed their work and in many instances recommended publication. In Tippett's case, he encouraged the composer to read the poetry of Valéry, Baudelaire, and Yeats, the plays of Shakespeare, Racine, Yeats, and the ancient Greeks, and to absorb the implications for modern art of the anthropological tomes of Frazer, Harrison, and Cornford. Tippett developed a "profound love" of Yeats's work and a conceptualization of ancient myth that has since saturated his dramatic work.[11] He became immersed in discussions of "poetry and belief" and the response of the artist to contemporary society. In one of his most important essays, written in 1953, Tippett discussed *The Family Reunion* and testified that "Mr Eliot is more acutely aware than anyone else in this country, perhaps indeed in all Europe, of all the considerations I have been trying to set out: the general spiritual

impoverishment of our life; the problem of a dismembered Christianity; the problem of transcendent experience per se; the problem of poetry and belief; the special problem of poetry in the theatre."[12] Tippett has acknowledged on many occasions that Eliot was not only an artistic but also a spiritual mentor.[13] Eliot's own spiritual quest had encompassed Christian mysticism, Eastern philosophy, and the psychology of religion. Since his conversion to Christianity and entry into the Church of England in 1927, his writings had adopted the themes and conditions of his faith. This placed him in an antagonistic position in relation to those he mentored. "The era of Joyce," he wrote in 1935, "is of those who have never heard the Christian Faith spoken of as anything but an anachronism."[14] While not averse to plundering its symbols, Tippett eschewed the dogma of Christianity, which he believed was irredeemably tied to Western puritanism. Nonetheless, he allowed the possibility of a more universal religion or of spiritual experience. He developed an artistic credo that stated "that the faculty the artist may sometimes have to create images through which these mysterious depths of our beings speak to us . . . I believe it is part of what we mean by having knowledge of God."[15] Tippett upheld his own spiritual experiences to be as valid as Eliot's, even if he could acknowledge that the latter would reject them as theologically false.[16]

Tippett may have been dismissive of Eliot's Christian and Catholic orthodoxy, but he was enlightened by his example nonetheless. Despite his radical political leanings and the skepticism of friends, Tippett was intrinsically catholic in his intellectual tastes. In the 1930s he investigated psychology in the hope of better understanding his own homosexuality and from the later years of the decade assiduously notated and analyzed his dreams in Jungian terms.[17] In 1935 he wrote an agitprop play and attached a foreword that, while displaying a ruddy complexion of anticapitalist rhetoric, demonstrates evidence of the quest for a creed more than a political affiliation.[18]

It was surely inevitable that Tippett would invite Eliot to collaborate on a composition. The invitation was made, and refused on a matter of principle. Tippett had devised a plan for an oratorio dramatizing in symbolic terms the current racial and political tensions in Europe. Eliot may have recoiled from the antiwar sentiments but conveyed to Tippett his conviction that in the musical work poetry should be subordinate to music, and that his poetry would obscure the effectiveness and purpose of music.[19] There may have been other reasons for Eliot's refusal; some twenty years later, in spite of considerable financial incentive and

entreaties from one of the century's finest composers, Eliot admitted himself incapable of fathoming the process of musical composition. He wrote to Stravinsky:

> I am more than doubtful of my own qualifications of such a task. I have had no formal musical education, or I should say my education in performance on the piano was begun at the age of ten and ended at the age of twelve. At the age of twelve I could, to some extent, read music, or at least render simple pieces as Schubert's Serenade with the aid of the musical score. This knowledge has completely vanished. I am now unable to read a note, and it seems to me that some proficiency in music is the necessary part of the equipment of a librettist.[20]

These factors did not apparently limit Eliot's contribution to the work by Tippett that was to become *A Child of Our Time* (1941). Eliot instructed Tippett to use "simple Biblical" phrases to aid comprehension. In a gesture of homage to *The Waste Land*, Tippett composed a text that is a web of literary and mythical allusion. The hero is martyred—a direct reference to the death of Christ (and Becket)—as scapegoat for the transgressions of humankind. Thus Tippett drew a symbolic line backward in time to the biblical story and thence to the ancient myths of death and rebirth.

Once Tippett could accept the potency of Christian symbolism, he came to understand, additionally, the potentiality of Eliot's interpretation of "music." The point of confluence of their spiritual values lies in their understanding of the condition of music or, more accurately, Tippett's interpretation of Eliot's understanding of the condition of music. Eliot's appreciation of music was possibly enhanced, rather than hindered, by his lack of technical knowledge or experience in the practice of music. Music, in an abstract sense, represents the ephemeral and the unknowable. It is well known that *Four Quartets* was inspired by the absolute music of Beethoven's string quartets. When Eliot told Stephen Spender of his admiration, he described an atmosphere of "heavenly or at least more than human gaiety" and "the fruit of reconciliation and relief after immense suffering."[21] Eliot told Tippett that he was impressed by Beethoven's freedom of invention. Tippett, by inference, concluded that Eliot believed he possessed a similar ability.[22]

Achieving a music of poetry was the tacit ambition of Eliot's poetry and verse dramas. He described the musical poem as one "which has a musical pattern of sound and a musical pattern of the secondary meaning of the words which compose it, and . . . these two patterns are indissoluble

and one."[23] These twin ideals of musical sound and pattern have prompted inexhaustible deliberations by Tippett.[24] The conduit of Tippett's comprehension of Eliot's definition of music was the latter's gloss on the late plays of Shakespeare. A "music of poetry" seems to have been intertwined in Eliot's mind with a "submarine music" in these plays.[25]

According to Charles Warren in his book on Eliot and Shakespeare, when in the late 1920s Eliot was reappraising Shakespeare, he became "obsessed" with the music of poetry.[26] In 1929 Eliot commended G. Wilson Knight for his "Myth and Miracle: An Essay on the Mystic Symbolism of Shakespeare" and in the following year wrote the introduction to Knight's study of Shakespeare's plays, *The Wheel of Fire*. Knight's presiding theory was that Shakespeare's last plays represented an unprecedented commentary on the mystery of death and rebirth, of "loss in tempest and revival to the sounds of music."[27] Knight commented on the conjoining of music and mystic symbolism, citing examples in Shakespeare's plays in which resurrections and reunions take place to the accompaniment of ceremony and music. It was the "paradisial radiance" in *Pericles*, which he regarded as "a perfect commentary on those Shakespearean meanings which I had unveiled."[28] In the minds of Knight and Eliot the most outstanding recognition scene in all of Shakespeare's works was that of *Pericles*, in which Marina, the lost daughter, is restored to her father. Shakespeare summoned the music of the spheres to endow the scene with a supernatural effect:

PERICLES: O heavens bless my girl.
 [Music plays]
 But hark what music? Tell Hellicanus, my Marina,
 Tell him o'er point by point, for yet he seems to dote,
 How sure you are my daughter—but what music?

HELLICANUS: My lord, I hear none.

PERICLES: None? The music of the spheres! List, my Marina.

LYSIMACHUS: It is not good to cross him, give him way.

PERICLES: Rarest sounds, do ye not hear?

LYSIMACHUS: Music my lord? I hear.

PERICLES: Most heavenly music!
 It nips me into listening, and thick slumber
 Hangs upon mine eyes; let me rest. [Sleeps]
 (V, i, 215–26)[29]

In this music Eliot perceived Shakespeare seeing "through the dramatic action of men into a spiritual action which transcends it."[30] It was to the music of *Pericles* that he referred in composing his poem *Marina* (1930), with its synesthesia of "scent of pine and the woodthrush singing through the fog."[31]

Knight's concomitant proposition in regard to these plays is that "Shakespeare's autonomous poetry corroborates the death-conquest announced by Christianity," a slant on the works that Eliot applauded in his introduction to Knight's book.[32] Of all Shakespeare's plays, Knight ordained *The Tempest* as "the most perfect work of art and the most crystal act of mystic vision in our literature."[33] The restoration of relationships in that play has a sacred dimension: music reaches beyond character and beyond reality to a heavenly fount of forgiveness and reconciliation. After the shipwreck the victims miraculously survive, with

> Not a hair perish'd;
> On their sustaining garments not a blemish,
> But fresher than before
> > (I, ii, 217–19)[34]

The "twangling" music of Prospero's island is the unparalleled representation of the marriage of "art" and the mystic vision as described by Knight.

Still evaluating Knight's ideas in 1937, Eliot delivered two lectures on "Shakespeare As Poet and Dramatist" at Edinburgh University.[35] The prominent references to music in these discussions are worthy of close reading, given the coincidence of their date and Eliot's meetings with Tippett, as well as Tippett's subsequent comments on them. The lectures have never been published in full. In 1951 Eliot published "Poetry and Drama," which transcribes certain passages, and he did refer to the talks again in the preface to *On Poetry and Poets* (1957). There he discarded them, unconvincingly, as "badly written."[36] On the contrary, they illuminate Eliot's perceptions of relations between music, poetry, and drama in a more candid manner than perhaps he was willing to allow.

Eliot began the essays by attempting to clarify whether Shakespeare's most popular play, *Hamlet*, is necessarily the greatest. On the subject of greatness, Eliot determined that

> in a great verse play of Shakespeare, there are, it seems to me, two patterns which can be distinguished but not divided: the dramatic and the

musical. One must be careful not to take this terms [*sic*] "musical," too literally. I am not comparing dramatic poetry to opera. I mean that it is something over and above plot, development of character, and conflict of character: a pattern of action in which the characters know or know they feel.[37]

The dramatic pattern is the surface design at the level of plot and character; the musical pattern is hidden from the characters themselves, becoming perceptible as the playwright speaks through the individual characters. This Eliot described as speaking "not out of character, but *beyond* character" (my italics). In these instances the audience is "lifted to another plane of reality," and—here is the definition of the musical pattern—"a hidden and mysterious pattern of reality appears as from a palimpsest."[38] Eliot recognized that Shakespeare demonstrated in these plays an ability to transcend the details of ordinary life in order to realize a dimension that, as he noted elsewhere, we see only out of the corner of the eye, or while drowsing in sunlight. The very substantial achievement of Shakespeare, in Eliot's mind, was "to see *through* the ordinary classified emotion of our active life into a world of emotion and feeling beyond, of which I am not ordinarily aware." Shakespeare's genius lay in his perception of humanity and such skill as to have unveiled "these strange lands of more than natural darkness and more than solar light."[39]

In his second essay on Shakespeare Eliot turned to an analysis of the opening scene of *Hamlet* and to the musical sound of poetry. Eliot later adapted this analysis for "Poetry and Drama," a version that was seen and analyzed in turn by Tippett. The character of Hamlet, according to Eliot, was a role in which every man could envisage himself. He commented on the simple and colloquial idiom of the first twenty-two lines of the play, drawing on musical terminology—"staccato," "rhythm," and "slower movement"—to elucidate Shakespeare's method. Eliot referred again to the musical pattern when comparing the simplicity of those lines with an increased intensity in subsequent lines. In his analysis, the transparently simple line, "So have I heard and do in part believe it" (I, i, 166), contrasts with the increased poeticism of the two that follow: "But, look, the morn, in russet mantle clad, / Walks o'er the dew of yon high eastern hill." Horatio's lyricism illuminates an instance of what Eliot theorized as "beyond character," the drama being metamorphosed from one of "ordinary classified emotions" into a "world of emotions and feeling beyond."[40] In these few lines Eliot exemplified the synthesis of the musical sound and the musical pattern.

Two years after the publication of "Poetry and Drama," Tippett published an essay on the seventeenth-century English composer Henry Purcell that, parenthetically, addressed Eliot's remarks in "Poetry and Drama."[41] Tippett latched onto Eliot's use of musical terminology in his discussion of *Hamlet*, noticing vocabulary that was more appropriate to a discussion of opera than of poetry. He alighted on the remark that "this is great poetry, and it is dramatic; but besides being poetic and dramatic it is something more," responding that "it is verse-drama. It is opera!" Tippett was enchanted by Eliot's reading of *Pericles*, classing the recognition scene as an ideal situation for opera. Where Eliot had sensed the momentary emergence of poetic consciousness, Tippett excitedly imagined that "a scena in recitativo strumentato goes over for a moment into arioso." Both Eliot's designations of musical sound and musical meaning could be conveyed, in Tippett's view, by the music of instruments and voices: "Eliot's point is that only a master like Shakespeare can so correlate the pattern of the drama with the pattern of the music of poetry that they are indistinguishable; and so create that something extra, which, if taken into music-drama, we call great opera."[42]

In 1962, while composing his most mystical work, *The Vision of Saint Augustine* (1965), Tippett was invited to compose instrumental music for a performance of *The Tempest* at the Old Vic in London. This provided him with the opportunity to refamiliarize himself with one of Shakespeare's last plays and revive his interest in Eliot's theories. He rediscovered the timelessness of Shakespeare, as apposite he believed as was the *Iliad* to the Greeks: Shakespeare is "absolutely universal . . . he's a sort of enormous cauldron which we pour things into and take things out of."[43]

Tippett inherited Knight's ideas as interpreted and translated by Eliot. In reassessing the pattern of the drama of *The Tempest*, however, the source he has acknowledged is not Knight but Robert Grams Hunter's *Shakespeare and the Comedy of Forgiveness* (1965).[44] Although Hunter builds on the work of Knight, the remarkable difference between the two lies in the significance accorded music: Grams Hunter confines his discussion to the two songs, while Knight presents both "miracle and music" as themes.[45] That Tippett arrived at an understanding of the play's "musical pattern" must be credited to his recollections of discussions with Eliot and, it might be assumed, unacknowledged reading.

Hunter outlines two redemptive plots in *The Tempest*. One concerns the regeneration of Alonso and the other the love of Ferdinand and Miranda. Christian symbolism is apparent when those shipwrecked

reappear unscathed, and the sailors are banished as Christ to the wilderness. Ferdinand is believed dead and is then "resurrected." While Alonso believed Prospero murdered, Prospero in turn "murdered" Ferdinand, yet these sins of the fathers are cleansed by the resurrection of the son. Broken relationships are given new life with the healing symbolized by the marriage of Miranda and Ferdinand. Reunion and resurrection are celebrated in a communion feast and in Ariel's songs of love and death.

Tippett's rereading of Shakespeare led directly to *The Knot Garden* (1970), an opera composed over a residual palimpsest of *The Tempest*. The opera is not a dramatization of the play or even a modernization of it. Tippett's act of reinterpretation imitates Shakespeare's own. Knight summarized this act in relation to *Pericles*, which is "the work of Shakespeare grafted on to an earlier play of different authorship, of which signs are apparent in some of the early scenes."[46] The more immediate impetus for this process of grafting was Eliot's *The Cocktail Party* (1949), which itself, as has been widely analyzed, is written with an underlying pattern derived from Euripides' *Alcestis*.[47]

Tippett has claimed that he liked *The Cocktail Party* the least of all Eliot's plays, and yet it is the play that is closest to the opera in plot and in the "musical pattern of the action."[48] Both *The Knot Garden* and *The Cocktail Party* are set in the present but with resonances "below the level of plot and character," revealing a pattern of death and rebirth. Music, in both instances, is essential to this design. In the early days of the opera's gestation Tippett wrote that he conceived "music" and "tempest" as polarities—"the Shakespearean idea of 'music' counter-poised to 'tempest'—or the sea in destructive action."[49] The tempest is the manifestation of the soul's disorder and the mind's disease, while music is the signifier of the harmony of the spheres and of body and soul. Shakespeare's pattern of "loss in tempest and revival to the sounds of music" is translated to the opera medium in verification of its universality.

THE TEMPEST: DISCORD

At its most superficial level, *The Knot Garden* follows Eliot's directive that comedy should have "an imbroglio of human confusion to be cheerfully cleared up."[50] Seven characters (the number in *The Cocktail Party*) gather in a suburban garden.[51] Some are related—Thea and Denise are sisters, Thea is married to Faber, and they have a ward, Flora. For them, the garden is their habitat, although Denise has been absent, fighting in a war for freedom and justice. The remaining characters have no apparent

connection to the garden or its inhabitants. The homosexual lovers, Dov and Mel, may be American, or at least foreign.

Mangus is an enigmatic figure, powerful yet distant from those around him. He is the architect of the tempest, depicted at the opening of the opera as a music that whizzes to a raucous climax and then subsides. In keeping with what Tippett refers to as "some strange magic," strangeness is apparent here in the employment of a music that defies the laws of harmony.[52] It is based on a twelve-note row—each pitch heard in strict order and without repetition—so avoiding the characteristics of melody. Any semblance of continuity in this string of pitches is broken by rests, by varying duration, disjunct shape, and the coloring of unusual instrumentation and use of glissandi. Mangus is also director of the psychological drama of attraction and repulsion that unfolds as the characters are required to act out scenes and songs purloined from Shakespeare, Eliot, Edward Albee, and Lewis Carroll. Further indications of disharmony will be apparent when characters are obliged to shout, scream, howl like a dog, mimic American accents, and speak in an exaggerated drawl. But the apogee of the tempest action is the staging in Act III of four charades derived from Shakespeare's *The Tempest*. The role play, in contemporary terms, is the equivalent of psychosexual therapy.

Tippett deliberated on several titles using the word *garden*.[53] The knot garden of the title is, like its Elizabethan namesakes, a contrivance that can be reshaped and rehewn at the whim of its designer. A "knot" alludes to something that is tied and yet can be untied, whether emotional (Ferdinand's "sad knot") or physiological (Miranda's "virgin knot").[54] In the opera these knots are psychological, apparent as shades of sexual entanglement are explored.

Tippett indicates at the outset that the scene, whether labyrinth or rose garden, changes with the inner situations. If the garden were ever finally visible, it might be a high-walled house garden shutting out an industrial city. The irreconcilability of the garden and the city (by implication, past and present) is epitomized in the troubled marriage relationship of Thea and Faber. Thea is ancient Earth Mother who takes refuge in her garden. Her music is a subdued and gentle rocking motif, heard in the "dark" instruments of horns and lower strings. Tippett hints that the garden may be Persian in origin, traditionally the meeting place of lovers. Indeed, Thea's garden is the sanctuary of memory. Like that in "Burnt Norton," it can be fragrant with the smell of roses, dappled with water and sunlight. When Thea moves to gather roses to arrange in a bowl, the

allusion to the dust on the bowl of rose leaves of "Burnt Norton," and to lost love, is palpable and almost certainly intentional.[55]

Flora, Thea's ward, is given a picturesque and archetypal name that locates and confines her in this garden. She is a flower, "a seedling / Waiting to transplant; Bud not flower." She is the innocent child of a pre-lapsarian world, one who imitates the eponymous character of *Alice in Wonderland* and yet approaches womanhood. Alice too had a vision of a garden: "she knelt down and looked along the passage into the loveliest garden you ever saw. How she longed to get out of that dark hall and wander about among those beds of bright flowers and those cool fountains."[56] Flora's name denotes her virginity and the potential for "deflowering." From her arrival in the garden it is obvious that she is fearful, her music simply an inarticulate, chromatic shiver to the sound of "Ah". It transpires that her fears are focused on Faber, and the meaning of Faber's command to her, to "Give me those flowers," is explicitly sexual.

By contrast to Thea and Flora, Faber (his name means "maker") belongs to the mechanistic world of the modern factory. He speaks in a brutal vernacular, referring to his wife as a "mother bitch" and demanding of one character, "Who in hell are you?" Faber's music is "jaunty," brittle, and antagonistic in jagged rhythms and accentuated chords. Even more redolent of a corrupted world is the character of Denise. She is visibly the victim of horrific torture. As Tippett envisaged: "I gave her a French name—like St. Denys, but then the feminine form . . . [she] is a freedom fighter, a woman of great moral purity and integrity, who went through the torture chambers as a lot of French women did."[57] No specific reference to Nazi atrocities is made in the opera, and Denise's afflictions might be viewed as having been sustained in any modern guerilla war. Her scars have psychological as well as physical pathology, disrupting her relationships with lovers and family, including Thea. Denise's aria, the longest of the opera, is highly virtuosic in its rapid shifts of articulation, dynamic nuance, and vocal range. At its center this aria requires piercing screams as a shocking revelation of her level of distress.

Dov, Mel, and Denise are visitors to Thea's garden. Dov, an American musician, is named after the biblical psalmist David and, as a homosexual, in recognition of David's love for Jonathan.[58] Dov belongs in the Californian city: in Act II he sings of his origins in a landscape of sky-scrapers and palm trees. He uses the language and instrumentation of the ghetto—"play it cool, play it cool"—to the sound of electric guitar and vibraphone. Together, Dov and his black partner, Mel, are associated

with a cacophony of percussion, plucked double bass, and jazz kit emblematic of urban America. They collaborate with Flora in a scene from *Alice in Wonderland*, playing Tweedledum and Tweedledee to her Alice. The relevance of that action is disclosed when in the course of the opera Dov gains some glimpse of the dreamworld of the garden, "the enclosing walls, the fountain, the girl, the lover, the music." But a shadow enters, an allusion to the words of "Burnt Norton," in which "a cloud passed, and the pool was empty."[59]

Mangus as Prospero is the ruler of this knot garden and sole instigator of supernatural events. He acts as magus, dominating and manipulating the characters at will. Superficially, his role corresponds to that of Sir Henry Harcourt-Reilly from *The Cocktail Party*, the reference reinforced when at the opening of the opera Mangus is seen reclining on a couch. As incongruous as the sight of Reilly lying on his own couch, the scene demonstrates that Mangus is a psychiatrist or, in Tippett's terminology, an "analyst."[60] Mangus then announces himself as a Prospero, and his magical powers are soon manifest in his ability to conjure gardening implements from the air. Mangus's magic is not, however, wielded to as beneficent an end as that of Prospero. His "therapy" inflicts physical pain (Thea gets to horsewhip Faber) and emotional distress on participants and observers. It cannot be said that they surface from "shipwreck" with "not a hair perish'd." The miracles of Shakespeare's drama are deliberately being questioned by Tippett.

THE MAZE

In Act I of the opera Tippett establishes the degree of disharmony among characters, while Mangus decrees the initiation of "Plays within the play." The ritualistic nature of this playing is denoted by a cocktail libation, a replication of the libation scene in *The Cocktail Party*. Tippett recalled that after seeing the play staged, "I didn't realise what the visual element would be, and particularly not the importance of the cocktail glasses. Now this was marvellous in the production I saw where the cocktail glasses, which are lifted first only for the cocktail party, are eventually lifted as libations, and as to the glory of God, or whatever. Now this I have always remembered."[61] Thea (momentarily playing the role of Circe) delivers a tray of cocktails to Mangus's conspirators, Dov, Mel, and Flora.[62] As the stage direction indicates, they "survey each other as in a ritual dance." As if the scene were not strange enough, Tippett adds music that freezes the action, a haze of pianissimo strings, cymbal

trills, piccolos, and muted brass. The erstwhile hint of mysterious and implausible events is confirmed when Dov begins to howl like a dog, "Bow-wow. Ow, ow, ow."

The accumulation of bizarre scenes and actions in this act is ostensibly bewildering (and certainly flummoxed one reviewer, who complained of "the homosexual in pink socks and suede shoes, plus the wife who takes a whip to her husband").[63] These details are no more perplexing, and no less significant, than the incomprehensible asides of *The Cocktail Party*. Tales of Lady Klootz and the wedding cake appear there to be as trivial as the list of ingredients of Alex's cooking (curry powder, mangoes, and eggs, to which he adds prunes and alcohol). Yet Tippett was well aware of the method in Eliot's apparent madness. He attributed the complex of inconsistent and bizarre detail in *The Cocktail Party* to "games" or role-plays of self-discovery.[64] Indeed, an early draft of the play required the characters to imagine themselves in roles for a film about a country-house murder.[65] In the final version four of the characters love or have loved one another and participate in a sequence of duets that analyzes these relationships. In corroboration, Tippett also recalled Mozart's *Cosi fan tutte* and Shaw's *Heartbreak House*, in which each character seems to fall in love with all the others. He judged that in the play there is "very little story-line or pure dramatic situation, and the action of the play is only ended when all the possible cross-relationships are exhausted and all the games with one another played."[66]

The staging of the opera's cross-relationships begins in earnest in Act II, the "Labyrinth" of the opera. With the garden now a maze, or the knot garden of the title, it continually shifts and spins. Confusion is wreaked upon the characters as they are blown about by some unseen force. The music describes this force in several bars of "Whirl," an artifice always presented in conjunction with the music denoting the tempest. It is described by Tippett as "non-music," being essentially a texture with an immutable function and appearance, built of layers of sound extended through repetition rather than development.[67] Thea is convinced that Faber is sexually attracted to Flora and, perversely, throughout the opera he makes feints at Flora. Mel and Dov are involved in a fragile relationship, neither certain of the other's feelings. Their uncertainties are confirmed when Thea, "like Circe," draws Mel toward her, and Faber initiates a seduction of Dov. These clashes of characters are facilitated by the "Dissolve" music, which Tippett envisaged as functioning in the manner of "cuts" in cinematic film. It is fast, loud, high pitched, and dissonant, at once accentuating tension and allowing for abrupt

changes of action, typically when switching from the frenzy of Mangus's machinations to the peacefulness of Thea's garden. When Mangus disappears at the end of the opera, this music will be heard in reverse, as the culminating deconstruction of the maze.

THE ISLAND

In Act III the garden is transformed into the island of *The Tempest*. As music is the signifier of magic on *The Tempest* island, so music transforms this garden into a place of enchantment. In Caliban's words,

> . . . the isle is full of noises
> Sounds and sweet airs, that give delight, and hurt not.
> Sometimes a thousand twangling instruments
> Will hum about mine ears; and sometimes voices
>
> (III, ii, 132–35)

Shakespeare's sweet and delightful music is the avatar of Prospero's "charms." In Act I the gestures of Mangus-Prospero the magician were accompanied by a static musical texture. As the couch is mysteriously whisked away, and secateurs produced, minute patterns in the music are repeated without any synchronization, creating a music that, like the cocktail music, conveys a loss of momentum. Over a span of three treble octaves a soft and delicate timbre is heard: a flute flutters, piano and temple block chime a sustained three-pronged chord while celesta and harp provide a high-pitched cycle of notes. Over all is the hieratic sound of a tolling gong.

Four scenes from *The Tempest* are acted out, among myriad additional fleeting references to that play. In Act I Mangus has been introduced as Prospero, while Mel had arrived in the opera dressed "fish-like" (some productions have given him flippers and a snorkel). In the words of the play, he is "A fish: he smells like a fish; a very ancient and fish-like smell" (II, ii, 25–26). He and Dov sing a ditty, "Ca-Ca-Caliban," derived from the "Ban Ban Caliban" of the play, and another referring to Ariel's song in Act I. But it becomes evident that these scenes are forewarnings of the more significant playacting of Act III. In a symbolic gesture, as the only black character in the opera, Mel is given the part of the base and monstrous Caliban. Dov—the name being a shortened form of "dove"—is Ariel, the winged Hermes, or the biblical holy spirit. Flora is Miranda, the nubile goddess who embodies purity and perfection.[68]

As Mangus-Prospero dons his cloak and circles his wand, he acknowledges the play's "bewildering moments" and encourages the audience, as he gestures, to imagine rocks, a distant storm at sea, and the garden island before them.

Of the four charade scenes, only one is literally adopted from Shakespeare's play, the remaining three being Tippett's dramatization of events only alluded to by Shakespeare. In each case the opera's characters are passive pawns in Mangus-Prospero's designs, playing out the scene like puppets to the puppeteer. In three out of the four scenes a character is given freedom from imprisonment or capture. In some cases an act of one character's volition alters the course of the charade. This action of self-determination precipitates a rejection of oppressing forces.

In the first charade Ariel is released from his tree, an event that the play reports had taken place twelve years earlier. It presents Tippett with an opportunity to depict Ariel celebrating his freedom by assaulting Caliban. There is no inkling of this outcome in Shakespeare's plot, enabling Mel-Caliban to cry, "you go beyond the script." The events of the second charade have also taken place before *The Tempest* play begins. Here Tippett has dramatized the circumstances of the imprisonment of Caliban. Shakespeare's Prospero tells how he had provided Caliban with lodging and taught him to speak. But Caliban had abused that privilege by attempting to rape Miranda, for which crime he was imprisoned and enslaved to Prospero. When this scene is transferred to the opera, it pictures Flora-Miranda sleeping while Mangus-Prospero watches through a telescope. Mel-Caliban attacks her, but the scene is prevented from following its prescribed course by the intervention of Denise. Mel-Caliban pleads in exoneration, simply, "I play the role he gives me."

After these disasters Mangus-Prospero promises the exercise of his "art" in a more positive aspect:

> *You shall savour such a scene*
> *Of tender reconciliation*
> *As dreams may show,*
> *Holding the mirror up to nature.*

The third charade ensues, being the only one to redramatize a scene from *The Tempest*. Dov-Ariel discloses Faber-Ferdinand and Flora-Miranda playing chess. This scene, in Act V, i, of the play, immediately follows the reconciliation scene between Prospero and Alonso. Prospero offers his forgiveness and hospitality, but Alonso is as yet unaware that his son Ferdinand has survived the shipwreck. Immediately Ferdinand and

Miranda are revealed, playing at chess. It is not so much a love scene as one depicting Alonso's discovery of the miraculous survival of his son and of the restoration of the filial relationship. In the opera Flora-Miranda and Faber-Ferdinand quote their lines in mocking tones: "Sweet Lord, you play me false" and "No, my dearest love, I would not for the world." Again the continuity of the scene is upset when Flora unexpectedly upends the chess board, accusing Faber of that very falsehood that Ferdinand had denied. As a result she is able to cry "Dov-Ariel, lend me your wings. I'm free: I'm free." Coincidentally, Thea recognizes that saving her marriage is a possibility. Mangus-Prospero throws Thea the queen from the chess set, and she reaches one of the most luminous moments of the opera. As she sings, "I am no more afraid," a music related to the opening tempest music is heard in inversion. Her expressive ululations are accompanied by music that draws her home to the tonal center of the opera and decorates it with rushes of rising scales and the rare sound of bells.

The final charade scene acts as a postscript to these events and is derived from a momentary reference at the conclusion of the play. Ariel has dutifully carried out Prospero's instructions, and in Act V, i, he demands the freedom promised to him as a reward. Prospero declares, "Thou shalt be free," and then a few lines later, "Untie the spell." The scene is considerably amplified in the opera, with Mangus-Prospero presiding as judge over the trial of Dov-Ariel. Brief quotations are taken from a scene in Act I in which Ariel had reminded Prospero of his promise to free him from servitude, and from Caliban's descriptions of his past. But the opera's scene is abruptly canceled by Mangus, who declares "Enough! Enough!" Alluding to Prospero's retirement, he resigns his powers by breaking his staff and drowning his book. Mangus is revealed in the words of *King Lear*, "a foolish, fond old man" (IV, vii, 60).

The immediate outcome of the charades is a paean to sexual liaison, inspired by a mélange of quotations. Mangus refers to a bittersweet music and to "that trickster Eros." All characters with the exception of Thea and Faber assemble to quote words from Goethe's poem, *Das magische Netz*, followed by a line from *The Tempest*,

> *We sense the magic net*
> *that holds us veined*
> *Each to each to all*
> *"Come unto these yellow sands."* [69]

Goethe's poem depicts girls braiding nets in which to catch the spears of boys. His metaphors are sexual and universal. So is Shakespeare's in Ariel's song "Come unto these yellow sands," as with magical music he envelops Ferdinand in feelings of love for Miranda. These allusions are the cue for a succession of departures, Mel with Denise, Flora alone, Dov trailing. As Flora departs, Mangus offers a final allusion to *The Tempest* by consigning her to a "brave new world" (V, i, 183). Miranda's brave new world was the world of men, having only discovered with the arrival of Ferdinand "how beauteous mankind is!" (V, i, 183). Thus the implication is that Flora is to fulfill her desires and to find her Ferdinand.

Like the machinations of Reilly, Mangus's actions (and their significance) are visible to some characters and not to others. Thea fails to notice the materialization of the secateurs and is constantly dismissive of what she regards as Mangus's meddling in others' lives (from the margins she accuses him of being "dabbler: pimp: voyeur"). He is as unwelcome in her garden as Reilly was to Edward's cocktail party. Thea, and to a certain extent Denise and Mel, are metaphorically blind to the full meaning of the action of the opera. Mel is the only character of this group to participate in *The Tempest* charades. With the "planes of reality" of *The Cocktail Party* in mind, these differentiations hint at a deeper meaning than that of a garden charade.

"MUTUAL FORGIVENESS"

Tippett has revealed that a quotation from Blake was in his mind for the duration of the period of composition of the opera. The quotation, "Mutual forgiveness of each vice: / Such are the Gates of Paradise," predicts a resolution of enmity.[70] Without this quotation having been made in the score, however, this resolution is equivocal, and more recognizably so in comparison with the conclusion of *The Cocktail Party*.

Act III of *The Cocktail Party* takes place two years after the play opens, as Edward and Lavinia prepare to host another cocktail party. The action has come full circle, presenting them as a model of harmonious marriage. Unexpectedly, Alex brings news that Celia has been killed in Kinkanja, crucified near an anthill. Her death was "just for a handful of plague-stricken natives," but it transpires that it was her choice to die in these circumstances.[71] By means of imagery and symbolism Eliot associates this tragedy with the Easter story. The death of one precipitates the redemption of others and the institution of a new order. The play ends, as does the opera, with the announcement of a beginning. Although Tippett

admired Eliot's method in the plays, he regarded the manner of Celia's
death (in an early version smothered with a juice attractive to ants) as
particularly gruesome. He was disconcerted by the details, finding that
"You are told in the last act that [Celia] had been with Africans, and these
wicked Africans had stretched her out like a cross and she had been eaten
by ants . . . It's a Christian attitude towards heathens, which . . . I find
offensive."[72] It was not so much the religious attitude that Tippett found
alarming but more the underlying racism. To a composer steeped in
socialist politics and fiercely critical of man's inhumanity to man, any
suggestion that murder is innate to the black unbeliever is distasteful.
Tippett has disclosed that Denise may be the opera's character corre-
sponding to Celia, but he was reluctant to ascribe to her character the
Christian symbolism accorded Celia. Seeming to have altered his opin-
ion since his approving comments in 1953, by 1970 Tippett could
remark, "Eliot's Christianity had done something to him. The figure who
appears to be like Denise rejects marriage, and goes out and you don't
see her again."[73]

In Denise's humanitarianism Tippett provides a critique of the role
of Celia. Yet Denise is superfluous to the design of the opera. Her only
participatory action is to interrupt the attempted rape of Flora, which
Tippett may have meant to symbolize a rescue or resurrection (perhaps
in some association with the Queen of the Night from Mozart's *The
Magic Flute*). Yet it is a seemingly insignificant gesture, accompanied by
no obvious musical or textual confirmation. Otherwise, Denise takes no
part in the charades, provides only a remotely plausible amount of per-
sonal conflict in her relationship with Thea, and serves to disrupt rather
than to further the drama of the relationship between Mel and Dov. Her
initial appearance as deus ex machina is inexplicable, dramatized by
flashes of lightning and surrealistic enhancement of her stature. Like Tip-
pett himself, her preoccupation is with humanity's moral failings, among
them what Denise condemns as "the lust of violence." Moreover, her
response is a cry for mortal justice: "I cannot forget. I will not forgive."
The moral intransigence of this statement in effect disqualifies Denise
from participating in the resolutions of the opera. Tippett's comparison
of Celia and Denise is ambiguous. To ascribe to Denise the centrality of
Celia is an interpretation of the surface alone. Whereas Denise is con-
cerned with moral values and their adverse manifestations, Celia is piv-
otal to the spiritual action of *The Cocktail Party*. She rejects marriage,
and life, in order to save life. Denise, in contrast, has rejected marriage
(by implication) in order to crusade against violence and in pursuit of

human rights. She leaves the scene of the opera with Mel, yet her contribution to the plot is inconclusive, and she is denied the salve of music experienced by the remaining characters.

SALVATION: MUSIC

Corresponding with the ritualistic playacting is a playsinging, the incarnation of the metaphorical music of the opera. In order to differentiate this playsinging from the singing naturally undertaken by singers in an opera, Tippett clothes that singing in referential garb. This referential music provides some of the most serene moments of the opera, witnessing to a healing or reconciliation. The first intimation of these powers occurs in the final ensemble of Act I, composed to a medley of blues song-texts. Tippett investigated authentic blues music and settled on the words of several with names such as "Honky Tonk" and "Turn on Your Love Light."[74] His characters are instructed to abandon their inhibitions, but not their emotions, and sing "Baby, do not torment me" (Mel in reference to Dov), "Brother, do not desert me" (Dov in reference to Mel), "Lover don't you see, I'm a little girl lost" (Flora in reference to Faber), "Can this play-boy be my true man?" (Thea in reference to Faber), and "Turn on your love light, let it shine on me" (Faber, in reference to Flora). The twelve-bar blues septet and boogie-woogie interlude provide regular rhythm, audible and accessible tonality, and a popular idiom that makes light of the characters' "blues". In Tippett's words, "one sings the blues when one's mood is 'blue', to discharge that mood by the song and to get the courage, or at least some renewal of strength, to go on again."[75]

The inclusion of a vernacular music with perilously colloquial texts has been widely criticised. Yet Tippett argues that the adopted context transforms them, "they are not blues as an expert in blues or jazz would write them, they are something to do with me."[76] The blues music represents a universal language of their time: "this means that I am not so much quoting as believing that the present-day world of sound is becoming anonymous, universal the world over. Part of the problem is to find vernacular metaphors that can not only be resounded in London or New York or Tokyo, but can even seep under the Iron Curtain and be secretly taped by young people in Moscow."[77] This music, however, provides only temporary relief from the confrontations, renewed in Act II.

There, the most memorable musical moment of the opera arises when Dov the musician comforts Flora, now in flight from Faber. He asks her if she ever sings, at which her cloud of despair lifts, and she

murmurs a verse of Schubert's song, "Die liebe Farbe," from *Die schöne Müllerin.*[78] The sudden departure from brittle atonal music to the sublime diatonic B minor symbolizes the transcendent moment. When Dov sings the translation, Tippett accentuates the ethereality of the sound by adding a filigree of high-pitched piano above. The sublime music—in the most tender moment of the opera—identifies the actuation of Flora's maturity, of the healing of her fears and strengthening of her resolve to resist Faber. The unmelodic and halting music that had characterized Flora to this point in the opera is banished. Ultimately, Flora will depart radiant and dancing. Dance is to Tippett a ritualistic action, here a metaphysical statement as well as an indication of Flora's bodily freedom.[79]

Indeed, it can be argued that Flora is the compelling agent of change in the opera. As "flower" she belongs in the garden world, and as Miranda she participates in the island magic. She is Mangus-Prospero's accomplice, collecting costumes, approving of his actions. She is the mute character transformed by the power of music, individuated by the action of the charades. If there is a "death" in the opera, it may be the attack and attempted rape of Flora-Miranda, foiled by Denise. Furthermore, if there is a Fall, a rite of passage from innocence to (sexual) cognizance, it is this event. Flora's participation in the charade, and rejection of it, prompts the "salvation," by extension, of Thea and Faber.

Flora's apotheosis more clearly equals that of Celia. "Celia" may be a contraction of "Cecilia" and a reference to St. Cecilia, virgin and martyr.[80] But St. Cecilia is also the patron saint of music. It is known from the opening scene of *The Cocktail Party* that Reilly sings, in this instance a barroom ditty. Whatever its meaning, it swiftly adds to the mystery of the occasion. Later, as Reilly elucidates the meaning of Celia's death, the symbolism of her name becomes apparent. As if to underline the allusion, Reilly prefaces his explanation with a poetic quotation, reciting nine lines from Shelley's *Prometheus Unbound.*

> Ere Babylon was dust
> The magus Zoroaster, my dead child,
> Met his own image walking in the garden.
> That apparition, sole of men, he saw.
> For know there are two worlds of life and death:
> One that which thou beholdest; but the other
> Is underneath the grave, where do inhabit
> The shadows of all forms that think and live
> Till death unite them and they part no more![81]

The audience has been prepared for the transition, even if the relevance of the words is opaque. Eliot chooses to signal that events have moved "beyond ordinary classified emotion" by the metamorphosis from poetry within drama to great poetry in its own right, from prosaic conversation to a supremely musical verse. Eliot had been reminded of Shelley's lines when he read Charles Williams's novel, *Descent into Hell* (1937), in which a female character is obsessed with the thought of seeing her double.[82] The allusion to a heaven and a hell, the "two worlds of life and death," at this point in the play accentuates its author's awareness of a spiritual action. Even though Reilly describes Celia as a "woman under a sentence of death," it is understood that this was "the way of illumination."[83] More than the accretion of metaphors and double entendres, this musical moment is the revelation of the musical pattern, when, as Eliot planned, the "musical pattern of sound and a musical pattern of the secondary meaning of the words which compose it, . . . are indissoluble and one."

In the opera, the *Alice in Wonderland* playacting and blues playsinging foreshadow what the composer envisaged as "some ritual that takes the action deeper into some moment of truth."[84] The purpose of the *Tempest* charades is to effect a spiritual as well as a psychological healing, by emulating the pattern of Shakespeare's late plays. Alluding to Eliot's musical pattern, Tippett referred to the cross-relationship games as an arrangement "in a kind of pattern or as a kind of dance . . . Shakespeare's late comedies are the best models of all, exploring every avenue of possible forgiveness and reconciliation amongst individuals at war with each other."[85] Each of the characters is aware of participating in an opera within an opera just as the masque scenes of *The Tempest* itself are activated by "players pretending to be spirits pretending to be real actors, pretending to be supposed goddesses and rustics."[86]

The opera does allude to the progress of forgiveness and reconciliation identified by Grams Hunter in *The Tempest*. As he attends to the conflict between Thea and Faber, Mangus describes himself as a priest as well as a magician. He is not divine, but mortal, reliant as much as Prospero on his books and mantle. When Mangus intones, "We be but men of sin. So sounds the accusation," he alludes to Ariel's admonition of the banished sailors: "You are three men of sin" (II, ii). When Thea steps into Mangus's magic circle in Act III, her first word is "forgiveness."

In the penultimate scene, as Mangus dismisses the charade, he moves to the front of the stage and addresses the audience. Here, in one final example of playsinging, Mangus does not sing but instead uses a

Sprechstimme, a rhythmic speech. The manner in which the words are heard is both real—an actor addressing his audience—and unreal, in its exaggerated articulation. Accompanied by a mellifluous music he announces the breaking of his staff and drowning of his book. He is interrupted momentarily by the sound of a hymn, "full fathom five," in serene harmony. Shortly afterward Denise, Flora, Dov, Mel, and Mangus unite to intone the quotations from Goethe and Shakespeare. Like Reilly's quotation of Shelley, the reverential, even ecclesiastical, sound casts a meaning beyond that of the words. In a final benediction Mangus utters words that could be construed as Shakespeare's own:

> And, like the baseless fabric of this vision,
> The cloud-capp'd towers, the gorgeous palaces,
> The solemn temples, the great globe itself,
> Yea, all which it inherit, shall dissolve
> And, like this insubstantial pageant faded,
> Leave not a rack behind.
>
> (IV, i, 151–56)

Mangus thus concurs with the play's recognition of the fallibility of the world and its inhabitants.

The final scene and epilogue are reserved for the resolution of the crisis in the relationship between Thea and Faber. Their reunion represents the archetypal marriage that ends a comedy. To the sound of ethereal celesta scales, Thea puts away "the seed packets" while Faber puts away "the factory papers." Both speak in the same *Sprechstimme* as had Mangus, before uniting, as had the other characters, to sing in harmony with one another. Their previously irreconcilable worlds are reconciled. Each declares, "I encompass the vast night with an image of desire," acknowledging the work of the trickster Eros. But the line "our enmity's transcended in desire" implies that the denouement is one of more than physical fulfillment. The final line announces the curtain rising, not falling (a reference to Virginia Woolf's *Between the Acts*), prompting a rebirth and reinitiation of the action.[87] This final manifestation of concord climaxes in a wash of ascending harp and piano. "Music," or this sensuous sound, confirms a restoration and a resolution.

As assured as he was of his characters' journey, Tippett hesitated to adhere entirely to the "musical pattern." Soon after the first performance, and in reference to *The Cocktail Party*, Tippett attempted to deny the opera's dogma: "In 'The Knot Garden' you don't get this Christian

element at all; we're in a different world, outside Eliot's world, in a later world."[88] Tippett was even more critical in his autobiography, published in 1991, of the cloistered views expressed by Eliot in the later essays and plays.[89] It is his belief that they need updating in order to speak to a post-Christian world.[90] Rather than being able to right the wrongs of the world, Tippett acknowledged that "We now know that the world can't be put to rights either by direct political reasons or direct psychoanalytical reasons," and yet, "nevertheless we have to be in this world where people try."[91] The results of Mangus's conjuring are far more ambiguous than the triumphs of Prospero's artistry. Tippett, as skeptic, leaves it to "imagination and desire" to fuel a hope for the future.[92]

CONCLUSION

Commentators have justifiably criticized the conventionality of Eliot's musty English drawing room in *The Cocktail Party*.[93] Tippett's representations in *The Knot Garden* of the concerns of the late twentieth century—racial difference, internecine violence, and gay rights, among others—are undeniably more vivid to the audience conditioned by the modern media. But even if this is so, the opera is plainly less successful than Eliot's play in communicating a plausible human drama. *The Cocktail Party* achieved theatrical durability as a drawing-room comedy, independent of the appreciation of its "submarine" pattern. As Eliot remarked, "poetry is poetry, and the surface is as marvellous as the core."[94] This much cannot be said for the opera. Admittedly the challenge in a medium in which characters do not speak or act as they do in everyday life is to discover a means of conveying plausible action in a highly artificial setting. One reviewer commented that "in this particular garden you cannot see the wood for the trees," failing to discern any semblance of plot.[95] The remark underscores the inescapable conclusion that Tippett requires his audience to know and appreciate Shakespeare, if not the host of English drama and literature. While "cryptograms" (to use Eliot's term) can be tolerated in poetry, such obfuscation in opera or drama bewilders the bulk of its audience.[96] One possible diagnosis of the cause of this affliction was provided by Eliot, again in reference to *Hamlet*. That play, he theorized, suffered from an imbalance of ancient and modern and of the intersecting layers of the palimpsest. Such an imbalance is undeniable in the opera, where the various sources disrupt and confuse the coherence of the surface.

Nonetheless, Tippett has demonstrated the application of Eliot's musical pattern to opera and restored music to its place as religious metaphor.

When upon completion of composition Tippett happened to reread Eliot's plays, he discovered that "all *The Knot Garden* is in those plays."[97] Although Tippett has always served as his own librettist, this exchange between the arts of drama, poetry, and music ranks among the most potent artistic collaborations of the century. Eliot demonstrated to Tippett how he might invest the work with the riches of his artistic tradition, how to create a universal and archetypal drama, and how to create resonances "beyond" those visible and audible. In return, Tippett has honored Eliot, his acknowledged "spiritual father," in the most enduring way.[98]

NOTES

1. See Michael Tippett, *Music of the Angels* (London: Eulenberg, 1980), 117–24, reprinted as chapter 13 of *Tippett on Music*, ed. Meirion Bowen (Oxford: Clarendon Press, 1995), 109–16. The principal monographs on Tippett are Ian Kemp, *Tippett: The Composer and His Music* (Oxford: Oxford University Press, 1987), and Arnold Whittall, *The Music of Britten and Tippett* (Cambridge: Cambridge University Press, 1984), both of which note Tippett's acknowledgments of Eliot, but without venturing beyond sourcing quotations from Eliot's works. Whittall, however, comments that "It is difficult to exaggerate the depth and power of [Eliot's] influence on the computer, not in his role as a pessimistic observer of modern society . . . but as an evoker of archetypal images" (241).

2. Robert Medley, "The Group Theatre 1932–39: Rupert Doone and Wystan Auden," *London Magazine* 20 (Jan. 1981): 50.

3. Frank Vigor Morley (1899–1980) was a founding director of Faber & Faber. An American, he was a Rhodes Scholar and spent most of his life in Britain. He had four children, the eldest born in 1926. Eliot, like Tippett, enjoyed the vicarious family life at the farm. For Morley's own memories, see his "A Few Recollections of T. S. Eliot" in *T. S. Eliot: The Man and His Work*, ed. Allen Tate (Harmondsworth: Penguin, 1966), 93–116.

4. Tippett, *Music of the Angels*, 117.

5. Details from letter to the author from Mrs. Christina Morley, 9 Sept. 1989, and Michael Tippett, *Those Twentieth-Century Blues* (London: Hutchinson, 1991), 51. In a letter written in 1920 Eliot disclosed that he felt paternal toward men only five years younger than himself and that, even so early in his career, a number of young men had borrowed from his poetry. See Valerie Eliot, ed., *The Letters of T. S. Eliot* (London: Faber, 1988), 391.

6. See E. W. F. Tomlin, *TSE: A Friendship* (London: Routledge, 1988).

7. They sat next to one another only at a performance of *The Elder Statesman* in Edinburgh in 1958. See Tippett, *Music of the Angels*, 118.

8. Michael Tippett, "Sir Michael Tippett: The Man and His Music" [pamphlet] (Baarn, The Netherlands: Phonograph International B.V., n.d.), 7.

9. T. S. Eliot, *Selected Essays,* 3rd ed. (London: Faber, 1951), 229.

10. I am relying on the dates of the visit as Aug./Sept. 1934 given by Lyndall Gordon in *Eliot's New Life* (London: Oxford University Press, 1988), 45.

11. Tippett, *Those Twentieth-Century Blues,* 188.

12. Michael Tippett, "Drum, Flute and Zither" (1953) in *Moving into Aquarius* (London: Paladin, 1974), 81.

13. See, for instance, the reference in his autobiography, *Those Twentieth-Century Blues,* 50.

14. T. S. Eliot, "Religion and Literature," *Faith That Illuminates,* ed. V. A. Demant (London: Centenary, 1935), 39.

15. Tippett, *Music of the Angels,* 52.

16. Tippett, *Moving into Aquarius,* 81–82.

17. See Tippett, *Those Twentieth-Century Blues.*

18. The full text is reprinted in Tippett, *Those Twentieth-Century Blues,* 48.

19. For explanations see Tippett, *Music of the Angels,* 119, and Tippett, "The Man and His Music," 8. Tippett has usually explained Eliot's opinion in terms of a theory of Susanne Langer (see her *Feeling and Form*): "Eliot said that there are three kinds of operations on the stage: stage drama, ballet and opera. And that there are three means of expression—music, gesture and words, one of which was always on top, though all three were always there. In the drama proper, then, the words are on top, music is next and the gesture's at the bottom. . . . In the ballet, gesture's at the top, words are next and the music's at the bottom. That's very Eliot but it taught me all I wanted to know." Michael Tippett and Patrick Carnegy, "The Composer As Librettist," *Times Literary Supplement* 8 July 1977: 834. More recently Tippett has reported that "Eliot said, 'You've done it already. Anything I add will stick out a mile as so much better. You don't want words which already have the magic which your music should provide. You'd better learn how to do it yourself.' " *New York Times* 5 Sept. 1993: H21.

20. Eliot, letter to Stravinsky, 19 Mar. 1959, Sacher Stiftung, Basel.

21. Quoted in *T. S. Eliot and Mysticism: The Secret History of "Four Quartets"* (London: Macmillan, 1991), 19.

22. Michael Tippett, interview with the author, New England Conservatory, Boston, 19 Oct. 1989.

23. Eliot, *Selected Essays,* 33.

24. Tippett's most important discussion of music and poetry, specifically the poetry of Yeats, is in "Drum, Flute and Zither" (1953).

25. T. S. Eliot, Introduction, *The Wheel of Fire: Interpretations of Shakespearian Tragedy with 3 New Essays,* 4th ed. (London: Methuen, 1949), xix.

26. Charles Warren, *T. S. Eliot on Shakespeare* (Ann Arbor: UMI Research Press, 1987).

27. G. Wilson Knight, "Myth and Miracle" (1929) in *The Crown of Life: Essays in Interpretation of Shakespeare's Final Plays* (London: Methuen, 1948), 24. Eliot also acknowledged Colin Still, *Shakespeare's Mystery Play: A Study of "The Tempest"* (London: Palmer, 1921).

28. Knight, "Myth and Miracle," 28.

29. *Pericles, Prince of Tyre*, ed. Doreen Delvecchio and Antony Hammond (Cambridge: Cambridge University Press, 1998). According to the editors, music must be played, although other editions differ as to its timing in this scene (see their note on page 196).

30. T. S. Eliot, "Shakespeare As Poet and Dramatist," ms., Houghton Library, Harvard, II: 16.

31. T. S. Eliot, *The Complete Poems and Plays* (London: Faber, 1969), 109.

32. Additional note to Knight, "Myth and Miracle," 31.

33. Knight, "Myth and Miracle," 28.

34. *The Tempest*, ed. J. R. Sutherland (Oxford: Oxford University Press, 1939; repr. 1984).

35. Eliot, "Shakespeare As Poet and Dramatist," ms., Houghton Library, Harvard.

36. T. S. Eliot, *On Poetry and Poets* (London: Faber, 1957), 12.

37. Eliot, "Shakespeare As Poet and Dramatist," I: 10.

38. Ibid.

39. Ibid., II: 11.

40. Ibid., I: 9 and II: 11.

41. Michael Tippett, "Our Sense of Continuity in English Drama and Music" in *Henry Purcell: Essays on His Music*, ed. Imogen Holst (London: Oxford University Press, 1959), 42–51.

42. Tippett, "Our Sense of Continuity," 51.

43. Tippett, "The Man and His Music," 10–11.

44. Robert Grams Hunter, *Shakespeare and the Comedy of Forgiveness* (New York: Columbia University Press, 1965). See Tippett's reference to such comedies in his talk presented before the premiere, Dec. 1970, quoted in David Matthews, *Michael Tippett: An Introductory Study* (London: Faber, 1980), 81. Kemp provides a brief discussion of Hunter's theories in relation to *The Knot Garden* (*Tippett: The Composer and His Music*, 405, 412).

45. Knight, "Myth and Miracle," 13.

46. Knight, "Myth and Miracle," 16.

47. See Robert Heilman, "*Alcestis* and *The Cocktail Party*" in *Twentieth-Century Interpretations of Euripides "Alcestis,"* ed. John R. Wilson (Englewood Cliffs, NJ: Prentice-Hall, 1968), 92–104, among others.

48. Tippett, "The Man and His Music," 7.

49. Quoted in Eric Walter White, *Tippett and His Operas* (London: Barrie & Jenkins, 1979), 94.

50. Eliot, "Shakespeare As Poet and Dramatist," I: 10.

51. In the draft versions of the opera there were eight characters, the rejected character being Claire, a hospital worker. See White, *Tippett and His Operas*, 96.

52. Michael Tippett, "Music and Poetry," *Recorded Sound* 17 (Jan. 1965): 287. The row is heard outlined in octaves in the first five bars of the opera.

53. "Charade" was the exception. See White, *Tippett and His Operas,* 95. Tippett's *The Vision of Saint Augustine* was given the preliminary title of "Fenestra" (window) in reference to Augustine's mystical vision of a garden seen through a window. That work is indebted to "Burnt Norton" and to Tippett's investigations of mysticism and mystical experience. Composition of *The Vision* overlapped with the drafting of *The Knot Garden*.

54. I, ii, 224, and IV, i, 15.

55. Eliot, *Collected Poems and Poetry*, 171. In *The Confidential Clerk* the garden can be "a dirty public square" in the city or "a garden / Where you hear a music that no one else could hear, / And the flowers have a scent that no one else could smell." Eliot, *Collected Poems and Plays,* 473.

56. Lewis Carroll, *The Complete Works of Lewis Carroll* (London: Nonesuch, 1939), 19.

57. Tippett named Denise after St. Denys, patron saint of France. See Tippett, "The Man and His Music," 4.

58. Tippett, letter to Meirion Bowen, 8 Aug. 1967, in *Those Twentieth-Century Blues*, 238.

59. Eliot, *Collected Poems and Poetry*, 172.

60. Martin Browne noted how amused American audiences were at this gesture. E. Martin Browne, *The Making of T. S. Eliot's Plays* (Cambridge: Cambridge University Press, 1966), 185.

61. Tippett, "The Man and His Music," 8.

62. Tippett's partner, Meirion Bowen, describes Thea as Circe in "A Tempest of Our Time" in *The Operas of Michael Tippett*, ed. Nicholas John (London: Calder, 1985), 95. Circe was a sorceress or goddess living on the island of Aeaea in Italy. She gave visitors wine laced with a poison that turned them into beasts.

63. From the review of the first performance in the *Evening Standard*, entitled "Up the Garden Path," quoted on the back dust jacket of Tippett, *Those Twentieth-Century Blues*. The full review is reproduced in *A Man of Our Time*, ed. Colin Davis et al. (London: Schott, 1977), 95.

64. See the photo in which Eliot is drawing on a blackboard a plan of these cross-relationships, found in Peter Ackroyd, *T. S. Eliot* (London: Hamilton, 1984), illustration 57. Tippett was influenced by the "games" of Albee's *Who's Afraid of*

Virginia Woolf (1962). There are many parallels between the two works, not least the meaning of the principal female character being "afraid." Tippett discusses the play in David Matthews, *Michael Tippett: An Introductory Study* (London: Faber, 1980), 81.

65. See Browne, *The Making of T. S. Eliot's Plays*, 221–23. Eliot's game can be related to Coward's *Hay Fever*, which he saw in America at the time of writing *The Cocktail Party*. In that play a family manufactures an argument in order to regenerate their relationships, and their guests fail to understand the role play.

66. Quoted from a talk by Tippett given prior to the first performance of the opera, in David Matthews, *Michael Tippett: An Introductory Study*, 81. Tippett was also much influenced by the dream sequences in the play *A Sleep of Prisoners* (1951) written by Christopher Fry, a personal friend.

67. Tippett has explained, "I remember Harry Birtwistle saying to me that he occasionally writes some non-music. I think that is just what I wanted." Quoted in Tom Sutcliffe, "Tippett and *The Knot Garden*," *Music and Musicians* 19 (Dec. 1970): 54.

68. In his discussion of *The Tempest*, Knight quotes Still, who described Prospero as God, Ariel as the Angel of the Lord, Caliban as the Devil, and Miranda as the Celestial Bride. See Knight, *The Crown of Life*, 226.

69. I, ii, 375. The links to Goethe are discussed in C. N. Odam, "Michael Tippett's *Knot Garden*: An Exploration of Its Musical, Literary, and Psychological Construction" (master's thesis, University of Southampton, 1977), 33.

70. Quoted by Tippett in a BBC interview, 3 Dec. 1970. In a letter to a friend in 1942, Tippett described Blake as "a real mystical genius": see Tippett, *Those Twentieth-Century Blues*, 139.

71. Eliot, *Collected Poems and Plays*, 434.

72. Tippett, "The Man and His Music," 7.

73. Ibid.

74. The blues are all taken from Charles Keil, *Urban Blues* (Chicago: University of Chicago Press, 1966), 125–28, 141.

75. Tippett, *Music of the Angels*, 220.

76. Tippett, "The Man and His Music," 9.

77. Ibid.

78. Richard Elfyn Jones describes the musical quotation as an act of nostalgia, confirmed by the context of the song in Goethe's original. See *The Early Operas of Michael Tippett: A Study of "The Midsummer Marriage," "King Priam" and "The Knot Garden"* (Lewiston: Edwin Mellen, 1996).

79. Tippett's understanding of the significance of the dance is drawn from Yeats, who advocated a union of dance and music and verse. See Tippett, *Moving into Aquarius*, 149.

80. As designated by William Arrowsmith in "English Verse Drama (II): The Cocktail Party," *Hudson Review* 3.3 (Autumn 1950): 412.

81. Eliot, *Collected Poems and Plays*, 437. G. Wilson Knight discusses *Prometheus Unbound* in *The Starlit Dome: Studies in the Poetry of Vision* (London: Methuen, 1959).

82. Charles Williams, *Descent into Hell* (London: Faber, 1937), 19. Eliot discussed Williams (and mysticism) in "The Significance of Charles Williams," *Listener* 19 Dec. 1946: 895.

83. Eliot, *Collected Poems and Plays*, 437, 421.

84. Letter to Eric Walter White, Aug. 1964, quoted in White, *Tippett and His Operas*, 95–96.

85. Tippett, *Music of the Angels*, 219.

86. E. M. W. Tillyard, *Shakespeare's Last Plays* (London: Chatto, 1938), 80.

87. See White, *Tippett and His Operas,* 99, and Kemp, *Tippett: The Composer and His Music*, 411, n60.

88. Tippett, "The Man and His Music," 7.

89. Tippett, *Those Twentieth-Century Blues*, 272: he comments that even in the late 1930s, "It already then seemed to me that [Eliot's] prose was losing the sharpness and clarity of his earlier literary essays, chiefly because of the continual use of traditional Christian concepts and phraseology, understood and accepted only by those within the faith. A good majority of his compatriots were left out. Meanwhile, in the verse-plays, he turned his back on the dramatic and poetic intensity of *The Family Reunion*, publicly criticising it, for the unpoetic, almost undramatic, theatre-pieces of his final years."

90. In a postscript to *Moving into Aquarius* Tippett quotes Jung approvingly: "we live in the age of the decline of Christianity, when the metaphysical premises of morality are collapsing." Tippett, *Moving into Aquarius*, 167.

91. Tippett, "The Man and His Music," 5.

92. Tippett, *Moving into Aquarius*, 166.

93. Robin Grove, in reference to *The Elder Statesman*, notes that "Europe may have torn itself apart, Hungary be crushed, Soviet and American empires threaten each other with destruction, Suez heap humiliation on top of dishonor." Robin Grove, "Pereira and After: The Cures of Eliot's Theater" in *The Cambridge Companion to T. S. Eliot* (Cambridge: Cambridge University Press, 1994), 158–75.

94. Eliot, introduction, *Myth and Miracle*, xx.

95. *Evening Standard* review of the first performance. See Davis et al., eds., *A Man of Our Time*, 95. After a performance in 1989 a reviewer wrote that the opera's line, "The play has bewildering moments," is "the understatement of the year." John Cargher, "Knotted Opera," *Bulletin* (Sydney) 26 Sept. 1989: 112.

96. Eliot, Introduction, *The Wheel of Fire*, xx.

97. Michael Tippett, interview with Brian Magee, BBC, 1970.

98. Tippett, *Those Twentieth-Century Blues*, 50. The debt is perpetuated in Tippett's most recent works, his final opera, *New Year* (1989), alluding to a line from *Four Quartets*. See Suzanne Robinson, "*The Midsummer Marriage* in *New Year*: A Comparison of Tippett's First and Latest Operas," *Musicology Australia* 14 (1991): 25–36.

Movements in Time
Four Quartets and the
Late String Quartets of Beethoven

DAVID BARNDOLLAR

POETRY AND MUSIC

Comparing T. S. Eliot's *Four Quartets* with musical string quartets is both an obvious exercise and an infuriatingly elusive one. The poem's general title specifically invites the analogy, and understanding something about musical quartet forms can illuminate Eliot's purpose in structuring the poems as he does. But, as many critics have discovered, the analogy can be taken only so far. The two art forms are, after all, not equivalent, even though poetry is the most musically derived of all literary forms. The question for the literary critic becomes, "How far do I take the quartet analogy, and what use can I make of it in understanding the poetry?"

Musical phrases and poetic utterances do not correspond in tidy ways, since composers and poets do not construct their pieces in the same ways. Certainly poets employ meter and rhythm in their poetry, and much of the pleasure in words skillfully put together comes from their sounds. But such techniques are not, strictly speaking, musical. Conversely, musicians often use words to guide their thoughts in music. Choral works, art songs, and operas are obvious examples of language's appearance in music. Beethoven even used text to underpin the themes of the Finale of his last complete musical composition, the String Quartet in F Major, Op. 135 (see Figure 9.1). But these themes are not a verbal "statement" of the same nature as poetry. And text that is set to music is not made poetic by that association. Rather than trying to find a one-to-one correspondence of any kind between Eliot's poems and Beethoven's

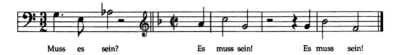

Figure 9.1. Beethoven, Op. 135, 4th movement, unperformed epigraph of themes. The title means "The Difficult Decision"; the text under the themes means "Must it be? It must be! It must be!" (translation by Michael Steinberg).

music, readers would be better served by using the musical analogy as a general rubric suggesting a similarity between the *effects* of the poem's structure and formal devices and the *effects* of similarly structured pieces of music. That is, readers should use the musical analogy to the extent to which it really applies to literature, which is in its results only.

Poetic understanding and musical understanding are essentially different things; but the media that generate these different modes of understanding may have similarities. Patterns and forms may be applied in distinct ways in the two media, but their general effects may be usefully compared and contrasted, in part to determine specifically how language and music differ. It seems clear that Eliot invites this kind of comparison by naming his poem cycle *Four Quartets*. He does not intend for readers to approach his poems *as* music, and readers should thus not look for techniques applicable solely to string quartets. It is conceivable, for instance, that the poem contains four distinct "voices" or "modes," just as a string quartet has four instrumental parts.[1] But what does it mean to be a "voice" in a string quartet? Part of the delight of string quartets is that the different instruments play different roles at times: sometimes taking the lead melody, at other times accompanying the others, and at still other times dropping out entirely. Poetic voice (a concept admittedly difficult to define) does not work in this way. Analysis that strictly maps poetry onto music, then, tends to find what it seeks, usually because the musical side of the analogy is not well delineated. Consider the following as a "musico-literalist" interpretation of the poems:

> The titles of the individual poems in *Four Quartets* each carry significant weight in placing the poems in context, much as a musical composition is set in a specific key or tonality. The titles thus correspond to musical keys. The particular keys can be identified by the initials of the titles: "**B**urnt **N**orton" indicates a key of B (natural) major; "**E**ast **C**okes" centers around C major (with the E natural in the scale); "The

Dry Salvages" signifies, of course, D-sharp major; and "**Little G**idding" is in the key of G minor.

Such an analysis would then show how each tonality is pertinent to the poem to which it belongs. While such processes are entertaining to concoct, a demonstration that they are appropriate to the work at hand is necessary, one which in the foregoing case is lacking. Some works of literature (for example, the "Sirens" episode in Joyce's *Ulysses*) deliberately court this combination of music and wordplay; but the works themselves signal this use of music in fairly obvious ways. *Four Quartets* does not.

The insights reached about the poems in such a way as described above may still be useful, but they usually could be reached without the use of the musical metaphor. In *T. S. Eliot and the Ideology of* "Four Quartets," John Xiros Cooper writes, "Most critical approaches to Eliot's *Four Quartets* that suggest the analogy, don't really do very much with it. They go about the business of interpretation in traditional ways that could have very easily proceeded without the drawing out of the musical parallel in the first place" (168). Whether or not these critiques could have been written without the parallel at all, most of them assume that such a parallel exists and then take it to its conclusion in the poetry without really defining it clearly in the music.[2] This lack of definition becomes more evident when one considers that these critical interpretations have little in common and in fact rarely seem to be in a dialogue with one another. If, on the other hand, the musical side of the analogy were explored first, and the insights from this exploration were applied to the poetry, perhaps significant similarities and differences could be revealed.

To this end, fruitful comparison may be made between *Four Quartets* and the string quartets of Bartók[3] or even of Haydn. After all, Haydn was the originator of the string quartet in its classical form, and Bartók's works are certainly a modernist counterpart to Eliot's modernist poetry. But as John Holloway reminds us, Eliot had studied Beethoven and almost certainly used these studies in *Four Quartets* (147–48). Therefore, Beethoven's quartets are a logical starting point for examining Eliot's use of the musical analogy in his poetry.

BEETHOVEN'S VOICES

The late quartets of Beethoven (Opp. 130, 131, 132, 133, and 135) rank among his finest works, and most people also consider them among the

finest works of their kind. They are generally regarded as his most personal compositions, exploring far-reaching musical and emotional territories while seeming to ignore any audience except the composer himself. Of course, many pieces of music do this, especially those written at the height of the romantic era in music; but Beethoven makes extraordinary use of the quartet form to intensify the personal quality of the music. The string quartet is a highly refined, urbane form of music that is frequently likened to a conversation among four intelligent people. Its instrumentation—two violins, a viola, and a cello—is designed to be heard in intimate settings, such as recital chambers or, as was frequent in Beethoven's Vienna, in large drawing rooms. The ensemble is designed for generally controlled utterances. Yet the flexibility and tonal range of the four instruments allow for great variety of expression. At times, the music can take the form of a melody accompanied by the other three voices; or the four voices can play in a chordal harmonic fashion, not unlike a chorale; or they can engage in polyphonic interplay in the manner of the fugues of Bach. Although Haydn wrote many skillful quartets for strings, Beethoven succeeded in stretching the expressive capabilities of the form to create music at once accessible and profound, simple at first hearing, yet dizzyingly complex and intricate upon lengthy analysis. The late quartets contain extreme pathos juxtaposed with childlike banter. They include several different structural forms, and their motives range from the simplest fragments of melody to leaping, extended multinote lines. There are even passages with virtually no discernible melody.

Although the late quartets of Beethoven make use of a wide variety of musical techniques and styles, they do not represent a complete sample of the range of possibilities for the string quartet. At the same time that they are broad-ranging, they are also intensely focused. This focus is what sets them apart from other works of their kind. For instance, Beethoven does not abandon traditional tonality in these works, even though he explores unusual tonal progressions in them. Nor does he invent new structural forms for the quartets. Instead, he adapts older forms and combines them in innovative ways. (The same can be said for Eliot, whose poetry is essentially metrical and stanzaic, though nontraditionally so.) For all their radical invention, then, these quartets are essentially conservative, even more so when their really striking invention is taken into account: their thematic interrelatedness.

Beethoven's Quartet in C-sharp Minor, Op. 131, will serve as a good example of this "radical conservatism." Unlike traditional three- or four-movement string quartets, including most of Beethoven's own early

quartets, Op. 131 consists of seven movements, two of which are really introductions for the movements that follow them. Furthermore, the first movement, traditionally a fast movement in sonata form (also called sonata-allegro form because of the usual fast tempo), is in this case a slow fugue (*Adagio ma non troppo*). While the last movement takes sonata-allegro form, and two others are in the standard forms of theme and variations and scherzo, the short "introductory" movements are closer to operatic recitative and choral hymn than to traditional chamber music forms. And unlike most quartets, the movements are to be played without a break. The end of each movement either segues into the next via some transitional material or pauses on an expectant fermata that sets the stage for the movement to come. In all cases, the new movement has been anticipated harmonically in the previous one; additionally, the tonality of the entire quartet is laid out in the opening movement. Traditional quartets comprise movements of essentially unrelated material, notwithstanding a return to the original key in the final movement. Beethoven's changes to the standard form serve to make his quartet more organic by connecting the movements in a more than coincidental way.

The movements are linked not only by common tonalities and by the absence of breaks but also by the motivic material itself.[4] In the opening statement of the fugue in the first movement, the first violin plays the theme shown in Figure 9.2 below. These four notes feature two sets of half steps (semitones): the step between the second and third notes, and the step from the first note to the fourth. Since the movement is a fugue, this simple theme is stated separately by each voice and is subsequently varied and developed for the rest of the movement, resulting in an emphasis on half-step motion, woven seamlessly among the four voices of the fugue. Semitones play a significant role in the quartet as a whole, appearing in many places where they might not otherwise be expected. The end of the first movement, for instance, has three instruments playing ascending octaves on the keynote C-sharp; the very next movement (begun without a break) has those same three instruments play a jaunty ascending octave on D, a half step higher than C-sharp. Such an abrupt transition would seem out of place if not for the lengthy preparation for it given by the development of the semitone idea in the fugue. The final

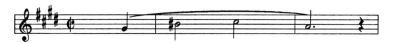

Figure 9.2. Beethoven, Op. 131, 1st movement, mm. 1-3.

Figure 9.3. Beethoven, Op. 131, 7th movement, mm. 21-25.

movement, in C-sharp minor as convention dictates, involves two themes in its exposition section as per sonata-allegro form. The second of these is a near restatement of the fugue theme (with an extension of the idea), shown in Figure 9.3. The C-sharp–B-sharp–A–G-sharp figure that begins this theme is a reordering of the fugue subject G-sharp–B-sharp–C-sharp–A. This recurrence of the same notes in proximity recalls the sound of the opening fugue, even though the rhythm of the final movement is more energetic. The same motif is manipulated even more in the first theme of the sonata-allegro movement (see Figure 9.4). The notes emphasized in this theme are the opening C-sharp, the quarter notes G-sharp and B-sharp, and the A falling on the fourth beat of measure 2. These four notes are the same four from the fugue, this time reordered C-sharp–G-sharp–A–B-sharp and given a completely different rhythm. Not only does the return to C-sharp minor contribute to a sense of coming home, but the thematic material itself is familiar to the audience. This use of similar material in distinct movements is Beethoven's greatest break from traditional practice. The string quartet was no longer a collection of four more or less unrelated sections but a unified work recalling its main ideas throughout the piece. This recurrence of material makes the C-sharp-minor quartet a focused study in mood and expression despite the seemingly expansive range of its innovations in structure and style.

In fact, all of Beethoven's late quartets share this inward-looking quality, as they each have their own cohesive characteristics that bind them together as tightly knit units. Yet they are knit together in some similar ways. The reason is that Beethoven used the two-semitone idea in several of his last quartets. The earliest to be composed was Op. 132, the String Quartet in A Major; its opening theme is shown in Figure 9.5. This

Figure 9.4. Beethoven, Op. 131, 7th movement, mm. 1-3.

Figure 9.5. Beethoven, Op. 132, 1st movement, mm. 1-2.

G-sharp–A–F–E progression is a transposition of the Op. 131 fugue theme with a reordering of the notes.[5] The String Quartet in B-flat Major, Op. 130, opens with a similar combination of ideas, with all four voices in two octaves (see Figure 9.6). The second through fifth notes play on the idea of the consecutive semitone intervals, and if transposed a full step, are the same sequence of notes as found in Op. 132 with the first note changed to descend a half step instead of ascending. And the original finale to Op. 130, the Grosse Fuge, or Great Fugue, in B-flat Major, Op. 133, includes the semitone idea in its "overture" (really an introduction to the piece), its subject, and its countersubject. Figure 9.7 shows its appearance in the overtura. Each of these works develops the semitone idea to an extent in their several movements. So each quartet is an independently cohesive work, but they all cohere in at least one fundamentally similar way. This working of similar material in diverse compositions has come to be known as cyclical music.

Beethoven did not intend the quartets to be grouped together in performance when he wrote them. True, several of his last pieces were written under the same commission of Prince Galitzin. And it is true that he wrote them within the same few years. Nevertheless, the idea of a cycle of quartets would have been foreign to him. It is still true, however, that examining the music as a group highlights some of the important innovations they incorporate as well as gives insight into the musical concerns of a supremely talented, deeply disturbed, deaf composer. Beethoven sought to expand the limits of the string quartet form in his last years. Paradoxically, he did so by compressing and simplifying his basic material while stretching the conventions of form and structure. Rather than do away with traditional forms (as composers such as Berlioz were to do in a short time) or traditional harmonies (not accomplished until the

Figure 9.6. Beethoven, Op. 130, 1st movement, mm. 1-2.

Figure 9.7. Beethoven, Op. 133, overtura, mm. 2-7.

atonal period of Schoenberg and Stravinsky), Beethoven worked within conventions, setting up his audience's expectations and then subverting them. In this way, Beethoven managed to create music simultaneously familiar and groundbreaking, broad in perspective yet narrow in focus. His late quartet cycle (if it can be called that) comprises individual works that each act in this way. In this sense, they are united by their overall effect as well as by some of the details of their content, despite being quite different and self-sufficient works of art.

ELIOT'S INSTRUMENT

Unlike Beethoven's works, Eliot's five-section poems were eventually published as a single group entitled *Four Quartets*, even though the earlier poems had been written ostensibly without a view toward a place in a larger collection.[6] Like the string quartets, they were composed within a few years of one another in the later part of the writer's career (both Eliot and Beethoven were about fifty at the time of their respective quartets' composition). And, like the string quartets, the four poems of Eliot's cycle are self-sufficient. To what end, then, should they be considered together? And how can an analogy with Beethoven's music—or any music at all— help us to understand the poetry?

The "movement" structure of the poems seems a good place to start. Eliot had written poetry in five sections before in *The Waste Land*, so this numerology was not wholly new. However, the strange, unannounced juxtapositions that characterize the earlier poem have become more regular and predictable, usually happening at verse paragraph breaks within a poem section rather than entering in a more imagistic fashion in the middle of a paragraph. The movement breaks thus take on more significance than in *The Waste Land* since they more clearly signal shifts in thought. The length and meter(s) of each movement, especially the fourth movements, provide a decidedly quartetlike variety. Classical quartets typically involve one lighter, shorter section, often placed third in four-movement quartets. These lighter movements, originally based on dance forms such as the minuet, provide a release of tension prior to the climax of the closing sonata movement. Beethoven's favorite kind of short

movement was the scherzo, whose name derives from the Italian for "joke." In his late quartets, the scherzos are lightning fast and often mocking in tone. Eliot's fourth movements serve the same purpose of relaxing the prosodic mood before concluding. They do not contain humor exactly, but they do break the tension built up in the longer, more serious sections that surround them. Although the other movements take different poetic forms, usually longer narrative ones, the fourth movements are more lyrical, more "song-like."

The longer movements themselves differ greatly in feel. Each is loosely divided into two parts, and these parts have different meters. The first section of "Burnt Norton," for example, has two parts: the first part in strong-stress (four-stress) meter, the second in loose iambic pentameter with intermixed strong-stress. By contrast, the first movement of "The Dry Salvages" consists of a section of lengthy lines containing five or six stresses each, but its second part mixes in some extremely short lines. In the context of the long lines, these shorter ones serve not to speed up the verse but to give unusual weight to the words in them, since they are striving to fill the space normally given to many more words. This weightiness implies a feeling of slowness in the poetry; the short lines are moments of extreme pathos, metrically speaking. The first movements are not alone in their metrical variations. The fifth movements typically grow shorter in line length by the end of each poem, serving to reinforce the awareness that the end is approaching. The eye tends to quicken on the final page of a work, and the shorter meter assists rather than retards the expected process of closure. A notable exception is the final half line of "East Cokes," which stands apart from the rest of its section, prolonging the end and giving it more weight.

These observations are pointless, however, unless they are tied to the meanings of the poems themselves. What, for instance, is the purpose of having the strong-stress meter in "Burnt Norton" at all, let alone having it return at the end of the movement? One feature of strong-stress meter is its implicit division into two hemistichs, a feature that Eliot uses to good effect. Each line presents a two-part idea: either a conjoining of two opposites ("Time present and time past"), a qualification of an idea ("Point to one end, which is always present"), or a definition ("If all time is eternally present, / All time is unredeemable"). Further, strong-stress meter suggests a somber, deliberate mood, perhaps from its association with Old English verse. In any event, the opening of the poem has the quality of a solemn pronouncement. The second part of this movement, however, shifts to a less somber narrative, accompanied by a shift in meter.

The dialogue with the bird ends with the statement that "human kind /
Cannot bear very much reality." This idea signals the return of the open-
ing meditation on the nature of time, and the closing lines of the move-
ment return to the opening meter and a partial quotation of earlier lines.
The same words return, only now they are colored by the intervening
material of the movement: the vision of the pool, the tree, the children,
and the sunlight. The effect is remarkably similar to the effect of sonata
form in music, a traditional quartet form. Themes are stated; they are de-
veloped in a free manner; and then they are recapitulated at the end,
incorporating the changes that have transpired during the development.
The return to the beginning provides a satisfying close to the section.

This same kind of analysis can be applied to many of the movements
in *Four Quartets*. Rather than go through them all here, let me mention
some of the poetic structures I find in Eliot that might gain interpretive
power from understanding a musical analogy from Beethoven. The first
movement of "East Coker," a movement with a consistent meter from
start to finish, contains the quotation from Sir Thomas Elyot on rustic
people dancing. The repetition of the poem's first line and the recollec-
tion of the older Elyot's dialect suggest analogies with two of Beetho-
ven's dancelike movements, the *Allegro ma non tanto* second movement
of the A-minor Quartet, Op. 132, and the *Alla danza tedesca* fourth
movement of the B-flat major Quartet, Op. 130, each of which has re-
peated main themes and different dance themes. The second movement
of "The Dry Salvages" takes the form of a modified sestina: the six lines
of the first six stanzas share a common rhyme scheme (with the identical
rhymes returning in the last stanza), and the rest of the movement plays
out the images of the sea, eternity, and experience with a final recollec-
tion of the Dry Salvages themselves. Compare this with the theme-and-
variations movement of the C-sharp-minor quartet, Op. 131, the *Andante
ma non troppo* fifth movement. The same simple theme is varied several
times, and the ending is a long coda that plays on the thematic material,
taking it farther and farther away from the tonal center of the movement
until it comes to an abrupt, understated close.

But while the notion of theme and variations may seem to fit the
"Dry Salvages" passage, other musical structures might fit just as well.
The concept of a fugue, a complex working of several themes, could
serve to illustrate the effect of several recurring ideas. Seldom are all the
permutations of a theme immediately evident to a fugue's audience; nei-
ther are Eliot's readers necessarily aware of the elaborate rhyme scheme
unless they stop reading to look for it. And the dance-form movements

"mirrored" in "East Coker" are based more on the idea of a dance rather than on any rhythmic change in the poetry. Perhaps the *Cavatina* (an operatic song) from the Quartet in B-flat-Major, Op. 130, would serve as a better parallel. It is a less formal structure, and Beethoven's version of it is one of his most soulful musical utterances, a blend of elegance and pathos (one short, and memorable, passage is marked *Beklemmt,* directing the violinist to play the line "agonized"). And what does one do with the quasi–*terza rima* passage in "Little Gidding"? Although it is conceivable to draw a parallel with a movement such as the *Heiliger Dankgesang* (Hymn of thanksgiving) of the Quartet in A Minor, Op. 132 (the *Molto adagio* third movement)—an extended passage in an old-fashioned musical mode, the Lydian, which gives it an antique flavor—the parallel serves as a convenience rather than a necessity. Even the basic idea of a sonata-allegro structure in the poetry can be overworked.

What all these forms have in common, however, is simple thematic materials; passages in which those ideas are developed, often with additional material; and a return to the original materials, changed in light of the development or episodes that make up the middle of the movement. This basic recycling of material—departure and return—is the primary musical element Eliot uses in his poems.[7] The material takes many forms: an image, a phrase, even a metrical structure. But whatever form the return takes, it serves as a reminder of the beginning, or of some earlier part. These returns appear in virtually every section of the poems. In "Little Gidding," the first movement begins with a presentation of coexistent opposites: "midwinter spring," "frost and fire," "between melting and freezing." The midsection describes a journey that is always the same, despite any differences in point of departure in place or time. The conclusion of the movement states: "Here, the intersection of the timeless moment / Is England and nowhere. Never and always." The paradoxes of the opening recur, but they are modified by the midsection's observations on the nature of the journey to Little Gidding. The second movement opens with an old man, fire, and a ruined church, all of which recall the history of Little Gidding alluded to in the first movement but which also anticipate the Dantean vision in the rest of the movement. The third movement picks up the image of the hedgerow and national history from the first movement, and by the end of the movement these images have been "renewed, transfigured, in another pattern." The lyric fourth movement plays on the images of the dove from the second movement, fire from the first and second movements, and Love, which appears in the third movement. And to close the poem, the fifth movement recalls

the recurrent phrase of "East Coker" ("What we call the beginning is often the end / And to make an end is to make a beginning"), an idea that prepares for the closing of the poem. The images of the rose and the dance from the first two movements of "Burnt Norton" appear in the opening of this section, as do the notions of time, love, history, and death and the yew tree (from "East Coker" and "The Dry Salvages"). In sum, the section recalls the important themes that have appeared in the poem cycle up until this point and offers to reconcile them by joining their end to their beginning. The closing section does just that: the fire of "Little Gidding" merges with the rose of "Burnt Norton" in a conclusion that takes the reader back to the beginning of the sequence:[8] This, after all, has been the primary theme of the poem: the link between such oppositions as past and future, life and death, stillness and motion, love and identity. The musical device of departure and return serves this theme admirably.

Eliot also makes use of metrical variation in a way that suggests music. The movements, and the sections within movements, often change in texture from one to the next. This effect is created by line length, stress pattern, recurrence of phrases, rhyme, and other sound devices. As hinted above, Eliot often uses cadencelike endings to his poems. He prepares the reader for a return of the main idea and the ending of a section by shortening the meter and compressing the images. While these effects are used in music, they are not uncommon in poetry (for instance, the couplet ending to a scene in blank verse); and so they are not specifically *musical* borrowings, but standard poetic devices. Their presence in *Four Quartets*, however, supports the idea that Eliot intended a cyclic effect not just in image but in sound.

The return to the beginning in *Four Quartets* differs from more typical literary returns. The idea of there-and-back-again is a primary narrative device in the oldest stories. In traditional narratives, though, development (of characters or situations) takes place explicitly during the journey and return, and the conclusion sums up those changes in a straightforward way. In Eliot's poems, the change is in the way readers view the recurring images, which have not changed except for their position in the poem. The image of the Rose, for instance, is explained no more in the final stanza than in the first one. However, its new resonance in the terminal position results from the reader's change in perspective—a movement despite stillness. Such a process is possible because of the temporal nature of poetry. Eliot himself makes this point in "Burnt Norton" V: "Words move, music moves / Only in time . . ."

Taking the musical side of this statement first, music achieves its effects in time. There is a buildup of emotions and tensions, especially in Beethoven's integrated quartets, from beginning to end. The end *as an ending* is unimaginable without the beginning preceding it. The achievement of a truly great conclusion is its tying up of the section while creating something new with that intangible, elusive quality that sets music apart from mere sound. The audience of such a piece hears the echoes of the music even into the ensuing silence. What has the music meant? Probably nothing that can be articulated clearly, and probably different things for different listeners. But the music has communicated something, even if only a sense of its identity as "music" and not mere sound.

Eliot's poetry does something similar. The integration of its various parts into a well-crafted whole conveys, if nothing else, a sense that the poems are "poetry" and not mere words. The resonances and echoes created by the structures within the poems carry meanings for readers engaged in the temporal process of reading (or hearing) the lines, meanings that overlie and enhance any semantic meanings the words themselves carry. The elusiveness of these resonant meanings is attested by the great number of works offering opposing views on the subject. I will go only so far as to say that many of the significant resonances are better identified, if not completely understood, by means of the musical metaphor.

CODA

Eliot and Beethoven differ in more ways than simply their chosen media. Beethoven's work changed the nature of string quartets by stretching them beyond their traditional limits. Eliot had already contributed many changes to poetry in his earlier work more in the symbolist-imagist vein. Although *Four Quartets* shows the influence of this work, it also relies on more traditional narrative poetic structures. While the meter is looser than poetry in the premodernist tradition, it makes use of many traditional metrical effects. In a sense, Eliot is reverting to a more controlled, subdued poetry after having exploded the boundaries in his earlier writings. In this way, *Four Quartets* resembles the last of Beethoven's string quartets, Op. 135, in its return to a sparser, simpler style. But even this interpretation is debatable: musicologists differ on whether Op. 135 is really a return to classical norms or constitutes a further stretching of the boundaries in the mode of the other late quartets. And certainly *Four Quartets* is not a "traditional" poem cycle.

Perhaps the best analogy between the two sets of quartets is their intimate, inward-looking personality. Each is a self-contained, organic body reliant on the traditions of its form to lend structure and meaning to its motivic materials. A reduction of either to a single sentence or summary would be impossible; yet one feels that it should be possible. The closing in of the works upon themselves creates this effect. Experiencing the works in this way—understanding them in time and over repeated times—is still the most rewarding way to approach either of them. This heightened awareness of time and its effects may be the most useful contribution to a reading of *Four Quartets* that a musical analogy from Beethoven has to offer.

NOTES

1. A. David Moody's *"Four Quartets*: Music, Word, Meaning and Value" is but one of several works to make exactly this analysis.

2. The analyses by Helen Gardner in *The Art of T. S. Eliot* and Keith Alldritt in *Eliot's "Four Quartets": Poetry As Chamber Music* are two of the more well known examples of these critical approaches. Significant as these studies are, they do little to explain why Eliot's approach is particularly musical rather than a different application of a more general principle that music also draws on (for instance, the surfacing of several voices at different times, which happens in both verbal and performing art and is not a strictly musical device).

3. See Mildred Meyer Boaz's *T. S. Eliot and Music: A Study of the Development of Musical Structures in Selected Poems by T. S. Eliot and Music by Erik Satie, Igor Stravinsky and Béla Bartók*. Hugh Kenner also suggests that Eliot was thinking about Bartók's quartets specifically while writing *Four Quartets* (306).

4. This analysis is based on Cynthia Woll's insightful commentary in CD-ROM format. Woll uses HyperCard stacks that accompany a recording of the quartet to illustrate, quite graphically, her analysis of the music.

5. Rather, the Op. 131 fugue theme is a transposition and reordering of this theme, since Op. 131 was composed after Op. 132. For purposes of this discussion, the order of composition matters little; what matters is the connection between the works.

6. See W. G. Bebbington, "Four *Quartets*?" 235–36.

7. Its most frequent appearance in poetry, the ballad refrain, occurs because of the ballad's origins in folk song.

8. The image of the rose appears several times in "Little Gidding" alone. The first movement refers to the "transitory blossom" in the hedgerow, and the

third movement recalls "the spectre of a Rose," suggesting both the blossom in the hedgerow as well as the War of the Roses. In this way the image makes sense even when "Little Gidding" is considered by itself; but the resonances of the rest of the passage strongly suggest a grand return to the beginning not only of the poem but of the poem cycle.

WORKS CITED

Alldritt, Keith. *Eliot's "Four Quartets": Poetry As Chamber Music.* London: Woburn Press, 1978.

Bebbington, W. G. "Four *Quartets?" Essays in Criticism* 39.3 (1989): 234–41.

Beethoven, Ludwig van. *Complete String Quartets and Grosse Fuge.* New York: Dover, 1970.

Boaz, Mildred Meyer. *T. S. Eliot and Music: A Study of the Development of Musical Structures in Selected Poems by T. S. Eliot and Music by Erik Satie, Igor Stravinsky and Béla Bartók.* (Ph.D. diss., University of Illinois at Urbana-Champaign, 1977.) Ann Arbor: UMI, 1977.

Cooper, John Xiros. *T. S. Eliot and the Ideology of "Four Quartets."* Cambridge: Cambridge University Press, 1995.

Eliot, T. S. *"Four Quartets": The Complete Poems and Plays, 1909–1950.* New York: Harcourt Brace Jovanovich, 1971, 115–45.

———. "The Music of Poetry." *Selected Prose of T. S. Eliot.* Ed. Frank Kermode. London: Faber & Faber, 1975, 107–14.

Fischer, Kurt von. *Essays in Musicology.* Trans. Carl Skoggard. New York: City University of New York, 1989.

Gardner, Helen. *The Art of T. S. Eliot.* New York: Dutton, 1959.

Holloway, John. "Eliot's *Four Quartets* and Beethoven's Last Quartets." *The Fire and the Rose: New Essays on T. S. Eliot.* Ed. Vindo Sena and Rajiva Verma. Dehli: Oxford Univeristy Press, 1992, 145–59.

Kenner, Hugh. *The Invisible Poet: T. S. Eliot.* London: Methuen, 1966.

Kerman, Joseph. *The Beethoven Quartets.* New York: Knopf, 1967.

Litz, A. Walton. "Repetition and Order in the Wartime Quartets." *Words in Time: New Essays on Eliot's "Four Quartets."* Ed. Edward Lobb. London: Athlone Press, 1993, 179–88.

Martz, Louis L. "Origins of Form in *Four Quartets." Words in Time: New Essays on Eliot's "Four Quartets."* Ed. Edward Lobb. London: Athlone Press, 193, 189–204.

Moody, A. David. "*Four Quartets:* Music, Word, Meaning and Value." *The Cambridge Companion to T. S. Eliot.* Ed. A. David Moody. Cambridge: Cambridge University Press, 1994, 142–57.

Radcliffe, Philip. *Beethoven's String Quartets*. Cambridge: Cambridge University Press, 1978.

Steinberg, Michael. "The Late Quartets." *The Beethoven Quartet Companion*. Ed. Robert Winter and Robert Martin. Berkeley: University of California Press, 1994, 215–82.

Woll, Cynthia. "Audio Notes." Ludwig van Beethoven, String Quartet No. 14, Op. 131. CD-ROM. Burbank, CA: Warner New Media, 1990.

"My God, What Has Sound Got to Do with Music?!"

Interdisciplinarity in Eliot and Ives

J. ROBERT BROWNING

AMERICAN WAYS

No line of direct creative influence has yet been drawn to connect Charles Ives and T. S. Eliot. Some reasons for comparing them need to be offered right at the start. They were both modernists, and they shared an interest in the poetics of quotation and allusion. They were also near contemporaries. Born in 1874, fourteen years before Eliot, Ives produced the bulk of his music between 1898 and 1918. None of it, however, was published or performed publicly until after the conclusion of World War I, and its composer remained relatively unknown, even among musicians, until the 1950s. Eliot was probably not familiar with Ives, although it is not beyond possibility that he was at least aware of him. A graduate of Yale (1894–98), Ives was residing in New York City and Connecticut while Eliot was attending Harvard, from 1906 to 1914. While at this time he did not publicize his music, he did share it with a small group of musicians and friends, a circle that possibly intersected at some point with Eliot's own. Assuming, however, that Eliot was not aware of Ives before the publication of *Four Quartets*, I believe comparison of their work may still be fruitful. Significantly, they are each widely accepted as *the* principal American modernist figure in their respective disciplines because, among other reasons, of their common devotion to formal innovation: namely, the virtuoso use of the significant fragment and their bent for quotation and other forms of borrowing.

Furthermore, both artists are especially "interdisciplinary" in their approach to art. Ives's philosophy of music was strongly influenced by

195

the American transcendentalist writers, Emerson and Thoreau. Given his programmatic compositions on works by Hawthorne, Emerson, and Browning, and his use of quotation and stream-of-consciousness style— techniques usually associated with literature—Ives is frequently described as a "literary composer." Critics have examined closely how his work resembles that of William Carlos Williams and James Joyce in form and content.[1] Moving in the opposite direction, Eliot was, from early on, much concerned about the musical potentialities of writing, which he inherited from the tradition of French symbolism and about which he came to speak at length in his lecture "The Music of Poetry" (1942). A number of his works are organized after principles, elements, and techniques common in music composition: sonata form, counterpoint, and leitmotif, to name but a few. This interdisciplinary approach has led Eliot scholars to Beethoven, Wagner, Bartók, Stravinsky, and even Berlioz in search of informing musical principles and influences. A small number of passing comparisons of Eliot and Ives may be found in the criticism on each artist, and these, in almost all cases, point to similarities between the densely textured collages found in *The Waste Land* and compositions by Ives such as *The Fourth of July* and the Fourth Symphony.[2]

I am aware of no studies, however, that have explored the potential of this comparison in any detail. In Ives and Eliot we have two artists conspicuously crossing the conventional boundaries established around their respective disciplines: a composer with a great need for literature, and a poet with a great need for music. For both, the *idea* of disciplinary boundary crossing, as well as the forms and other services gathered by such moves, serves in their respective projects of constructing a language that transcends the materiality of their "home" art. By way of interdisciplinary movement between the arts, they each point toward an ideal of spiritual completion beyond art. Significantly, their visions of completion are ideologically opposed to each other—defining two distinctively American paths of development. This difference is primarily reflected in the antithetical directions in which they move between the arts. The movement from music to literature in works by Ives enacts the composer's very American manner of idealism, his desire to actively engage on a conceptual level with the common people his music is about. Eliot's journey from literature to music is, on the other hand, toward what is usually considered a somewhat un-American social exclusivity, which is still curiously American in its vehemence and tone. Twentieth-century European intellectuals rarely celebrate the formal, traditional culture of

Europe with the zeal one often finds among the resident aliens from the new world. Eliot's is an aesthetic of transcendence too, but it moves away from the "common people," like the destitute commoners who inhabit *The Waste Land.* Whether or not a direct line of influence can be drawn between Ives and Eliot, comparative examination reveals much about the concepts, forms, and uses of interdisciplinarity that inform their work and our understanding of it.

CRITICAL ISSUES

Both Ives and Eliot explain their ideas about interdisciplinary composition in critical essays. The issues they address were by no means new at that time; treatises exploring the programmatic potential of music and the musical properties of poetry are commonplace after the sixteenth century. However, while the essays certainly contribute to this critical tradition, they should be viewed largely as companion pieces to their authors' own compositions. In the preface to *Essays before a Sonata* (1920), Ives explains that he intended the prose work to accompany his *Concord, Mass., 1845* piano sonata, composed between 1910 and 1915. J. Peter Burkholder has shown how the *Essays* can also be applied, with caution, to other works written between 1908 and 1918,[3] but clearly Ives envisioned the prose and the sonata as components operating together as a single unit. In his lecture "The Music of Poetry," Eliot also aligns his criticism with his artistic endeavors, if more generally: "I believe," he explains, "that the critical writings of poets . . . owe a great deal of their interest to the fact that at the back of the poet's mind, if not as his ostensible purpose, he is always trying to defend the kind of poetry he is writing, or to formulate the kind that he wants to write."[4]

The fact that both Ives and Eliot felt that the interdisciplinary aspects of their art needed explication is significant. Both were aware of the fuzziness of the boundaries separating the arts and understood that sympathetic readers and listeners would be needed to some extent for these pieces to function as they desired. To more fully realize the "literary" content of the *Concord Sonata*, Ives needed to persuade his listeners at least to entertain the idea that music actually can convey concepts ordinarily expressed only in literary terms. Similarly, a reader is not likely to hear "dissonance" or "cacophony" in a poem, no matter how harsh the passage may be in form or content, unless he or she is somehow otherwise alerted to the suitability of the musical analogy. One needs to be cued to hear the "music of poetry." Eliot's essay offers many such cues,

as do many of his poems themselves by way of musical titles and other references. The title, *Four Quartets*, for instance, inevitably proposes the analogy, inviting us to put the poem in the context of a very particular kind of music.[5]

Much of what we commonly identify as interdisciplinary in Eliot and Ives derives from cues supplied by either the critical essays, allusions in the compositions themselves, or structural forms conventionally associated with one of the other arts. While one can make a case that sonata form exists in *The Waste Land*, as has Paul Chancellor,[6] all that is truly extraliterary or musical about this structure are its origins and the various associations that have come to be attached to it. Insofar as it actually can be translated into literary terms, sonata form is not essentially musical. Quotation in Ives operates in the same way; there is nothing inherently literary about this device beyond our tendency to think of it as such. The disciplinary boundaries Ives and Eliot cut across are determined largely by convention. Such boundary crossing does not make music literary or poetry musical, per se, but it does extend our understanding of the formal limits of each medium, and it taps into the domain of associations belonging to the other art.

What Ives sought in literature differs greatly, of course, from what Eliot looked for in music. Let us take a closer look at each artist's theories about interdisciplinarity, principally as they are outlined in *Essays before a Sonata* and "The Music of Poetry." Consideration of the two artists together shows their particular interarts concerns to be more divergent than alike, with the exception of these common points: both turned to the other arts because their own disciplines did not offer the forms, techniques, and ideas they needed to realize their respective goals; and both strove to get beyond the materiality of their own mediums to arrive at a transparent, absolute aesthetic—an ideal language that they use to forward their respective views about society and spiritual truth.

On one level, Ives's concern with literature is very pragmatic; he wants his music to be about certain things, to express certain ideas and ideals, to be meaningful in the way that an essay or a novel can be but that music, almost as a rule, is not. The opening sentences of the *Essays* jump to the heart of the matter by asking this question: to what extent can music express "the value of anything, material, moral, intellectual, or spiritual, which is usually expressed in terms other than music?"[7] There were many precedents, of course, for programmatic music by Ives's time, among the better known are works by Berlioz, the *Symphonie fantastique* (1830), Richard Strauss's tone poems, and Debussy's symphonic "sketches," such

as *Nocturnes* (1899) and *La mer* (1905). Ives, however, was not satis-
fied with these efforts at musical description, which he considered
mannerist and thus lacking in substance. The distinction he makes
between "substance" and "manner" is critical to an understanding of
the kind of program music he aimed to create in certain of his mature
compositions.

In a passage in the *Essays* critical of Debussy, we find Ives looking to
literature for examples of what he desired to accomplish in music. After
dismissing the French composer's content as "too coherent" ("it is too
clearly expressed in the first thirty seconds") and as insubstantial as glis-
tening soapsuds, he continues:

> Or we might say that his substance would have been worthier if his
> adoration or contemplation of Nature—which is often a part of it, and
> which rises to great heights, as is felt, for example in *La Mer*—had
> been more the quality of Thoreau's. Debussy's attitude towards nature
> seems to have a kind of sensual sensuousness underlying it, while
> Thoreau's is a kind of spiritual sensuousness. It is rare to find a farmer
> or peasant whose enthusiasm for the beauty in Nature finds outward
> expression to compare with that of the city man who comes out for a
> Sunday in the country, but Thoreau is that rare country man and
> Debussy the city man with his weekend flights into country aesthetics.
> We should be inclined to say that Thoreau leaned towards substance
> and Debussy towards manner.[8]

Not content with description appealing only to the senses, and the philos-
ophy of life accompanying such art, Ives aligns his aesthetics with the
ethics and spiritual vision of the American transcendentalists and other
literary figures. His musical aspirations are more toward the essays of
Emerson and Thoreau, in all their complexity of philosophical thought
and feeling, than toward the aesthetic concerns of Debussy or James
McNeill Whistler and *l'art pour l'art*.

Integral to this idea of substance is Ives's focus in the majority of his
mature art on people—crowds buzzing in city streets; people making
music; individual authors; personal memories. A piece resorting entirely
to evoking a phenomenon of nature, such as the movement in Debussy's
Nocturnes entitled "Clouds," inevitably lacks the moral content or human
interest Ives believed art should acknowledge.

Return to the composer's opening question: How can music possibly
approach the conceptual expressiveness of literature, if at all? The *Essays*

provide no easy answers. Programmaticism is seriously questioned in the prologue with Ives's often quoted belittlement of music attempting to represent a stone wall with vines on it. "Can it be done," he asks, "by anything short of an act of mesmerism on the part of the composer or an act of kindness on the part of the listener?"[9] Later, the musical expression of conceptual values is placed under the same scrutiny: "A theme that the composer sets up as 'moral goodness' may sound like 'high vitality' to his friend, and but like an outburst of 'nervous weakness' or only a 'stagnant pool' to those not even his enemies. Expression, to a great extent, is a matter of terms, and terms are anyone's. The meaning of 'God' may have a billion interpretations if there be that many souls in the world."[10] The very existence, however, of these writings as essay-programs meant to be read *before* one listens to the *Concord Sonata* argues that music can be involved in complex, conceptual texts. Ives does not insist here that there can be objective correlation between music and language; words themselves, as he suggests above, are not stable identities. But in the case of the sonata, he does want his auditor to be thinking about the music in certain "literary" or conceptual ways. The composer's nephew, Brewster Ives, recounts how his uncle would first read passages out loud to him from Emerson, Hawthorne, the Alcotts, and Thoreau, and then perform the music, so as "to convince me that the music was expressing the words of the author."[11] The need for Ives to actively promote his music's conceptual potential is essential here, so that this step—in either its oral or written form—becomes an integral component of the composition.

The essay on Hawthorne concludes with a series of items that the music "may have something to do with," each possibility separated with a decidedly unproscriptive "or." Included are a number of specific literary references—*The House of the Seven Gables* and *The Celestial Railroad* among them—but the final items are increasingly vague and effectively deconstruct any particular reading one may have bought to the exclusion of others: "or something personal, which tries to be 'national' suddenly at twilight, and universal suddenly at midnight; or something about the ghost of a man who never lived, or about something that never will happen, or something else that is not."[12] So while the essay prompts the reader/auditor to entertain literary possibilities for the music, it still allows for the idea of the medium's transcendence over semantics.

Eliot's "The Music of Poetry" is similar to Ives's *Essays* in that it seeks to expand the ways we normally think about a particular discipline. Eliot opens with comments about literature's "range" or, more accurately,

about his own range as a "man of letters." He neither wants to limit his discussion to the "purely literary" nor move too far beyond his own territory. If we understand the "purely literary" to mean the conventionally literary, Eliot's interdisciplinarity should be connected with his artistic progressivism ("our first concern is always the perennial question, what is to be done next? what direction is unexplored?"[13]). Music, Eliot suggests, is a discipline from which poets can learn much, particularly with regard to rhythm and structure. In the lecture's final section, the sister art is presented as a repository of new possibilities for poetic form and principles of organization, from the development of symphonic movements to the workings of counterpoint. In the same way that Ives turned to literature largely as an inspiration for new musical directions, so Eliot looked to music to enlarge techniques of poetic expressiveness.

Chief among Eliot's list of various uses for music in the lecture is his idea that the poetic tradition is cyclical, alternating between verse composed of very current, colloquial speech and verse that takes the common tongue and develops its "musical possibilities." By this pattern, in Eliot's broad strokes, Wordsworth is an example of the former, Milton an example of the latter, and Shakespeare an example of both. Where, then, should the author himself be placed? As one very much concerned in his career with both speech rhythms and "musical" elaboration, Eliot appears to be a synthesis of both poles. In *The Waste Land* this synthesis is particularly apparent: numerous fragments of conversational language, unmoored from conventional connecting material, are used in arrangements that have greater musical than literary weight. Similar to Ives, although certainly not to the same extent, Eliot believes the artist must work from the materials at hand to create a work that can transcend locality. Contributing to this process for both artists is their use of interdisciplinarity: Ives's incorporation of essays and notes that direct the auditor's attention to broad moral and philosophical principles; Eliot's use of unconventional or "musical" forms that decontextualize colloquial materials and interrelate them with elements from a broad range of historical periods and cultures.

These boundary crossings also involve each artist's desire to transcend the materiality of their respective disciplines. In an unpublished lecture delivered in 1933, Eliot has been quoted as saying that in his work he tried "to get beyond poetry as Beethoven, in his later work, strove to get beyond music"—to create a poetry "so transparent that we should not see the poetry."[14] This idea of aesthetic purity is commonly associated with the symbolist poets, who as we know contributed greatly

to Eliot's interest in music. In the interests of bringing poetry closer to music, the symbolists dislocated language from conventional semantic values, thus placing greater attention on each word's aural qualities and symbolic potential. In his book on the group, for which Eliot wrote the foreword, Joseph Chiari explains how their verse "aimed at creating a state of trance whence will rise the unheard music, the vision of the absolute."[15] In seeking to "get beyond poetry," Eliot cultivated this rarefied "musical" language of sound, suggestion, and privileged referentiality in his own works; the forms and references borrowed from music in *Four Quartets*, for instance, serve to place the poem in an aesthetic category hierarchically above verse that is more "purely literary," more semantically straightforward and quotidian. Chiari explains how Mallarmé "came to realize that the *logos—God's expression*—was beyond the human, and could not be heard or apprehended, for it was silence—the absolute, source of all things—and the poet, if he were absolutely logical, could only remain silent."[16] Music, for the symbolists and for Eliot, serves as a vehicle for approaching, if not quite reaching, this godly language.

Ives too sought to create art that transcends art, but as a musician he looked for completion in the opposite direction from Eliot. With a profound interest in representing human experience and the spiritual substance that makes it noble, Ives could not be satisfied in his later works with the abstract language of the European classical tradition. What this tradition lacked was a closeness to life, a concrete particularity that his American sensibility required. To make art that transcends art, Ives did not need to cultivate a more rarefied language as did Eliot; this he already had. Rather, what was needed was a language that would allow for more concrete communication. For entirely different reasons than Eliot, Ives valued the voices of popular culture because he heard in these the voice of the divine: "in every human soul there is the ray of the celestial beauty; and therefore every human outburst may contain a partial ray."[17] This idealism is memorably expressed in the following anecdote about George Edward Ives, the composer's father:

> Once a nice young man (his musical sense having been limited by three years' intensive study at the Boston Conservatory) said to Father, "How can you stand it to hear old John Bell (the best stone-mason in town) sing?" (as he used to at Camp Meetings) Father said, "He is a supreme musician." The young man (nice and educated) was horrified—"Why, he sings off key, the wrong notes and everything—and that horrible, raucous voice—and he bellows out and hits notes no one

else does—it's awful!" Father said, "Watch him closely and reverently, look into his face and hear the music of the ages. Don't pay too much attention to the sounds—for if you do, you may miss the music. You won't get a wild, heroic ride to heaven on pretty little sounds."[18]

The spiritual music Ives's father speaks of is found in individual people and must be approached with a minimum of mediation—certainly without the interference of an overly formalized musical education, which can only get in the way of one's ability to "hear" such music. In seeking to express the "substance" or "celestial beauty" of people like old John Bell, Ives rarely insists that his music speak for itself. Verbal explanations, stories, clarifications, and other comments about the music abound in his essays, letters, memos, and on musical manuscripts. Because the conceptual content behind a work such as the *Concord Sonata* was so important to the composer, and because he was not always such a firm believer in music's ability to express particular semantic values, Ives uses his writings, among other purposes, to provide a degree of clarity or direction for those who desire it. As poetry needs the assistance of music to become more rarefied for Eliot, music needs the assistance of verbal language to become more "substantial" or conceptually expressive for Ives. In both cases a more complete language is being sought.

Significantly, the respective interdisciplinary directions Ives and Eliot travel in their pursuit of artistic transcendence reflect their very different political and religious ideologies, including their contrasting visions of the nature of transcendence itself. Ives's movement toward verbal expressivity is integral to the composer's romantic belief in the essential divinity of common people: with words, Ives makes his challenging compositions more accessible and/or relevant to listeners who might otherwise approach classical music genres with trepidation or indifference. To this end, the content of the *Essays* and *Memos* is predominantly nonspecialist in nature, and Ives's writing style in these works is conversational, down-to-earth, and often humorous—decidedly nonacademic. The transcendence he is working toward in literary music is based on a strong democratic sense of community. Even the ultimate height he envisions for art—an idealized music, presently unattainable, past all need for literary assistance—remains firmly human and egalitarian: "But we would rather believe that music is beyond any analogy to word language and that the time is coming, but not in our lifetime, when it will develop possibilities inconceivable now—a language so transcendent that its heights and depths will be common to all mankind."[19] Ives's

efforts to explicate his music in a literary context may be understood as
a necessary step on the path to this transcendent romantic language: for
twentieth-century, postmannerist music to reach its full spiritual potential,
it must first follow the lead of literature, in which Ives finds the only
viable expressions of human "substance" available to him in art.[20] In these
two ways, then, as facilitator to listeners and as model to composers, Ives
uses literature to make music relevant to people more broadly and to
move art closer to the goal of making a language of human unity.

Eliot's movement from accessible semantics to musical sublimity,
on the other hand, enacts the poet's hierarchic social vision, his classi-
cist academicism, and royalist politics. In contrast to the thoroughly com-
munal culminating moment of Ives's idealism, Eliot's artistic pinnacle is
socially and intellectually exclusive, even though he theorized extensively
about the need for sustaining the organic community and communal val-
ues. Somewhere just below logos, which Eliot understands with the
symbolists as a silence beyond human apprehension, we find the elites
of the sociocultural hierarchy[21]—Becket, say, in *Murder in the Cathedral*
or Harry, the Lord Monchensey, in *The Family Reunion*. These are inter-
pellated or chosen in *Four Quartets* in terms of a particular kind of cham-
ber music, which, while not quite as rarefied or semantically abstruse
as the divine hush itself, still challenges the listener. But calling the few to
attend excludes the many. The "music" of the poem does not embrace old
John Bell; it merely admits his type as specimen inhabitant of the ideal-
ized peasant or fishing communities paternalistically revered in "East
Coker" I and "Dry Salvages" I. Only the privileged few, it turns out, can
know the rarest "sounds" the poem makes. And the poem spares no effort
in letting you know you are not one of them.

TWO WORKS

I want to turn now to a specific comparison, namely the significant for-
mal similarity between the Fourth Symphony and *The Waste Land*. Both
works are marked by the liberal use of quotation, allusion, reference in
detail, and by the adoption of the method of collage in the general form
of the works. In both compositions, borrowed material is a conspicuous
presence; indeed, it is the fundamental substance out of which these
works are formed. Of particular interest here are the ways in which quo-
tation functions as a versatile interdisciplinary element, serving the con-
trasting interdisciplinary needs of the two men.

Eliot uses quotations for their referential and representational quali-ties—on literal, symbolic, and textural levels—and these are integral to what he identifies as the musical aspects of verse. In his lecture on the topic, he reminds us that music in poetry is not divorced from meaning. This said, the formal aspects of quotation play a crucial role in moving Eliot's poems towards the "condition of music." Structurally, quotation can be a very flexible unit of composition, as *The Waste Land* demon-strates. In this single poem there are quotes in several different languages, of many different lengths, appearing in a variety of different arrange-ments. As one can see in Eliot's use of the Rhine maidens' lament from Wagner's *Die Götterdämmerung*, quotation and fragmentation frequently go hand in hand. Following two brief treatments of the borrowing— "Weialala leia / Wallala leialala"—all that is needed to re-evoke the refer-ence is a curt "la la."[22] In instances of fragmentation such as this, the aural qualities of words come to the fore but without sacrificing referentiality. The freedom from connecting material allows fragments of quotation to be used somewhat like musical motives—that is, as short recognizable "ideas" or sequences of sound that can be interrelated with other material in a variety of ways. And here we return to the idea that certain formal arrangements are by precedent and convention associated more with music than they are with literature. Eliot's use of quotation as a funda-mental element of composition enables the poet to pursue the forms he found in music with greater flexibility and assurance.

It is interesting that "collage," a term from the visual arts, is com-monly used to describe the dense sections of overlapping quotations and other material that occur in *The Waste Land* and the Fourth Symphony. The interarts aspects of Ives's and Eliot's work, of course, extend well beyond music and literature. But similar to the idea of Eliot writing poetry in sonata form, collage in literature or music are examples of one art exploring its own formalistic potential from the lead of another. Analogy is involved to varying degrees in all these cases. Because music, poetry, and visual art differ materially, the manifestations of collage, sonata form, epigram, and so on, produced by each will inevitably be dif-ferent in certain fundamental respects.

Burkholder has shown that the Fourth Symphony does contain what may be described generically as collage: similar to an artist attaching paper cutouts to a prepared canvas, Ives adds numerous fragments of borrowed tunes to an already coherent musical structure.[23] His proce-dure differs from a visual artist's, however, in that the appended tunes are

placed not only over top the coherent main structure but all around it. In his *Still Life* of 1911–12, Picasso begins with a surface of imitation chair caning, and nearly every object or image he adds to the work partially obscures this surface, relegating it to the background. In the second movement of the Fourth Symphony, on the other hand, we find a much more complex composition: while some tunes are asserted over the main structure, most compose a musical "mud" that seems to span somewhere between the "middleground" and "background." Even when it can be physically determined that a particular tune has been obscured by the sur- rounding music, Ives is not willing to concede that it ceases to be audi- ble: "The Professors and musicians say—'If you don't hear this sound (and a graph does not show the waves of this sound), isn't that proof that they are canceled?'—NO—How does the listener know that he doesn't hear? . . . Can he be any surer about that than an architect can be sure that a certain grain of sand is not in his dam—because he doesn't see it there?"[24] Regardless of whether we are willing to entertain, to this extent, the idea of aural transparency, there can be little doubt that in music Ives does offer the listener a greater array of "levels" to explore than may generally be found in visual collage, a fact underscored by Michael Tilson Thomas's 1991 recording of the Fourth Symphony: "The sym- phony is given a whole new perspective by digital technology," Thomas explains. "Actually, you *can* hear through all the levels—close, middle distance, far away. You can listen through the mass of sound to what's happening in the second clarinet and the second percussion. The Sony recording achieves this huge aural perspective."[25]

The purpose of the Fourth's polyphony is to create the sense of a vis- ionary space, a place filled with the tunes of daily life in early twentieth- century New England, yet removed from their locality.[26] According to the composer himself, the program of the work concerns "the searching questions of What? and Why?, which the spirit of man asks of life." More specifically, the prelude asks these questions and "the three succeeding movements are the diverse answers in which existence replies."[27] The second movement, commonly referred to as the "Comedy," has been de- scribed as resembling New York's Times Square during "a particularly vertiginous rush hour."[28] Short bursts of recognizable melodic scraps, original motives, and a wide array of sounds that defy classification come and go with various degrees of suddenness, consistently denying the listener any sense of conclusion. In some sections this thick montage becomes the very fabric of the music, a saturation analogous to that found

in the final lines of "What the Thunder Said." The "answer" that this tumultuous movement offers regarding life's great questions is, of course, anything but an answer. The exceedingly sober fugue of the third movement, on the other hand, offers a very clear solution—it has been described as "an expression of the reaction of life into formalism and ritualism"[29]—but in the overall context of the symphony, its conformist ease also fails to satisfy.

If the second movement provides examples of collage being used to represent waywardness in the quest for spiritual fulfillment, then the fourth movement shows how Ives uses the form to express spiritual struggle and resulting transcendence. Appropriately, the music focuses on variations of "Bethany" ("Nearer, my God, to Thee"), a clear example of one way the composer uses musical quotation semantically. While no words are actually sung here, the hymn's melody refers the informed auditor to its text; quite literally, by the end of the movement, when this hymn comes to the fore, the music communicates that the symphony's spiritual quest has finally progressed "nearer" to God. Significantly, "Bethany" does not appear in either of the previous two movements, which have proven to be false paths.

Both musically and contextually, the fourth movement is a grand expression of synthesis. In addition to "Bethany," fragments from at least eleven hymns are incorporated into Ives's text; but, quite unlike the cacophony and hubbub of the second movement, all of these tunes are "interrelated in an intricate web of melodic resemblance."[30] Despite the many layers of tunes sounding on top of one another, Burkholder observes, the texture of the whole creates a complex yet unified impression. Even on the level of individual tunes, this idea of union is expressed: an important musical theme in the movement is one Ives creates by fusing similar melodic phrases from "Bethany" and "Missionary Chant." The well-known tune "Martyn" is then related contrapuntally to the two hymns and the new theme. Contextually, the three quotations work well together because each is concerned with the matter of salvation.

In comparison with Eliot's cosmopolitan scope, Ives's dense use of regional New England quotations may be considered parochial. It can be argued, however, that the composer's work is no less expansive. In his own defense, Ives reasons that "if local color, national color, any color, is a true pigment of the universal color, it is a divine quality, it is a part of substance in art—not of manner."[31] It is this "universal locality" that Michael Tilson Thomas detects in the symphony:

Walt Whitman contemplated writing a prose-poem, or something like it, about music. His central idea revolved around the notion of myriad songs sounded in unison, songs of different peoples, of countries: soldiers' marching songs, lullabies, hymn tunes, dance-hall music, the sounds of battle, the songs of Hindu mystics—all these different songs of humanity, seemingly in conflict, yet somehow harmonized into one great universal song. The Fourth Symphony is as close as you can get to that universalist vision in American music.[32]

While Ives does not incorporate anything as exotic as Hindu songs into his work (he would have considered such international reaching—so effortless for Eliot—to be manneristic), his uniting of so many disparate genres from his own musical experience—song, hymn, march, sonata, fugue, symphony—indicates a sensibility that is not limited by the gravitational force of mere categories. The high culture of fugue and the popular culture of march and song both ultimately dissolve into a single material in the Fourth, as do dogmatic definitions of spiritual identity: "A conception unlimited by the narrow names of Christian, Pagan, Jew, or Angel!" Ives writes. "A vision higher and deeper than art itself!"[33]

Collage, as many commentators have noted over the years, plays an equally important role in *The Waste Land*. Similar to Ives's symphony, the poem uses the form to bring a great number of voices together, some in conflict (as in the second movement) and, in some instances, into more harmonious interaction (as in the fourth). A suitable section of the poem to compare to the fourth movement is "The Fire Sermon." Eliot uses collage here, as elsewhere, to bring fragments of human experience into a wider, suprahistorical perspective. His aim? To understand, perhaps, the fragility and fintitude of the human at the end of time. While the juxtaposition of stylistically heterogeneous fragments is frequently jarring, and meant to be so, the succession of meanings is quite the opposite. Frequently Eliot is striving for "interpenetration and metamorphosis" between his quotations; that this should take place under the nose of stylistic disparity only increases the intensity of successful unions. In these lines, for example, quotations of the Buddha's Fire Sermon and Augustine's *Confessions* are intermingled:

> *Burning burning burning burning*
> *O Lord Thou pluckest me out*
> *O Lord Thou pluckest*
>
> *burning (308–11)*

Stylistically, these lines may be described as jarring or "dissonant"; the sheer minimalism of the two voices defies union. When we consider their respective meanings, however, they are found to be almost seamlessly fused. The Buddhist references concern the fires of human passion, hatred, and infatuation, while Augustine's lines are derived from God's challenge to Satan in *Zechariah* iii: "is not this a brand plucked out of the fire?" which refers to Joshua's conversion from atheism to belief.[34] In this light, we find that the quotations are linked on the level of their contextual references to human vices and/or disbelief (fire), and to the need for deliverance from these failings. Their arrangement on the page implies that, at least for now, such deliverance is not possible. As he recognizes in the poem's notes, Eliot has managed to bring together elements from the East and West, the religions and philosophies of two very different cultures. In a similar fashion, other quotations acting as representatives of various moments and perspectives in human history are yoked together, creating a complex web of meaning.

But *The Waste Land*, of course, is not primarily about union and harmony. While cultural connections are indicated on the level of Eliot's sources and references, formally and stylistically the poem enacts cultural disconnection. One of several sections that can be profitably compared to Ives's second movement is "The Burial of the Dead," which offers a similarly jarring and often confusing organization of voices. At least ten can be identified in the section's seventy-six lines and, like Ives's motives, these too are fragmented—just as we begin to grow familiar with one voice and expect it to develop or come to some fruition, it is suddenly broken off by a paragraph break or is eclipsed by a new and different voice. It is often difficult, however, to be entirely sure where a given speaker ends and another begins. While the first verse paragraph contains at least three "voices," this does not necessitate the existence of three speakers; a case can be made that just one, explicably multifaceted individual is the source of them all.[35] Indeed, if the poem's "Notes" are in fact part of the poem, then the cosmopolitan and polymath author of the "Notes" is certainly able to "do" the poem in different voices.

It is tempting to compare this profusion of voices in *The Waste Land* to Ives's musical "mud." In both cases, discordant stylistic heterogeneity is used as a means of portraying modern human experience more truthfully. In performance, however, there is a great difference between musical and literary "mud": where the composer's voices frequently mass together and come at us in a torrent, the poet's must be read one at a time and will no doubt proceed at the reader/auditor's own pace. Where

Ives's mud tends to overwhelm, Eliot's learned ventriloquism tends to intimidate. Largely, this distinction has to do with the very different ways in which music and poetry are taken in. Both works pose great challenges to their audiences, and neither allows for any sense of complete understanding. But where Ives creates an experience for the listener that communicates this impossibility at a single sitting, Eliot's scholarly-seeming notes are calculated to draw the reader into the poem's complexities over an extended period of time, to ensure that a certain degree of effort is exerted on the path to intellectual alienation. In effect, the notes create the impression that the poem *can* be understood, that enlightenment *is* possible, yet the help they provide toward such an end does not satisfy, at the end of the day, the promises they seem to make.

Beyond the many voices of *The Waste Land* and the Fourth Symphony, two very different authorial voices can be discerned. One obvious way of approaching the opposed social-political-religious visions of Ives and Eliot in these works is to consider the two very different places from which they are made to speak—America and Europe. For Ives, the concept of America carries very specific idealistic connotations. Among other things, it represents a commitment to freedom of thought and an accompanying spiritual honesty, which the composer frequently speaks of in gendered terms as a form of masculine strength. Integral to these ideals is Ives's ardent appreciation of diversity and individuality and his firm belief in "the innate goodness of humankind."[36] This "American" optimism is evident in the composer's anecdote about old John Bell, as it is in his treatment of individual voices in the Fourth Symphony. Dissonance in Ives is not usually an expression of human or spiritual discord in any negative sense. A forerunner to the kind of reverence for aural diversity (and experimentation) found in John Cage, Ives uses dissonance as a natural extension of the conventional tonal register, a vast range of sounds the European tradition had left largely unexplored. In the fourth movement, lack of consonance represents a multiplicity of individuals; and yet these many voices, as observed above, create a unified impression. While the third movement also offers unification, it does so at the expense of allowing individual voices to speak. The democratic optimism of the symphony as a whole is expressed in the way the final movement uses many individual voices, insisting that they each be played, simultaneously creating a new sound that includes them all.

The voices of *The Waste Land* lack any such democratic harmony—if they are united at all, it is in their mutual sterility and isolation. Significantly, Eliot locates the poem in postwar Europe, his adopted home.

In this context, multiplicity and fragmentation are signs not of freedom and individuality but of disorder and decline. Our interest in a quoted fragment in *The Waste Land* and the Fourth Symphony should concern not so much what it was, as what it has become, within its new context. Consistently in Eliot's poem, the metamorphosis that quotations undergo represents a fall. The lines from Spenser's "Prothalamion" used in "The Fire Sermon," for example, move from their original celebratory ethos to lamentation in the context of Eliot's description of a physically and spiritually polluted Thames (lines 175–79). Quotations are frequently made to sound discordant. Quite unlike Ives's fourth movement where the borrowed fragments share melodic resemblances, the collage of *The Waste Land*'s final verse paragraph is designed to defy aural synthesis; each borrowed voice, despite the many new voices now surrounding it, remains utterly isolated. When the poem does offer instances of cultural connection, as at the end of "The Fire Sermon," they occur at a level of reference not accessible to readers without the necessary learning. Indeed, they silently invite the uninitiated to get themselves off to the library.

If to Eliot's use of the quoted fragment and the forms of organization it enables we attach his efforts to further the musical possibilities of verse, then "music" should be interpreted as contributing to the isolation of voices in *The Waste Land*. On a formalistic level, fragmented quotations become a means of approximating the flexibility of musical motives, simultaneously distancing the poem's allusive details. Armed with this basic unit of composition, Eliot pursues the symbolist ideal of an absolute, musico-poetic aesthetic, a poetry that "gets beyond" poetry, separating readers who are able to "hear" its "music" from those who find in it only fragmentation. Disparity and difficulty of interpretation become symptoms of a culture divided between those who know and the others who do not. While Ives also demands a great deal of effort from his listeners, difficulty is not a condition he laments—it is a positive aspect of life's abundant diversity rather than a sign of societal or cultural decline: "beauty in music," he observes, "is too often confused with something that lets the ears lie back in an easy chair."[37] At the same time, an integral part of Ives's American idealism is the desire for forthright self-expression; if his compositions are often overwhelming in their mass and complexity, Ives speaks in his accompanying writings with a down-to-earth voice that can greatly assist us in our efforts to appreciate the music. For the composer, this accessible literary component helps to move music from the abstraction of the European tradition toward greater semantic clarity and meaningful communication with people.

Comparative examination of the ways Ives and Eliot use interdisciplinarity reveals that the *direction* an artist moves in crossing artistic boundaries is ideologically significant. In this particular comparison, there is consistency in the meanings of their respective disciplinary migrations: both, for one thing, are thoroughly American and speak to the sometimes hidden complexity of American culture. Ives's American idealism reaches out from the European music tradition toward literature, and Eliot's very American Old World conservatism extends from literature to European music. To a certain extent, as I have observed, these moves function formally, helping the artists to push beyond the conventional limits of their "home" mediums. Perhaps more important, however, they become active metaphors for transcendence. As George Ives uses synaesthesia to describe how to behold the divine in old John Bell ("Watch him closely . . . look into his face and hear the music of the ages"[38]), the younger Ives and Eliot both use the idea of passage to an *other* art to represent the heights of human potential. The different directions of these passages enact the artists' contrasting modernist credos.

NOTES

1. See Walter E. Johnston, "Style in W. C. Williams and Charles Ives," *Twentieth-Century Literature* 31.1 (1985): 127–136; and Peter Dickenson, "A New Perspective for Ives," *The Musical Times* 115.1580 (1974): 836–838.

2. See, for example, J. Peter Burkholder, *All Made of Tunes: Charles Ives and the Uses of Musical Borrowing* (New Haven: Yale University Press, 1995) 369; Henry Cowell and Sidney Cowell, *Charles Ives and His Music* (New York: Oxford University Press, 1955): 147.

3. J. Peter Burkholder, *Charles Ives: The Ideas behind the Music* (New Haven: Yale University Press, 1985): 5–6.

4. T. S. Eliot, "The Music of Poetry," *Partisan Review* 9.6 (1942): 452.

5. For a discussion on the contextual significance of music in *Four Quartets,* see John Xiros Cooper, "Music As Symbol and Structure in Pound's *Pisan Cantos* and Eliot's *Four Quartets*" in *Ezra Pound and Europe*, ed. Richard Taylor and Claus Melchior (Amsterdam: Rodopi, 1993): 177–89.

6. Paul Chancellor, "The Music of *The Waste Land*," *Comparative Literature Studies* 6.1 (1969): 21–32.

7. Charles Ives, *Essays before a Sonata and Other Writings*, ed. Howard Boatwright (New York: Norton, 1961): 3.

8. Ibid. 82.

9. Ibid. 3.

10. Ibid. 8.

11. Vivian Perlis, *Charles Ives Remembered* (New York: Norton, 1974) 74.

12. Ives, *Essays* 42.

13. Eliot, "The Music of Poetry" 451.

14. Quoted in Alex Aronson, *Music and the Novel: A Study in Twentieth-Century Fiction* (Totowa, NJ: Rowman, 1980): 17.

15. Quoted in Ronald Bush, *T. S. Eliot: A Study in Character and Style* (New York: Oxford University Press, 1984): 177.

16. Ibid.

17. Ives, *Essays* 97.

18. Ives, *Memos*, ed. John Kirkpatrick (New York: Norton, 1972): 132.

19. Ives, *Essays* 8.

20. Ibid. 100–101.

21. Cooper 182.

22. Eliot, *Collected Poems: 1909–1962* (London: Faber, 1963) 74. Further references are given in the text by line number.

23. Burkholder, *All Made of Tunes* 370.

24. Ives, *Memos* 67.

25. Quoted in Jan Swafford, "Answering the Unanswerable Question," *Gramophone* (Feb. 1991): 1494.

26. Burkholder, *All Made of Tunes* 391.

27. Quoted in Swafford 1494.

28. Ibid.

29. Quoted in Burkholder, *All Made of Tunes* 402.

30. Ibid. 408.

31. Ives, *Essays* 81.

32. Quoted in Swafford 1495.

33. Ibid. 1494.

34. B. C. Southam, *A Student's Guide to the Selected Poems of T. S. Eliot*, 5th ed. (London: Faber, 1990): 132.

35. Michael H. Levenson, *A Genealogy of Modernism* (Cambridge: Cambridge University Press, 1984): 171.

36. Burkholder, *Charles Ives: The Ideas* 9.

37. Ives, *Essays* 97.

38. Ives, *Memos* 132.

Benjamin Britten and T. S. Eliot
Entre Deux Guerres and After

C. F. POND

INTRODUCTION

The English composer Benjamin Britten, born in 1913, is not usually considered a modernist, at least in comparison to figures like Arnold Schoenberg or Igor Stravinsky. Unlike these composers, Britten was not responsible for pioneering new methods of composing contemporary "serious" music in the first half of the twentieth century.[1] Britten never completely abandoned tonality, and he embraced the twelve-tone system only partially in some of his mature and late works. Nevertheless, in the first part of this essay, I want to consider Britten as someone on the "side" of modernism. Although not always manifestly, or by manifesto, a modernist once established as a British composer of international standing, Britten undertook early in his career what we might now call the unmapping and remapping of English music, in particular English vocal music. He did so in conscious opposition to the music, and some of the ideologies, of the Victorians, Edwardians, and Georgians: Parry and Stanford, Elgar, Vaughan Williams, and others.

In the 1930s and early 1940s, Britten's attempt to refashion English music was connected with W. H. Auden, a poet he collaborated with on a number of occasions and whose views on politics and politically committed art he quickly came to share. Out of this friendship grew music for film and theater, the symphonic song cycle *Our Hunting Fathers*, Op. 8 (1936), the song collection *On This Island*, Op. 11 (1937), a number of other songs, some only recently published or performed, and the operetta on American pioneering mythology, *Paul Bunyan* (1941). To a significant

degree, Auden allowed Britten to break away from Edwardian and Geor-
gian models of English word setting, from folk song–like material that car-
ried nationalist overtones, and from the late-romantic idioms of Brahms,
Wagner, Strauss, and Sibelius. But Britten's refashioning of English music
between about 1935 and the end of the World War II also, I believe, can
be understood in the light of the persuasive and influential modernism of
T. S. Eliot.

At first glance, such contextualizing may seem unnecessary: as a
poet, Eliot was unlikely, after all, to influence Britten *musically*, and
Britten had far fewer personal ties with Eliot than with Auden. The his-
tory of Britten's relationship with the older poet is, indeed, mostly one
of failed collaborations and meetings.[2] And although by the late 1960s
Britten owned Eliot's complete poetry and had thirty years' acquaintance
with it, there is no conclusive evidence that he was familiar with Eliot's
criticism and journalism, especially the early modernist essays. More
than Auden, however, Eliot provides a touchstone, allowing us to see
how Britten both fit and did not fit modernist agendas between the wars.
On the one hand, discussing Britten in tandem with Eliot allows us to see
just how widespread certain modernist ideas had become—ideas about a
cosmopolitan tradition that was not inherited but "obtain[ed] . . . by great
labour," or about professionalism in art, for instance. On the other hand,
viewing Eliot through the eyes of a composer like Benjamin Britten
gives a sense of how unfocused the edges of modernism could be and of
how personal concerns and readings could take the place of centralized
and "impersonal" ones—readings that Eliot did much to promote, at least
publicly, and that academic criticism echoed until fairly recently.

There is, of course, another and in a sense nearer connection with
Eliot, one that provides more immediate justification for discussing him
and Britten together. In the 1970s Britten set two of Eliot's shorter
poems, "Journey of the Magi" and "The Death of Saint Narcissus," to
music. Eliot may allow us to describe some aspects of Britten's position
vis-à-vis modernism, as we shall see in the first part of this essay, but
Britten also allows us, in a quite literal way, to sound Eliot. *Canticle IV:
Journey of the Magi*, Op. 86 (1971) and *Canticle V: The Death of Saint
Narcissus*, Op. 89 (1974) mark a nearness to Eliot that Britten did not
achieve within the poet's lifetime. They also mark the final arrival point
of Britten's conscious creation of a Purcellian vocal tradition in the years
following the World War II, since the canticle as a genre was modeled
on some of Henry Purcell's *Divine Hymns*. Intentionally or not, the Eliot

canticles are appropriate to the poet they set, deriving from Britten's sense of Purcell's music as "present" as well as past. For this reason, if no other, some laying-out of similarities between Eliot's and Britten's "modernist" sense of tradition seems suitable. But these late canticles of Britten can also be understood partly as personal readings of, even tributes to, Eliot as a religious poet. Britten felt an affinity for Eliot's verse not, I believe, *because* Eliot was a modernist, but because Eliot appealed to him on both personal and practical grounds, and because Eliot's poetry, itself highly musical, presented a challenge that Britten wanted finally to take up. The second part of this essay will look at how Britten responded to that challenge, as well as at the ways in which Eliot viewed the difficulty, or desirability, of having his own verse set to music.

PROFESSIONALS

In April 1918 Eliot contributed an essay to *The Egoist* called "Professionalism, Or . . ."[3] It was a belated response to an article that had appeared two months before in the *Times Literary Supplement (TLS)*, in which the writer had strenuously attacked professionalism in art.[4] He argued that "poetry in England has been a living art so long because it has had the power of freeing itself from professionalism" (50)—that is, from "mechanical invention" (49), an unnecessary or unnatural difficulty of style that got in the way of transcendent expression. Professionalism, he argued, made us "aware of the difficulty, not of the art" (49). By a confusing doubling of terms, however, it was also "a device for making expression easy" (49).[5] "Great" art was easy in another sense: "We feel that we could have done it ourselves . . . indeed, where our aesthetic experience of it is complete, we feel as if we were doing it ourselves; our minds jump with the artist's mind. We are for the moment the artist himself in his very act of creation" (49). It is likely that Eliot would have found this understanding of the aesthetic experience inadequate, given its naïve assumptions about interpretation and intention.

What Eliot stressed in his own essay was not the reader's or viewer's understanding of the "act of creation" but the artist's: "Surely professionalism in art is hard work on style with singleness of purpose" (61). The forceful cadences of this statement privilege style, rather than theme or form, as the central concern of the poet. Such emphasis is typical of Eliot's early modernism and can be related to the more famous statements on impersonality in art that he was to make a year or so later in

"Tradition and the Individual Talent." But Eliot's definition of professionalism also raises the question of *whose* style counts in the eyes of other artists and of the public.

The underlying argument between Eliot and the *TLS* writer had less to do with aesthetics, I think, than with tradition, history, and what Eliot saw as England's artistic insularity—with British nationalism, in other words. He attacked the "British worship of inspiration" and the corresponding "dislike of the specialist" (61) that characterized the English upper classes in particular.[6] A suspicion of professionals, Eliot thought, was "behind all of British slackness for a hundred years and more" (61). As Louis Menand has pointed out, this is audibly the voice of an outsider.[7] But Eliot's stance regarding the professional artist was also one way of defining his difference not as an American but as a modernist. Professionalism allowed Eliot to draw a distinction between himself and the establishment, between the modernism he advocated and the kind of poetic renaissance forecast by Edward Marsh in the first volume of *Georgian Poetry*.[8] "This volume is issued in the belief that English poetry is now once again putting on a new strength and beauty": in the event, that new "strength" turned out to be modernist.

As in many of the essays Eliot wrote for *The Egoist*, the essay on professionalism included an attack on the nintheenth century. Eliot purported to find writers like Carlyle, Thackerey, Ruskin, and George Eliot "Conspicuously . . . anti-professional" (61). Taken out of the context of his extended argument with the Georgian establishment in the 1910s, Eliot's assertion that the nineteenth century was "anti-professional" is not credible, however, and should not be taken at face value. The rise of professionalism, including the formation of professional associations, in fact began in the second half of the nineteenth century (Menand 113–19). Eliot's own professionalist stance can be understood as part of this process: "Insofar as art still banked on the unprofessional side of its reputation" in the early years of the century, "the artist was . . . beginning to lose vocational ground" (Menand 117). Eliot was interested in gaining ground for modernism, and ten years on he had largely succeeded.

Just as Eliot argued in favor of professionalism at the start of his career, so Britten argued in favor of professionalism at the start of his, and indeed all his life. Like Eliot, Britten can be seen as one example of the rise of the professional artist in the twentieth century. In a 1963 interview he said that he "passionately believed in professionalism" and that as a composer his aim was "to tear all the waste away; to achieve perfect clarity of expression," a statement comparable in emphasis to Eliot's

belief that professionalism means "hard work on style with singleness of purpose."[9] But although both Eliot and Britten may have worked with single-mindedness, professionalism is not a simple issue of how either poet or composer "practiced." Eliot's early stance on professionalism may accurately have reflected his own seriousness of purpose as a young poet, but it was also a provocative modernist "move" against the establishment and the Georgians. Britten composed as a professional, but I doubt whether his music would have sounded any less "Brittenesque" had he not thought of himself as professional, although the kinds of occasions and performers he composed for might have differed. His public position regarding professionalism, like Eliot's, was part of a larger cultural debate.

THE FOLK-ART PROBLEM

In the case of Britten, that debate was about the nature and role of music in modern British society, about Englishness, and about an English musical tradition. While living in the eastern United States during the early years of the war, Britten published an article called "England and the Folk-Art Problem."[10] In it he relates two issues in contemporary music: the status of the composer as amateur or professional, and the kind of musical material that might furnish the basis for English music. Elgar, he writes, "represents the professional point of view, which emphasizes the importance of technical efficiency and welcomes any foreign influences that can be profitably assimilated.[11] Parry and his followers, with the Royal College of Music as their center, have stressed the amateur idea *and they have encouraged folk-art*, its collecting and teaching.[12] They are inclined to suspect technical brilliance of being superficial and insincere. This difference may not be unconnected with the fact that Elgar was compelled to earn his living by music, whereas Parry was not. Parry's national ideal was, in fact, the English Gentleman (who generally thinks it rather vulgar to take too much trouble)" (71).

This is only partly a case of disliking the musical styles of composers of the "Parry school": Vaughan Williams, John Ireland, Herbert Howells, Bax, Bantock, Butterworth, and a whole host of others who wrote and published music between the turn of the century and World War II. Britten's description of the two "schools" of English composers is rather idiosyncratic and, like Eliot's condemnation of the nineteenth century as "anti-professional," needs to be read cautiously: Parry was not influenced by folk song and did not encourage its teaching, for example,

whatever he may have felt about his status as a composer. On the other hand, Vaughan Williams, whom Britten scrupulously avoids mentioning, did play a prominent role in the folk song revival in the early years of the century. There is undoubtedly a class issue involved in Britten's dislike of the "English Gentleman composer": Parry had been educated at Eton and Oxford; Vaughan Williams similarly came of the "small gentry" and had private means. Britten, like Elgar, had to earn his living by composing.[13] The issue is not so clear-cut as this summary suggests, however, since Britten came from the middle classes but had, like Parry, gone to a "public school."[14] The dislike registered by Britten's disparaging tone of voice in describing Parry's "national ideal" came from his relative *nearness*, in class terms, to composers like Parry or Vaughan Williams.

Sensitivity to class, then, was part of Britten's dislike of the "English Gentleman composer," but a more fundamental point of contention was "folk art" and the problem of just what should be the tradition supporting contemporary English music. For a composer like Ralph Vaughan Williams, as for a number of others in the first decades of the century, folk song represented the way forward for English music. As Vaughan Williams argued in his series of lectures on "national music" in 1932, the folk-song revival at the turn of the century had "freed us from foreign influences which . . . we could not get rid of": "The knowledge of our folk-songs did not so much discover for us something new, but uncovered for us something which had been hidden by foreign matter."[15] Native folk song, along with the music of Tudor England (which Vaughan Williams believed to be closely connected with folk song) provided an antidote to late German romanticism.

In 1941 Britten felt very different about the value of folk song as a basis for what he called "organized music" (Britten, in *Modern Music* 72), although any discussion of his position must take into account his own later folk-song arrangements.[16] He did not believe that folk songs— "concise and finished little works of art"—could provide an adequate basis for thinking in "extended musical form" (73). Nor did Britten believe that folk song provided a helpful model for English word setting: "I recall a critic once asking me from whom I had learned to set English poetry to music. I told him Purcell; he was amazed. I suppose he expected me to say folk music and Vaughan Williams" (Schafer 120). For both musical and textual reasons, then, Britten tended to equate a reliance on folklike material with amateurism and technical inability—an equation that was somewhat self-serving and, as in the comment on Vaughan Williams, dismissive.

The charge of "technical incompetence" is frequently made in the letters and diaries from the 1930s. After hearing a broadcast concert in December 1935, for instance, which included works by Elizabeth Maconchy, Grace Williams, R. O. Morris, Robin Milford, and Vaughan Williams, Britten wrote to Grace Williams:

> After you of course the music in the programme was finished. I struggled for about three or four minutes with R. O. Morris & then switched off. I tried to be politely interested in Robin Milford, but failed utterly. The fifteen biblical songs [*Five Mystical Songs*] of R.V.W. finished me entirely; that 'pi' [pious] and artificial mysticism combined with, what seems to me, technical incompetence, sends me crazy. I have never felt more depressed for English music . . . especially when I felt that that is what the public—no, *not* the public, the critics love and praise. (*PFL* 364)

The sarcasm of this description provides a measure of how uncongenial such music was to Britten's own musical thinking. But it also reflects his impatience to receive public performance and critical acclaim for music that, in the 1930s and early 1940s, was often criticized for being "brilliant" and "clever" but not profound or emotionally engaging. Certainly, it was not always music that allowed the listener's mind to "jump with the artist's mind" in its act of creation. Britten's comment in 1941 on the establishment's suspicion of "technical brilliance" had more than a touch of personal bitterness behind it. In place of what he felt was a "[pious] and artificial mysticism" in the music of a composer like Vaughan Williams, and indeed in much English music of this period, Britten wanted to write music that was satirical (often politically so), witty, and cosmopolitan. It is important to remember, too, that Britten was not only musically precocious in an environment that he felt distrusted brilliance; he was also both homosexual and a pacifist. For these reasons, as much or more than because of his "modernism," Britten moved uneasily in the circles of the musical establishment and in British society.[17] And yet he felt himself to be an English composer, and wanted, I believe, to be *the* English composer of the twentieth century.

TRADITION AND THE INDIVIDUAL COMPOSER

In order to achieve this kind of public recognition, Britten needed to refashion musical Englishness and English musical taste. He did so partly by redefining the modern composer's musical inheritance. Like Eliot

twenty and thirty years before, Britten promoted a tradition that was European and sought in his music to create a sense "not only of the pastness of the past, but of its presence."[18] In terms of the English past, Britten jumped over the nineteenth century (including the recent musical "renaissance") in favor of the seventeenth: his return to a Purcellian manner of vocal writing suggests an interesting parallel with Eliot's early championing of the Jacobean playwrights and poets in favor of the romantics, even if some of Eliot's preferences were later to change.

Some of these similarities regarding tradition can be found in an essay written in the early 1950s by the tenor Peter Pears, for whom Britten composed many of his songs and operas (and who was also his lifelong partner). Pears describes Britten's chosen inheritance in terms that, consciously or not, echo one of Eliot's most influential essays, "Tradition and the Individual Talent," as well as Britten's own views on "amateurishness":

> Britten has never claimed to be an innovator; the generation of revolutionaries was the previous one to his. He felt early that the academic tradition in this country was built on stale amateurishness and pretentious muddle. He learnt that as a result of the explosions in the musical world of the first decades of this century, the younger composer had to build his own tradition. In endeavouring to do this, Britten has gone to the purest stream of modern music. Monteverdi, Purcell, Bach, Haydn, Mozart, Schubert, Verdi and, of later figures, Mahler, Berg and Stravinsky—from all these he has learnt much in his search for the classic virtues of a controlled passion and the "bounding line."[19]

Eliot had used a nature metaphor similar to "the purest stream of modern music" in defining (or redefining) tradition in 1919: "The poet must be very conscious of *the main current* [of the past], which does not at all flow invariably through the most distinguished reputations" (55).[20] Eliot very cleverly navigates around the obstacle of reputation in setting up a continuity of greatness in the first part of "Tradition and the Individual Talent," for he suggests here that the canon of "masters" should not be based on fame but on another quality. This quality is carefully left undefined while Eliot implies that the ability to detect and respond to it is not a matter of personal taste or idiosyncrasy. But both Eliot's and Britten's "traditions" were, we can now see, just that: Eliot's later navigation around the rock of Milton's reputation is comparable to Britten's around Beethoven.[21] Judged next to Eliot's subtle manipulation of the reader's

sensibility in "Tradition and the Individual Talent," Peter Pears is more clumsy in arguing the validity and objectivity of the tradition he defines for Britten. Yet he relies in the end on a strategy similar to Eliot's in the second part of "Tradition," deliberately separating personal emotions from aesthetic concerns. The "classic virtues of a controlled passion" suggest Eliot's more famous theory of impersonality.

I would not read much into these verbal parallels were it not for an explicit parallel drawn earlier in the essay between Britten's music and the modernism Eliot helped initiate. "Was it Wyndham Lewis who said that all art must be satirical today?" Pears asks. "Much of Britten's work has a satirical edge, though not immediately apparent" (61). Pears makes this comment in relation to one of Britten's most overtly satirical pieces, the "Rats Away!" movement of *Our Hunting Fathers*, in which a Latin prayer is broken into by cries of "Rats! Rats!" and ends on an ironic "Amen." But the satirical fragmentation of language at the end of a movement Britten hoped would "cause a good amount of comment" at the first performance in 1936 (*LFL* 429) is not really comparable in effect and scope to the mosaic of fragments in *The Waste Land*. Britten's satire is more direct and his fragmentation of material more local, in one of his most overtly "modernist" works, than in Eliot's major modernist poem. After the 1930s, Britten moved away from such overt satire—a better point of comparison with Eliot than simply an early satirical style. The issue here is not whether Britten's music does show such a thoroughgoing satire (I am not convinced that it does), so much as why Pears chose consciously, if briefly, to align Britten with the modernism that Lewis, and the early Eliot, represented.

Britten's own early work had often been criticized for a technical virtuosity that "got in the way" of expression. Pears's response in 1952 was to declare that a subtle but pervasive satire informed Britten's work, thus turning to advantage the enemy's own weapon: Britten was satirical because all contemporary art that counted was satirical. And yet by the end of the essay on the vocal music, Pears summarizes Britten's work to date as classical and restrained. The tension between these two opposing representations of Britten, as satirist and as classicist, indicates his complex position within contemporary British music. Like much of the 1952 *Commentary*, Pears's essay suggests a certain defensiveness on the part of Britten's admirers. But the gap between the two representations of Britten also suggests, on the one hand, the difficulty of pigeonholing Britten's musical style and tendencies and, on the other, the ambiguity of Britten's position in relation to high modernism, musical or otherwise.

In 1941 Britten had listed as British modernist composers William Walton and Constant Lambert, Elizabeth Maconchy, Lennox Berkeley, Elizabeth Lutyens, and Alan Rawsthorne, composers with whom he implicitly allied himself against the older "folk-art" generation. But by the early 1950s, Peter Pears (presumably with Britten's prior knowledge) summarized Britten's work as a mixture of restraint and reinnovation: Britten, concludes Pears, is "most certainly a renovator, and having thus cleansed his house, he has a right to feel at home in it" (73). As Pears outlines it, the tradition in which Britten feels "at home" is European, but it does not consist wholly of the contemporary set of influences Britten had listed ten years earlier in connection with British musical modernism: Bartók, Stravinsky, Webern, Berg, Hindemith, and the "younger French school" (Britten, in *Modern Music* 72). By the postwar years, Britten's chosen predecessors formed not an avant-garde but a conservative inheritance.

The parallels with Eliot are striking. By 1928 Eliot had begun publicly to dissociate himself from his earlier writings, particularly from some of the views in *The Sacred Wood*.[22] As a critic and publisher, as well as a poet, Eliot had already begun to move from the bohemian fringes of high modernism into the inner circles of the literary establishment. As with Britten twenty years later, satire tended (although not invariably) to give way to classicism and a nonironic seriousness of purpose. Eliot's definition of tradition, initially formulated in opposition to what he perceived to be a narrow literary inheritance promoted by the establishment, gave way to a sense of tradition that itself became "establishment" in its implications. Eliot's belief in tradition remained firm beneath a changing definition. The same might be said for his professionalist stance. From a provocative means of defining his, and modernism's, opposition to the Georgian poets, Eliot's professionalism became one aspect of his own later role as distinguished poet, critic, public lecturer, and influential publisher. Yet the fact that Eliot did not publicly insist on professionalism with the same determination that Britten showed throughout his career suggests Eliot's greater sense of security as a public figure. Long after professionalism had served its purpose as an anti-Georgian, antiestablishment creed, Britten continued to invoke it. Such tenacity of belief suggests that professionalism was, for Britten, more than a modernist stance. The degree to which he insisted on professionalism as a primary defining characteristic is a measure both of the degree to which he was ambitious to become Britain's foremost composer of the twentieth century and the extent to which he felt his position within the musical establishment to be insecure and ambivalent. It is hardly surprising that Peter

Pears, as one closely involved in Britten's ambitions, should have argued Britten's importance on two fronts in the 1952 essay. Satirical modernist and restrained classicist: Britten occupied both poles.

THE DIFFICULTY OF SATISFACTION

Eliot's poetic voices and personae constantly examine the medium that gives them life. In the evocative lines from "East Coker" in which the limits of expression and poetry are recognized (II, 18–21), Eliot's concern with history and tradition—with poetic fashions—has become less important than the "satisfactory" construction of meaning through language. Such metapoetic concerns are characteristic of Eliot, running through his work from the early dramatic monologues to *Four Quartets*. They are also one of the reasons Eliot's larger poems generally resist musical treatment: because they do not tell a story or provide a succession of images, metaphors, and so on, such statements provide little that can be effectively translated into music. Paradoxically, by threatening to undermine the stability of language itself, these moments in which a speaker examines the problem of meaning remain within the bounds of language—and outside the bounds of music.

This is not to say that the metapoetic and metaphysical passages in Eliot could not be set to music, since any words, from Shakespeare to a shopping list, can furnish the basis for a song. Eliot, however, strictly controlled which of his poems were set to music, as a survey of the settings made during his lifetime suggests.[23] This suggestion of wariness is confirmed by an unpublished letter of 1962: "I have to be very firm about the setting to music of poems which I do not wish to have appear in that way," Eliot wrote to the Master of Magdalene College, Cambridge, regarding some settings by an undergraduate composer.[24]

> My permission in the past has always been given for more lyrical passages such as those which are entitled Landscapes and an occasional chorus from THE ROCK for use on some religious occasion. . . . Stravinsky, with my full permission and encouragement, has set Section four of my poem LITTLE GIDDING to music, but ASH WEDNESDAY is a different matter altogether; it does not seem at all suitable for the purpose.[25] . . . If I gave permission even once for the publication of my text with a musical setting, I should find it almost impossible to resist leaving the whole of my verse to the disposal of composers.

I think Eliot exaggerated the danger composers presented: as he points out, much of his work does not provide "lyrics in the proper sense of being suitable for singing." Composers would presumably discover that Eliot's verse did not give a good return on the investment and leave the major poems alone for the kinds of reasons outlined above. But Eliot's aesthetic grounds for concern are worth taking more seriously. He felt that a musical setting, like illustrations and academic commentary or notes, fixed the meaning of the poem. All three kinds of interpretation would come between him and his readers: "An artist is providing the illustrations which should be left to the imagination of the reader, the commentator is providing information which stands between the reader and any immediate response of his sensibility, and the music also is a particular interpretation which is interposed between the reader and the author. I want my readers to get their impressions from the words alone and from nothing else's.[24] Eliot's poetic speakers may often be dissatisfied with the imprecision of language, but Eliot himself felt that he had written precisely—or at least satisfactorily—what he wanted.

When it came to musical settings, the poetry did "matter." The fact that the poetry mattered, for Eliot as for many of his readers, is one reason for some of the criticism Britten's fourth canticle, *Journey of the Magi*, has received. Especially for listeners long familiar with the poem, Britten may seem to take undue liberties with his text, destroying the clipped, dry tone of the original through excessive verbal repetition and fragmentation. I want briefly to explain why I think Britten set the poem as he did.

The fragmentation of the text results from several distinct manners of word setting used for different illustrative purposes in the canticle. For instance, in passages of recitative or recitative-like writing, Britten often distributes the words unevenly between the countertenor, tenor, and baritone, breaking the text into small disconnected units. This fragmented, even pointillist, writing serves to convey the incoherence of this journey, as well as to vary what might otherwise be fairly conventional recitative. Both the "camel men cursing and grumbling" and the disturbing tavern with its "six hands . . . dicing for pieces of silver" are depicted in this way. Elsewhere, Britten employs an overlapping repetition of lines to create a more mysterious and dreamlike effect (see Figure 11.1).[26] The treatment of the words here has obvious illustrative purposes, with the magi singing "in snatches" and then reproducing, in the interweaving of minor and diminished scalic passages, the haunting voices that accuse them of folly. Neither kind of verbal repetition seems to me problematic, even if the first is uncharacteristic of Britten.

Figure 11.1. Britten, *Canticle IV: Journey of the Magi*, Op. 86, mm. 98-106. Reproduced by kind permission of Faber Music Ltd., London.

More difficult to justify is the treatment of the words in the passages of close harmony, which serve as a refrain in the rondolike structure of the canticle. Thus, in place of the terse and forceful cadences of Lancelot Andrewes that open the poem, the canticle opens with a curious repetition or doubling-up of words (Figure 11.2). There is little precedent for this kind of harmonic writing and this kind of textual treatment in Britten's

Figure 11.2. Britten, *Canticle IV: Journey of the Magi*, Op. 86, mm. 1-14.
Reproduced by kind permission of Faber Music Ltd., London.

music, but I think such writing can be explained for related musical and interpretative reasons.[27] The juxtaposition of harmonically unrelated intervallic cells on "cold" and "coming" (marked y and z) sets up an "equivocal tonality" generating the "harmonic life" of the entire canticle.[28] This tonal issue is not resolved until the end of the piece, and then in a surprising manner, as we shall see. Expanding the text in the initial bars of the piece (and in the subsequent close harmony refrains) allowed Britten to underline what the canticle is "about" in musical terms: tonal ambiguity and resolution. The question is whether Britten achieved such emphasis at the expense of the text.

Britten chose to read "Journey of the Magi" as a psychological and dramatic narrative rather than a meditational poem. In some quite literal ways, he translates that journey into musical terms. The bass ostinato of the opening (marked x), which is centered uneasily around G, is clearly a journeying motif, similar to such motifs in earlier Britten works.[29] I believe literal-mindedness is at work in the close harmony of the vocal writing as well. Both the confinement of the voices within a narrow compass and the static repetition of the words signal the difficulty of the journey at hand. But at the same time such writing is highly imaginative, not only because Britten effectively uses the different tone colors of countertenor, tenor, and baritone, but because the close harmony signals the psychological state of the magi. In an introduction to his first opera thirty years earlier, Britten had written that the composer "should not be afraid of a high-handed treatment of the words, if the prosody of the poem allows it and the emotional situation demands it."[30] In the opening bars of *Canticle IV*, the magi do not progress harmonically and have not progressed emotionally in unraveling the meaning of the birth. Like the poem, the canticle can be heard as yet another attempt to return and to resolve, through memory, a troubling event. The listener's response to this canticle of course remains a matter of personal taste, but I suggest that Britten's treatment of the words can be defended on the interpretative grounds outlined here. Paradoxically, it is because Britten departs from and indeed destroys the careful pattern of words in Eliot's poem that his setting remains quite close to some of its meanings.

In the same introduction in which Britten argued for "a high-handed treatment of the words," he also wrote that his aim as an opera composer was "to crystallize and hold the emotion of a dramatic situation at chosen moments" (8). In terms of opera, this meant returning to a Mozartean model in favor of the continuous structure of Wagner's music dramas. But Britten's attempt to crystallize and hold emotions in music extended to other forms, too, and certainly to both the Eliot canticles. I want, finally,

to examine the "chosen moment" of *Journey of the Magi* and *The Death of Saint Narcissus* for what they tell us about the relationship between Britten's manner of setting up and resolving tonal conflicts or ambiguities and his response to Eliot as a religious poet.

The central moment of Eliot's 1927 poem is conveyed in a phrase that turns on the specifically Christian meaning of "satisfaction" but also carries a self-deprecating dryness of tone: "it was (you may say) satisfactory" (l. 31). The effect of such an oblique and deliberately undramatic reference to the birth of Christ is difficult to translate into musical terms. In the pencil markings Britten made in the copy of the poem he used for his setting, from Horace Gregory's anthology *The Triumph of Life: Poems of Consolation for the English-Speaking World*,[31] Britten noted several possibilities for this moment: "[Hodie Christus natus est]," "Interlude," and "(Carol?)."[32] In the event, Britten extended and dramatized the moment of Christ's birth by introducing the plainsong *Magi videntes stellam* into the piano, repeating "satisfactory" eight times in the vocal parts to fit such a long quotation (Figure 11.3).[33] This quotation of music

Figure 11.3. Britten, *Canticle IV: Journey of the Magi*, Op. 86, mm. 61-69. Reproduced by kind permission of Faber Music Ltd., London.

from the First Vespers for the Feast of the Epiphany represents a crucial change from the poem. Eliot had not only anticipated Christ's betrayal and crucifixion through the imagery of "three trees on the low sky" and the hands "dicing for pieces of silver" before arriving at the birth itself; he also questions the positive nature of this event in the final section of the poem. By placing the "satisfactory" moment in the center of the poem, Eliot sets up an ending that is open and unresolved. Britten, however, celebrates the divine manifestation both more directly and more hopefully. The quotation of *Magi videntes stellam* introduces an apprehension of the divine that is outside the realm of words, not subject to the provisional nature of language hinted at in the parenthetical "you may say." The magi remain within this limited sphere of understanding, unable to grasp the meaning of Christ's birth fully, as the G-naturals of their repeated "satisfactory," sung against the F-sharp–G-sharp of the piano's left hand, indicate. (This implied confusion becomes manifest a little further on in the canticle, when the three voices sing, in unison, a chromatically distorted version of the plainsong melody.) But for the listener, the divine significance of this event is audible in the rapturous quotation of the plainchant, above the confusion of the magi.[34] We hear the epiphany that the magi themselves do not.

The plainchant from the Vespers for the Epiphany allowed Britten neatly to resolve the harmonic issues of the canticle as well. The key to which the piece has been directed from the opening bass ostinato is G minor (as the key signature indicates). The final vocal phrase is firmly in this key, and the mood of resignation it symbolizes continues in the coda in the arpeggiated G-minor triads of the piano's left hand. However, Britten juxtaposes—and links—this resolution with another that is not tonal but modal, through a reintroduction of the plainchant melody. Instead of the earlier coloring of F-sharp–G-sharp in the left hand (derived from the journeying ostinato), the G-*natural* of the tonal resolution provides, at the same time, the basis for a Lydian "sonority" (Evans 413), a mode that traditionally symbolizes clarification. The moment of death is also the moment of rebirth, the moment of grace—a transformation that the magus of the poem can only wish for.

The "chosen moment" of *Canticle V: The Death of Saint Narcissus* takes the wished-for death of the first Eliot canticle a step further, to physical dissolution. Like "Journey of the Magi," this early unpublished poem, written around 1914–15, is concerned with satisfaction. But where the satisfactory moment of the later poem carries connotations of Christian dogma and ritual (however ambivalent the response of the

magus), the satisfaction Narcissus achieves is sexual, the culmination of the erotic and indeed masturbatory imagery in the poem. It is the final outcome of a failed spiritual quest to move beyond the self and to transcend the concerns of the body.

Britten claimed not to understand what Eliot's early poem on the death of Saint Narcissus was about (Carpenter 565), probably partly a genuine response to the bizarre evolution of Narcissus as tree, fish, and then young girl and old man,[35] and partly, no doubt, a defense against possible accusations that his decision to set what is clearly a very homoerotic text had voyeuristic overtones. That Britten was attracted to the text partly because of its focus on the male body seems indisputable, given his earlier settings of homosexual or homoerotic poetry in his song cycles and operas.[36] But I think that to attribute Britten's choice solely to the homoerotic potential of Narcissus is to simplify what this canticle represents. It is certainly not a coincidence that Britten decided to set a text concerned not only with male beauty, but also with death, shortly after his final opera, *Death in Venice*. Even more than in this opera, erotic and sexual desires have become conflated with spiritual longing and can find their resolution only through death. At the same time, we should remember that Britten had a strong dramatic sense, and that Eliot's poem offers a drama in miniature. Both poem and canticle reenact vividly the story of a man who "could not live men's ways" (l. 17). Narcissus is another in a long line of Britten characters who are outsiders, and like that initial outsider, Peter Grimes, his conflicts are internal and psychological as much as external and social.

Thematically and in narrative terms, then, Eliot's early poem fits into the larger picture of Britten's oeuvre. At the same time, the musical procedures of the Narcissus canticle represent a return to more characteristic Britten techniques after the departures of *Journey of the Magi*. The word setting is more conventional, and the structure of the poem more closely followed in Britten's elaboration of the poem's narrative into the arch form of the canticle.[37] In harmonic terms, however, the Narcissus canticle shows an economy of means similar to that of *Journey of the Magi* and presents a similarly satisfying use of symbolic tonal ambiguity and resolution. Again, a brief look at the musical procedures will provide insight into Britten's reading of the poem.

In the opening four bars of the canticle, Britten juxtaposes C-sharp minor and C major, in the harp accompaniment as in the vocal line (Figure 11.4).[38] Whether we want to understand this tonal juxtaposition as a kind of literal translation of Narcissus's spiritual-sexual crisis, the C-sharp

Figure 11.4. Britten, *Canticle V: The Death of Saint Narcissus,* Op. 89, mm. 1-4. Reproduced by kind permission of Faber Music Ltd., London.

minor–C major oscillation here, like the unrelated intervallic cells that opened *Canticle IV,* generates the melodic and harmonic material of much of the piece. After the exposition and expansion of this key conflict in the A and B sections,[39] the episodic treatment of Narcissus as tree, fish, and human moves through less related keys but, as Peter Evans points out, "even here . . . the material suggests conflicting [key] areas" (417). We might expect the instability of such continuous tonal ambiguity to break down tonality altogether, and indeed, some readings of this canticle strongly suggest that Britten could not effect closure: "there is, inevitably, a disintegration at the end, where the first and last phrases of the first section are recalled, and E emerges from the C sharp minor/C major complex as the only possible point of rest. The final vocal phrase outlines a Lydian E major, but the harp's 'shadow' retains more C major elements, and its final Es are therefore echoes which are already shivering into dissolution."[40] Such dissolution comes only after a cathartic return to the material of the B section, however, including the illustrative melisma associated with the image of Narcissus as a dancer and the "walking" rhythms of the harp first heard in the description of Narcissus moving "between the sea and the high cliffs" (Figure 11.5). In the poem the depiction of Narcissus's surrender to the "burning arrows" ushers in a return to the present tense: "Now he is green, dry and stained / With the shadow in his mouth." Britten responds very sensitively to this narrative

Figure 11.5. Britten, *Canticle V: The Death of Saint Narcissus,* Op. 89, mm. 129–36. Reproduced by kind permission of Faber Music Ltd., London.

closure, I think. The almost savage celebration of the C sharp minor/C major conflict in Figure 11.5, at the moment Narcissus embraces death, paradoxically achieves a catharsis that allows, in the final bars of the canticle, for the sympathy accorded this figure consumed by self-longing.[41] That sympathy can be heard not only in the clarifying return to the opening material but also in the final progression to the shared mediant of the key conflict that underlies the entire canticle: whether we call such sympathy "resolution" or "dissolution" seems to me immaterial.

Where does this leave us in terms of Britten's reading of two of Eliot's more ambivalent or ambiguous religious poems? In *Journey of the Magi*, the inclusion of the epiphanic plainchant at the "chosen moment" of the birth, as in the piano coda, would seem to indicate a more certain spiritual belief than Eliot's around the time of his conversion in 1927. In fact, I believe the opposite to have been the case. Britten's allowance for both divine revelation *and* human uncertainty in the harmonic structure of *Journey of the Magi* can be heard as a measure of his need for spiritual reassurance toward the end of his life. The quotation of the plainchant, like the experiments with word setting, is a sign of Britten's certainty as a craftsman, a "professional" composer, and does not necessarily reflect a certainty of religious belief. That Britten was looking for reassurance and turned to Eliot to find it is borne out by Donald Mitchell's comment that Eliot's verse was "among the few things Britten found himself able to read" (*PFL* caption to photograph no. 328) toward the end of his life. "From the authority of it he derived calm and courage," a comment that indicates that Britten may have been reading the *Four Quartets* in particular at this time.[42] And yet neither text that Britten chose to set, interestingly, is one calculated to provide this kind of courage: both "Journey of the Magi" and "The Death of Saint Narcissus" are, in different ways, about crises of authority and self-command. Although in *Canticle IV* Britten had modified that crisis by the addition of a level of divine understanding, *Canticle V* represents not only a preoccupation with the theme of death but also compositional maturity brought to bear on the enduring social and spiritual malaise Britten seems to have felt as a homosexual. Just as it is hard not to hear a joyous celebration of Britten's relationship with Peter Pears in the original canticle of 1947, even though this setting of Francis Quarles's "My Beloved Is Mine and I Am His" is not dedicated to Pears, so it is difficult in this final canticle not to read a less happy but equally personal subtext in the spiritual and sexual battle of Saint Narcissus.

DEGREES OF SATISFACTION

In his 1942 lecture on "The Music of Poetry," Eliot said that "in a poem of any length there must be transitions between passages of greater and less intensity, to give a rhythm of fluctuating emotion essential to the musical structure of the whole."[43] Eliot's own concern with "musical structure," like his concern for "meaning," makes his poetry difficult to translate into music. In fact, I think it would be fair to say that his work cannot be translated into music and remain *poetry*, as he conceived of it.

But his verse can certainly be interpreted through musical setting. As Eliot's comments in the 1962 letter suggest, such interpretations tell us less about the poet's mind than they do about the composer's.

In the case of *Journey of the Magi* and *The Death of Saint Narcissus*, the encounter between Eliot's verse and Britten's musical imagination produced works that I think can be read as personal in a number of ways. Not by any means direct autobiographical statements, these canticles nevertheless "sound" like Britten both in thematic—or dramatic—and musical terms. They represent Britten's "passionate belief" in professionalism, since both settings, like so much of his music, were composed with particular performers and occasions in mind.[44] At the same time, these canticles represent Britten's sense of tradition and his use of innovation within an accepted paradigm, that of Western tonal harmony. Both Eliot canticles show a continuing fascination with tonal juxtaposition and ambiguity. Although Britten's tendency ultimately to resolve such ambiguities does not place him in the forefront of twentieth-century musical modernism (and distinguishes his work from the often open-ended or fragmentary works of high literary modernism), it does position him, if ambiguously, on the "side" of modernism.

By the late 1940s, when Britten had become an established composer of international standing, his work had begun to show a classicism akin to that of Eliot's post–*Waste Land* poetry. Yet Britten did not command the degree of authority as a cultural figure that Eliot did. In terms of their politics and lifestyles, too, Britten and Eliot were in many respects at opposite poles. By the late 1920s Eliot had declared himself (with a proviso about the worth of the terms) to be "classicist in literature, royalist in politics, and anglo-catholic in religion" (*For Lancelot Andrewes,* ix); Britten was a socialist, a pacifist, and a homosexual, and he entertained doubts all his life about the value of Christian ritual (even though he composed a good deal of music for it) and dogma. Nor did Eliot's and Britten's taste in poetry and music correspond in some important ways: where Eliot revered Wagner, Britten moved away from this composer's operatic writing to return to Mozart; where Britten loved the poetry of Thomas Hardy and Walter de la Mare all his life, Eliot worked against both men's apparent simplicity of style and thematic compass. But for Britten, Eliot's poetry came to "matter" in interrelated practical and personal terms, so that as an "old man" he chose to explore, in two short musical settings, a poet who he clearly felt was congenial to him regardless of political, social, and sexual differences. In the two poems he set to music, Britten, like Eliot, was attempting to find—or to create—spiritual satisfaction through aesthetic clarification.

NOTES

1. See Arnold Whittall, "Along the Knife-Edge: The Topic of Transcendence in Britten's Musical Aesthetic" in *On Mahler and Britten: Essays in Honour of Donald Mitchell on His Seventieth Birthday*, ed. Philip Reed (Woodbridge, Suffolk, Eng.: Boydell Press, Britten-Pears Library, 1995) 290–98. Whittall contrasts Britten and Peter Maxwell-Davies, writing that "because Britten is not a modernist, the degree of conflict within the musical fabric as a whole is less extreme" than in some of Maxwell-Davies' work (294). Throughout this essay, I use *modernist* to describe works that do not fully resolve the contradictions and tensions they set up, or, in the case of music, do not function within the paradigm of Western tonal harmony.

2. In 1944 Britten hoped that Eliot would agree to write the text for a Christmas production by Sadler's Wells, for which he had been asked to compose the music. In the event, the production did not take place. See *Letters from a Life: The Selected Letters and Diaries of Benjamin Britten 1913–1976*, ed. Donald Mitchell, 2 vols. (London: Faber, 1991) 1250–52. In 1949 Britten invited Eliot to speak at the second Aldeburgh Festival, but Eliot turned him down because of other commitments. Letter to Benjamin Britten, 30 May 1949, The Britten-Pears Library, Aldeburgh, Suffolk, England. A more important connection between Eliot and Britten was the setting up in 1964 of a music department at Faber's to publish Britten's music, although it was in fact Peter du Sautoy and Richard de la Mare who were directly responsible for the creation of this department. According to Donald Mitchell, Eliot "warmly welcomed the idea of Faber's publishing Britten's music." Caption to photograph no. 328 in the pictorial biography *Benjamin Britten 1913–1976: Pictures from a Life* (hereafter *PFL*), comp. Donald Mitchell and John Evans (London, Boston: Faber, 1978). In 1966 Britten became one of the directors of Faber Music and a member of its board, both positions he held until his death (*PFL*, no. 330).

3. *The Egoist* v. 4 (Apr. 1918): 61.

4. "Professionalism in Art," *Times Literary Supplement* (31 Jan. 1918): 49–50.

5. Eliot incorrectly quotes this sentence, possibly from memory, in his essay ("Professionalism is a device for making things easy"), along with the statement that "Decadence in art is always caused by professionalism."

6. Edward Marsh's prefatory note to the final volume of *Georgian Poetry* (London: Poetry Bookshop, 1922) provides an instance of the "worship of inspiration" Eliot disliked: "Much admired modern work seems to me, in its lack of inspiration and its disregard of form, like gravy imitating lava. Its upholders may retort that much of the work I prefer seems to them, in its lack of inspiration and

its comparative finish, like tapioca imitating pearls. . . . I have tried to choose no verse but such as in Wordsworth's phrase

> The high and tender Muses shall accept
> With gracious smiles, deliberately pleased.

Inspiration remained the criterion for artistic success. Eliot's early journalism was designed to counteract just such a reliance on nineteenth-century poets for a standard by which to judge contemporary poetry.

7. *Discovering Modernism: T. S. Eliot and His Context* (New York: Oxford University Press, 1987) 123.

8. Prefatory note, *Georgian Poetry, 1911–12* (London: The Poetry Bookshop, 1912; repr. 1916).

9. R. Murray Schafer, "Benjamin Britten" in *British Composers in Interview* (London: Faber, 1964) 113–24; 118.

10. *Modern Music*, ed. Minna Lederman 8 (Jan/Feb. 1941): 71–75.

11. Britten lists "the most obvious influences" on Elgar as Wagner, Tchaikovsky, and Franck (71). The emphasis on "foreign assimilation" bears comparison with Eliot's in his poetry and critical essays.

12. My emphasis. Parry was director of the Royal College between 1894 and his death in 1918.

13. Britten commented in a 1959 interview: "My struggle all the time was to develop a consciously controlled professional technique. It was a struggle away from everything Vaughan Williams seemed to stand for." *High Fidelity Magazine* (Dec. 1959), quoted in Humphrey Carpenter, *Benjamin Britten: A Biography* (London: Faber, 1992) 51. Despite private means, however, Vaughan Williams worked full-time at composing, teaching, and earlier at collecting folk songs, editing the *English Hymnal,* and so on. He was effectively a professional musician and composer who believed as little as Britten in "inspiration." In terms of making a living by composing, Britten was far luckier than Elgar, who supported himself through orchestral playing, arranging, orchestrating, and teaching until in his forties. Michael Kennedy, *Portrait of Elgar*, 2nd ed. (London: Oxford University Press, 1982) 24–25, 50–51. Britten did compose a considerable amount of music for film, theater, and radio in the 1930s and 1940s but never taught piano or composition to support himself.

14. The school was Gresham's, Holt, in Norfolk, the same school that Auden had attended between 1920 and 1925. In the 1920s it was seen as a "progressive" school, attracting the children of middle-class liberal families. See Charles Osborne, *W. H. Auden: The Life of a Poet* (London: Methuen, 1980) 22, for a description of the school and its emphasis not on Greek and Latin but on science and history. Although not in the same league as Eton in the hierarchy of English "public"

(i.e., private) schools, Gresham's still provided a "public school" education. For Britten's experience there between 1928 and 1930, see Carpenter, 26–34.

15. *National Music*, The Mary Flexner Lectures on the Humanities, Bryn Mawr College, Nov. 1932 (London: Oxford University Press, 1934) 75.

16. Britten published six volumes of English, French, and Irish folk-song arrangements between 1943 and 1961, along with *Eight Folk Song Arrangements* in 1976. Written for voice and piano or voice and harp, these arrangements transform folk songs into "art songs." Such transformation might be seen as an inevitable aspect of folk song arranging since such music is traditionally unaccompanied, but I think Britten's arrangements were also deliberate attempts to replace the arrangements of Vaughan Williams and those who followed him. As Philip Brett has argued, Britten's "benefited as much as any composer from the [Cecil] Sharp syndrome and made sure that he had a stake in folksong while emphasising his independence from the 'Pastoral school' by what means were available, largely the very different accompaniments he devised." "Toeing the Line: To What Extent Was Britten Part of the British Pastoral Establishment?" *The Musical Times* 137: 1843 (Sept. 1996): 7–13; 9. Vaughan Williams, interestingly, was far less harsh in his response to Britten's first volume of folk-song arrangements than Britten was toward the older composer's use of folk song: "Do these settings spring from a love of the tune? Then, whatever our personal reaction may be we must respect them." *Journal of the English Folk Dance and Song Society* IV.4 (Dec. 1943), quoted in *PFL* 347.

17. Britten's pacifism, rather than his sexual orientation, was to cause him greater difficulty, at least publicly, during World War II. See *PFL* 869–73 for the details of the public attention and criticism that Britten, along with Auden and Christopher Isherwood, received for moving to the United States in 1939 shortly before the war began. Britten and Pears in fact returned in 1942 and worked as conscientious objectors, giving concerts for the Council for the Encouragement of Music and the Arts (CEMA) (Carpenter 176). But Britten's homosexuality undoubtedly played an equally strong, if more private, part in his sense of being an outsider in English society. See Philip Brett, "Britten and Grimes" and "Postscript" in *Benjamin Britten: "Peter Grimes,"* comp. Philip Brett, Cambridge Opera Handbooks (Cambridge: Cambridge University Press, 1983) 180–96.

18. "Tradition and the Individual Talent I," *The Egoist* VI.4 (Sept. 1919): 54–55; 55.

19. Peter Pears, "The Vocal Music" in *Benjamin Britten: A Commentary on His Works from a Group of Specialists*, ed. Donald Mitchell and Hans Keller (London: Rockliff, 1952) 59–73; 73. I take Pears to use "bounding line" in the sense of "springing upward" rather than "confining," since wide interval jumps are characteristic of Britten's vocal writing.

20. My emphasis. It is clear from Eliot's use of "current" earlier in the essay ("We have seen many such simple currents soon lost in the sand") that he does not have in mind an electrical metaphor but one indicating a directional flow of ideas, conventions, and so on, through time. Modernism thus stands at the mouth of this current—the natural delta, so to speak, of the past.

21. In a speech given at the University of Hull in 1962 when receiving an honorary degree, Britten said of Beethoven: "When I was very young, my music was inclined to be hectic, to rely on exciting crescendos and diminuendos, on great climaxes—in one word, to rely on 'gestures.' But for myself I felt the danger of this technique, so I turned away from that great pillar of music . . . to Mozart, the most controlled of composers, who can express the most turbulent feelings in the most unruffled way." He added, "But why should anybody be interested in this but me?" before going on to say that composers should "keep quiet" about their private judgments of other composers, advice he had not always taken himself. His comments include criticism of "one of the greatest artistic figures of our time," probably Stravinsky, for publicizing misleading and "arrogant" views, but Britten also, interestingly, mentions "what Eliot has said about Milton." Reprinted in *The London Magazine* 3.7 (Oct. 1963): 89–91. I quote from pp. 89–90.

22. In *For Lancelot Andrewes* (London: Faber & Gwyer, 1928, 1929) ix–x.

23. See appendix E4 in Donald Gallup, *T. S. Eliot: A Bibliography* (London: Faber, 1969) 353–59. Of the major poems, only the fourth sections of "Burnt Norton," "East Coker," and "Little Gidding" are set from *Four Quartets*—significantly those passages that are lyrical or impressionistic or that use metaphor and image to convey their meanings. The only section of *The Waste Land* to have been set, according to Gallup, is likewise the fourth section, "Death by Water," again more impressionistic and capable of standing on its own. Of the settings listed in Gallup, only about two-thirds were actually published, and it seems reasonable to assume that there exist other unpublished settings by minor or lesser-known composers (see note 24 and the Checklist in the Appendix of this volume).

24. Letter to Sir Henry Willink, 9 Nov. 1962, Magdalene College, Cambridge. All passages from this letter are reproduced by kind permission of Valerie Eliot and the Master and Fellows of Magdalene College, Cambridge.

25. The "purpose" in this case was an hour-long choral work that Oxford University Press had commissioned from the young composer Derek Bourgeois, then an undergraduate at Magdalene College, Cambridge. Bourgeois was not given permission, and he set Lewis Carroll's *Jabberwocky* in place of *Ash Wednesday*. His song setting of the passage beginning "In order to arrive there" from "East Coker" was allowed to be performed in an Arts Council concert that

had already been arranged and was to take place a week later. In fact it was included as part of a concert series in several performances in and around London. Bourgeois had also made a setting of the first *Prelude* while still at school and in 1978 composed a "Triumphal March" using the text of that name from *Coriolan*, broadcast by the BBC in 1980. (Private communication by telephone and letter with Derek Bourgeois, Nov. 1996.)

26. All excerpts from the scores of *Canticle IV: Journey of the Magi*, Op. 86, and *Canticle V: The Death of Saint Narcissus*, Op. 89, are reprinted by kind permission of Faber Music Ltd.

27. In terms of the canticles, the only precedent is to be found in *Canticle II: Abraham and Isaac*, Op. 51 (1953), where close harmonic writing for two voices renders the voice of God speaking to Abraham at the opening and toward the end of the piece. These passages of recitative, however, do not involve any verbal repetition.

28. Peter Evans, *The Music of Benjamin Britten* (London: J. M. Dent, 1979, 1989) 411, 412. My own analysis is based on the more extended analysis provided by Evans, 411–14, but does not correspond with his on all interpretative points.

29. A similar ostinato, also based around G, is used as a "journeying motif" in the second song of *Winter Words: Lyrics and Ballads of Thomas Hardy*, Op. 52 (1954), a setting of "Midnight on the Great Western."

30. *Benjamin Britten: "Peter Grimes,"* ed. Eric Crozier (London: The Bodley Head, 1946) 7–8; 8.

31. *The Triumph of Life* (New York: Viking, 1943) 433–34. The text for the first canticle of 1947 was also taken from this anthology. *Words: Text Sources for the Works of Benjamin Britten*, comp. D. A. Surfling, 1979, The Britten-Pears Library.

32. This is the order of markings reading from left to right across the bottom of the page, but it is likely that Britten first decided to use an interlude here and then suggested two possibilities (which he may not have intended to use strictly as interludes), since these are both in parentheses. Britten had set the text of "Hodie Christus natus est" thirty years earlier in *A Ceremony of Carols*, Op. 28. Did he contemplate a reference to his own music?

33. The quotation is from the Antiphon that precedes the Magnificat of this Vespers service, as Britten notes in the front of the published score. The plainsong lasts for twenty-four bars and takes up about a minute in a total timing of approximately eleven minutes.

34. Again, Britten's musical imagination has a literal dimension: the plainchant is heard at the highest piano *tessitura* of the canticle, while the vocal parts remain fairly low in the voice, especially for the countertenor.

35. Arnold Whittall comments: "It is safe to say that Britten never set a more complex poem." *The Music of Britten and Tippett: Studies in Themes and Techniques* (Cambridge: Cambridge University Press, 1982) 272.

36. For instance, in *Les Illuminations*, Op. 18 (1939), which includes the prose poem "Antique"; in *Seven Sonnets of Michelangelo*, Op. 22 (1940), dedicated "To Peter" [Pears], which sets some of the love sonnets Michelangelo addressed to Tommaso de' Cavalieri; and in *Nocturne*, Op. 60 (1960), which includes the poem from Coleridge's *The wanderings of Cain* describing "A lovely Boy . . . plucking fruits." The operas *Billy Budd*, Op. 50 (1951), *The Turn of the Screw*, Op. 54 (1954) and *Death in Venice*, Op. 88 (1973) all have self-evident homoerotic narratives or subtexts. Britten consistently, if indirectly, treated homosexual themes throughout his career. On the other hand, to interpret Britten's "homosexual" works, including *Canticle V*, as voyeuristic is to misunderstand them. As the accompanist Graham Johnson has commented, "everything [Britten] wrote from the deeper well-springs of his sexuality was absolutely self-revealing" (Carpenter 518).

37. What we might label as an A-B-A structure in the poem, corresponding to the shifts from present tense to past tense and back to present, becomes an A-B-C-B'-A' structure in the canticle. See Evans, 415–16, for a more detailed listing of the structural correspondences than I can give here. As with *Journey of the Magi*, the discussion of the musical issues in this canticle is based on Evans's more thorough analysis, 415–18.

38. C-sharp minor is written enharmonically—that is, the triad G-sharp–E–C-sharp is rendered by a-flat–E–D-flat.

39. Corresponding to the first verse paragraph, and the second and third paragraphs together, of the poem.

40. Whittall, *The Music of Britten and Tippett* 273. Whittall reproduces the final section of the canticle, 274.

41. Lyndall Gordon comments: "This final picture of the failed saint, sealed in Eliot's matter-of-fact condemnation, has the unexpected effect of generating abrupt sympathy." *Eliot's Early Years* (Oxford: Oxford University Press, 1977) 93. Whether or not Eliot was condemning Narcissus, as Gordon herself does in much of her interpretation, I think she is right to find an unexpected sympathy in these closing lines, as I believe Britten did.

42. The one critical work on Eliot that Britten owned was Raymond Preston's short monograph, published just after World War II, *"Four Quartets" Rehearsed: A Commentary on T. S. Eliot's Cycle of Poems* (London: Sheed & Ward, 1946). It is possible that Preston's anti-intellectual stance, combined with his emphasis on the religious nature of *Four Quartets*, influenced Britten's own reading of Eliot's poetry as a source of spiritual comfort.

43. *On Poetry and Poets* (London: Faber, 1957) 26–38; 32.

44. *Canticle IV*, composed for James Bowman, Peter Pears, and John Shirley-Quirk for performance at the 1971 Aldeburgh Festival, was in fact criticized at the time by the critic William Mann as being composed merely to provide a piece for these three singers (see Carpenter 520). *Canticle V* was composed for Peter Pears and the harpist John Osian-Ellis and first performed at Schloss Elmau in Upper Bavaria in January 1974 and subsequently at the 1974 Aldeburgh Festival.

Reading Aloud and Composing
Two Ways of Hearing a Poem

DAVID BANKS

INTRODUCTION

English is not usually thought of as a musical language. Italian is thought of as a musical language; Welsh is sometimes cited as a musical language; but not English. Nevertheless, without wishing to enter into any controversy about the authority or otherwise of a poet's own reading of his work, the fact that a recording of T. S. Eliot reading "Journey of the Magi" is available, and that Benjamin Britten set this poem to music as *Canticle IV,* provides a rather rare opportunity to compare a poet's reading with a composer's setting of the same text. This may provide us with information on the relationship between language and music in general, and on the specific text under consideration here. In this essay,[1] therefore, I shall compare an analysis of Eliot's stress and intonation with Britten's score; I shall first compare the stress patterns of the reading with the musical rhythm, and then the intonation patterns with the melodic line. This raises problems relating to the cohesion of the text, which are studied from the point of view of the semantic chains present in the poem and its thematic structure. Finally, I will consider how this thematic structure is treated in Britten's setting.

The analysis of stress and intonation that I shall use is that developed in Halliday 1966, 1967, 1970, and 1985, and of which extensive discussions can be found in Taglicht 1984, Watt 1994, and Tench 1996. Some time ago, Leech (1969) suggested certain parallels between music and poetry, but he did not use them in the ways in which I hope to do here. In recent years some have suggested highly detailed models of

English poetical meter, and on occasion these have given rise to controversy (e.g., Cureton 1992, 1994, 1995; Barney 1995). However, these attempts have rather different goals to the present study that I consider to be empirical and functional, and consequently, whatever their merits, I do not consider these models pertinent in this case.

English is normally considered to be a stress-timed language, as opposed to a syllable-timed language like French. In a stress-timed language the unit of rhythm is the foot, and each foot lasts approximately the same length of time. Each foot consists of one stressed syllable followed by a variable number of unstressed syllables or by none at all. The more rhythmic the speech, the more the length of time that each foot takes up will be similar. In natural speech the approximation of the length of the feet is to some extent elastic, but, in any case, the addition of an unstressed syllable will not alter the length of the foot by more than about 10 percent, so the notion of feet being of equal length is correct for practical purposes. This distinguishes English from syllable-stressed languages, where it is the individual syllables that are of approximately equal length. Consider the following, where a single oblique line, /, marks a foot boundary, and a double oblique line, //, marks the boundary of a tone group or unit:

(1) // Vthe / man / over / there //
(2) // Vthe / man over / there //
(3) // Vthe / gentleman in the / corner //

In (1), the foot /man/ contains a single stressed syllable and no unstressed syllables; in (2), which has the same words but is encoded differently, the foot /man over/ contains a stressed syllable followed by two unstressed syllables; in (3), the foot /gentleman in the/ has one stressed syllable and four unstressed syllables. But each of these feet takes up approximately the same length of time. Or to be more exact, the extra unstressed syllables do make the foot longer but only fractionally longer. It is possible for the stressed syllable to be missing, in which case we find an empty beat; this is indicated by the symbol V, as in the first foot of (1)–(3) above. When this happens in extended speech, the empty beat is signaled by a slight but perceptible hiatus.

The foot is the constituent of the tone unit, which may have one or more feet. The tone unit contains one tonic syllable. The tonic syllable usually has more prominent stress, and it is the place where a movement of pitch indicates the intonation of the unit. By convention, the tonic syllable is underlined.

(4) // Vthe / man over / there is the / *chair*man //

Thus, in (4), the first foot has an empty beat, in the second and third feet *man* and *there* are stressed syllables, and in the fourth foot *chair* is the tonic syllable.

The tonic syllable also plays a determining role in identifying the information structure of the tone unit. Information structure is the way information that the speaker treats as being already available to his hearer (given information) and information that he treats as not being available to his hearer (new information) are organized. The tonic syllable marks the culmination of new information. In the unmarked case the tonic syllable will fall on the last lexical item. The boundary between given and new information in these cases will be theoretically indeterminate and in practice determined by context. Given information will usually be presented first in the tone unit, but in marked cases it is possible for given information to follow the new.

The patterns of pitch movement that are signaled by the tonic syllable can be divided into five basic tones: tone 1 is a falling tone; tone 2 is a steep rising tone; tone 3 is a low rising tone, interpreted by some commentators as a level tone; tone 4 is a fall followed by a rise; and tone 5 is a rise followed by a fall. These are known as primary tones and can be subdivided into secondary tones, but the five primary tones will be adequate for the purposes of this essay. Indication of the tone used is given at the beginning of the tone unit, as follows:

(5) // 1 Vthe / man over / there is the / *chair*man //

In (5), the intonation falls (tone 1) on the tonic syllable *chair*.

PHONOLOGY AND MUSIC

The relationship between phonological features—like stress and intonation—and music seems rarely to have been given extended consideration. Fónagy (1983) is one of the rare attempts, but his treatment is basically of Hungarian, with some reference to French.

The words of vocal and choral music are notoriously difficult to understand without following a written text, even if the language in question is one's own native tongue. Benjamin Britten is particularly rare, in that the words of his vocal and choral music, at least to my ear, but I think to most other people's too, remain clear in performance. It is also

fortuitous that among his compositions there are some settings of Eliot's poems, notably "Journey of the Magi," which he set as *Canticle IV* (Britten 1972). Since we also have a recording of Eliot reading this poem, it is possible to compare Eliot's reading with Britten's setting. It is also perhaps worth bearing in mind that among Eliot's many comments on music, he once said in a lecture, "I believe that the properties in which music concerns the poet most nearly are the sense of rhythm and the sense of structure" (Eliot 1942).

STRESS AND RHYTHM

The foot as described above bears a certain similarity with the bar in music, at least to the extent that the first beat in both is stressed. Comparison is, however, complicated in this case by the rhythmical choices Britten has made. He uses a variable time signature, sometimes changing from bar to bar, including nonstandard time signatures such as $\frac{5}{8}$ or $\frac{7}{8}$. Moreover, strings of quavers (eighth notes) are frequently written out separately, thus eliminating any indication of intermediary beats, almost as though Britten wanted to smooth out the rhythm of the text, as in Figure 12.1.

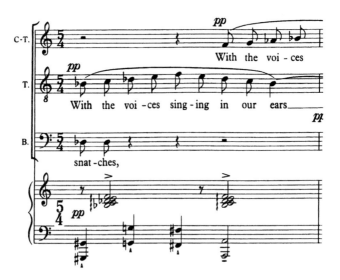

Figure 12.1. Britten, *Canticle IV: Journey of the Magi,* Op. 86 mm. 101. Reproduced by kind permission of Faber Music Ltd., London.

In other cases, although the quavers are written out separately, phrase marking reintroduces the possibility of secondary beats, as in Figure 12.2.

There are some things that music permits that are impossible in a reading. First, the composer may repeat words or phrases, thus highlighting them by that very repetition; second, the composer may use a number of voices; in this case there are three: countertenor, tenor, and baritone.

In Eliot's reading, the end of a line almost invariably corresponds to a tone unit boundary. There are only three lines where this is not the case: 33, 34, and 35. The break from lines 33–34 and from 34–35 is between a verb group and its complement; and the break from lines 35–36 is between a preposition and its completive.

If there is a correspondence between the foot of the reading and the bar of the music, then it is possible to formulate a weak and a strong hypothesis:

(a) *Weak hypothesis*: The tonic syllables of the reading will fall on the beat in the musical setting.

(b) *Strong hypothesis*: All stressed syllables of the reading will fall on the beat in the musical setting.

The main way in which a syllable can fall on the beat is to occur on the first beat of the bar. It can also be considered on the beat if it falls in a

Figure 12.2. Britten, *Canticle IV: Journey of the Magi,* Op. 86, mm. 27. Reproduced by kind permission of Faber Music Ltd., London.

secondary beat position—for example, on the third beat of a ¼ bar. In addition, an otherwise unstressed beat can be marked for stress, as in Figure 12.3 or Figure 12.4.

The weak hypothesis can be tested by considering the tonic syllables of Eliot's reading and comparing them with the places where those syllables fall in the musical setting. Eliot's reading contains 71 tonic syllables. Of these, 49 fall on the first beat of the bar, and a further 9 can also be considered to fall on the beat. The distribution is as follows:

first beat of bar	49	69.0 percent
secondary beat position	5	7.0 percent
marked for stress	2	2.8 percent
secondary beat and marked for stress	2	2.8 percent
Total	58	81.7 percent

Only 13 tonic syllables, 18.3 percent of the total, do not fall on the beat. The weak hypothesis can therefore be said to be correct for roughly 80 percent of the cases.

Figure 12.3. Britten, *Canticle IV: Journey of the Magi,* Op. 86, mm. 192. Reproduced by kind permission of Faber Music Ltd., London.

Figure 12.4. Britten, *Canticle IV: Journey of the Magi,* Op. 86, mm. 207. Reproduced by kind permission of Faber Music Ltd., London.

Eliot's reading contains a further 97 stressed but nontonic syllables. Of these, 63 (64.9 percent) fall on the first beat of the bar; a further 7 fall in a secondary beat position. No additional syllables are marked for stress. Therefore, a total of 70 (72.2 percent) of these nontonic stresses fall on the beat, and 27 (27.8 percent) do not. The strong hypothesis can be tested by conflating the results for tonic and nontonic stresses. This reveals that out of a total of 168 stressed (tonic and nontonic) syllables, 113 (67.3 percent) fall on the first beat of the bar in the musical setting, and a further 16 fall in other musically stressed positions, giving a total of 129 (76.8 percent) in some musically stressed position. The extent to which the strong hypothesis can be said to be true is therefore only slightly less than that of the weak hypothesis.

Some of the tonic syllables that fall in musically unaccented positions can be accounted for by the composer giving a different interpretation or emphasis to that given in the reading. In two cases where Eliot stresses an adjective, the following noun is on the beat in the music; in two cases the inverse happens: Eliot stresses a noun, and a preceding adjective is on the beat. In three cases, an extended cadence gives the impression that the musical line has taken over from the text, as in Figure 12.5.

Figure 12.5. Britten, *Canticle IV: Journey of the Magi,* Op. 86, mm. 133. Reproduced by kind permission of Faber Music Ltd., London.

INTONATION AND MELODY

In considering Eliot's intonation, the first thing that strikes the analyst is the very ordinariness of Eliot's reading. Its predominant feature is the use of tone 1 (fall), which occurs on 55 occasions, that is, in 77 percent of the tonic syllables. Tone 3 (low rise) is used 13 times (18 percent of the tonic syllables). Tone 2 (high rise) is used only twice, and tone 4 (fall-rise), once. Tone 5 (rise-fall) is not used at all.

Since both intonation and melody are concerned with pitch movement, it is interesting to consider whether there is any correspondence between the rise and fall of pitch in intonation and that in musical melody. I have therefore considered the musical cadences used in the score at those points that correspond to the use of tone 1 in Eliot's reading. The cadences were categorized as *fall*, finishing at a lower pitch than they started; *rise,* finishing at a higher pitch than they started; *even*, having a level pitch; and *unclear,* those that presented a more complex pitch movement that did not fit easily into any of the other categories. The results for tone 1 are as follows:

fall	29	53 percent
rise	14	25 percent
even	11	20 percent
unclear	1	2 percent

On the basis of these figures it would be tempting to see some correlation between intonation and melody, since falling tone seems to correspond to a falling musical cadence in over half of the cases. However, if the occurrences of tone 3 are considered, one finds the following:

fall	7	54 percent
rise	3	23 percent
even	2	15 percent
unclear	1	8 percent

If there was some genuine correlation, it might be expected that occurrences of tone 3 would correspond to rising or perhaps even cadences. In fact this is not the case. Indeed, the striking thing about the figures for tone 3 is their similarity to those for tone 1, which seems to suggest that the distribution of cadences is something that depends on purely musical criteria, or, at least, is unconnected to any corresponding intonation form. It is true the numbers involved are small, but since the hypothesis for tone 3 is not confirmed, and the distribution for tone 3 is very similar to that for tone 1, one must conclude that, so far, we have no evidence to indicate a correlation between intonation and musical cadence.

INTONATION AND INTERPRETATION (AN INTERESTING DETAIL)

Eliot uses tone 2 on only two occasions. These occur in lines 35–36, and are hence in the section, lines 33–36, which, as was mentioned above, is the only part of the poem where the end of the line does not correspond to a tone group boundary. The relevant part of Eliot's reading is as follows:

(11) // 2 were we / led all that / way for / *Birth* //2 Vor / *Death*? //

In principle, there are two ways of presenting this type of question: either as a closed list or as one that is open. For example, if I say,

(12) // 2 do you want / *tea* //1 Vor / *coffee* //

with tone 2 (rising) in the first unit and tone 1 (falling) in the second, I present a closed list. There are no other possible choices. I present tea

and coffee as being the only things that are available. On the other hand, if I say,

(13) // 2 do you want *tea* // 2 Vor / *cof*fee //

with tone 2 in both units, I present an open list, that is, one to which other items can be added. Thus, here, tea and coffee can be taken as examples of the drinks that are available but do not exclude other possibilities. So, "I wouldn't mind some water/milk/beer, please" would be in order as a response to (13) but not to (12). It is consequently highly significant that Eliot uses tone 2 in both of these tone units. My own natural reading of these two units would treat birth and death as a dichotomy, which would involve a closed list with tone 2 followed by tone 1, and random questioning seems to indicate that this is generally the case. Eliot, on the other hand, does not treat birth and death as a dichotomy but as an open list. This seems to indicate that he is treating them as simply two of the possible things they were led there for, leaving the idea that there may well be others. If this is so, then it seems to have significant implications for the possible interpretations of the poem as a whole and the psychology and personality of the Magus in particular. If he treated birth and death as a dichotomy, as a closed list, then we might say he had a certain insight into what was going on in this birth that he had witnessed. Even if he cannot see what the relationship between birth and death is, he does see that it is a matter of life and death, that perhaps it was a birth that in some way involved a death, the future death of Christ, or the death of Old Testament man. At all events we are into theological territory, and this reading would imply that the Magus had at least some inkling of this. On the other hand, if we accept Eliot's reading, with birth and death as an open list, the picture changes radically. We can no longer say that he has any sort of insight into what was going on. On the contrary, he is totally mystified; he does not know what they were led all that way for at all. It could have been birth or death or anything else. Birth and death are just two of the innumerable features he picks out of the air, from the very many he could have chosen. So the line becomes one that indicates total incomprehension, rather than vague insight.

INFORMATION STRUCTURE

As was mentioned in the introduction, one of the functions of the tonic syllable is to indicate the focus of new information, thus helping the

hearer to distinguish that which the speaker is presenting as being their common ground, information to which they both already have access, from that which the speaker wishes to present as being new to his hearer. The former is given information, the latter new information. In the unmarked case the tonic syllable and hence the focus of new information falls on the final lexical item. This is the case in (4) above, repeated here for convenience:

(4) // Vthe / man over / there is the / *chair*man //

Compare (4) with this rather more marked example:

(14) // Vthe / man over / *there* is the / chairman //

In (14), the tonic syllable falls on *there,* which constitutes new information. This would fit most easily into a context where the identity of the chairman is in question, where perhaps the hearer had mistaken someone else for the chairman: *Not this man here, but the man over there.* Thus, in (14), the fact that there is a man who is the chairman constitutes the given information; his identification indicated by *over there* is new. Returning to (4), we know that *chairman* provides the focus of the new information. What we do not know is how much of the rest of the unit is included in the new information and how much is to be considered given. At one extreme, the role of *the man over there* may be in question, in which case this would be given information and only *the chairman* will be new; at the other extreme, this could be an unsolicited piece of information, in which case it could be totally new, with no given at all. So, in the unmarked case the information structure is theoretically ambiguous and is usually determined by the context.

In Eliot's reading almost all tone units have an unmarked tonic syllable, that is, they fall on the final lexical item of the unit. As we have just seen, in these cases the division between given and new is determined by context, and in the limiting case there may be no given at all, the whole of the tone group being made up of new information. This indeed appears to be the case in Eliot's reading of "Journey of the Magi." In prose this would be rare, but poetry has different criteria. Could it be the case that the condensation and concision of poetry (or, at least, this type of poetry) leads to the reduction of given information to a minimum? Given information is by definition that which the writer presents as capable of being retrieved by the reader, and to that extent may be thought of

as potentially redundant. In prose, the use of given information helps the reader to see the links that run through the text; its comparative absence in poetry may be one element in what is perceived as making poetry more difficult.

In Eliot's reading there are three exceptions to the general pattern of unmarked information structure; that is, there are three examples of marked tonic syllable. These occur in lines 3, 22, and 39. Taking line 22 first:

(15) // 1 Wet, below the / *snow* line //

This is probably simply a case of Eliot's treating *snow line* as a compound noun rather than a modifier-plus-head structure. If this is the case, then it is not really marked, the compound *snow line* being treated as the final lexical item, and it can be treated as being really unmarked. In line 3:

(16) // 1 VFor a / *journey* // 1 Vand such a / *long* / journey //

the first occurrence of *journey* carries the tonic syllable and is unmarked, but in the second occurrence the tonic falls on the modifier in *long journey,* thus making long the culmination of the new information, and *journey* is treated as given. Line 39 is similar:

(17) // 1 Vlike / *Death* // 1 *our* death //

in that the first occurrence of *Death* is unmarked and carries the tonic syllable, whereas in the second occurrence, *our death,* the modifier carries the tonic, and is thus presented as the culmination of new information, and *death* is treated as given. This seems quite natural in that *journey* and *death* occur, and hence are given, in the preceding unit. It is also interesting to note in passing that both the second occurrence of *journey* and the second occurrence of *death* fall on the first beat in Britten's musical setting.

SEMANTIC CHAINS AND THEMATIC STRUCTURE

The fact that the poem is predominantly made up, at least potentially, of new information raises a question about the nature of cohesion in the text. In most texts there is a relationship between given and new information

such that new information at one stage in the text can become the given information at a later stage. This is one of the ways in which a text coheres, forms a unity, and distinguishes itself from an unrelated series of clauses. Since this feature is reduced in the present case, there must be other strategies that are used to create the unity of the poem. Semantic chains are a major candidate for this role (Halliday and Hasan 1976, 1989; Hoey 1991; Martin 1992). These can be of two basic types: either they are lexical items that are semantically linked or they are grammatical items and proforms that are anaphorically linked to other items in the text. Both of these interact to form chains that run through the text, or parts of it. There appear to be four major chains in "Journey of the Magi." The first related to the *journey,* first mentioned in the title and continuing with *coming–journey* (twice) *–ways,* and so on. Also in the title is *Magi,* which provides another chain, though this is usually encoded in pronouns: *we–our–I,* and so on. There also appears to be a more tenuous chain relating to discomfort that includes *cold–worst–sharp–dead (of winter).* And one small but highly significant chain is created by *birth–death.* There are, in addition, a number of smaller, intermediate chains.

It is interesting to consider these chains in terms of the thematic structure. Within a clause, theme is what the speaker takes as his starting point, and as such it always occurs at the beginning of the clause. What he then says about his theme is what follows and constitutes the rheme. There are three types of theme. The most important for our immediate purposes is the experiential theme, which relates to the content of the message, and so will be one of the major constituents of the clause, subject, predicator, complement, or circumstantial adjunct. This may be preceded by textual or interpersonal themes. Textual themes link the clause to other parts of the text—for example, conjunctions—and interpersonal themes indicate features relating to the speaker himself. Only the experiential theme is always present, and it is only the experiential theme that concerns us here.

In Figure 12.6, the first column gives the experiential themes of the first stanza of the poem. The lines show the lexical chains that are formed, and the second column gives the rhematic items that enter into these chains. Some more tenuous links are indicated with a dotted line. The numbers indicate the lines of the poem.

It will be seen that the journey chain crisscrosses from theme to rheme. It starts with *journey* of the title and *cold coming* as thematic item; this is followed by *journey* in rhematic position; the chain returns to theme for *long journey* and *ways,* and this is followed by a long link to

Figure 12.6. Experiential theme and rhematic links.

travel in rhematic position before returning to the anaphoric item *this* in thematic position, which I take to be linked to the journey chain although its scope might be read as being more general. The Magi chain, on the other hand is exclusively rhematic, with the possible exception of *we* in line 8. This *we* is thematic within its own clause, but this clause is rank-shifted (embedded) as qualifier of *times*. Consequently, it forms part of the rhematic material in relation to the higher clause and has been classed as rhematic here.

The numerous smaller chains that appear in the first stanza are basically thematic. The chain that I described previously as being more tenuous is thematic with the exception of *sharp*, which falls within the rheme. Otherwise, only two very small chains do not fall into this pattern.

One theme stands out as being enigmatic. The definite article of *the voices* implies that it should link into a chain or constitute part of our common knowledge—that is, knowledge of the world and so external to the text. In the first case it would be endophoric, in the second exophoric. Neither of these appears to be the case; we have no means of knowing which voices are being referred to. Thus, the absence of an identifiable referent makes *the voices* enigmatic and in some way mysterious. Would it be too far-fetched to see this as foreshadowing the Magus's incomprehension at the mystery surrounding the birth, later in the poem, discussed previously?

The second stanza presents a different picture (see Figure 12.7). Here there are far fewer theme-theme and rheme-rheme links and more that cross over from one to the other. Some of the links are more complex—for example, *three trees* links to *vine leaves* on a simple semantic level, but cultural knowledge also links it to *pieces of silver*. More significant for our purposes, the Magi chain, hitherto rhematic, switches from rheme to theme in the link from line 21 to line 26. A further interesting feature brought out by this analysis is that the final theme of the first stanza was the general deictic *this*, and here again in the second stanza the final theme, if we discount the parenthetical *you*, is *it*, functioning as a deictic with the general content of the preceding text as its referent.

Figure 12.7. Theme-rheme links in stanza two.

Turning to the third stanza, we find that the Magi chain remains initially thematic (see Figure 12.8). In my analysis this is initially so until line 35, where *we* appears as rhematic. However, this occurs in a polar question *were we led . . .* , and many commentators (e.g., Halliday 1985; Bloor and Bloor 1995; Eggins 1994; Thompson 1996) consider that the finite, here *were*, that part of the verb group used to signal the interrogative nature of the clause, does not exhaust the thematic material, and that the following constituent, here*we*, should be considered as part of the theme. If this is accepted, then the Magi chain continues to be thematic until line 37, and even thereafter the rhematic examples are all either the oblique case *us*, or possessive, *our*. The birth/death chain, on the other hand, is basically rhematic. On only one occasion, line 38, does *this birth* appear as theme.

Thus, there seems to be a significant relationship between semantic chains and thematic structure working through the poem. The Magi chain, which is the only one that stretches throughout the poem, is exclusively rhematic in the first stanza, and basically thematic in the third, with a switch from one to the other occuring in the middle of the second stanza. This means that initially the Magi constitute part of what is being said about something else, but toward the end of the poem they become

Figure 12.8. Theme-rheme links in stanza three.

the starting point for what is said. The general pattern of each stanza is different. The first has chains that are mainly either thematic or rhematic; in the second the chains tend to switch from theme to rheme and back again; the third stanza combines both of these features, having strong theme-theme and rheme-rheme links as well as considerable crossover.

BRITTEN AND THEME

Thematic structure and information structure are concerned, in part, with the way certain items are focused, highlighted, or emphasized. One of the ways in which a composer can highlight an element of the text being set is to repeat a word or words of the text, either linearly in the flow of the melody or in counterpoint with another voice. I would now like to consider the ways in which Britten uses repetition of text in his setting of "Journey of the Magi." In Figure 12.9, the first column gives the themes

1	A cold coming	coming	x2
2	Just the worst time	the worst time	x3
3	such a long journey		
4	The ways	the ways (deep)	x2
	the weather	the weather	x2
5	The very dead	very dead	x4
6	the camels	camels	x2
7	Lying		
8	There	(times)	x2
10	the silken girls	(sherbet)	x2
11	the camel men	Then the camel men	x2
12	running away	running away	x3
	wanting		
13	night-fires		
	the lack		
14	the cities		
	the towns		
15	the villages	villages	x2
	charging high prices	(dirty and) charging high prices	x3
16	A hard time	a hard time	x4
17	At the end	At the end (we preferred to travel all night	x3
18	sleeping	sleeping (in snatches)	x5
19	the voices	with the voices (singing)	x5
		(in our ears)	x3
	saying	saying	x3
20	this	this (was all)	x3

Figure 12.9. Theme-rheme links and musical repetition.

of each clause, and column two shows the words that are repeated in Britten's setting. Where the repeated words are part of the rheme, they are given in brackets. The number of times a segment is repeated is indicated by a number preceded by ×—for example, × 3 indicates "repeated three times."

It will be seen that in the first stanza, the repeats are all thematic from lines 1–12, with the exception of lines 8–10, which constitute a flashback, and hence a certain parenthesis in the text. From line 15 onward, where the repetitions recommence, the situation is more complex but remains basically thematic, though often in association with part of the rheme.

In both the second stanza (see Figure 12.10) and the third (see Figure 12.11) the repeats are mainly rhematic. One might notice in passing that the word *satisfactory* seems particularly significant for Britten, being repeated no less than nine times.

Thus, Britten's repeats are mainly thematic at the beginning of the poem and become rhematic later. In fact, Britten's changeover point corresponds more or less to the point where the Magi chain switches from rheme to theme. One of the results of this is that the Magi chain rarely appears in Britten's repeats. It is possible that the Magi chain, being made up of pronominal items, except for the word *Magi* itself in the title to which the pronouns refer, does not lend itself to the emphasis that repetition implies. The comparative absence of lexical content may mean that the item is perceived as having little to emphasize. The rare occasions when an item from the Magi chain does occur in a repeated segment do

21	at dawn		
22	Wet		
	smelling	(and a water mill beating the)	x2
24	three trees		
25	an old white horse		
26	we		
27	Six hands		
28	feet	feet	x2
		(wine skins)	x3
29	there	there (was no)	x3
	we	(continued)	x2
30	arrived	(evening)	x2
	not a moment too soon		
31	it		
	you	(satisfactory)	x9

Figure 12.10. Rhemes and musical repeats in stanza two.

32	All this		
	I		
33	I		
	set down		
34	set down	set down (this)	x6
35	were		
36	There		
37	We		
	I		
38	had thought		
	this Birth	(bitter)	x2
39		(for us)	x2
		(like Death, our death)	x2
40	We	(Kingdoms)	x2
41	no longer at ease	(alien)	x2
43	I	I (should be glad of ano-)	x3

Figure 12.11. Rhemes and musical repeats in stanza three.

not counteract this general impression. The exceptions in the first stanza
are *at the end we preferred to travel all night*, where the element *we* from
the Magi chain is buried in a mixture of thematic and rhematic material,
and the possesive *our* of *in our ears*. In the third stanza we find the oblique
us, in *for us*, and again the possessive in *our Death*. So these last three
instances are oblique or possessive. In the possessive cases it is likely that
it is the heads of the nominal groups, *ears* and *Death*, that form the centers
of the repeated material. Finally, and perhaps significantly, the thematic *I*
of the final clause consitutes one of Britten's repeats.

BRITTEN'S DYNAMICS

A further way in which the composer can lay stress on elements of the
text being set is through the use of dynamic marking. Large sections of
Britten's score are comparatively hushed, with many piano and double
piano markings and rarely rising above mezzo forte. Those occasions
when he does use stronger dynamic markings seem, consequently, sig-
nificant. There are four occasions when this occurs in the first stanza.
In *the weather sharp*, there is a crescendo rising to sforzando on the final
syllable. The phrase *the camels galled* begins forte with a following
crescendo. The line *There were times we regretted*, begins forte and has
a crescendo on *we regretted*. Finally, the phrase, *Then the camel men curs-
ing*, begins forte and has a following crescendo. What is interesting here

is that on each of these occasions Britten is highlighting items treated as new information by Eliot in his reading. The words *sharp, camels, galled, regretted*, and *cursing* all carry tonic stress. So in the first stanza, although Britten does not dynamically highlight all of Eliot's tonic syllables, where he does use a strong dynamic marking it highlights a tonic syllable of the reading.

The second stanza presents a totally different picture. None of Britten's strong dynamic markings in this stanza corresponds to tonic syllables in the reading. In the phrase *Then we came to a tavern*, each of the words carries a forte-piano marking, except *tavern*, which is simply forte, with the melody switching from voice to voice. The phrase *Six hands at an open door*, is also treated with forte-piano marking on each word. A forte marking followed by a crescendo occurs on *dicing for pieces*, but a decrescendo follows on *of silver*, which carries the tonic stress in the reading. Also marked forte is the phrase *And feet kicking*.

The third stanza has only three strong dynamic marks, but these follow the pattern established in the first stanza and correspond to tonic syllables of the reading. The phrase *set down this* is marked forte, and *Birth or Death* has a crescendo rising to forte on *Death*. Both *this* and *Death* carry tonic stress. Even more striking is the phrase *this Birth was hard and bitter agony*. The phrase begins piano but is then marked molto crescendo, reaching double forte on *bitter*, and *agony* has additional stress marks on each of the syllables. In the reading *agony* carries tonic stress.

So, although there is no systematic relationship between tonic stress and new information on the one hand, and dynamic musical marking on the other, where Britten uses strong dynamic marking in the first and third stanzas this does correspond to tonic syllables, and hence to new information, but in the second stanza, this is never the case.

CONCLUSION

In this essay I hope to have shown that a comparison of Eliot's reading of "Journey of the Magi" and Britten's setting of the poem shows that there is a strong correlation between stress in the reading and musical beat. Whether there is any correlation between intonation and melody is not borne out by the evidence available here. The information structure of the reading is mainly unmarked, suggesting that given information may be reduced to a minimum. Consideration of the semantic chains present in the poem and its thematic structure shows that chains tend to be either thematic or rhematic in the first stanza; to cross over from one to the

other in the second stanza, and to combine both features in the third. The Magi chain is rhematic at the beginning of the poem but becomes thematic halfway through. When Britten repeats words of the poem, these are usually from the theme in the first half but from the rheme in the second half. Britten's dynamic marking highlights new information in the first and third stanzas but not in the second.

These remarks seem to indicate that the poem is structured in two overlapping ways. Both the thematic structure and Britten's dynamic marking of new information seem to be organized according to the three printed stanzas. Some might even see a reflection of sonata form in this tripartite structure, particularly with the increasing complexity of the thematic structure and the apparent combination in the third stanza of the features of the two preceding stanzas. This is overlain with a structure in two parts, indicated by the thematic treatment of the Magi chain and Britten's use of repetition, which turn around a point in the middle of the second stanza.

Over and above the details of this particular analysis, I hope to have demonstrated the interest of comparing spoken and musical versions of the same text.

NOTE

1. Earlier versions of parts of this paper were given at the ESSE/3 Conference in Glasgow, September 1995, and at the 8th Euro-International Systemic Functional Workshop in Nottingham, July 1996. I would like to thank Martin Davies for his comments on earlier drafts of this paper. It goes without saying that he is in no way responsible for any shortcomings that remain.

WORKS CITED

Barney, T. 1995. "A Response to Richard Cureton's *Rhythm and Verse Study.*" *Language and Literature* 4.1: 49–54.

Bloor, T., and M. Bloor. 1995. *The Functional Analysis of English: A Hallidayan Approach*. London: Arnold.

Britten, B. 1972. *Canticle IV: Journey of the Magi, for Countertenor, Tenor, Baritone and Piano, Op. 86*. London: Faber Music.

Cureton, R. D. 1992. *Rhythmic Phrasing in English Verse*. London: Longman.

———. 1994. "Rhythm and Verse Study." *Language and Literature* 3.2: 105–24.

———. 1995. "A Response to Tom Barney." *Language and Literature* 4.1: 55–59.

Eggins, S. 1994. *An Introduction to Systemic Functional Linguistics*. London: Pinter.

Eliot, T. S. 1942. *The Music of Poetry*. Glasgow: Jackson.

———. 1963. *Collected Poems 1909–1962*. London: Faber & Faber.

Fónagy, I. 1983. *La vive voix. Essai de psycho-phonétique*. Paris: Payot.

Halliday, M. A. K. 1966. "Intonation Systems in English." *Patterns of Language: Papers in General, Descriptive and Applied Linguistics*. Ed. A. McIntosh and M. A. K. Halliday. London: Longmans, 111–133.

———. 1967. *Intonation and Grammar in British English*. The Hague: Mouton.

———. 1970. *A Course in Spoken English: Intonation*. Oxford: Oxford University Press.

———. 1985. *An Introduction to Functional Grammar*. 2nd ed. 1994. London: Arnold.

Halliday, M. A. K., and R. Hasan. 1976. *Cohesion in English*. London: Longman.

———. 1989. *Language, Context and Text: Aspects of Language in a Social-Semiotic Perspective*. 2nd ed. Oxford: Oxford University Press.

Hoey, M. 1991. *Patterns of Lexis in Text*. Oxford: Oxford University Press.

Leech, G. N. 1969. *A Linguistic Guide to English Poetry*. London: Longman.

Martin, J. R. 1992. *English Text, System and Structure*. Amsterdam: John Benjamins.

Taglicht, J. 1984. *Message and Emphasis: On Focus and Scope in English*. London: Longman.

Tench, P. 1996. *The Intonation Systems of English*. London: Cassell.

Thompson, G. 1996. *Introducing Functional Grammar*. London: Arnold.

Watt, D. L. E. 1994. *The Phonology and Semology of Intonation in English: An Instrumental and Systemic Perspective*. Bloomington: University of Indiana Linguistics Club Publications.

Orchestrating *The Waste Land*

Wagner, Leitmotiv, and the Play of Passion

MARGARET E. DANA

TOWARD THE INVISIBLE THEATER

"Wagner, more than Frazer or Miss Weston, presides over the introduction into *The Waste Land* of the Grail motif," Hugh Kenner wrote in 1959.[1] Yet, although so many other aspects of Eliot's poem have been studied, Wagner's influence has received little attention. Eliot's famous opening note to the poem indirectly suggests this influence when he acknowledges his debt to Jessie Weston's anthropological study of the Grail legends, *From Ritual to Romance*. Weston herself was a Wagnerite whose first published book was devoted to a study of Wagner's sources,[2] and her more famous later work also bears evidence of her Wagnerian interests. Paying scant heed to Galahad, Lancelot, or Gawain, *From Ritual to Romance* is focused on the literature concerning Parsifal, the Grail hero whom Wagner had made the central figure of his last music drama. But it is not only through Weston that Eliot's attention would have been drawn to the work of the German composer; it came also to him from another important source indicated by his citation of a line from Verlaine's sonnet "Parsifal." Verlaine's poem originally appeared in the *Revue wagnérienne*, a journal published from 1885 to 1887 that thoroughly documents the symbolists' veneration of Wagner. Of all the operas it was *Parsifal* that appealed most strongly to the symbolist taste for ritual, myth, and moments of ecstasy—elements celebrated in Verlaine's sonnet. Thus in two areas of particular interest to Eliot—his concern with comparative religion and cultural anthropology, on the one hand, and his affinity with symbolist poetry, on the other—*Parsifal* loomed large.

Parsifal, first performed in Bayreuth in 1882, was accorded unique status by Wagner himself. Not only was it his last work, it was the most sacred, one for which he invented a special term, calling it *Ein Bühnen-weihfestspiel*, or Stage Dedication Festival Play.[3] Unlike his earlier operas, which had been performed widely throughout Europe, England, and the United States, *Parsifal* was the object of a special interdict. Wagner decreed that it be presented only in Bayreuth, a provision honored for thirty years. It was in 1914, Eliot's first year in London, that the interdict was lifted; the first full productions of *Parsifal* immediately took place in Covent Garden and some fifty opera houses in Europe.[4] This was an event of major importance, stimulating a new surge of interest in Wagner's work. Though there is no direct evidence that Eliot actually attended a performance, it would be very strange if he had not done so. Eliot's allusions to *Tristan und Isolde* and *Götterdämmerung* in *The Waste Land* testify to his familiarity with the work of the German composer. His Parisian friend Jean Verdenal was a Wagner enthusiast whose letters to the poet refer to performances he had seen.[5] Among Eliot's London friends, Virginia Woolf was particularly moved and influenced by Wagner's music.[6] Above all, Wagner was simply "in the air," a giant figure in the cultural landscape during the years preceding the writing of *The Waste Land*. And Parsifal constituted the most significant treatment in recent times of the Grail story, which Eliot had chosen as his central theme. John Hollander and Frank Kermode are surely right: "That *The Waste Land* is a Wagnerian work is so obvious that only the dip in Wagner's reputation between the 1920's and 1960's can explain the relative neglect of the fact."[7]

The Wagner who would have interested Eliot would not have been the manipulator of grandiose stage effects and hypnotic illusions who concealed the gigantic orchestra to enhance the spell of the music drama in his *Festspielhaus* at Bayreuth.[8] This was the side of Wagner that Hitler was later to turn to sinister political purposes, and it is alien to Eliot's understated, ironic poetic stance. Neither would Eliot have found appealing Wagner's nineteenth-century approach to myth, with its cumbersome apparatus of water nixies, dwarves, magic spears, and its commitment to romantic narrative and to dramatic techniques already worn out by Tennyson and the Pre-Raphaelites. It was Wagner's use of music to develop a more complex subjectivity for his characters and a greater range of tonal flexibility and intensity for the orchestra that would have attracted Eliot most.[9]

However, before we turn to these elements, certain aspects of Wagner's handling of the Parsifal legend deserve attention. First, Wagner has given the material a Christian interpretation that is not to be found in his medieval source, Wolfram von Eschenbach's *Parzival*. The Christianization of the Grail texts is a process Weston discusses, and one that had already begun contemporaneously with Wolfram's version. It becomes important to Eliot in the fifth section of *The Waste Land*. Second, Wagner dramatizes the narrative as ritual; his use of the Catholic Mass in Acts I and III looks forward to liturgical elements in Eliot's later poetry and to the title of the first section of *The Waste Land*, "The Burial of the Dead."

Further, Wagner has retained Wolfram's conception of the story as a *Bildungsroman*. *Parzival* differs from other Grail romances in its emphasis on the hero's development from naïveté to wisdom. Out of the long meandering tale of Wolfram, Wagner has created a symmetrical three-act drama, each act focusing with ceremonial intensity on a crucial episode of this development. Act I of *Parsifal* presents the naïve youth who fails out of lack of experience to respond to his first Grail vision and is dismissed as "nothing but a fool."[10] In Act II he becomes "welthellsichtig" (cosmically clear-sighted)[11] through his encounter at Klingsor's castle with Kundry, the eternal temptress. Wagner has made compassion the element crucial for Parsifal's success in his quest: "Durch Mitleid wissend / Der reine Tor" (Through pity knowing / The pure fool).[12] Through experiencing Kundry's kiss Parsifal mysteriously gains an understanding of the compulsive aspect of sexuality, which enables him to pity both her and Amfortas, the Grail king she had seduced; he sees beyond the compulsion to the deeper desire for redemption that impels them both, and it is this compassion that enables him to resist her, destroy the dark spell that drives her, and regain the sacred spear that had wounded the king. In Act III he returns to the Grail castle to heal Amfortas and become the new king. In Lucy Beckett's words, the central theme of the story is "the long journey towards something once seen and not understood, which can at last be recovered only through fidelity and the growth of understanding."[13]

This pattern of a protagonist who is unable to respond to his first vision but is given a second chance becomes a crucial paradigm for *The Waste Land* and Eliot's later poetry. While *The Waste Land*'s protagonist is hardly the simple youth of Wolfram and Wagner, he experiences a failure similar to Parsifal's in the early Hyacinth garden episode. And although he never returns triumphantly to the Grail castle, he does have a

moment of insight when the Thunder speaks in section V. The Thunder's second command is "Dayadhvam," sympathize, and the speaker's rueful response is that we live each alone in Bradleyan isolation, unable to understand or help each other. Several recent readings of the poem have focused on lack of feeling and relatedness as the central reason for the failure of the quest.[14] But whatever lessons are learned or not learned by Parsifal and the protagonist of the poem, it is significant that neither Wagner nor Eliot treats this development as a gradual accretion of experience occurring through the course of time. Rather, both present it in terms of epiphanies, timeless moments that are unexplainable in rational causative terms.[15]

Finally, Wagner's *Parsifal* lays powerful stress on sexuality, which is not to be found in his thirteenth-century source. The crucial figure is Kundry, in whom he combines several of Wolfram's female characters into one complex figure who is both seductress and Magdalene.[16] As temptress, it was she who, under a curse, seduced Amfortas and made him vulnerable to wounding by the sacred spear. But she becomes the means of Parsifal's education and final success. Wagner seems to have grasped the sexual nature of the symbolism of the Grail and Spear, and the centrality of fertility to the Grail myth, well in advance of the cultural anthropologists. Eliot's emphasis on sexual malaise in *The Waste Land* has been evident to readers since the initial appearance of the poem, and his ambivalence toward feminine sexuality has been particularly noted by recent readers.

But while Edwardian poets and novelists were most influenced by Wagner's mythic content and themes,[17] Eliot was one of a new generation of writers—Woolf, Conrad, Forster, Joyce—who would find the German composer a source not only for content but also for technique.[18] Wagner's conception of the relationship between music and drama had developed—especially after his reading of Schopenhauer—to a point at which, in the last operas, the music took primacy over the other elements. "Music," Wagner wrote in 1870, "does not represent the ideas inherent in the phenomena of the world but on the contrary is itself an idea of the world." Drama, on the other hand, "expresses the only idea of the world *sufficient to music*" (emphasis mine).[19] This "metaphysics of music" was reiterated in 1872 when he referred to the dramas as "deeds of music which have become visible,"[20] a memorable phrase that is curiously suggestive of one aspect of the imagist program. By the time he was ready to stage *Parsifal*, he was finding the visual theatrical element so irrelevant that he wrote to his patron, Ludwig II, "I now feel like inventing the invisible theatre."[21]

Unlike his operatic contemporaries, Wagner gives the great musical themes to the singers only in moments of heightened intensity. Usually the vocalizing is done in recitative while the more complex music lives a separate life in the orchestra. Further, Wagner's radical chromaticism frees the music from the limitations of diatonic structure, enabling it to float from one tonal area to another with protean dexterity and to create new and subtle harmonic shifts and combinations. Above all, Wagner's use of the *Grundtema* (otherwise known as leitmotiv, a term Wagner himself never used) makes possible a new kind of dramatic musical structure and intensity. In Wagner's compositional style, the leitmotiv is a melodic phrase that characterizes and represents a theme, person, or object and that is capable of variations as well as connections with other motifs to form a web of interrelationships.

Providing new possibilities for the interweaving of poetic and literary as well as musical themes, Wagner's method was quickly adopted by early twentieth-century poets and novelists. Analysis of the resulting patterns of imagery became a primary concern of the New Criticism. The richness of imagery in *The Waste Land* made it a favorite New Critical hunting ground for image clusters, especially since the poem lacked most of the more conventional unifying devices and interpretive pointers. The close readings of this period, drawing on the Coleridgean paradigm of the relation of part to whole, oscillated back and forth between the single image and "the whole poem" in search of identifiable patterns. With the help of concepts like ironic contrast and tone, the method produced some brilliant results to which all subsequent readers of the poem are indebted.[22]

Beginning with I. A. Richards, critics such as F. R. Leavis and F. O. Matthiessen have suggested, without elaborating, that the poem's organization is analogous to that of music.[23] These comments seem to refer to the interweaving of thematic material, which, amid the proliferation of seemingly unconnected episodes and characters, becomes, in a more radical way than in earlier poetry, the thread to be followed through the labyrinth. Such an approach has been fruitful, but it has overlooked other musical aspects of the poem. In his 1942 essay, "The Music of Poetry," Eliot himself commented that

> the properties in which music concerns the poet most nearly, are the sense of rhythm and the sense of structure. . . . The use of recurrent themes is as natural to poetry as to music. There are possibilities for verse which bear some analogy to the development of a theme by different groups of instruments; there are possibilities of transitions in a poem

comparable to the different movements of a symphony or a quartet; there are possibilities of contrapuntal arrangement of subject-matter.[24]

This passage provides the basis for a musical analysis of *The Waste Land* in the terms Eliot has suggested: the use of recurrent themes, orchestration, transition, and counterpoint. Only the first of these has been explored. Yet music is vital to the poem.

Many kinds of music occur in *The Waste Land*, but the kind of music Wagner wrote is vital to its whole structure, enabling the poem's powerful subjectivity in ways that go far beyond the use of Wagnerian allusions. In addition to their shared use of tonal effects, music and poetry are both temporal forms whose patterns of repetition and contrast must be recognized moment by moment and held in memory from first to last. Eliot's suggested terms provide an excellent guide for analysis of the patterns, a guide with the important advantage of having been sanctioned by the poet himself. The multiple voices of the poem may be seen as analogous to multiple instruments accompanied by an orchestral commentary that carries them into patterns of juxtaposition. The transitions between images and moods resemble musical shifts in tone, exercises in a counterpoint of feelings and ideas. Above all, the Wagnerian technique of leitmotiv provides a means of unifying and intensifying the movement of the poem. *The Waste Land* is unique among Eliot's poems in its need for heightened Wagnerian effects. I shall read the poem in light of the qualities of intensity that such a musical structure makes possible.

ORCHESTRATION AND COUNTERPOINT

> *There are possibilities for verse which bear*
> *some analogy to the development of a theme*
> *by different groups of instruments.*
> —T. S. ELIOT, "THE MUSIC OF POETRY"

Anyone who argues for a Wagnerian influence on Eliot must fly in the face of his statement that "It is in the concert room, rather than in the opera house, that the germ of a poem may be quickened."[25] But Wagnerian opera is a special case, far more symphonic than the work of his contemporaries. In no area is Wagner so universally admired as in his use of orchestral colors and blendings. Even Theodor Adorno, who finds most aspects of Wagner's music meretricious, praises him as "the first to make subtle

compositional nuances tangible and to render the unity of compositional complexes by colouristic methods."[26] Wagner's operas place his characters within a rich orchestral flow. Although these characters partake to some extent in the musical vocabulary of the *Leitmotiven*, the themes most typically lead an independent life of their own in the orchestral accompaniment. A motif can tell the audience something the characters do not yet know, as when the orchestra reveals Parsifal's identity before he knows it himself in Act I. Deryck Cooke's brilliant analyses of motifs in *The Ring* provide many examples of the ways in which orchestral commentary makes connections for us, adding to or ironically qualifying a scene.[27] There is poignancy as well as irony in the characters' lack of awareness of these orchestral comments. Enclosed in their own phenomenal time, they cannot see the larger patterns in which they move.

The Waste Land presents us with a gallery of characters whose appearances succeed one another in serial fashion, seemingly unrelated by any obvious plot such as Wagner's operas provide. Sometimes we hear their voices; sometimes their actions are described for us. Eliot's original title for the poem, "He Do the Police in Different Voices," suggests not only a variety of voices but also an authorial presence that places and interprets them. Because there is no direct authorial commentary, the varied rhythms and styles in which they are presented, and the use of literary allusions to frame, interrupt, or modify their discourse, constitute a particularly important indirect form of commentary that is analogous to the way in which Wagner orchestrates his characters. And, as in Wagner, the characters are unaware of this knowing orchestral commentary that surrounds them.[28]

Marie, for example, is unaware that her remark that "summer surprised us" directly follows the opening monologue, which has been meditating on winter and spring—that it has been positioned so as to seem almost to flow out of the monologue, with the result that unusual emphasis is placed on her casual talk of the seasons. Her chatty triviality is suggested not only by the activities she recounts but also by her macaronic style of discourse. In contrast to the terse control of the first seven lines, Marie's conversation is a series of images loosely connected by no less than six "ands" in twelve lines, four of them at the beginnings of lines. Her story of childhood sledding in the mountains is thus represented orchestrally as the unassimilated memory of a woman who has not understood or ordered her own experience. She was frightened, but adds, contradictorily, "In the mountains, there you feel free," and continues, as if

she had not noticed the lack of transition, "I read, much of the night, and go
south in the winter." There is a curious bilingual play on words in the near
rhyming of "echt deutsch" with "archduke" that is clearly unintended on
her part—a bit of sly ironic orchestral commentary on her chauvinism and
class snobbery.[29]

In *The Waste Land* Eliot has taken the decisive step Wagner did not
take toward the "invisible theater" of the letter to Ludwig. He has elimi-
nated the "stage action" and created a drama of subjectivity in which
the characters are entirely at the mercy of the orchestral flow. Like the
Thames River, which is one of the poem's basic metaphors, this flow car-
ries them into bizarre juxtaposition with other characters in other times
and places. They become flotsam and jetsam in a movement that, though
appearing random, may be governed by forces deeper than the rational
narrative-constructing mind.

The next voice jars harshly against Marie's flighty chatter:

> *What are the roots that clutch, what branches grow*
> *Out of this stony rubbish? Son of man,*
> *You cannot say, or guess, for you know only*
> *A heap of broken images.*[30]

The powerful words of the Hebrew prophet pronounce the world a waste
land and mercilessly expose the pathetic efforts of Marie and the mono-
loguist to shield themselves from it. The balanced rhythms, biblical dic-
tion, and parallel syntax support the prophet's authority. He speaks as if
in contempt of the protagonist's unspoken question, thus revealing what
we otherwise might not have known at this point—that there is a protago-
nist who is looking for something vital and permanent in this land. But
the prophet denies him any possibility of coherent knowledge, asserting
the hopeless fragmentation and disorganization of such knowledge as he
possesses. He describes a pitiless world where there is not even the illu-
sion of shelter or nourishment. Under the shadow of the red rock, which
might seem to offer a hiding place, he reveals "fear in a handful of dust,"
thus naming the feelings that were denied earlier.

It is a moment of horror that recoils into its opposite, the ecstatic
memory of love in the Hyacinth garden. This crucial episode—the first
Grail vision of the poem—is framed orchestrally by two allusions from
Tristan und Isolde that comment powerfully on its significance. The first,
the Sailor's song from the beginning of Act I, brings fresh winds and the
hope of homeland and love into the barren waste land:

> *Frisch weht der Wind*
> *Der Heimat zu*
> *Mein Irisch Kind*
> *Wo weilest du?*

As heard in the opera, this song is a melancholy version of the forward-thrusting motif of the ship's movement toward Cornwall, already heard contending in the overture with the theme of Isolde's love-longing as she is carried unwillingly away from her own homeland and toward her unwanted marriage to King Mark. Perversely hearing the song as a mockery of her own feelings, Isolde is aroused to demand her fateful confrontation with Tristan, whom she reproaches for his betrayal. The young woman—"the hyacinth girl"—in Eliot's poem, although unaware of the tragic operatic context in which she has been placed, also speaks words of reproach (II. 35–41). But it is her lover's trancelike paralysis that is most important here. In experiencing a moment of ecstasy that overwhelms him, he is like Parsifal on his first visit to the Grail castle: seeing the vision, "looking into the heart of light," but powerless to comprehend or respond. The line endings emphasize his inability to grasp the moment. The second allusion, from the final act of *Tristan*, records the failure:

> *'Oed und leer das Meer'*

This is the song of the shepherd whom Tristan's companion, Kurvenal, has asked to keep watch over the sea for the arrival of Isolde, who alone can heal the wounded hero. The shepherd has been instructed to pipe a happy song when Isolde's sail appears, but this is a sad message: the sea is empty. Thus the radiant memory seems in its conclusion to confirm the prophet's harsh judgment of the protagonist's inability to know. Yet, even without the Parsifalian parallel, this self-confessed "nothing" seems to contain a hopeful potential in its suggestion of the Buddhist state of "unknowing," one of the necessary stages toward enlightenment, and the "heart of light" image reinforces this possibility. It is interesting to note that at one time Wagner contemplated writing an explicitly Buddhist opera, *Die Sieger*, some of which was eventually incorporated into *Tristan*.

The scherzolike Tarot episode that immediately follows this passage introduces Madame Sosostris, "famous clairvoyante," a figure who looks backward to the caged Cumaean sibyl and the Hebrew prophet and forward to the blind Tiresias. Kundry-like, she tells the protagonist his name

("Here, said she, / Is your card, the drowned Phoenician Sailor") and his fortune ("Fear death by water"). Though she is lacking in genuine wisdom (caged, in her own way, as much as the sibyl), her cards speak true, and the archetypes of Belladonna, the man with three staves, the Wheel, and the one-eyed merchant will soon appear. As orchestrally presented, she is a little like Marie, not only in her chattiness, but also in her failure to see the significance of the successive images she displays or to connect them in a meaningful pattern. Parataxis links the succession of cards without defining their relationships. She seems unaware of the significance of the blank card, noting merely that it represents something she is "forbidden to see," or of the absence of the Hanged Man, yet the fact of her mentioning these absences is an orchestral means of bringing them into play, and part of a pattern we have begun to see in which hope and possibility are kept alive in paradoxical ways. An important further instance of this pattern lies in the parenthetical allusion to *The Tempest*: "Those are pearls that were his eyes. Look!" Picking up the hint of metamorphosis in the Hyacinth garden scene, this line from Ariel's song announces fully for the first time the motif of transformation that will become linked with Philomela's voice in section II.

Madame Sosostris, clearly an urban type, is succeeded by the imagery of the "Unreal city," the Baudelairian motif that relocates the waste land in the modern metropolis. Allusions to Baudelaire, Dante, and Webster reverberate in the orchestral commentary. The crowd of ghosts that flows over London Bridge (a river superimposed upon a river) contains characters caught in the flow of time, unredeemed and "undone." The address to Stetson identifies the protagonist with Dante's pilgrimage through the Inferno. Speaking as a sailor to a former comrade ("You who were with me in the ships at Mylae!"), he addresses the ghost in a mocking tone reminiscent of the Hebrew prophet's address to himself. The sardonic, bizarre imagery of a buried, possibly sprouting corpse echoes in a minor, discordant key the earlier imagery of waste land and garden. Seldom has "blooming" seemed such an ugly prospect. The admonition to keep the dog "far hence" lest he dig up the corpse is a sinister version of the prophet's demonstration of "fear in a handful of dust" and of Madame Sosostris's warning.

But the links that a close reading can find among these passages are all conjectural, and, as the variety of commentary shows, can differ markedly depending on the assumptions the reader brings to the text. What is always far more striking is the deliberate disjunction that both defies and challenges connection. Interpretive attempts to find order and unity here always tend to allegorize a poem that has clearly chosen

to present a modernist surface of uncertainty and ambiguity. Leaving the reader to connect the dots, the poem relinquishes control in a thoroughly un-Wagnerian way, eluding closure just where Wagner would have sought it through the logic of dramatic convention.

A more convincing case for interpretation, at least structurally, can be made for the second section, "A Game of Chess." Here the contrast between women of two different social classes has been obvious to most readers; it is easily translatable in musical terms as a form of counterpoint. The description of Belladonna's room is orchestrated with a richness and density new to the poem. The rhythm, mostly iambic pentameter, flows through long sentences of syntactic complexity. The effect of "rich profusion" is created not only by the syntax but by the many objects and the way in which they seem to act and interact of their own volition. The chair glows, the mirror doubles the candlelight, the glitter of jewels rises to meet the light reflected on the table. Belladonna's perfumes lead a disturbingly active life, troubling, confusing, and stirring the sense in verbs that recall the summons of spring in the first seven lines of the first section; here memory and desire are being mixed, and the reader is overwhelmed and drowned in a multitude of sense impressions. Art objects are reminders of the world of nature excluded from this suffocating boudoir. The interplay of lights and odors gives way to the "inviolable voice" of Philomel transformed into the nightingale, seen in a painting above the mantel that, like a window, offers a possible opening into another dimension. But "dirty ears" hear her song as only "Jug jug," and other forms stare out from the walls, hushing all the frenzied movements into a strangled silence. Belladonna's hair, spread out in fiery points as she brushes it, glows into words, "then would be savagely still." Orchestrally, the passage counters movement with stasis, expressiveness with silence.

When she speaks to the protagonist, whose footsteps had been heard shuffling on the stair, her voice emerges in staccato gasps, contrasting the fluent rhythms of the preceding description.

> "*My nerves are bad tonight. Yes, bad. Stay with me.*
> "*Speak to me. Why do you never speak. Speak.*
> "*What are you thinking of? What thinking? What?*
> "*I never know what you are thinking. Think.*

The protagonist's silence, in turn, counterpoints her frantic demands. The word *nothing* repeats three times in quick succession and becomes a drumbeat as she pounds against his lack of response. His memory of

"eyes" as "pearls" gives him a brief glimpse of another dimension, a way out of the trap. But the memory of *The Tempest*, with its magical, transforming sea change, fades orchestrally into ragtime, a mere tatter, a derisive song accented by the extra syllable tucked mockingly in Shakespeare's name. And to Belladonna's frantic cries of "What shall we do now?" he can think only of the trap they are in: the monotony of hot water at ten, a closed car at four if it rains, a game of chess that will surely end in stalemate.

The orchestral flow now carries us into a pub scene. Unlike Belladonna's room, the new setting is not described. The publican's reiterated statement, "HURRY UP PLEASE ITS TIME," serves to indicate the ambiance, also constituting an important ground tone that reminds us, as well as the characters, of the temporal movement in which we and they are caught. Yet the publican is no more aware that his commonplace announcement of closing time has become an ominous refrain than are the Cockney speakers that their goodbyes will be orchestrally transformed into a line from Ophelia's mad scene. The working-class diction of the woman speaker, the gossipy tone, and the shorter sentences, nearly always presented in end-stopped lines, stand in marked contrast to the Belladonna section. Moreover, while the passage focuses on the plight of a man and a woman, Albert and Lil, we hear their story secondhand through the account of a woman "friend" who has designs on Albert. Lil is overwhelmed by the physical drain of poverty, five children, and a sexually demanding husband. The pathos of her situation is distanced by the other woman's readiness to take advantage of it, as well as by the sordid details of rotting teeth and an abortion. The orchestral effect, in light of the Belladonna section, is a contrast between upper-class sterility and working-class fecundity, but there is also a parallel in the difficulties of relations between the sexes, a parallel enhanced by the fact that both scenes occur at night and in enclosed spaces, which signify entrapment.

The conclusion comments on both contrast and parallel in its ironic modulation from the working-class "goonight" of Bill, Lou, and May to the "good night, ladies" of popular song to the ironic "good night, sweet ladies" from Ophelia's mad speech. The ladies are not sweet, nor is the night good. Belladonna, Philomel, Lil, and Ophelia merge into a single figure of violated feminity whose complaint is unattractive to the world's "dirty ears." This group of women blighted by the sexual malaise of the waste land will later be augmented in section III by the indifferent typist, whose encounter with the young man carbuncular is orchestrally parodied by allusions to Goldsmith's poem, and the Thames-daughters, whose sad

lower-class tales of betrayal are set in ironic counterpoint to Wagner's Rhinemaidens wailing for their lost gold.

Eliot's contrapuntal juxtapositions of contemporary people and speech patterns with literary characters and styles suggested to early commentators that he was using the past to parody the present. But when seen in terms of "the development of a theme by different groups of instruments," they reveal parallels between past and present, between one social class and another, and between life and art. It is the last that is perhaps most interesting. By isolating certain moments from the ongoing temporal flow of both life and literature, the poem allows us to see the narrative as a model of life because its characters are unable to foresee the future or to grasp the larger pattern of which they are a part. It is this inability that gives both literature and life their poignancy, and, for all its satirical bite, there is poignancy in *The Waste Land*.

Irony underlies the literary allusions as well as the scenes from contemporary life. The *Tristan und Isolde* fragments, for instance, represent moments of limited awareness. The sailor sings of his plaintive hope for love in ignorance of its immediate effect on Isolde, or of her dilemma, or of the way in which his song foreshadows the final act of the opera; the shepherd's sad observation that the sea is empty is made not long before Isolde's sail actually appears; and it is interesting that both comments are made by speakers who are "ordinary people," essentially outside the tragic action. What makes the literary fragments so paradigmatic is that, as art, they are parts of a larger whole; we know how the story will end, though the characters do not. Eliot's poetic orchestration, then, makes us conscious of a larger pattern that the orchestra knows and at which it is always hinting. In doing so, it suggests that there is also a larger pattern in life, hidden though it may be from those who live it day by day.

The poem presents us with three levels of awareness. There are the characters like Marie, the sailor, and the shepherd, who are oblivious to the larger pattern and speak only of their own immediate concerns. At the other extreme is Tiresias, who knows and foresees all but is here, as in Oedipus, powerless to change events. This level of consciousness is clearly implicated in the *aboulie*, or inability to act, which so troubled Eliot throughout his life, but especially in the period in which he was composing this poem.[31] Tiresias knows too much, and his knowledge brings only a paralyzing sense of futility. Finally, in the intermediate position, there is the protagonist, whose crucial role will be considered in the next section.

TRANSITION

> The words . . . are required to define the rhythm
> of the first feeling, and they must also allow for
> the melting of one experience into another.
> —DENIS DONOGHUE [32]

"The art of composition is the art of transition," Wagner wrote in a letter to Mathilde Wesendonck.[33] It is the movement of tone, mood, and feeling with which he is concerned in this statement. Modulations in music can bridge contrary states of feeling, as in the example he provides of the phrase "Liebe bringt Lust und Leid" (Love brings delight and sorrow). The key should change, he says, when we come to the word "Leid" (sorrow), and yet the whole musical phrase must express the way in which delight and sorrow are also linked in the experience of love. It must "articulate their conditioning of each other."[34]

The motif of the Eucharist, or Sacred Meal, which opens the prelude to *Parsifal*, is a powerful instance of Wagner's skill in this art of combining contrary emotions within a single musical statement. A long, slow musical line played in unison by clarinet, bassoon, and double violins and cellos, it is austere in its monody. The opening notes rise slowly, outlining an A-flat major triad, to E, climb one note higher to F, and pause, as though exhausted. In contrast to this hesitant initial rising line, the central, most expressive part—augmented by the alto oboe and marked as a crescendo—turns back on itself in a three-note segment that reaches the tonic A-flat only to fall back in frustration to G, and then sinks, in a second three-note segment, all the way back to C. Rising through D-natural—the first slight touch of chromaticism—to E, the line then falls back all the way to the initial tonic A-flat for the rising four-note Spear motif, then falls back to B-flat and resolves on C. The rising and falling patterns are Wagner's most important means here of enacting oppositional dramatic movements; the impulse to rise toward tonic resolution is checked and forced back on itself. The motif is repeated three times, the second time an octave higher and with diatonic harmonies; the third time much more darkly, with chromatic harmonies, a harrowing development of the central backward-turning section, and an anguished shimmer on the frustrated second G of the three-note segment.[35]

In its painfully slow tempo and its rising and falling patterns, this complex motif suggests the tortuous pathways of aspiration, despair, and renewed longing that the drama will unfold. It tells in musical terms the

story of Amfortas, the Grail king, recounting in miniature his heroic struggle to protect the sacred relics of Grail and Spear, his fall into sin and suffering, and his present half-despairing hope for redemption. The motif of the sacred Spear of Longinus is embedded within the Eucharistic theme for two related reasons: first, because the Spear shed the blood of Christ, which redeems mankind and is contained in the Grail; and second, because it was also this Spear that inflicted Amfortas's incurable wound. The way in which the musical line doubles back on itself in the central section is analogous to the way in which the Spear turned back on its would-be protector when he violated his vow of chastity. Far from the hymn of thanksgiving and abundance we might have expected from a theme centered on the Sacred Meal, the motif in its entirety seems to yearn toward a redemption always just out of reach.

The famous seven-line monologue opening *The Waste Land* shows Eliot's mastery of the art of transition through poetic resources. The speaker of the monologue sections, although a character in the poem, differs from the others in important ways. Unlike them, he is an ongoing presence who, although trapped in the waste land, seems to undergo a development. Further, he is self-conscious, aware of the other characters and of his own participation in the orchestral flow. His monologues are thus orchestral passages in which there is no disparity between voice and commentary. His moods range through contrary feeling tones that connect and "condition" one another, as in Wagner. The primary conflict with which the poem begins is between the desire for stasis and the proddings of the natural growth process:

Reversing the traditional associations of spring with the joyful reawakening of life, Eliot's nameless speaker asserts that April is cruel, and the final *l*'s of both words assist the equivalence. But the line does not conclude with that flat statement. The participles that end the first three lines

prevent syntactical closure and work on the side of life, forcing the continuity of existence that the speaker resists. The present tense forms of "breed," "mix," and "stir" would have produced a different effect. The participles create a sense of inevitable ongoingness—"breeding," "mixing," and "stirring"—which is, nevertheless, negative and disturbing. Rhythmically, the lines have a falling cadence, and the caesuras before the participles give them a dead weight at the line endings so that, counter to their denotative demand for ongoingness, they make it difficult to continue. The fourth line closes the sentence with balanced accented phrases that precisely name the opposing forces. Lilacs, memory, desire, spring, and rain would normally have pleasant connotations, but they are here embedded in a context that subverts them, as if a love song were to be played in a minor key. Indeed, April is represented as very much like Belladonna, as a woman who in her disturbing sexuality contrasts unfavorably with motherly Winter:

> Winter kept us warm, covering
> Earth in forgetful snow, feeding
> A little life with dried tubers.

Here the rhythm of the participle-ending line is sustained, but the meanings are reversed. "Covering," and "feeding" are maternal functions associated with the sleep of forgetfulness rather than the call to awaken. The continued participial construction not only emphasizes the contrast but also suggests the parallel—that waking and sleep, life and death, are complementary. Finally, although the sleep is initially presented as warm and cozy, the seventh line reframes it as a diminishment. The contrasting themes of life and death are interwoven in a complex texture expressing resistance against life's perpetual demand for renewal. The longing for release has already been introduced in the epigraph from Petronius, where the caged Cumaean sibyl, asked what she wants, says she desires death. But the title of this first section, "The Burial of the Dead," is ironic, since *requiem aeternum* is just what the characters seem to want but cannot attain.

The mood of death-in-life and world-weariness, though at odds with the central Western poetic tradition that connects spring with life and love, is not without literary precedent. One thinks of Coleridge's Ancient Mariner, Yeats's Byzantium poems, and Eliot's own Prufrock and Gerontion. But the two most significant literary parallels are Dante's *Divine Comedy* and Wagner's *Parsifal*, both of which begin in April on Good Friday with a speaker in a desolate state of mind. The cruelty of April,

the dangers of breeding, the mixing and stirring of memory and desire—all are present in the first act of *Parsifal*. Two of the characters long for death. The first, Kundry, is reminiscent of the Cumaean sibyl, having been similarly cursed with unending life. The second is the Grail king, Amfortas, whose dilemma constitutes the raison d'être of Parsifal's quest. It is Amfortas's duty as king to uncover the sacred life-giving Grail on Good Friday each year before the eyes of his celibate knightly brotherhood in Montsalvat. The sight of the holy relic not only renews the purpose of the Order but also sustains the life of his ancient and heroic father, Titurel. But when Amfortas unveils the Grail, its power will cause his blood to stir, renewing the physical agony of his wound and the even greater spiritual anguish of his guilt. The climax of the first act of the opera is the powerful aria in which he laments the cruel necessity forcing him to officiate in this ritual of renewal that, for him, will bring only excruciating pain. Carl Dahlhaus has written interestingly of Wagner's use of chromaticism in this aria to link Amfortas's suffering with the perpetrators of his downfall, Kundry and Klingsor, who are typically presented chromatically.[36] The aria constitutes a strong parallel to the opening mood of *The Waste Land*.

The monologue that opens section III, "The Fire Sermon," invites comparison with I. 1–7 in its reconsideration of the themes of life and death, spring and winter. As the first passage meditates on winter from the standpoint of spring, so this one meditates on spring from the standpoint of winter. But by this time the protagonist has become a more complex figure whose tonal modulations are often abrupt and even more difficult to follow. He has already endured the unwanted stirrings of memory and desire depicted in the first two sections, and the flow of consciousness has become agitated. Like Hamlet in his soliloquies, he feels his way through metaphors that lead not to action but to further metaphors in a process doomed to self-destruction. He begins by experiencing a profound sense of loss, countered by his sardonic reflections that spring, when it comes, will bring only tawdriness.

> The river's tent is broken, the last fingers of leaf
> Clutch and sink into the wet bank. The wind
> Crosses the brown land, unheard. The nymphs are departed.
> Sweet Thames, run softly, till I end my song.

The passage begins with an elegiac evocation of nature's desolation in the wintry season in the *ubi sunt* tradition, brought to closure by the refrain from Spenser's marriage poem, "Prothalamion," an ironic contrast that

changes the melancholy mood to satire in the next five lines, which bring the Thames into focus. But if the river carries no physical "testimony," it is burdened with emotional debris. The sense of nature's loss is redirected by the speaker's cynical reflection that what is lost is the detritus of sordid "summer nights," and the classical nymphs are reinterpreted as working-class women exploited by well-to-do young businessmen. The phrase, "Departed, have left no addresses" gives a sardonic modern twist to the idea of transience; not only the urban idea of a street address but also the callous anonymity of a one-night stand is suggested. Sexual encounter has become as easily thrown away as the bottles and cigarette butts.

With the reference to Lake Leman, the satirical tone now modulates into an expression of profound grief. Including the sense of loss of the earlier lines as well as the bitter sense of betrayal of the satirical ones, this line also brings a broader historical and biblical perspective to bear on the situation, placing it within a human experience of disillusionment and broken promises that stretches back through the ages. By substituting for Babylon the Swiss Lake Leman, a personal reference to Eliot's visit to Switzerland to consult the therapist Roger Vittoz for help with his psychological problems, the poet also locates his own personal dilemma within this broader framework. The lyric speaker momentarily sees himself as the Hebrew recorder of the woes of his people, as he has already seen and continues to see himself as the heir of Spenser's Renaissance vision of human possibility and failure.

Haunted by his memories of poetic responses of the past, the speaker returns again to the refrain from the "Prothalamion," modulating with this repetition back into a melancholy sense of his own limitations and transience:

> Sweet Thames, run softly till I end my song,
> Sweet Thames, run softly, for I speak not loud or long.

The idea of transience suggests a carpe diem line from Marvell, but the speaker's disgust reasserts itself, parodying the allusion and shifting the tone to the grotesquerie of a *danse macabre*.

> But at my back in a cold blast I hear
> The rattle of the bones, and chuckle spread from ear to ear.

The graveyard imagery of bones and grinning skull combines with the reappearance of the rat ("I think we are in rats' alley," section II), a motif now fully developed to create a sense of death and decay that envelops the earlier hopefulness of the *Tempest* allusion (II. 187–92). The naked

bodies of the departed lovemaking nymphs merge into the bodies of the speaker's brother and father; their whiteness suggests the color of both bones and dice; and all the implications come together in the forlorn image of "bones cast in a little low dry garret," an echo perhaps of the "little life of dry tubers" in I.

A repetition of the Marvellian refrain brings another sardonic parody; this time what the speaker hears is the raucous sounds of "horns and motors" bringing "Sweeney to Mrs. Porter in the spring." But as these harsh sound effects modulate into a silly music-hall ballad about Mrs. Porter and her daughter, the mood suddenly shifts from the ridiculous to the sublime: "Et O ces voix d'enfants chantant dans la coupole." The line from Verlaine's sonnet "Parsifal" is an allusion within an allusion, an ecstatic response to an ecstatic moment in Wagner's opera when the voices of the choir boys are heard singing from the dome of the Grail chapel. It occurs here as a sudden and piercing evocation of the beauty and joy whose absence the speaker has been lamenting and is immediately followed by the related motif of the nightingale's song. Both images resonate with the hope of transformation through suffering, and their emergence from the darkness of the preceding passage constitutes an important example of the close relationship between horror and joy in this poem. Yet, despite or perhaps because of these moments of intensity, the river of consciousness does not carry the protagonist toward his quest but toward conflagration and dissolution.

INTENSITY

> *Why, for all of us, out of all that we have heard,*
> *seen, felt, in a lifetime, do certain images recur,*
> *charged with emotion, rather than others?*
> —T. S. ELIOT, THE NORTON LECTURES[37]

Intensity is an aesthetic value Eliot (and modernism in general) inherited from the symbolists, a criterion he used throughout his criticism and a quality he hoped to attain in his own poetry. In no poem does he need it so urgently as in *The Waste Land*, whose formidable task is nothing less than to ask "the overwhelming question" that Prufrock spent a lifetime evading. Although he is asking it for his own time, the infertile landscape he seeks to save is not only that of modern Europe devastated by a world war; it is the plague-ridden Thebes of Oedipus, the wilderness of the Hebrew prophets, the dark wood of Dante's *Divine Comedy*, the rotten

state of Hamlet's Denmark, and Wagner's *Götterdämmerung*. Above all, it is the wounded land of the wounded Fisher King of the Grail legends, Eliot's chosen metaphor because, as Weston had suggested, this is the overarching fertility myth that includes all the others.

In Wolfram's *Parzival*, the healing of the wounded king and his land depends on a vision and a question. The Grail legends are concerned with the beatific Grail vision, but Eliot's original choice of Kurtz's horrific dying vision from *Heart of Darkness* as epigraph suggests that the Conradian sort of vision was also a possibility present in his mind as he composed the poem. Kurtz was Marlow's "choice of nightmares" because he was able to see the vision and articulate it—to "sum up," as Marlow put it. This dark "summing up," portrayed in the passage Eliot originally chose, and described by him to Pound as "somewhat elucidative,"[38] represents the moment of highest intensity in Conrad's novel. Eliot's praise of Baudelaire in an early essay is grounded on the French poet's ability to raise his imagery of the horror of the modern city "to the first intensity" in his poetry.[39] Baudelaire's "Fourmillante cité" is a central, recurrent motif of this poem in which, as Helen Gardner has written, "the abyss" gapes so widely.[40] For Eliot, I think—as for Conrad—either sort of vision was preferable to the tawdry distractions with which the bulk of humankind makes shift. *The Waste Land* is a poem in which horror, paradoxically, is closely kin to ecstasy, perhaps because only the most intense feelings can awaken the quester from his apathy to the urgency of his task.

The Wagnerian leitmotiv at its greatest, as in *The Ring*, *Tristan und Isolde*, and *Parsifal*, is a highly compressed symbolic statement densely packed with meaning, capable of plunging into the most abysmal depths or of soaring to the highest peaks of transcendence. For Eliot, it is the literary allusion that can possess this kind of intensity. Certain lines of poetry seem to have had a power to move him that was beyond analysis. "Those are pearls that were his eyes" from Ariel's song in *The Tempest* is such a line. Ten years after writing *The Waste Land*, in the last of his Norton Lectures, Eliot speculated on the nature of Shakespeare's image-making power and connected it with deep subterranean memories: "Again and again the right imagery, saturated while it lay in the depths of Shakespeare's memory, will rise like Anadyomene from the sea." In a closely related passage discussing Coleridge's sources for "Kubla Khan," he writes: "The imagery . . . , whatever its origins in Coleridge's reading, sank to the depth of Coleridge's feeling, was saturated, transformed there—'those are pearls that were his eyes'—and brought up into daylight

again."[41] Thus the *Tempest* line seems to be for Eliot a metaphor for the mysterious poetic process itself, likening it to a sea change that occurs too deep in the mind to be studied consciously. The line surfaces at unexpected moments in *The Waste Land*. When Madame Sosostris identifies the protagonist's card as that of the drowned Phoenician sailor, he thinks, "Those are pearls that were his eyes. Look!" and he remembers the line later during Belladonna's hysteria.

Another transformative line that seems charged with intensity for Eliot is Marvell's "But at my back I always hear," from a poem that haunts "Prufrock" as well as section III of *The Waste Land*. A further example is the "Ara vos prec" passage from Dante's encounter with Arnaut Daniel in Purgatorio XXVI, from which Eliot derives one of the fragments in the monologue at the end of *The Waste Land* ("Poi s'ascose nel foco che gli affina"). Eliot quotes the entire passage in his note to that line. He had given the 1920 English edition of his poems the title *Ara Vos Prec*. "Sovegna vos," another phrase from the passage, appears in Part IV of *Ash-Wednesday*. A. Walton Litz has commented on the "talismanic" quality for Eliot of these lines; it is as if they constituted for him "a sacred text."[42] Ecstatic images tend to occur in association with horrific ones, as though intensity has the power to evoke its opposite. In section II, the ominous "stirring" of perfumes in Belladonna's claustrophobic boudoir evokes the opposite image of a "window" through which can be seen Philomela, whose song "filled all the desert with inviolable voice." In section III, imagery of rats, decay, and cacophony leads to the sublime moment of the choirboys' song from the Verlaine sonnet. Often it is human music or birdsong that announces or generates moments of epiphany.

But the poem uses such moments sparingly. The mood of the first three sections is mostly one of gloom and hopelessness. Wandering in the long stretches of dry, seemingly senseless landscape, both protagonist and reader thirst for signs of meaning. While this atmosphere does give the infrequent moments of horror and ecstasy a kind of oracular potency, these moments of intensity seem to lead nowhere. There is a psychological and spiritual problem here with which Christianity is familiar: a conviction of sin is necessary for salvation, but it can easily become a debilitating despair rather than a call to action. This is an ever-present danger in *The Waste Land*, and indeed it is far from clear in the early sections whether the protagonist will ever act. Although the crepuscular violet tones of section III lead finally to the *Götterdämmerung*-like conflagration from which the protagonist is plucked, his purgation by fire and water seems to lead only to the predicted death by drowning of section IV.

The reborn protagonist who appears in section V enters a context full of Christian allusions (which until this point have been sparse). The poem has come full circle, as *Parsifal* does; it is not only springtime again, it is Good Friday and the period just following it. There is a strong sense of despairing aftermath such as the disciples must have felt after the crucifixion. The allusions to Gethsemane and Golgotha resituate the former imagery of garden and waste land within the specifically Christian myth of the dying god, which Weston had described as a late version of the fertility rituals and Grail legends. It is in this context that the protagonist finally becomes the quester, rediscovering his "almost blunted purpose," or perhaps discovering it for the first time. What sets him on his quest at last is not the intensity of visions of horror or ecstasy, but, rather, the most basic of human needs—thirst. The compelling motif is now the search for water in a dry land, and it is the absence of water that finally drives him along the mountain road, which leads to the hallucinatory (but perhaps real) vision of the unrecognized Christ of the journey to Emmaus, and to the horrific surreal images of hooded hordes, falling towers, whistling bats, and tolling bells that accompany his approach to the Chapel Perilous of the Grail legends. Despite the many allusions, it is finally the sterility of the waste land itself that the protagonist finds intolerable in the face of his desperate need. If it is intensity that drives him, it is the intensity not of an ecstatic vision but of a deprivation that forces him to confront even the horrors of the Chapel. "If there were the sound of water only," gasps the speaker in a passage whose exhausted music reaches close to silence. The unheard but remembered water-dripping song of the hermit thrush becomes the emblem of his longing. As he approaches the chapel, the delirium of thirst produces the eerie "whisper music" fiddled on the woman's long black hair and "voices singing out of empty cisterns and exhausted wells." It is the crow of the cock that at last breaks the spell and announces the Thunder.

The Thunder speaks in an ancient nonhuman voice. Its deep cracklings and rumblings evoke a primordial awe that is the very ground of myth. Thunder is also the ground of human music, which imitates it in the drumbeat heard in the primitive rites Conrad described, or in Wagner's *Rheingold* when Donner summons the rainbow. It becomes also the basis for human speech when, as transcribed by the Upanishad, it is heard as speaking the first syllable uttered by most human infants: DA. Full and complete though it is in its presence, however, it needs translation if it is to become meaningful in human life. The poem provides two levels of translation. Datta, Dayadhvam, and Damyata (Give, Sympathize, and Control)

represent the first level: words from an ancient Sanskrit text that reach as far back toward the origin of the Indo-European language as we can go and that also have an onomatopoeic appropriateness. But, though closer to human experience, these imperatives are still on a high level of abstraction. Like all divine commands, they must be retranslated into the language of the hearer's own time, place, and circumstances. This is the moment that is crucial in the Grail legends, for if the hearer is simply overwhelmed by the numinous presence and fails to interrogate it for its personal significance to him (as in the Hyacinth garden), he will have failed in the quest.

The hearer's question will always and inevitably be only a partial one, individual and specific. It can never encompass the plenitude of meanings contained in the original DA, but that is not necessary. The Word must become words if it is to transform human life, and words are always finite and contingent. If he can find words to respond to the voice of presence, they will inevitably lead the speaker back out of the vision into his life—into his "sole, solitary self," as Keats put it after a similar experience. And he must return to ordinary life, bringing with him what fragments of the vision he has been able to grasp, or the whole quest has been for nought.

It is back in ordinary life that we find the speaker at the end of the poem. In one sense, nothing has changed. In another sense, everything has changed.[43] He is still the "Son of man" who knows "nothing" but "a heap of broken images"; but in another sense these have been transformed into "fragments" to shore against his "ruins." If the fragments seem a fragile defense, and if the ruin seems inevitable, this amounts to his acceptance of the contingency in which we must all live. This acceptance is the transformation that occurs at the poem's end. The protagonist is now able to consider a practical, life-affirming question: "Shall I at least set my lands in order?"

The fragmentary allusions that come in the concluding monologue point to the protagonist's return to a life that contains both suffering and hope.

> *London Bridge is falling down falling down falling down . . .*

The nursery rhyme words accept the knowledge of life's continual fragmentation.

> *Poi s'ascose nel foco che gli affina . . .*

The words in which Dante describes the poet Arnaut Daniel returning to the refining fire after having spoken to Dante in his native Provençal—

the language of *fine amour* for the Italian poet, and a play on words that Dante may have intended—speak of a purgatorial process that must continue before final transformation is possible. The idea of hiding himself in the flame after his self-disclosure is significant as well. The first lines of the poem spoke of the desire for the "covering" of winter, but this is a new kind of covering—not the forgetfulness of sleep, but a garment of flame in which the stirring of memory and desire is accepted as essential for redemption. It is also a covering of the nakedness that Daniel has briefly exposed to Dante, the same sort of covering necessary to Adam and Eve after the Fall and their recognition of their nakedness—the covering necessary to contingent humanity.

> *Quando fiam uti chelidon . . .*

The longing for the transformation of the Philomela myth continues as a part of human existence that must be accepted and lived.

> *Le Prince d'Aquitaine à la tour abolie . . .*

Residing in his ruined tower, Novalis's prince accepts the terms of life and even finds a kind of sanctuary in them, like Sisyphus returning to his rock. The similarity between "abolie" and the name of Eliot's emotional disorder, "aboulie," is surely not accidental.

> *Why then Ile fit you. Hieronymo's mad again.*

Like Hamlet's, Hieronymo's feigned madness in *The Spanish Tragedy* is the cover beneath which he can pursue his quest to find justice through the "fitting" and necessary disguise of language. The poem's final Sanskrit words return to the Thunder's ancient wisdom, which can never be fully grasped or embodied but which enables and blesses the continuance of the human quest.

Thus this quest poem is ultimately both a failure and a success—a failure in that it does not achieve renewal, but a success in that it provides the vision and interpretation, however incomplete, which enable the quester to continue his life and search. It was a courageous effort that had to be made. In making it, Eliot drew on all the resources of both Western and Eastern traditions that were most talismanic and oracular for him. The conclusion of the poem records his honest admission that the ritual produced no magical transformation. But what it did produce was something valuable—the ability to go on.

The Waste Land is Eliot's only Wagnerian work—the only poem in which he employs leitmotiv and a full Wagnerian orchestra, as it were, for

the sake of this sort of intensity. In *Ash-Wednesday* and *Four Quartets* he will continue the quest through other modes of the music of poetry—liturgy and the austerity of chamber music. Their quieter tones will reflect an acceptance of the fact that the Grail question can never perhaps fully be asked, because "Words strain / Crack and sometimes break, under the burden" ("Burnt Norton") and "Because one has only learnt to get the better of words / For the thing one no longer has to say" ("East Coker").

NOTES

1. Hugh Kenner, "The Death of Europe" in *The Invisible Poet: T. S. Eliot.* London: Methuen, 1959. Repr. in *Modern Critical Interpretations of "The Waste Land,"* ed. Harold Bloom. New York: Chelsea, 1986, p. 23.

2. Jessie Weston, *The Legends of the Wagner Drama: Studies in Mythology and Romance.* London: David Nutt, 1896.

3. Lucy Beckett, *Richard Wagner: Parsifal.* Cambridge: Cambridge University Press, 1981, p. 87.

4. Ibid., 95. The first production in London was at Covent Garden on 2 Feb. 1914. However, Wagner's wishes notwithstanding, there had been many performances of the opera before 1914. On 3 Mar. 1886, for example, the Metropolitan Opera mounted a concert performance in New York. The first staged performance by the Met was Christmas Eve 1903.

5. *The Letters of T. S. Eliot,* Vol. I, ed. Valerie Eliot. New York: Harcourt Brace Jovanovich, 1988, pp. 23, 28.

6. John Louis DiGaetani, *Richard Wagner and the Modern British Novel.* London: Associated University Presses, 1978, pp. 109–13. See also William Blissett, "Wagnerian Fiction in English," *Criticism* 5 (summer 1963), 242–44, 255–58; and "Wagner and *The Waste Land*" in *The Practical Vision*, ed. Jane Campbell and James Doyle. Waterloo, Canada: Wilfrid Laurier Press, 1978, pp. 71–85. See also Herbert Knust's monograph, *Wagner, the King and "The Waste Land."* Penn. State Studies, No. 22, 1967; and George K. Morris, "Marie, Marie, Hold on Tight," *Partisan Review* 21 (1954), 231–33.

7. John Hollander and Frank Kermode, eds., *The Oxford Anthology of English Literature*, Vol. II. New York: Oxford University Press, 1973, p. 474. See also the discussion in Bryan Magee, *Aspects of Wagner.* Oxford: Oxford University Press, 1988 (orig. publ. 1968), pp. 47–56.

8. A description of the theater may be found in Simon Williams, *Richard Wagner and Festival Theatre.* Westport, CT: Praeger, 1994, p. 119.

9. To use a distinction created by Elliot Zuckerman, he would have been a "Tristanite" rather than a "Wagnerite"; that is, he would have been drawn by a

private, direct response to the music rather than by Wagner's ideology. *The First Hundred Years of Wagner's "Tristan."* New York: Columbia University Press, 1964, p. 30.

10. *Parsifal*, I.530.

11. Carl Dahlhaus, *Richard Wagner's Music Dramas*. Tr. Mary Whittall. Cambridge: Cambridge University Press, 1979, p. 144.

12. *Parsifal*, I.221–22. In Wolfram, by contrast, what Parzival must learn is faithfulness. See Beckett, p. 2.

13. Beckett, p. 22.

14. In his essay "To Fill All the Desert with Inviolable Voice," A. D. Moody argues (unconvincingly to my mind) that the speaker learns sympathy in the course of the poem, and that (interestingly for my topic) he learns it through music: "The music sympathises with what the seer would repudiate" (p. 58). In *The Waste Land in Different Voices*, ed. A. D. Moody. London: Edward Arnold, 1974.

15. The relationship between time and timelessness is discussed in Nancy K. Gish, *Time in the Poetry of T. S. Eliot: A Study in Structure and Theme*. Totowa, NJ: Barnes & Noble, 1981. See also Alan Williamson, "Forms of Simultaneity in *The Waste Land* and 'Burnt Norton' in *T. S. Eliot: The Modernist in History*, ed. Ronald Bush. Cambridge: Cambridge University Press, 1991.

16. Beckett, pp. 8–13.

17. The influence is discussed in Raymond Furness, *Wagner and Literature*. New York: St. Martin's Press, 1982; and in Magee, ch. 4.

18. DiGaetani devotes a chapter to Wagner's influence on each of these novelists.

19. Quoted in Dahlhaus, p. 5. The passage comes from Wagner's essay on Beethoven.

20. Ibid. The passage comes from Wagner's essay "On the Term 'Music-drama.'"

21. Quoted in Williams, p. 140.

22. The major essay is of course that of Cleanth Brooks, "*The Waste Land*: Critique of the Myth," in *Modern Poetry and the Tradition*. Chapel Hill: University of North Carolina Press, 1939, ch. 7.

23. F. O. Matthiessen, *The Achievement of T. S. Eliot*. Boston: Houghton Mifflin, 1935, ch. 2; F. R. Leavis, "T. S. Eliot" in *New Bearings in English Poetry*. London: Chatto & Windus, 1950, ch. 3. Orig. publ. 1932.

24. T. S. Eliot, "The Music of Poetry" (1942) in *On Poetry and Poets*. New York: Farrar, Straus, and Cudahy, 1957, p. 32.

25. Ibid.

26. Theodor Adorno, *In Search of Wagner*. Tr. Rodney Livingstone. London: NLB, 1981, p. 71.

27. Deryck Cooke, *I Saw the World End: A Study of Wagner's "Ring."* London: Oxford University Press, 1979; and *An Introduction to Wagner's "Der Ring des Nibelungen."* London Records FFrr RDN S-1. See also his essay "Wagner's Musical Language" in *The Wagner Companion*, ed. Peter Burbidge and Richard Sutton. London: Faber & Faber, 1979, in which he makes the important point that the labels were applied to the motives by commentators, not by Wagner himself, and that they are used musically in a much more complex way than is often assumed.

28. In his studies of the novel, Bakhtin has used the term *orchestration* to talk about the heteroglossic dialogue made possible by that genre. Eliot's poem is certainly full of such polyvocal effects, giving us a wide range of languages, historical periods, and social classes, and it might be interesting to study the poem from this point of view. What interests me most here, however, is the way in which music and poetry, as temporal forms, create an ongoing flow of sound that envelops the discourse of their characters. See M. M. Bakhtin, *The Dialogic Imagination: Four Essays*. Ed. Michael Holquist. Tr. Caryl Emerson and Michael Holquist. Austin: University of Texas Press, 1981, pp. 325–381.

29. Although, as I have shown, Eliot uses linguistic and poetic resources such as syntax and rhyme to achieve these effects, their ultimate dependence on social context is demonstrated by John Xiros Cooper in *T. S. Eliot and the Politics of Voice: The Argument of "The Waste Land."* Ann Arbor: UMI Research Press, 1987.

30. All quotations are from T. S. Eliot, *The Complete Poems and Plays*. New York: Harcourt, Brace & World, 1952.

31. Valerie Eliot, Introduction to *The Waste Land: A Facsimile and Transcript*. New York: Harcourt Brace, 1971, p. xxii. T. S. Eliot used the word in a letter to John Aldington, 6 Nov. 1921.

32. Denis Donoghue, "The Word within a Word" (1974), repr. in *T. S. Eliot: Critical Assessments*, Vol. II, ed. Graham Clarke. London: Christopher Helm, 1990, p. 336. I am indebted to his discussion of the oracular quality of Eliot's use of language.

33. Quoted in Magee, p. 83.

34. Ibid., pp. 10–11. The passage comes from *Oper und Drama*, 1851.

35. My analysis has benefited from the discussion of the score in Arnold Whittall's chapter, "The Music," in Beckett, pp. 61–68.

36. *Parsifal*, I.441–90. Dahlhaus, p. 151. See also Zuckerman's discussion of the parallels between Amfortas and Tristan in relation to chromaticism, pp. 25–26.

37. T. S. Eliot, *The Norton Lectures* (1932–33), publ. as *The Use of Poetry and the Use of Criticism*. London: Faber & Faber, 1964, p. 148.

38. Valerie Eliot, *Facsimile.* Editorial note to *Heart of Darkness* epigraph, p. 125.

39. T. S. Eliot, "Baudelaire" (1930) in *Selected Essays.* New York: Harcourt, Brace & World, 1950, p. 377.

40. Helen Gardner, *The Art of T. S. Eliot.* New York: Dutton, 1959, pp. 78–98. I am indebted to her discussion of "the boredom, the horror, and the glory" in *The Waste Land.*

41. Eliot, *The Norton Lectures,* pp. 146–47.

42. A. Walton Litz, "The Allusive Poet: Eliot and His Sources," in Bush, 143–44.

43. Milton Miller, "What the Thunder Meant," *ELH* 36 (1969), 448–52. His discussion of the thunder passage has been very helpful to me.

A Tale of Two Artists
Eliot, Stravinsky, and Disciplinary (Im)Politics

JAYME STAYER

DISCIPLINARY DIFFERENCES

On 11 December 1963, when T. S. Eliot and Igor Stravinsky were nearing the end of their remarkable careers, the two artists dined together with their wives and Robert Craft at New York's Pavillon.[1] At that point in time, their similar reputations as elder statesmen and legendary artists could hardly have been more secure. That their work had profoundly shaped the direction of twentieth-century literature and music was no longer an issue for critics and commentators, but a matter of public record and a topos of the popular imagination. Even the headwaiter knew this, remarking to the attendant as Eliot and Stravinsky prepared to leave the restaurant: "There you see together the greatest living composer and the greatest living poet." If Eliot and Stravinsky were embarrassed by such overt adulation, they were certainly used to it. In any case, Vera Stravinsky debunked the headwaiter's grand claim with a colloquial shrug: "Well, they do their best."[2]

Since the early 1960s, a lot of debunking of grand claims has been going on, and much of it to the good. But in the field of Eliot scholarship, little of that debunking has been carried out with Mrs. Stravinsky's understated wit. For the past thirty years, the quiet grumbling that went on during the poet's lifetime regarding his work, politics, and criticism has been raised to a high decibel level. And few in the academy are carrying the banners Eliot once raised: literary modernism is out of favor; political and religious conservatism isn't hip; and the New Critical flag that once colonized English departments has been burned and discarded.

But even more than a distaste for Eliot's professed allegiances underscores why everybody seems to be talking about why we shouldn't be talking about the poet: misogynist, homophobe, reactionary, fascist, elitist, anti-Semite. Bibliographic indices reveal that most of the recent work on Eliot explores these darker elements. Some of that criticism has been vacuous, inaccurate, and prosecuted with vindictive glee; some of it has been painfully accurate and deeply troubling to literary scholars. More than any other dead white European male, Eliot has become the Poet You Love to Hate: his politics are suspect, his opinions bigoted, his poetry incomprehensible, and he was a snob and a fogey to boot. Any headwaiter proclaiming Eliot a great poet nowadays is likely to forfeit a tip.

Stravinsky's reputation, on the other hand, has lost none of its luster. Every year, new laudatory biographies and critical commentaries are heaped on bookstore shelves. Stravinsky's music continues to be recorded, and his early ballets in particular enjoy a wide currency in concert presentations. Some of Stravinsky's banners are still flying as well: musical modernism has not gone out of favor; complicated rhythms, urbane orchestrations and allusive throwbacks are still hipper than hip; and music scholars continue to bloody themselves wherever the neoclassical flag is unfurled. Even music appreciation textbooks—the surest indicator of popular opinion and critical consensus—do not blush to refer to the composer in the glowing terms that the New York headwaiter used in 1963: Stravinsky was, and is, "arguably the most significant composer of the twentieth century."[3]

What accounts for this radical divergence of opinion about Eliot and Stravinsky—a divergence that has come about only since their death? And is it merited? To the casual observer, it might look like a case of history is setting things right, the way Willa Cather's unjust neglect has been rectified and Rudyard Kipling's work downsized from the canon. But the devaluation in Eliot's stock is not merely a result of a wake-up call to what is problematic in his work; rather, his dethroning comes as a result of a political thrust within the academy—a thrust that many Stravinsky scholars have desperately (and so far, successfully) resisted.[4]

Within the academy, the political and cultural emphasis in literary studies has trained an unforgiving gaze on Eliot, while to a large extent the entrenched formalism of music studies concentrates on the technical innovations of Stravinsky, rather than on the political, rhetorical, ethical, or cultural aspects of his music. Scads of scholarship have been written on the relationship of Eliot's aesthetics—his theory of "impersonality," his emphasis on order and tradition—to the political theories that undergird

them, while Stravinsky's relationship to these same aesthetic theories has, until very recently, been divorced from their political roots.[5] As the academy has constructed Eliot and Stravinsky in such different ways, the interdisciplinary work that does bring them together has had to start from scratch. Much of it, not surprisingly, is technical in nature, since scholars looking for correspondences in the absence of a historical or cultural frame must inevitably scout for details.[6]

A closer look at the conflicting statuses of these two artists reveals that the depoliticized Stravinsky, who is the glorified hero of postmodernism, and the politicized Eliot, who is the scapegoat of modernist sins, bear little resemblance to their historical counterparts. By examining the rhetorical strategies by which these artists have been constructed, I can not only make some salutary (if inadequate) corrections, I can also complicate the way academics have subscribed to the differing ideologies of the two disciplines that created such caricatures. After considering the ways in which these artists' reputations have become cemented in literary and music studies, I will undertake a close rhetorical reading of the work of Fredric Jameson, whose analysis of Eliot and Stravinsky, while claiming to be politically and historically situated, misses the manifold similarities between these artist and merely rehashes the shibboleths of the two disciplines.

DISCIPLINING ELIOT

> *Disciplines look at what they recognize, or more*
> *precisely, see only what they recognize no matter*
> *where they look.*
>
> —PATRICIA HARKIN [7]

As a graduate student determined to write on Eliot, I knew that I was joining the losing side of a battle when a fellow student announced what she considered to be the essential facts about Eliot: he had written *The Waste Land,* he was a fascist, and he had arranged to have his wife incarcerated. The source of this last scuttlebutt, I soon learned, was Michael Hastings's fictionalized account of the poet and his first wife, the play (later a movie), *Tom and Viv.* Based loosely on T. S. Eliot's hasty marriage to Vivienne Haigh-Wood and her eventual incarceration, the play forcefully insinuates itself as a biography of the couple by bluffing a scholarly—as opposed to fictional—apparatus: interviews, quotations, "evidence," and so on, were consulted in its construction. In a series of

interviews with the playwright, Maurice Haigh-Wood (Vivienne's brother) had confessed that when he had seen Vivienne on his last visit to the sanitorium in 1947, he realized that he had done something "very wrong." Hastings gives us the juicy morsels as they dropped from Haigh-Wood's mouth: "She was as sane as I was. . . . What Tom and I did was wrong. And Mother. I did everything Tom told me to."[8] In this admission, not only have we found the smoking gun, but Eliot's apparent desire to conceal it: he locked away a perfectly sane woman, bullied his brother-in-law into complying, and made everyone shut up about it. This is thrilling stuff, which Hastings substantiates with a pithy epigraph by Edith Sitwell: "At some point in their marriage Tom went mad, and promptly certified his wife."[9]

It is Haigh-Wood's tag line—"I did everything Tom told me to"— that serves as a major premise of the play and that is even more interestingly at odds with the facts than Hastings's other distortions of biographical data. Haigh-Wood's own guilt most likely accounts for this revisionist view of Vivienne's incarceration. It turns out that Haigh-Wood is the one most responsible for the incarceration of his sister, not Eliot. At the time of Vivienne's incarceration, Eliot had been separated from her for six years, a fact the play conveniently ignores. There is a letter, written by Maurice Haigh-Wood and addressed to Eliot, dated 14 July 1938 (Eliot left Vivienne in 1932), which informed the poet that Vivienne's doctor had recommended that she be certified. As the signatures of two relatives were required, and as Eliot had not divorced Vivienne, Maurice had to approach Eliot in order to follow through on the doctor's recommendation to have Vivienne certified. So much for Maurice doing "everything Tom told [him] to."

Other slights to Eliot and historical fact abound in the play, but what is instructive about it is not so much its inaccuracies but that the play seemed to have appealed to those who already had a bone to pick with the poet. The play and film, then, were accepted as largely true, for they flattered the beliefs of those who wanted them to be true. Hastings begins the blustery preface to his play by relating a striking anecdote. Asking a "radical feminist" friend of his how she would have written the same play, he was given the response:

> "If I'd written that play, Tom would have gone to jail for his male characteristics. Viv would have written *The Waste Land* and become the most famous poet of the century. She later married Oswald Mosley and turned the offices of Faber & Faber into a printshop for the British Union of Fascists. And she and Mosley had four daughters—

Marghanita Laski, Myra Hindley, Ruth Ellis and Margaret Thatcher. Then, around 1960 Viv won the Nobel Peace Prize. Her kids quarantined the adult male population following compulsory sterilization. All other males under age were subject to curfew laws. Shortly after her death at a great age, a female Pope would promptly canonize Viv."[10]

That Hastings clearly approves of the story (a "gay fanfaronade," he calls it) is evident in his laudatory inclusion of it, as well as in the point it makes apropos of his own version. The point of this story, he tells us, "is that at times to reclaim the past a different view is required." In other words, if the truth doesn't serve your ideological purposes, then make up one that does.

My discussion of *Tom and Viv* seems to fall outside of my purview, which is how Eliot has been constructed by an academic discipline. But, as I've alluded, it struck a chord among academics who wanted it to be true. A look into the discipline of music is instructive here. When the comparatively respectful films *Amadeus* and *Immortal Beloved* were released, musicologists wasted no time in trouncing their inaccuracies and redeeming what they thought were the inappropriately sullied reputations of Mozart and Beethoven. But Eliot critics' resistance to *Tom and Viv*, while steady, never made the kinds of inroads in the movie's critical reception as music critics' resistance to *Amadeus* and *Immortal Beloved*.[11] The average music student can tell you what's inaccurate about those films. The average literature student, on the other hand, has absorbed the premises of *Tom and Viv* as lore.

Another reason for referring to the effect that Hastings's play has had on Eliot's reputation is that it not only fed into an academy intent on defaming Eliot, it also fed *from* that same source. Consider, for example, what has come to be my favorite instance of irresponsible scholarship on Eliot: J. Mitchell Morse's "A Fascist Cryptogram in *The Waste Land*?" In this short article, Morse claims that the Thames daughters' chants ("Weialala leia")—direct quotes from Wagner's *Götterdämmerung*— have a covert, fascist meaning that can be revealed with reference to an obscure travel piece by Valery Larbaud. Larbaud's "Lettre d'Italie" describes a scene of frenzied calls between chefs and waiters, "urging each other on with d'Annunzian and fascist cries of 'Eja, eja, eja, alalá!'" What Eliot's poem has to do with the memories of a French writer who recalls the ejaculations of Italian servers, or what such cries have to do with fascism proper, are never made clear in Morse's article. Indeed, Morse does not even say what that fascist meaning might be. But perhaps

the ultimate silliness of Morse's article is that the travel letter that he cites as allusive evidence was written in 1924: two years after Eliot's poem was in print.

Less silly is the way Morse backs up his argument with predictable disciplinary bias. Here, Morse makes breezy references to Eliot's discussions of politics published in the *Criterion* during the interwar years. "Only once, as far as I can discover," Morse writes, "did [Eliot] explicitly say he preferred fascism to democracy: 'I confess to a preference for fascism in practice' . . . But his works, until the bombs began to fall, were full of expressions of sympathetic interest in it, modified by occasional expressions of praise with faint damns."

Yet more incendiary evidence: a direct quote from Eliot, which Morse slaps down like a trump card and which Hastings's play manages to make sound even more scary. (In the play, Hastings's Eliot character sneers in a speech—which the real Eliot never gave—"I have a preference for fascism which I dare say most of you share. My objection to fascism is that it is pagan.") Note the rhetorical bomb that Morse drops on Eliot, whose writings, he claims, were full of "sympathetic interest" in fascism, at least "until the bombs began to fall." Morse's two-sentence summary of Eliot's political thought claims that the interwar Eliot preferred fascism to democracy, that his inhibitions about it were merely poses ("faint damns"), and that he modified his position only once the disastrous consequences of fascism had become apparent.

That Eliot had an interest in fascism is no secret. Much of the intelligentsia of the 1920s were enamored of fascism's earliest phases. Since the world had fallen apart in the Great War, and the Bolshevik revolution threatened even greater chaos in its wake, many intellectuals (and the bourgeoisie, of course) thought that a strongly centralized government was the only possible solution to economic crises and ethnic rivalries. Many of these people thought that democracy was either partly or largely to blame for the war and that therefore some new system was needed.

It is these seemingly reasonable people—who pronounced democracy ineffective, who feared the bloody consequences of communism to their east, and who considered fascism as an alternative—whom Eliot is addressing in these *Criterion* essays of 1928 and 1929. And he tells them that they're heading into dangerous waters. Hear Eliot in 1928: "I cannot share enthusiastically in this vigorous repudiation of 'democracy.' When the whole world repudiates one silly idea, there is every chance that it will take up with another idea just as silly or sillier." Silly ideas like communism and fascism. While conceding to specific criticisms of democratic

practices, Eliot warns, "it is another thing to ridicule the *idea* of democracy." More of a cultural theorist than a practical politician, Eliot suggests a reframing of the problem: "The modern question as popularly put is: 'democracy is dead; what is to replace it?' whereas it should be: 'the frame of democracy has been destroyed: how can we, out of the materials at hand, build a new structure in which democracy can live?'"

Eliot fears that the rush to replace democracy with fascism is based on laziness. Democracy is burdensome because it requires thought: "[O]ur newspapers pretend that we are competent to make up our minds about foreign policy, though we may not know who is responsible for cleaning the streets of our own borough." Eliot warns that if order and discipline are the only things people want in a system of government, then "in this state of mind and spirit human beings are inclined to welcome any regime which relieves us from the burdens of pretended democracy. Possibly also, hidden in many breasts, is a craving for a regime which will relieve us of thought and at the same time give us excitement and military salutes." Eliot, even in 1929, does see the sinister elements of totalitarian government.

But Eliot does not see the political or economic doctrines of fascism and communism as being very different; only their "enthusiasms" are different, he claims. And in the summary to his discussion of fascism and communism is where Eliot writes that nasty sentence. But note how radically the meaning changes once the preceding sentence is restored: "The objections of fascists and communists to each other are mostly quite irrational. I confess to a preference for fascism in practice, which I dare say most of my readers share."

Given a choice between the two, Eliot does prefer fascism, in practice, to communism, but the more pressing problem is how to make democracy work so that neither of these extreme forms of government becomes necessary. I'm not sure what to make of Morse's distortion of Eliot: to accuse Eliot of preferring fascism to democracy on the basis of these articles is either a disastrous misunderstanding or an intentional misrepresentation.[12]

Fortunately, most Eliot scholarship—even the work that is hostile to the poet—is not so reckless. But one can learn a lot from a culture by surveying its extreme elements. In more mainstream accounts of Eliot (Morse is mainstream, though: his article was published in a well-respected journal), these rhetorical cannonades hurled by the extremists are displaced by seemingly more dispassionate rebuffs of his work. But more dispassionate doesn't necessarily mean more reasonable. And to

find such unreason, one has only to look at the anthologies, whose bland scholarship capsules speak in the impersonally objective voice of the profession. Two examples to show how Eliot's standing as a modernist has been revised beyond recognition: the old and venerable *Norton Anthology of English Literature* and the new and sassy *Poems for the Millennium.*

One can almost always count on the *Norton Anthology* to introduce an author in a way that simultaneously obstructs the work and muddles the critical wisdom. Even though the authors of the introduction to Eliot concede that his influence was enormous, they qualify the poetry: "His range as a poet is limited, and his interest in the great middle ground of human experience (as distinct from the extremes of saint and sinner) deficient."[13] This is curious. Anyone who would claim that Eliot is deficient in exploring the neuroses, ennui, and shortchanged happiness of everyday human experience needs to reread "Prufrock." And the second section of *The Waste Land.* And *Four Quartets*, with that memorable line of regret: "through the door we never opened." And what do the editors mean by limited range? Eliot wrote some verse that was pyrotechnically allusive and economical and some verse that was deliberately flat and prosaic. He wrote poetry of pain and alienation and at least one straight-forward love poem ("A Dedication to My Wife"). He wrote plays, mono-logues, choruses, religious verse, satirical portraits, and cat poems. What more could you want in a poet?

In spite of what they see as the poet's deficiencies, the *Norton* edi-tors do admit that Eliot's general standing is that of "*the* poet of the mod-ern Symbolist-metaphysical tradition." In other words, Eliot is the most important poet of what to postmodernists is the least relevant tradition in literature. That Eliot's verse is indebted to the French *symbolistes* and to English metaphysicals is well documented, but exploration of the two fields is hardly a major interest of Eliot scholarship, old or recent. Eliot is not only indebted to the symbolists and metaphysicals, but to most other strands of literature as well, including the romantic strains he disavowed. But what used to be the received critical wisdom was that Eliot's great contribution to poetry was the startling new configurations of those strands. It was the astonishing break with past forms and conventions of narrative that early century critics recognized as the start of something new, or "modernist." Eliot was so much a leader of this movement that many referred to the kind of art it engendered as "high modernism." So for readers turning to *The Norton Anthology* who might reasonably expect to hear that Eliot is a high modernist, or at the very, very least, a

modernist, they learn instead: the range of Eliot's poetry is limited, its contents are irrelevant to Most Folks, but it gets good marks for being exemplary of a specialized tradition within a broader poetic landscape.

Anyone familiar with the polemics of the 1920s and 1930s knows that Eliot's impact was simply volcanic. Here is Edmund Wilson in 1922, glancing back at Eliot's achievement so far: "Mr. T. S. Eliot's first meagre volume of twenty-four poems was dropped into the waters of contemporary verse without stirring more than a few ripples. But when two or three years had passed, it was found to stain the whole sea. . . . His productions . . . turned out to be unforgettable poems, which everyone was trying to rewrite."[14] And that's how singularly important Eliot was to modernist poetry *before* he wrote *The Waste Land*.

During these turbulent years of early modernism, "Eliot" was certainly not synonymous with "poetry," but anyone who had an investment in literature did have to contend with Eliot's creative and critical stock. Even those who, like William Carlos Williams, consciously swam against the tide still had to come to terms with Eliot's work. And Williams had to swim for his life. In the midst of the clamor of *The Waste Land*'s publication on both sides of the Atlantic, the *Dial*'s award of two thousand dollars to its author, the scandal in the popular press that the poem was possibly a hoax, and the waves of commentary that immediately engulfed the poem, Williams sulked in his autobiography: the appearance of *The Waste Land* was "the great catastrophe to our letters."[15]

And it is Williams's gripe that the editors of the new anthology *Poems for the Millennium* use to introduce *The Waste Land*. Note the rhetorical trope of *occultatio*—"emphasizing something by pointedly seeming to pass over it"[16]—at work in the first sentence of their commentary: "Williams's description of Eliot's masterwork, *The Waste Land*, as 'the great catastrophe to our letters,' along with Eliot's own conservatism & the aid & comfort he gave to the Anglo-American academicizers of the 1930s & onwards, shouldn't obscure the contribution of his work (up to the present) to the more extreme, often subterranean developments."[17] Eliot has three strikes against him here but is allowed to hobble to first base anyway. From outside the narrow confines of the academy, these must seem like pretty odd grudges to hold. If on the political spectrum, Eliot's "conservatism" is all he is guilty of (no mention of fascism here), then one might reasonably ask: what's wrong with that? The answer: in academe, "conservatism" is a liberal cryptogram for intolerant fascism. One might also reasonably ask: what's wrong with Eliot giving "aid and comfort" to his British and American colleagues?

The answer: because those piffling "academicizers" were conservative New Critics who helped disseminate Eliot's ideas that the editors are busy trying to squelch.

But on the plus side of Eliot's poetry, those "subterranean developments" (?) that the editors don't want obscured in spite of all their listed obscurantisms include Eliot's collage technique and its possibilities "for holding multiple experiences in the mind as simultaneity &/or reoccurrence [*sic*]." They even add their own obscurantism to the short list of Eliot's accomplishments: "No question too [*sic*] that he helped to clarify & reinterpret the activity of individual consciousness in the formation of alternative world-images." I'm not exactly sure what an "alternative world-image" is, or if I've ever come across one in Eliot's poetry. Nor do I have the least idea of how "the activity of individual consciousness" might help me to reinterpret the business of forming a world-image thingy, but apparently it's something Eliot's poetry does to the editors and of which they approve.[18] Could be worse, though. Instead of including only one poem of Eliot's in their enormous, two-volume work, they could have excluded Eliot altogether.

One of the great strengths of *Poems for the Millennium* is that new voices get a hearing. Lots of obscure poets and translated work sit side by side with older, canonical stuff that helps to complicate any complacent understanding of modernism, and thus, of Eliot. There's also a helpful chunk of historical context at the beginning of the volume. A full twenty-seven pages are given over to translations of Stéphane Mallarmé, who died before the twentieth century began but whose influence was significant to several modernists. As any admirer of Mallarmé would expect, those twenty-seven pages aren't used very economically; owing to his odd typography, three or four words drip down a page, and one entire page is left blank between words.

Any anthology must make well-informed inclusions and exclusions, and this modernist anthology's twenty-seven-page allotment to a non-modernist seems luxuriously bountiful when compared with the stingy space given over to Eliot. In this first volume devoted to mapping out modernism—an eight-hundred-page millstone—can you guess the least number of pages on which they could squeeze *The Waste Land*—the one measly poem of Eliot's that they deem worthy of inclusion? Zero. Yep, they figured out a way to exclude Eliot from a modernist anthology. After the commentary, which sets up *The Waste Land* as poorly as can be imagined, the editors put Eliot's title in brackets, remarking that the poem

is "easily available" elsewhere. Leaving aside the fact that Mallarmé is almost as easily available (and any of the dozens of authors they include), here is a specific instance in which Eliot is slyly written out of history, while Mallarmé gets a whole page of white space, and the editors unlimited space to befuddle readers with their incomprehensible commentary.

While the first sentence of the commentary on *The Waste Land* uses the trope of *occultatio* to get away with denigrating a crumbling reputation, the final sentence uses the related trope of *apophasis*—pretending to affirm what is really denied[19]—in order to ignore Eliot without seeming ignorant: "While not reprinted here, *The Waste Land* has an obvious place within the mappings represented by the present volume." That "obvious place" is not so obvious if you have to bulldoze through their commentary and hike to the library to find it.

It's hard to smugly defend Eliot as smugly as he's been trashed though, if only for the simple reason that Eliot himself sowed the seeds of his current treatment. As almost everyone agrees, his prejudices in the early verse are especially disconcerting. And the snubbing Eliot has been receiving of late is perhaps prefigured by his own criticism, which at times betrays an unmistakable high-handedness. The political bent of current criticism is not something of which, in theory, Eliot would have disapproved, either. Pace the New Critics, Eliot argued from early in his career that literary criticism cannot proceed on literary standards alone but must use "explicit ethical and theological standards."[20]

TWO STRAVINSKYS

> *Heresy is often defined as an insistence upon one half of the truth.*
>
> —T. S. ELIOT[21]

By comparison, Stravinsky's angelic reputation might very well be attributed to the fact that the composer spent a significant portion of his life browbeating people into thinking that his music had no political or ethical dimension. "Music," Stravinsky wrote in an incautious moment, "is essentially powerless to *express* anything at all."[22] And for a long time, while seeming to disagree with his *boutade* (why talk about music if it doesn't mean anything?), Stravinsky scholars have willfully subscribed to it.

In the discipline of music, the most imposing text that propagates canonical readings of canonical composers is *The New Grove Dictionary*

of Music and Musicians. A music student hunting for information on Stravinsky's personal life, for example, would find the following half-truths in the Stravinsky entry written by Eric Walter White: in 1905, Stravinsky married his first cousin, Catherine Nossenko. She bore him four children and was ill with tuberculosis much of the time, so Stravinsky kept his family near spas and hospitals in Switzerland so that she could be treated. Catherine died in 1939.

In this entry White also discusses Stravinsky's affair with Vera de Bosset, whom he had met in 1921 and whom he eventually married after his first wife's death. According to White, Stravinsky "fell deeply in love with her, and she with him." How the lovers arranged this awkward situation while Stravinsky's wife was still alive is put rather simply by White: "During the next 18 years they saw as much of each other as possible—mainly in Paris, but sometimes also when she was able to accompany him on concert tours."[23]

Another indicator of Stravinsky's general reputation in the academy is the standard biography: *Stravinsky: The Composer and His Works*, now in its second edition, written by the same author of the *Grove's* entry, Eric Walter White. Here we get a much more detailed picture of Stravinsky's life. Drawing on accounts from Stravinsky's memoirs, White relates an incident in 1932 when Stravinsky, on tour in Italy, had "received a summons" from Mussolini. During the ensuing meeting, Stravinsky made a mental note of the Duce's improper French accent. When the talk turned to music—Mussolini mentioning that he played violin—Stravinsky "quickly suppressed a remark about Nero." White also gives Stravinsky's description of the Duce as "quiet and sober, but not excessively polite." To this account quoted from Stravinsky's memoir, White adds the comment: "Afterwards Stravinsky remembered that [Mussolini] had cruel eyes."[24]

To further clarify Stravinsky's prescient and commendable politics during the interwar years—the same years that have landed Eliot in so much hot water—White gives us a summary of the political turmoil and its effect on Stravinsky: "The Fascist dictatorship had been established in Italy for some years; and the meteoric rise of the Nazi party in Germany was causing serious disquiet. In his *Dialogues*, Stravinsky recounts an unpleasant incident that occurred in 1932 to a Jewish friend of his (Eric Schall, the photographer) when he and Vera de Bosset were together in Munich."[25] Aside from *Grove's* and the standard biographies, the most readily available sources on the composer's life are by

the composer himself. Both *Grove*'s and the standard biographies rely heavily on these sources. Unlike Eliot—who rarely spoke about elements of his past, such as his first marriage, and who, before his death, burned many letters and had others locked away until the year 2020— Stravinsky is a veritable wellspring of self-information: he wrote no fewer than seven books about himself in collaboration with other writers.

The combined view we get from all of these sources is that Stravinsky was a man who, even though splitting his duties for eighteen years, was a hard-working husband and provider as well as a discreet lover and eventual husband to his mistress; he was a friend to Jews when the world was turning against them; and he was an enemy of fascism, particularly of cruel-eyed fascists with lousy French accents.

One of the first challenges to this rosy account came with the publication, by Robert Craft, of Stravinsky's correspondence. Craft begins the first volume of the selected correspondence with an introduction that confesses his dismay at the difference between the young Stravinsky and the older man he knew, a "very different, incomparably more likable human being"[26] than the author of the letters now on view.

Far from keeping his mistress a secret from his invalid wife as White implies, Stravinsky told Catherine about his infatuation with Vera, insisting that he could not live without her. Stravinsky "expected his wife not only to accept the triangular relationship," Craft relates, "but also to join him in admiring and befriending the younger woman. Since Catherine had always subordinated her wishes to her husband's, he correctly anticipated that she would do the same in this new situation. It might be said that she had no alternative, for her illness precluded a full participation in his life, and divorce between two people so closely united was unthinkable."[27] Stravinsky arranged for them to meet while he was out of the country, and the two women, amazingly, became friends. Catherine's letters reveal an extraordinarily accommodating woman who wrote to her husband's lover, as often, and with as much affection, as to her husband. Even more astonishingly, Catherine cooperated in keeping the affair a secret from Stravinsky's overbearing mother for sixteen years.

Another oddity of the correspondence that Craft notes is the fact that Catherine begs for money in almost every letter. Stravinsky's own mother had to borrow cash from the housekeeper, and Catherine led a very modest life in a sanatarium. As Craft points out, Stravinsky had plenty of money but was a notorious tightwad. (A meticulous record-keeper too, he

once entered in his ledger a ten-cent offering to a beggar.) But Stravinsky loved the good life; his economy extended only to others, not to himself. Always nattily dressed, his tailoring bill in May 1932 was three thousand francs. While on tour in America in 1937, Stravinsky sent for casks of expensive French wines to accompany him, as he had complained on an earlier tour that no good wines could be found there.

And what about Stravinsky's commendable politics? When Jewish musicians were being persecuted by Nazis, Stravinsky worried less about the fate of his colleagues and more about a possible decrease in German royalties. Having been asked by the Jewish conductor Klemperer—a personal friend and a supporter of his music—to sign a petition protesting the forced exile of Jews, Stravinsky balked, writing to his publisher: "Is it politically wise to join in this common cause?"[28]

Shortly after Hitler took power, Stravinsky's name made it onto a list of Jewish composers, and as Stravinsky was Russian, there was further suspicion that he might be Bolshevik as well. To counter these charges and thus assure himself performance privileges in the Nazi state, Stravinsky drew up a letter to his publisher in order to authenticate his genealogy, emphasizing that his father was of Polish Catholic ancestry and a member of the Russian hereditary nobility, while his mother's ancestors were Russian Orthodox.[29] Stravinsky only protested Nazi accusations of "international" and "Bolshevik" art when his own music made it into the "Entartete Kunst" exhibit ("Degenerate Art") in Munich 1938, though many friends had asked for his support in protest earlier.

Nor was Stravinsky's anti-Semitism bound merely to his personal financial security. When, in 1915, Carl van Vechten posited in print that Stravinsky might be Jewish, Stravinsky furiously demanded a public retraction. And when a Parisian newspaper described the composer, in 1931, as "Jewish–thin, *roux*, wearing a *pince-nez*," the light red–haired, pince-nez-wearing Stravinsky fired back: "I am not Jewish . . . do not have red hair, and wear a *pince-nez* less frequently than spectacles with ear frames."[30]

As for Mussolini having cruel eyes, Stravinsky would have had plenty of occasion to notice such details, since the composer was an ardent fan of the Duce, whom he met, willingly, several times. Before their first meeting, Stravinsky was interviewed by Alberto Gasco, of Rome's *La tribuna*, who recorded the composer as saying, "I don't believe that anyone venerates Mussolini more than I. To me, he is the *one man who counts* nowadays in the whole world . . . I have an overpowering

urge to render homage to your Duce. He is the savior of Italy and—let us hope—of Europe."[31] After their first meeting, Stravinsky and Mussolini often exchanged greetings and inscribed gifts.

For Stravinsky, as for the interwar Eliot, the chaos that the Bolshevik revolution unleashed did not bode well for future peace in a Europe still recovering from the Great War. But for Stravinsky, unlike Eliot, the revolution had had very personal consequences. Himself a member of the titled Russian aristocracy, Stravinsky had been dispossessed of a considerable property, which the Bolsheviks seized. Exiled from his homeland and deprived of an income, his hatred of communism bordered on the violent. Stravinsky's politics were usually tied to his purse strings, hence his affinity for Mussolini's brutally effective fascism. (Hence, also, his later proclamation on politics, after he had been naturalized in prosperous, postwar America: "As far as I'm concerned," said the wealthy Stravinsky from his Hollywood home, "they can have their Marshals and Fuehrers. Leave me Mr. Truman and I'm quite satisfied."[32])

But his conflicting pronouncements and later evasions about politics notwithstanding, Stravinsky was a man who needed his trains to run on time. Craft remarks that Stravinsky had an "obsessive, almost pathological need for order."[33] This need for order can be seen not only in his detailed accounts of his personal finances or in his preference for autocratic regimes but in his art as well. After the greatest crisis of his composing career, Stravinsky turned to serial composition—the most obsessively ordered form of composition imaginable. His neoclassical phase in particular can be understood as an attempt to control his art with reference to an existing, ordered tradition. The works from this period are a gold mine of historical forms, allusive gestures, and a pathological need to cloak his art in the respectability of a Western tradition.

In 1936, when Stravinsky was at the height of his campaign for discipline and order, the composer delivered a book inscribed to Mussolini, as well as a small gold medal as a symbol of his solidarity with the Italian forces, who were then at war with Ethiopia. In a letter to Yury Schleiffer, in Rome, Stravinsky explained: "In presenting this small gold token to the Treasury of the Italian State, I feel the satisfaction of participating in the fine deeds with which Italian patriots have shown allegiance to their party." Craft observes that those "fine deeds" included bombings of defenseless Ethiopian villages. One might say, without a shred of vindictiveness, that Stravinsky was full of sympathetic interest in fascism even after the bombs started falling.

DISCIPLINARY TIC

> *The Ezra Pound affair, not to mention more*
> *recent revelations about Martin Heidegger*
> *and Paul de Man, may have forced the literary*
> *world to struggle with the [relationship of*
> *fascism to the arts], but the musical world has*
> *scarcely begun to wake up.*
> —RICHARD TARUSKIN[34]

All this has the makings of a bad play. One trembles to envision Hastings composing the scene: Stravinsky groveling before the Duce, confessing to a preference for fascism and polygamy. But in spite of these appalling revelations about the composer's life, the Stravinsky front has not crumbled. In fact, while musicologists tread carefully over these biographical facts, most music theorists seem entirely nonplussed by them. Recently, the prominent Stravinsky scholar Pieter C. van den Toorn—irked by all this politicization in the academy—published a defense of formalist analytical methods: *Music, Politics, and the Academy*. Since we are in the wake of Stravinsky's dissembling in his conversation books, I want to call attention to van den Toorn's take on the status of these books. Contrasting the polemical nature of Stravinsky's comments about neoclassicism to his later turn to serialism, van den Toorn remarks: "For the opportunistic nature of much of Stravinsky's early commentary stands in contrast to the *icy integrity* with which he seems to have cloaked himself in later years, above all during the years of his 'conversations' with Robert Craft, from about 1957 to Stravinsky's death in April 1971"[35] (emphasis mine). Yet these conversation books were just as opportunistic with regard to Stravinsky's new aesthetic agenda: twelve-tone music. After years of declaring the primacy of French neoclassicism and shouting down the German romantic line, the newly serialized Stravinsky finally gave in himself and tried to reposition his work as coincidental with that very line: "I relate only from an angle to the German stem."[36] The rhetoric isn't as fierce, but this is just as spurious as the neoclassical Stravinsky. I can't keep from pointing out, either, that it is in this very same conversation book—*Dialogues and a Diary*—that Stravinsky makes his remarks about receiving "a summons" from Mussolini. That a music theorist would interpret as "icy integrity" both Stravinsky's opportunistic repositioning of his late work as well as the dissembling of his politics is yet another example of that disciplinary tic of seeing only what one wants to see.

THE RITE AND CONTEXT

> *. . . if one had said, yawning and settling a shawl,*
> *"O no, I did not like the Sacre at all, not at all."*
> —T. S. ELIOT, IN A NOTEBOOK
> PARODY OF "PRUFROCK"[37]

Richard Taruskin has done fascinating work on how Stravinsky's early work, particularly *Le Sacre du printemps* (the rite of spring), has become unhitched—with Stravinsky's blessing—from its original political roots and content. Music theorists' analyses of *The Rite*, or of any score, reduce its essential meaning to its component structure—how the thing was made. To many music theorists, the key to understanding a work lies not in the task of historicizing its conception and reception, or in understanding the political, rhetorical, or ethical dimensions of the work, but in decoding the "evidence" of the score. Which sounds reassuring enough, except that that evidence is usually so tendentiously manufactured as well as being in essential contradiction with other arguments that claim the same primacy. For example, music theorists have argued that the *Rite* is in the key of D minor, or that the harmonic structure is related to one "source chord" or a particular pitch-class set, or that its rhythmic structure is generated from one cell.[38] If scholars in the discipline of English were to wade through these analyses, I imagine they would pronounce music theory the apotheosis of New Criticism. Here, not only are works separated from the world, but the idea of "meaning" in a human, political, or rhetorical sense is entirely abandoned. And it is this sanitized Stravinsky of the D minor *Rite* that the discipline of music (with help from Stravinsky himself) has presented to the rest of the academy.

Originally conceived as a ballet of primitive rituals of renewal with Massine's new style choreography, Stravinsky's music for *The Rite*—pounding rhythms, attenuated melodies, dislocation, and abrupt juxtaposition—accompanies the sacrifice of a virgin, "The Chosen One." Yet in spite of all of the action that builds toward the sacrifice, there is no real drama here at all: as critics have noted, the Chosen One betrays no terror at being killed. Truman Bullard has argued that the characters in *The Rite* "are in the grip of a frighteningly indifferent society; they are devoted to a god that they collectively comprise and from which they do not yet know how to distinguish themselves."[39] Stravinsky's music is remarkable because, like the characters who are compelled of necessity to murder, it is equally pitiless with its explosive orchestra and ferocious accents.

For Taruskin, the "terrible dynamism" of the music "persuades us—nay, coerces us—to share its point of view. Rarely has an antihumanist message been so irresistibly communicated."[40]

In spite of the scandalous success that accompanied its Paris premiere in 1913, Stravinsky soon began to prefer *The Rite* as a concert piece. Taruskin suggests that Stravinsky's preference for having his ballet performed as if it were not a ballet is perhaps because the famous riot at its premiere occurred not as a result of resistance to the music—which went largely unheard due to the many who hollered at the stage or each other, and the rest who stalked out—but a resistance to the choreography. Stravinsky and Diaghilev dropped its original choreography after its first few performances, and later in his life Stravinsky emphasized its musical aspects, rather than its storyline. As early as 1920, the composer began retreating from his original statement that the music had come to him in a vision of the final scene, insisting instead that it was a musical "theme" that had inspired the work. So Stravinsky's reasons for disinfecting the ballet perhaps had something to do with his wounded ego: all this attention to dancers, talk of primitivism, and taking of sides meant people weren't hearing his music.

But Stravinsky's wounded ego cannot possibly be the reason that keeps contemporary music theorists from cordoning off the *Rite* from its original context. Rather, the argument that it is the very denial of the ego—the suppression of the human subject—that is at the root of this ballet is what makes historical analysis of the ballet so tricky and music theoretical analyses so appealing.

In spite of the toned-down choreography and Stravinsky's post-1920 spin on *The Rite* as pure music, at least one critic writing in London wasn't fooled by the new production. That critic was T. S. Eliot. Not only did he recognize the disturbingly modern primitivism of the ballet, he also recognized its relevance for a postwar culture. Writing of London's 1920 season, Eliot reviewed the ballet, the controversial choreography of which Diaghilev had by then revised:

> To me the music seemed very remarkable—but at all events struck me as possessing a quality of modernity which I missed from the ballet which accompanied it. . . . The spirit of the music was modern, and the spirit of the ballet was primitive ceremony. The Vegetation Rite upon which the ballet is founded remained, in spite of the music, a pageant of primitive culture. It was interesting to any one who had read The Golden Bough and similar works, but hardly more than interesting. In art there should

be interpenetration and metamorphosis. Even The Golden Bough can be read in two ways: as a collection of entertaining myths, or as a revelation of that vanished mind of which our mind is the continuation. In everything in the Sacre du Printemps, except in the music, one missed the sense of the present. . . . Stravinsky's music . . . seem[ed] to transform the rhythm of the steppes into the scream of the motor horn, the rattle of machinery, . . . and the other barbaric cries of modern life; and to transform these despairing noises into music.[41]

What Eliot liked about Stravinsky's music—and which he wished had been part of the ballet as well—was the link between modern and primitive. The tame choreography did not shock him into believing that link. In the version Eliot saw, the choreography merely suggested the first sense of Frazer's *The Golden Bough*: the ritual of virgin sacrifice as an "entertaining myth." But what Eliot wanted was "interpenetration" to have occurred between the dancing and the ferocious music. For Eliot, the dancing trivialized the rite, making it "hardly more than interesting" to an anthropologist, merely, "in spite of the music, a pageant." What he wanted was the second sense of Frazer: a blood-and-guts affair that would shock the audience into recognizing its present mind as a continuation of that vanished, antihumanist mind.

Part of Eliot's ideological affinity with Stravinsky rests in his citation of Frazer's *Golden Bough*, a work that heavily influenced *The Waste Land*. First published in 1890, this anthropological work claims to trace the roots of all rituals back to one ur-myth of sacrifice and regeneration. Such a work was immensely interesting to Eliot: a study that "scientifically" outlines a collective mind underneath a fractured Europe as well as hints at the connection (though the Victorian Frazer was wise enough not to state it explicitly) between such socially accepted rituals as the Eucharist and the bloody sacrifices of pagan culture. The aesthetic celebration of primitivism in *The Rite*, with its attendant concepts of communal brutality and loss of ego, was not just a fad popularized by Stravinsky but also an abiding interest of other modernists caught up in the new political manifestations of early twentieth-century Europe.

What attracted Eliot to Stravinsky's severe music was the notion that "tradition" might stretch further back than footnotes can reach; that "tradition" might be more bloody than Homer and more primitive than Shakespeare. It is in this sense that neoclassicism, as an aesthetic pose, was seen by some critics (Adorno one of the first) as a reactionary tendency.

Stravinsky's and Eliot's call for order and tradition, in this context, takes on more distinctively political connotations.

One of the formative influences on the conservative political roots of Eliot's aesthetic was T. E. Hulme. In his 1912 lecture "Romanticism and Classicism," Hulme is speaking about not only the aesthetic differences between romanticism and classicism but their political differences as well. "Here is the root of all romanticism," Hulme writes: "that man, the individual, is an infinite reservoir of possibilities; and if you can so re-arrange society by the destruction of oppressive order then these possibilities will have a chance and you will get Progress." [42] Revolutionary politics as naively optimistic romanticism, in other words. And here is Hulme's equally provocative definition of the politics of classicism: "Man is an extraordinarily fixed and limited animal whose nature is absolutely constant. It is only by tradition and organisation that anything decent can be got out of him." [43] Reactionary politics as ascetically disciplined classi-cism, in other words.

In describing how such politics are manifested aesthetically or techni-cally, Hulme uncannily foreshadows the neoclassical projects of both Eliot and Stravinsky: "In the classical attitude . . . [i]f you say an extravagant thing which does exceed the limits inside which you know man to be fas-tened, yet there is always conveyed in some way at the end an impression of yourself standing outside it, and not quite believing it, or consciously putting it forth as a flourish." [44] It's an excellent definition *avant la lettre* of the neoclassical mask. One can see peeking through Hulme's description Stravinsky's self-conscious stylizations and Eliot's Laforguian facades. Neo-classical aesthetics presuppose a certain emotional distance or objective con-trol, on the part of the artist; neoclassical politics require "tradition and organisation." Eliot would soon be leading the troops on both fronts, calling for "the necessity for austere discipline." [45]

By the early 1920s, Eliot and Stravinsky had both turned their art in the service of stomping out romantic Bolshevism with austere, classical discipline. Hulme's prophesy of the advent of "a period of dry, hard, classical verse" [46] was fulfilled by Eliot and Pound, who took a renewed interested in tightly controlled forms. Eliot's versions can be seen in his *Poems* (1920) and the precisely rhymed quatrains therein. And as this turn to regimentation had its roots in a Hulmean understanding of poli-tics, it is no mere coincidence that the majority of Eliot's anti-Semitic sentiments can be found in these cruelly ordered poems.

In Stravinsky, that austerity manifested itself as a banishment of strings from his orchestra. Rejecting swooning melodies and lush orchestrations,

Stravinsky turned away from his ecstatically Rimskian *Firebird* and *The Rite* and began to foreground the squawky woodwinds and aggressive percussion in such pieces as his *Symphonies of Wind Instruments* and what Taruskin has nimbly described as "those prickly piano pieces of the middle 1920s": the *Concerto*, the *Serenade in A*, and the *Sonate*.[47] The composer also turned from loosely programmatic music to the discipline of hardened forms.

And in yet another remarkable aesthetic/political parallel in the lives of Eliot and Stravinsky, this turn to ascetic discipline manifested itself in both men as a spiritual turn, at nearly the same time, to a conservative religion: in 1926, Stravinsky returned as a regular communicant to the Russian Orthodox faith in which he was raised, and in 1927, Eliot was received into the communion of the Anglican faith. Both artists then turned their work in the service of their religion as well: Eliot with his *Ash-Wednesday* (1930), and Stravinsky with his short setting of the "Our Father" (1926) and his monumental *Symphony of Psalms* (1930) composed, according to the score's inscription, "à la gloire de DIEU."

All of these correspondences between Eliot's politicized aesthetic and Stravinsky's similar poses provide ample material for politically minded critics. The current Marxist objection to Eliot's *The Waste Land*, for example, is that Eliot used progressive techniques—dislocation, narrative fragmentation, juxtaposition—for reactionary ends. Working against the drift of history, Eliot's avant-garde techniques in *The Waste Land*, Terry Eagleton argues, "wrenched apart routine consciousness so as to revive in the reader a common identity in the blood and guts."[48] Eagleton's reading of Eliot is almost identical to Eliot's (and Adorno's) reading of Stravinsky.

One would think that if Eliot, a conservative who was full of sympathetic interest in political meanings, noticed such elements in Stravinsky, then savvy theorists of the Left would balk at the attempt to disengage politics and history from Stravinsky's work, particularly since Adorno—no slouch when it came to relating politics and music—had outlined the connection long ago.

THE ECLIPSE OF UNIQUELY PRIVATE WORLDS

> *Always historicize!*
> —FREDRIC JAMESON [49]

Jameson has been one of the savviest Marxists of recent times; his work has been particularly harsh to modernist writers such as Eliot and

Wyndham Lewis. And yet in the work of Jameson, one so attuned to
unconscious political strivings that reveal themselves in artistic tech-
nique, nothing is stranger than his readings of Eliot and Stravinsky. Like
the mind of the academy itself, Jameson connects the technical aspects
of Eliot's work to a problematic and inaccurate worldview (moder-
nism), while Stravinsky's technique is said to foreshadow the postmod-
ern enterprise. In a short, five-paragraph section of *Postmodernism; or,
The Cultural Logic of Late Capitalism,* Jameson argues that there are
fundamental differences between the modern (particularly high mod-
ernism) and the postmodern. And the two artists whose work most rep-
resents these different eras are Eliot and Stravinsky, respectively.

Under the heading "Pastiche Eclipses Parody," Jameson begins the
section with the assertion: "The disappearance of the individual subject,
along with its formal consequence, the increasing unavailability of the
personal *style,* engender the well-nigh universal practice today of what
may be called pastiche."[50] This introductory sentence asserts straight-
forwardly that the unavailability of style engenders pastiche. So which
are we to believe: the heading (pastiche eclipses parody) or the first sen-
tence (pastiche eclipses style)? Pastiche, Jameson's next sentence con-
tinues, "is to be sharply distinguished from the more readily received
idea of parody." And describing this sharp distinction between parody
and pastiche is the apparent job of this whole section.

Jameson's very next sentence, a new paragraph, begins: "This last
found, to be sure, a fertile area . . ." Which would lead us to believe that
we are embarked on an explanation of the fertile ground found by "par-
ody," to which his phrase "[t]his last" clearly refers. But watch where
the sentence ends (I'll back up to get a running start): the concept of
pastiche "is to be sharply distinguished from the more readily received
idea of parody. This last found, to be sure, a fertile area in the idiosyn-
cracies of the moderns and their 'inimitable' styles: . . ." We end up on
the word "styles" followed by a colon—a grammatical signifier indicat-
ing explanation. That punctuation mark pushes us inexorably forward
to some concrete examples, which we desperately need in this abstract
formulation. But if, instead of moving forward, one backs up and notes
how we got from "parody" (which is a type of imitation) to "style"
(which is, in Jameson's scare quotes "inimitable"), then one has caught
the key that Jameson uses to effect his purpose. In this brief section, two
incompatible terms—*parody* and *style*—are switched back and forth in
a rhetorical tour de force. Part of the genius of Jameson's sleight of hand
rests in the apparent mode of this passage: he appears to be explaining
the important distinction between pastiche and parody. While the reader's

attention has been drawn to the nuanced distinction between these two forms of imitation, Jameson throws up a verbal smoke screen of ill-defined terms in order to let the more significant distinction between imitation and style go unnoticed, and therefore be interchangeable.

Yet one doesn't need to have a black belt in literary theory to know that style and parody are not interchangeable but are distinct notions of voice. Style, whether musical or linguistic, is a cohesive code, or recognizable set of mannerisms, whether an individual's, a group's, or an era's. Parody, on the other hand, is parasitic of style: one needs a style already in place in order to parody. Back to those examples, with another running start:

> This last [concept of parody] found, to be sure, a fertile area in the idio-syncracies of the moderns and their "inimitable" styles: the Faulkner-ian long sentence with its breathless gerundives, Lawrentian nature imagery punctuated by testy colloquialism, Wallace Stevens's inveter-ate hypostasis of non-substantive parts of speech ("the intricate eva-sions of as"), the fateful, but finally predictable, swoops in Mahler from high orchestral pathos into village accordion sentiment . . .

These examples Jameson gives are encapsulations of an author's or com-poser's style, which are, in his words and scare quotes, "inimitable." Faulkner's long sentences and Mahler's peculiar orchestrations are indeed idiosyncratic, can be parodied, but I'll clarify, they are not examples of modernist parody proper. Jameson enables this crucial distinction—a par-odic style or a style that can be parodied—to be buried by using the trope of *prosopopoeia*: giving an inanimate object or concept the properties of an acting agent. In this Jamesonian sentence, it is parody that "found" a fertile area in modernists' styles. So we cannot tell if he means that mod-ernists use parody as a stylistic mode or that their styles are so idiosyn-cratic ("inimitable") as to be virtually self-parodic.

Although Jameson implicates Eliot elsewhere as a purveyor of this type of modernist, "inimitable" style, Jameson does not try to encapsulate Eliot's style here as an example of modernist technique, which is telling: a good description of an Eliotic style would blow Jameson's cover, since Eliot's style is both idiosyncratic—recognizable and inimitable—as well as a style that was formed mainly through types of imitation, including parody and pastiche.

Jameson further stresses his point, whatever that may be, regarding modernist style in his next sentence: "All these strike one as somehow 'characteristic', insofar as they ostentatiously deviate from a norm which then reasserts itself, in a not necessarily unfriendly way, by a systematic

mimicry of their deliberate eccentricities." How facile the obfuscation is:
the beginning of the sentence seems to be referring to style (all the
related words except "style" are in place: "characteristic" and "norm"),
but it ends in a reference to "mimicry." Another part of Jameson's rhetor-
ical genius is that not only are the concepts "style" and "parody" shifted
inexplicably, but their related synonyms are often used against their orig-
inal, or common-parlance, sense, which further disrupts the reader's
attempt to keep them separate.

Even more disorienting is the grammar of this sentence, which is
impossible to unravel (if anyone is keeping tally, this device is called
amphibogia). Note especially the ambiguous placement of the essential
word: "mimicry." Not only is its grammar placement opaque, its actor is
ambiguous as is its referent: who or what is doing the mimicking, and
who or what is being mimicked? The brilliant deployment of the word
lies not only in its ambiguous referent, its unknown actant, and the gram-
matical lacuna it occupies, but also in its connotative equivocation as
well: one cannot tell if "mimicry" is a synonym for parody or pastiche.
Let me replay the sentence, with editorial: "All these *[these examples of
the "style"? or these modernist authors?]* strike one as somehow 'char-
acteristic' *[scare quotes: characteristic, but not "really"]*, insofar as
they *[the style or the authors?]* ostentatiously deviate from a norm which
then reasserts itself *[an abstract noun–"norm"– is doing the asserting
here, not the author]*, in a not necessarily unfriendly way *[this preposi-
tional phrase interrupts the sense, and its double negative (not . . .un-)
and hedging adverb further slow it down]*, by a systematic mimicry
*[what mode is mimicry: parody or pastiche? and who is mimicking? the
style, the author, or the norm? and what is being mimicked? the style, the
norm, the style's eccentricities, or the norm's eccentricities?]* of their
deliberate eccentricities *[whose eccentricities? the style's, the author's
or the norm's?]*." The sense is impenetrable, but the effect is analyzable:
style becomes magically separated from the idea of "norm." In its place,
the word "mimicry" does its ambiguous work.

This kind of equivocation continues, the tedious exegesis of which I'll
spare my reader in order to skip to Jameson's reading of Stravinsky. After
relegating the older, high modernist culture to parody, Jameson continues
in the final paragraph by arguing that Stravinsky is the spokesperson for
the new wave of pastiche that begins to eclipse parody. "Stravinsky is the
true precursor of postmodern cultural production. For with the collapse of
the high-modernist ideology of style—what is as unique and unmistakable
as your own fingerprints, as incomparable as your own body . . . —the
producers of culture [i.e., Stravinsky] have nowhere to turn but to the past:

the imitation of dead styles, speech through all the masks and voices stored up in the imaginary museum of a now global culture." Here's that same switch. The previous paragraph's formulation of modernism was that its dominant mode was parody—a form of "speech in a dead language." Yet here we are told that high modernism consists in an "ideology of style." In another essay dealing with the historical encroachment of pastiche over parody (which uses some of these same sentences I've been analyzing), Jameson explicitly names Eliot, this time still without a definitive description of Eliot's "stylistic practice":

> [I]f the experience and the ideology of the unique self, an experience and ideology which informed the stylistic practice of classical modernism, is over and done with, then it is no longer clear what the artists and writers of the present period are supposed to be doing. What is clear is merely that the older models—Picasso, Proust, T. S. Eliot—do not work any more (or are positively harmful), since nobody has that kind of unique private world and style to express any longer.... Hence, once again, pastiche: in a world in which stylistic innovation is no longer possible, all that is left is to imitate dead styles.[51]

But if high modernist style is unique, private, individual—"unmistakable as your own fingerprints," to use Jameson's own terms—then how can the dominant mode of modernism be parody, which is once removed, an imitation of someone else's fingerprints? Jameson's two central concepts of modernism, style (unmediated) and parody (mediated), cannot coexist, cannot explain the same phenomenon. Even if we grant one of Jameson's distinctions—that the difference between Eliot and Stravinsky is the difference between parody and pastiche—it's not at all clear how an analysis of Eliot's and Stravinsky's works would be able to maintain such a binary.

TWO LANGUAGES, ONE SPACE

> *Immature poets imitate; mature poets steal.*
> —T. S. ELIOT

> *A good composer does not imitate; he steals*
> —IGOR STRAVINSKY[52]

If I were to test Jameson's distinction against the allusive practices found, for example, in Eliot's *The Waste Land* and Stravinsky's *Oedipus Rex*, I can find many correspondences, first of all, in the content—and

therefore the political significance—of their appropriational strategies. Both of these works partake consciously and polemically in the aesthetic of neoclassicism and are therefore complicit in the problematic politics that many Marxists have read into that aesthetic. It is in their respective critical poses that Eliot invokes Homer and the literature of Europe, while Stravinsky points—always with a Bloomian anxiety— to the Russian and German lines of Western art music. Their work follows suit. Eliot's *Waste Land* does invoke that tradition: Dante, Shakespeare, Baudelaire, the Bible, and Webster are used as allusive reference points and even, some have argued, as structural models. Likewise, *Oedipus Rex* pays homage to Mussorgsky, Verdi, Rossini, and Baroque opera conventions.

But Eliot's and Stravinsky's aesthetics do not include the wide body of lowbrow culture from which they both liberally stole. *The Waste Land* appropriates chatty memoirs, lower-class dialect, bawdy camp songs, Tarot cards, and contemporary newspaper accounts; *Oedipus Rex* revels in Keystone Kops music, Russian Cossack dances, hoochy-koochy dances, and the trumpet fanfares of early 20th Century Fox films. Surely the most fortuitous correspondence between the two works must be their campy allusions to the music hall. In the second section of *The Waste Land*, in the midst of a tense dialogue between a hysterical woman and an impassive man, lines from the Siegfield Follies intrude startlingly: "O O O O that Shakespeherian Rag— / It's so elegant / So intelligent."[53] And in *Oedipus Rex*, during Creon's self-important repetition of the oracle, Stravinsky quotes a Folies Bergères melody. (Stravinsky later commented on this allusion, found at figure 40 of the score: "The girls enter, kicking."[54]) In both the poem and the opera, the music-hall allusions self-consciously disrupt the apparent seriousness of what is supposed to be going on.

Besides correspondences in allusive materials and in aesthetic poses, there are also many correspondences in method and effect. But a good description of those methods requires an even more nuanced taxonomy of imitation than pastiche and parody.

There is a gap in critical theory between style and imitation: as the critical lexicon has it, one can have a style, or one can imitate someone else's style. Some of the variants of imitation (parody and pastiche) help to bridge that gap, but it is not clear where they reside. If we think of style and imitation in this mutually exclusive way, then we're stuck with an analytical method that forces us to think of Eliot's or Stravinsky's style as partly authentic Eliot/Stravinsky and partly Eliotic/Stravinskian imitation of something else. This binary of style/imitation, then, seems

an unhelpful tool for examining these artists, since much of what makes Eliot authentically Eliot and Stravinsky authentically Stravinsky are those very co-optations of others' voices.

The Russian literary theorist Mikhail Bakhtin helps fill these gaps. For Bakhtin and other postmodernists, a voice or a style—no matter how individual or idiosyncratic, or even deliberately monologic—is always constituted by other voices. This is part of what makes Bakhtin so appealing to many postmodernists; Bakhtin's theory of the self as being constituted by others fits nicely with poststructuralist and Marxist accounts of the fragmented self. Such a theory would therefore seem to be at odds with explications of high modernism as an era of "unique private world[s]," to quote Jameson, and a theory that would be alien to Eliot scholars.

But Bakhtin's notion of style and voice has been apparent to Eliot scholars long before Bakhtin became fashionable in the West. As scholars have noticed, Eliot's juvenilia is pretty dull and nondescript until he starts imitating the poetry of Jules Laforgue; then his poetry first takes wing, finds an authentic voice. That Eliot would sound most like Eliot when he started to imitate someone else should make us suspicious of a critic who tries to claim that Eliot's (or any high modernist's) style is unmediated until it takes recourse to parody proper—a radical and obvious form of imitation.

Bakhtin thinks of style as a unified language (what Jameson would call original, "unmistakable" as fingerprints), while stylization (Jameson: "imitation of dead styles") is not unitary. So far Bakhtin and Jameson are in agreement. Here are some further distinctions Bakhtin makes between style and other types of stylization:

> Every authentic stylization . . . is an artistic representation of another's linguistic [and I would add "musical"] style, an artistic image of another's language. Two individualized linguistic [or musical] consciousnesses must be present in it: the one that *represents* (that is, the linguistic consciousness of the stylizer) and the one that is *represented*, which is stylized. Stylization differs from style proper precisely by virtue of its requiring a specific linguistic consciousness (the contemporaneity of the stylizer and his audience), under whose influence a style becomes a stylization, against whose background it acquires new meaning and significance.[55]

While a style is the unified language of a singular artistic consciousness (which is still, paradoxically, made from the dialogic interaction of other

voices), stylization is a self-consciously dialogic form: a type of language in which two consciousnesses, each speaking a different language, are present. The contemporaneous language (Stravinsky's or Eliot's) casts a special light over the language that is being stylized. Stylization is an internally consistent mode; the stylizer creates a "free image"[56] of the language being stylized, illuminating it without introducing into the stylization words, phrases, or elements of the stylizer's own contemporaneous language. The internal consistency of a stylization results from one language working with another to illuminate it.

Two quick examples to ground this definition. From *The Waste Land*, the second section begins with an elegant stylization of the language of epic ceremoniousness, using Shakespeare's *Antony and Cleopatra* as a dialogizing background:

> *The Chair she sat in, like a burnished throne,*
> *Glowed on the marble, where the glass*
> *Held up by standards wrought with fruited vines*
> *From a golden Cupidon peeped out . . .*[57]

Two voices are working in tandem here: Eliot's language illuminates Shakespeare's, hence: stylization.

Likewise, in Stravinsky's *Oedipus Rex*, the "Gloria" that greets Jocasta's arrival has been read as a stylization of the epic ceremoniousness of Mussorgsky's Coronation scene. There are no Stravinskian "wrong notes" here: the trumpets and timpani blaze away in a stable tonality; imitative entries of the voices alternate with stark splashes of C major homophony, and the instrumentation changes to underline those radical changes in texture. No one would confuse this music with the tonal, orchestral, or gestural manner of Stravinsky's *Rite*, yet neither would anyone mistake this for authentic Mussorgsky. Hence, it's Stravinsky/Mussorgsky, or what Bakhtin would call a stylization. In both the Eliot and Stravinsky examples, the artist's voice (Eliot's or Stravinsky's) works in tandem with the other voice in an internally consistent way to create a free image of the language being stylized (Shakespeare's or Mussorgsky's).

While a stylization carries its own interests into an alien language, the stylizer does not use his or her own alien material. Bakhtin: "Should contemporaneous linguistic material (a word, a form, a turn of phrase, etc.) penetrate a stylization, it becomes a flaw in the stylization, its mistake: an anachronism, a modernism."[58] Bakhtin terms this flawed kind of stylization a variation. While a stylization is a free image of a language in another's language, a variation "joins the stylized world with the world

of contemporary consciousness."[59] A variation is not an image of an alien language then, but a discussion with that language, a variation, Bakhtin argues, "projects the stylized language into new scenarios, testing it in situations that would have been impossible for it on its own."[60] Two more examples. From *The Waste Land*:

> . . . *The nymphs are departed.*
> *And their friends, the loitering heirs of City directors;*
> *Departed, have left no addresses.*[61]

The meaning of this passage hinges on the linguistic irrelevance of the first line to the others. A reference to the nymphs in Spenser's "Prothalamion," the first line points to a specific, past stratum of poetic diction, as well as a mythical past, while the "loitering heirs of City directors" refers to the specific present of the poem. Yet the diction remains lyrical, is uninterrupted. Spenser's language is flawed with an intentional anachronism to test it in a new scenario.

Another example of Bakhtinian variation can be found at the beginning of Act II of *Oedipus Rex*. When Jocasta, the Queen of Thebes, enters (or is revealed by a curtain) to silence the noisy argument concerning the validity of oracles, her regal entrance has been prepared for by the rousing choral fanfare referred to above. Her recitative begins with appropriately stately instrumentation: flutes and a harp. Stephen Walsh characterizes the effect of this instrumentation, after the clamors of trumpets and timpani, as "an index of her standing and dignity" as well as containing "a suggestion of bardic insight, a sense of tapping down to deep and ancient roots."[62] She sings (in Latin) words of Racinean dignity: "Are you not ashamed, princes, to bicker and howl in a stricken city, raising up your personal broils?"[63] The generic expectations of recitative have, by and large, been fulfilled: the recit begins with a reduced instrumentation, and the vocal line is straightforward, with little melisma. But at the climax of the recit, on the words "clamare, ululare" (bicker, howl), a piano interrupts with a startling diminished chord. The meaning of this gesture cannot be understood through a formalist analysis of how diminished chords are built or how they should resolve. Rather, the listener must recognize the specific gesture—the upswept arpeggio—as a reference to a genre of music: namely, cocktail lounge singing, and more particularly, the broad arpeggio as that stock gesture by which a pianist clears the smoky air for the sultry chanteuse.

So there are two languages occupying the same space here: (1) the recitative as an eighteenth-century musical convention used for aristocratic

characters and placed before the more musically substantive aria and (2) a piano arpeggio as a twentieth-century musical convention used for calling attention to a husky-voiced singer. Both eighteenth-century recitative and twentieth-century arpeggio precede the aria or song but exist in different ideological zones: the former for characters (conventionalized opera roles) of noble birth, the latter for women (professional singers) whose cultural connotation is one of sexual potency. Jocasta contains this double-voiced meaning; she is both queen and incestuous lover. This recitative is not an example of stylization, as the intention of a stylization is for one language to illuminate the other. Here, both languages are at cross-purposes, yet their dual intentions contribute to a singular characterization of Jocasta, hence: a variation.

Bakhtin's distinctions exist on a continuum, and instead of defining the rest and giving examples of each, I'll just lay out the terms for quick inspection: <style proper—stylization—variation—parodic stylization—rhetorical parody>. Moving from left to right, the gradations of voice go from unitary style to double-voiced discourse whose intentions are in tandem, then in tandem but in competing contexts, then in disagreement, then to a unitary discourse that destroys the objectified language. If one wants to pull the linear continuum into a two-dimensional taxonomical space, then Bakhtin's brother (Nicholas Bachtin, also a linguist) has four other registers to measure where a language fits on scales that are colloquial (social, professional, geographical dialect), synchronic (from the prosaic to highly lyrical), diachronic (past to present), and diaglossal (shifts among foreign languages).[64]

Besides being adaptable for musical and linguistic systems, the great advantage of using such maps to locate registers, and contexts of voices, languages, and styles, is that the scales are both continuous and contiguous; instead of a random assemblage of terms haphazardly used and deployed as in Jameson, these scales are both nuanced and clear. A Bakhtinian reading of Eliot and Stravinsky, if it were to be worked out in more detail, would point to the similarities of the technical strategies they used and the rhetorical effects of the works and would complicate the disciplinary methods that have been assembled around their compositional strategies.[65]

Bakhtin's more nuanced distinctions also show us that not all stylization is, to use Jameson's terminology, "speech in a dead language." Adorno's estimation of Stravinsky's imitative practices uses even stronger terminology. With regard to the voraciousness of Stravinsky's appetite, in *Oedipus Rex*, for "dead" styles to copy, Adorno spits: "Universal

necrophilia is the last perversity of style."[66] If we deflate the polemical force of "dead" (or its implied, positive other, "alive"), and instead replace it with a rhetorical taxonomy that describes the ways in which different languages are used and sound against or with one another, then this Marxist reading seems less convincing.

What is most frustrating about Jameson's reading of Eliot and Stravinsky is not only that he misses all of the interesting ways in which their techniques are similar, but that after all of his heady theorizing, which claims not mere history for his interpretive strategies but "History" itself,[67] we end up with a very unoriginal interpretation, the clichés with which the academy has contented itself: a politicized Eliot who is "positively harmful," bogus, and monologic and an ahistorical, depoliticized Stravinsky whose techniques are liberating, prescient, and postmodern.

To summarize: my comparison of Eliot and Stravinsky, particularly within a historical, political, and finally a Bakhtinian framework, provokes me to ask the following question of Jameson's, and the academy's, separation of the two. Under what rubric, in the name of which philosophical inquiry, or for which political reasons shall we continue to make a mutually exclusive binary out of two artists, who, besides being friends, both pledged allegiance to the same aesthetics, comparable politics, and similarly conservative Christian religions, and who in their works appropriated similar materials in similar ways in similar arts for similar effects?

FROM THE TRENCHES

Leaving such rarefied air behind, let me conclude with two notes on Eliot and Stravinsky from the trenches. As an instructor at a community college, I'm not as constrained by disciplinary turf wars as those who teach at four-year institutions. I teach in a humanities department and therefore can teach both literature and music courses and can watch the effect, firsthand, of both Eliot and Stravinsky on undergraduates.

My first note is a short one on the irrelevance of Eliot. The last time I taught an Introduction to Literature class, many of my students were challenged and fascinated by Eliot's "Prufrock" and the middle-period poems. They could see that the erudition—normally a stumbling block— was necessary for the things Eliot wanted to get across. I remember in particular one student's comment that Prufrock's ambivalence came as a welcome relief to the romantic poetry we had been studying and to the Hallmark sentiments of his cultural ambit. And yet while many of my students enjoyed Eliot, they were also sophisticated enough to note the

objectified role of women in Prufrock's consciousness. This poem helped my students understand complicated formal properties of language and also served as a springboard for larger discussions going on in the academy and the world.

My second note is a longer one on the depoliticization of Stravinsky and music studies. The discipline of music is certainly a more varied place than it was twenty years ago, thanks in particular to such hard-won spaces as feminism and ethnomusicology. But music theory still maintains a firm grip, particularly with regard to Stravinsky studies. I've mentioned van den Toorn's defense of formalism, which uses Stravinsky as a linchpin. The final chapter of his study is a conciliatory epilogue that still manages to plead the side of formalist methods:

> But why should talk about sex, gender, politics, and society bring us closer to music and its appreciation, a sense of its immediacy, than talk—even "technical" or systematic talk—about its polyphony, motives, dissonance, and twelve-tone aggregates? Why should the former be judged sympathetically humanist, democratically nonspecialist and correctly interdisciplinary, the latter distant and distancing, as if the materials of music were by nature off-putting, a nitty-gritty bound to inhibit appreciation and to alienate those truly in touch?[68]

The questions are rhetorical, and such a device in this context helps van den Toorn to appear as an accommodating intellectual defending a beleaguered position. But I feel compelled to respond to his questions in a way his argument does not anticipate. I will say, first of all, that I am not an antiformalist: no student gets out of my music appreciation class without a clear idea of what polyphony and dissonance are. But I will insist that talk of sex, gender, politics, and society is indeed more humanist and "correctly interdisciplinary" because to the African American student who makes a political statement by entering my classroom with headphones blaring rap music, talk of the political dimension of music is infinitely closer to her experience than talk of twelve-tone aggregates. Furthermore, my blue-collar students are not only intimidated by such specialized formalist terms, they are also highly skeptical of the very field of "classical" music itself and its unfortunate connotations of elitism, class snobbery, and dull cerebral machinations. Instead of ignoring this tension or their fears, I poll my students at the beginning of every semester and find that they associate classical music with intellectuals, royalty, homosexuals, and rich white people—in other words, with the Other, the Not Me.

The cheeriest, most down-to-earth formalist, armed with a clear definition of twelve-tone aggregates, will make few inroads in such a climate unless those class and race barriers are not only addressed but also remain on the table as a source of knowledge about music.

I will never be in a position to question whether or not van den Toorn's formalist methodology gives him a sense of immediacy with music. But I know from direct experience that my very postmodern students can receive no sense of immediacy, when attending their first symphony concert, if they feel inadequate or are nervous about what to wear and when to clap. Some of my students have admitted to me that they do their listening homework with headphones on in order to escape the incomprehension or ridicule of their family members. For my students, not only are formalist methodologies foreign, but classical music itself— even concert etiquette—is burdened by a politics of exclusion that they must negotiate as part of the way they hear and understand.

And what more interesting way, really, to teach music? My students already know that the production and reception of music is not a technical affair but a human endeavor. Blue-collar students find the rhetorical and political aspect of music its most accessible bridge: that there exist not-so-subtle links between sexual intercourse and operatic duets, that Bach would want to instruct the spirit, that polyphony would give way to homophony as the consumer-oriented middle class rose, that comic opera would help overturn hierarchical political structures . . . these are political and economic contexts that make classical music relevant and hearable for students at a very basic level. Their own music—rock, rap, country, Christian—is happily soaked in similar contexts.

My use of Bakhtin here, while certainly academic, is not so much "correctly interdisciplinary" as it is helpful. The disciplinary rigor of music theory, particularly pitch-class or set theory, reduces all musical languages to a common denominator, which is not helpful if one is trying to keep track of the ways in which different languages coexist. And such disciplinary rigor can be a red herring if the very competition of languages is an essential element of a work's meaning. Bakhtin is also helpful because his interdisciplinary methods can be adopted for any discipline in which artists revoice one another. Those methods are therefore useful in drawing parallels between artistic endeavors in different media and in comparing technical strategies as well as political and historical contexts.

Stravinsky's music is not nearly as sanitized and mechanistic as some theoretical accounts make it out to be. And Eliot's oeuvre isn't nearly as

crude and irrelevant as others have argued. Both artists are bigger, more interesting, more human than the disciplines that presently contain them. For Eliot and Stravinsky scholars, or anyone cramped in a myopic methodology or knee-jerk ideology, a healthy dose of interdisciplinarity can provide welcome, fresh perspectives.

NOTES

1. A shorter version of this paper was given at the Midwest Modern Language Association Conference, Chicago, Nov. 1997. I would like to thank Don Bialostosky, Eric Rapp, and John Mauk for commenting on drafts.

2. This incident is recorded in Robert Craft, *Stravinsky: Chronicle of a Friendship*. Rev. ed. Nashville: Vanderbilt University Press, 1994, 389.

3. Craig Wright, *Listening to Music*. 2nd ed. St. Paul: West, 1996, 348.

4. It would be rash to ascribe the differences in popularity of these artists exclusively to scholarly preoccupations. Eliot's and Stravinsky's work exists, after all, in a vast market unencumbered by academic pettinesses. Stravinsky's *Rite of Spring*, which once incited a riot at its premiere, has been co-opted by the most banal of mainstream media: the Disney cartoon. Aside from parodies, Eliot's difficult verse has less potential for commercial appeal.

5. For an account of how the neoclassical polemic took shape, see Scott Messing, *Neo-Classicism in Music: From the Genesis of the Term through the Schoenberg/Stravinsky Polemic*. Ann Arbor: UMI Research Press, 1988. For a provocative account of how the discipline of music, and Stravinsky himself, have worked to deflate the problematic content of *Le Sacre*, see Richard Taruskin, "A Myth of the Twentieth Century: *The Rite of Spring*, the Tradition of the New, and 'The Music Itself.'" *Modernism/Modernity* 2.1 (1995): 1–26.

6. Because of Eliot's admiration for Stravinsky's *Sacre*, for example, a few scholars have compared his *Waste Land* with that ballet, although not in the pregnant terms that Eliot sets out in his "London Letter." See James Longenbach, "Guarding the Hornèd Gates: History and Interpretation in the Early Poetry of T. S. Eliot." *ELH* 52 (1985): 503–27, and, by the same author, "Hart Crane and T. S. Eliot: Poets in the Sacred Grove." *Denver Quarterly* 23.1 (1988): 82–103. Most notably, Mildred Meyer Boaz finds parallels such as lack of dramatic development, displaced accents, and fragmentation in the two works, but she is mainly concerned with aural and structural similarities, not similarities in meaning or aesthetic agenda ("Musical and Poetic Analogues in T. S. Eliot's *The Waste Land* and Igor Stravinsky's *The Rite of Spring*." *Centennial Review* 24 [1980]: 218–31.) For a comparison of Eliot's and Stravinsky's aesthetics, see W. Bronzwaer, "Igor Stravinsky and T. S. Eliot: A Comparison of

Their Modernist Poetics." *Comparative Criticism* 4 (1982): 169–91. Bronzwaer does a commendable job rehearsing the ethical implications but slights the historical/political dimension. For a general cultural comparison, see Glenn Watkins, *Pyramids at the Louvre: Music, Culture, and Collage from Stravinsky to the Postmodernists*. Cambridge: Belknap, 1994.

7. Patricia Harkin, "The Postdisciplinary Politics of Lore." *Contending with Words*. Eds. Patricia Harkin and John Schilb. New York: MLA, 1991, 124–38, 130.

8. Michael Hastings, Introduction to *Tom and Viv*. Harmondsworth: Penguin, 1995, 21.

9. Hastings 11.

10. Hastings 13.

11. For example, the music appreciation textbook from which I teach (Wright 1996, see note 3) has a page devoted to the film *Amadeus*. It encourages students to see the film but carefully points out its inaccuracies as well. I can't imagine the *Norton Anthology of Literature* or any anthology of poetry, correcting the distortions of Hastings's play. *Tom and Viv* (the film) received generally good reviews in the popular press (*Rolling Stone*, Siskel and Ebert, et al.), while the highbrow media (*The New York Review of Books*, *The New Yorker*, National Public Radio) not only found the historical inaccuracies troubling but thought the play poorly made as well.

12. Let me clarify that I don't intend my rebuttals to Morse's and Hastings's flimflam to stand as thoroughgoing clarifications of Eliot's position or biography. First of all, my corrections are intended to shed a different light on accounts that have clearly distorted agendas. Second, to those who have struggled through Eliot's work, letters, and biographical data, my contributions here may seem little more than return volleys. If one decides, after having struggled with the poetry, or perhaps after having only seen a play, that one doesn't like Eliot's poetry, then that's another matter. I won't presume to tell people that they should enjoy Eliot's work, nor would I insist on how they should respond to it. But scholars whose moral vanity would tempt them to write Eliot out of history or dismiss his work as unimportant, have a mountain of evidence to refute.

13. *The Norton Anthology of English Literature*. Gen. Ed. M. H. Abrams. 5th ed. Vol. 2. New York: Norton, 1986, 2,174. The front pages of the volume list David Daiches and Jon Stallworthy as editors of the section on the twentieth century, but the introduction is unsigned.

14. Edmund Wilson Jr., "The Poetry of Drouth." *The Dial* 73 (1922): 611–16.

15. William Carlos Williams, *Autobiography*. New York: New Directions, 1967, 146.

16. Richard A. Lanham, *A Handlist of Rhetorical Terms*. 2nd ed. Berkeley: University of California Press, 1991, 104.

17. Jerome Rothenberg and Pierre Joris, eds. *Poems for the Millennium* Vol. 1. Berkeley: University of California Press, 1995, 382.

18. Another indecipherable sentence (with yet another error) makes reference to Eliot's early work in philosophy but in a way that throws out Bradleyan jargon without explaining it: "As Charles Reznikoff has pointed out, a de facto relation exists between Eliot's 'objective correlative,' say, & the process of seeing & hearing as key to a felt perception of the world that was at center [*sic*] of 'Objectivist' practice (see below) & informs the work of many later poets." Having struggled through Eliot's philosophical preoccupations myself, I must admit it is quite a feat to make his stark terms sound like so much new age looniness.

19. Lanham 19. The official definition of this trope is "pretending to deny what is really affirmed," but as I cannot locate a name for this exact trope, I assume this covers it, as the rhetorical strategy is the same.

20. T. S. Eliot, "Religion and Literature." Originally appeared in *The Faith that Illuminates*, ed. V. A. Demant, 1935. *Selected Prose of T. S. Eliot*. Ed. Frank Kermode. New York: Harcourt, 1975, 97.

21. T. S. Eliot, "The Idea of a Christian Society." *Christianity and Culture*. San Diego: Harcourt, 1977, 41.

22. Igor Stravinsky, *An Autobiography*. New York: Norton, 1962. 53. Stravinsky spent the rest of his life hedging and qualifying this claim. For the final, exasperated retraction of it, see his *Expositions and Developments*, 101–3.

23. Eric Walter White, and Jeremy Noble, "Igor Stravinsky." Reprint of same entry in *The New Grove Dictionary of Music and Musicians. The New Grove Modern Masters*. New York: Norton, 1984, 145.

24. Eric Walter White, *Stravinsky: The Composer and His Works*. 2nd ed. Berkeley: University of California Press, 1979, 104.

25. White 104.

26. Robert Craft, Preface to *Stravinsky: Selected Correspondence*. Vol. 1. Ed. Robert Craft. New York: Knopf, 1982, xiii.

27. Ibid. 4.

28. Robert Craft, "Stravinsky's Politics: Left, Right, Left." *Stravinsky in Pictures and Documents*. Eds. Vera Stravinsky and Robert Craft. New York: Simon, 1978, 553.

29. Igor Stravinsky, *Stravinsky: Selected Correspondence*. Vol. 3. Ed. Robert Craft. New York: Knopf, 1985, 235–36.

30. Craft (1978), 554.

31. Quoted in Harvey Sachs, *Music in Fascist Italy*. New York: Norton, 1987, 168.

32. Richard Taruskin, "The Dark Side of Modern Music." *New Republic* 199.10 (1988): 28–34, 32.

33. Craft (1978), 551.

34. Quoted in Taruskin (1988), 32.

35. Pieter C. van den Toorn, *Music, Politics, and the Academy*. Berkeley: University of California Press, 1995, 151.

36. Igor Stravinsky, *Dialogues and a Diary*. New York: Garden City, 1963, 14.

37. Quoted in T. S. Eliot, *The Waste Land: A Facsimile and Transcript of the Original Drafts*. Ed. Valerie Eliot. San Diego: Harcourt, 1971, 127, n3.

38. Most analyses of *The Rite*, even textbook introductions, are formalistic. See Pieter C. van den Toorn, *Stravinsky and "The Rite of Spring": The Beginnings of a Musical Language*. Berkeley: University of California Press, 1978; Elliot Antokoletz, *Twentieth-Century Music*. Englewood Cliffs, NJ: Prentice-Hall, 1992; Robert Morgan, *Twentieth-Century Music*. New York: Norton, 1991; Allen Forte, *The Harmonic Organization of "The Rite of Spring."* New Haven, CT: Yale University Press, 1978. The "D minor" hypothesis can be found in Robert Moevs's review of Forte (1978) in *Journal of Music Theory* 24 (1980): 103. The best deconstruction of these kinds of formalist claims can be found in Taruskin's review of Forte (1978) in *Current Musicology* 28 (1979): 114–29, as well as in the responses to this issue in *Music Analysis* 5 (1986): 313–37.

39. Quoted in Taruskin (1995), 18.

40. Ibid. 20.

41. T. S. Eliot, "London Letter." *Dial* 71 (1921): 452–53.

42. T. E. Hulme, "Romanticism and Classicism." *The Collected Writings of T. E. Hulme*. Ed. Karen Csengeri. Oxford: Clarendon Press, 1994, 116. Hulme's essay was not published until 1924, well after his death in World War I. Csengeri, following Wallace Martin, has put the date of Hulme's "Romanticism and Classicism" as "late 1911 or early 1912."

43. Ibid.

44. Ibid. 63.

45. Quoted in Lyndall Gordon, *Eliot's Early Years*. New York: Noonday, 1977.

46. Hulme 69.

47. Taruskin (1988), 32.

48. Terry Eagleton, *Literary Theory: An Introduction*. Minneapolis: University of Minnesota Press, 1983, 40–41.

49. Fredric Jameson, *The Political Unconscious*. Ithaca, NY: Cornell University Press, 1981, 9.

50. Fredric Jameson, *Postmodernism; or, The Cultural Logic of Late Capitalism*. Durham: Duke University Press, 1991, 16–18. All quotes from this section on pastiche, except for the one identified below, are taken from these pages.

51. Fredric Jameson, "Postmodernism and Consumer Society." *Modernism/Postmodernism*. Ed. Peter Brooker. London: Longman, 1992, 168–69.

52. T. S. Eliot, "Phillip Massinger." *Selected Prose of T. S. Eliot*. Ed. Frank Kermode. New York: Harcourt, 1975, 153. Igor Stravinsky quoted in Peter Yates, *Twentieth-Century Music*. Westport, CT: Greenwood, 1980, 41.

53. T. S. Eliot, *The Waste Land. Collected Poems, 1909–1962*. San Diego: Harcourt, 1963.

54. Quoted in David Nice, "The Person of Fate and the Fate of the Person: Stravinsky's *Oedipus Rex*." *Oedipus Rex/The Rake's Progress/Igor Stravinsky*. Ed. John Nicholas. Opera Guide 43. London: Calder, 1991, 15.

55. Mikhail M. Bakhtin, *The Dialogic Imagination*. Trans. Caryl Emerson and Michael Holquist. Austin: University of Texas Press, 1981, 362.

56. Ibid.

57. Eliot (1963).

58. Bakhtin 363.

59. Ibid.

60. Ibid.

61. Eliot (1963).

62. Stephen Walsh, *Stravinsky: "Oedipus Rex."* Cambridge Music Handbooks. Cambridge: Cambridge University Press, 1993, 46.

63. Translation by Walsh 85.

64. Nicholas Bachtin, "English Poetry in Greek: Notes on a Comparative Study of Poetic Idioms." Originally appeared in *The Link: A Review of Medieval and Modern Greek* (1938–39). *Poetics Today* 6 (1985): 333–56.

65. The applications of Bakhtin to Stravinsky are myriad, but in this context I'll simply add that this discussion of style and voice shows how arbitrary is the standard division of Stravinsky's work into "original compositions" and "reorchestrations." For a fuller account of Bakhtinian applications to these two artists, see my dissertation, "The Dialogics of Modernism: A Bakhtinian Approach to T. S. Eliot's *The Waste Land* and Igor Stravinsky's *Oedipus Rex*." Ph.D. diss., University of Toledo, 1995. See also Calvin Bedient, *He Do the Police in Different Voices*. Chicago: University of Chicago Press, 1986; and Tony Pinkney, "*The Waste Land*, Dialogism, and Poetic Discourse." *The Waste Land*. Eds. Tony Davies and Nigel Wood. Buckingham, Eng.: Open University Press, 1994, 83–104. Bedient's text, occasionally belabored by Freudspeak, is otherwise indispensable as a close reading of Eliot's poem. Pinkney's article is likewise

interesting, though it is marred by some troublesome errors in its application of Bakhtin.

66. Theodor W. Adorno. *Philosophy of Modern Music.* Trans. Anne W. Mitchell and Wesley V. Blomster. New York: Seabury Press, 1973, 204.

67. Jameson (1981).

68. van den Toorn (1995), 228.

Checklist of Musical Settings of Eliot's Works

BRENT E. WHITTED AND ANDREW SHENTON

1. Anhalt, Istvan. 1952. "A Cold Coming We Had of It." [bar. solo, piano].
2. ApIvor, Denis. 1951. "The Hollow Men." [bar. solo, men's chorus, orch.]. London: Oxford University Press.
3. ———. 1950. *Landscapes* [cycle: t solo, ch. ensemble].
4. ———. 1946. *Lavenders Blue* [voice and piano].
5. Archer, Violet. 1973. *Landscapes* [SATB a cap.]. Waterloo: Waterloo.
6. Bargielski, Zbigniew. 1971. "Rose Garden." [a or bar. solo, b. cl.]. MS.
7. Beecroft, Norma. 1956. "The Hollow Men." [s, t soli, SATB a cap.].
8. Beeson, Jack. 1951. *Two Concert Arias* [concert aria: voice, piano, orch.].
9. Berio, Luciano. undated. *Laborinthus II* [sound recording RCA LSC 3267].
10. Beversdorf, Thomas. 1957. "No Man Has Hired Us." [oratorio: b solo, sa., tb., combining to form SATB, br. oct., str. orch.].
11. Bliss, Arthur. 1975. *Shield of Faith* [SATB, s and bar. soli, org.]. London: Novello.
12. Bourgeois, Derek. 1962. *Six Songs of Wandering* [cycle: bar. solo, piano].
13. Britten, Benjamin. 1972. "Canticle IV: Journey of the Magi." [c-t, t, bar., piano]. London: Faber.

335

13a. ———. 1977. "Canticle V: The Death of St. Narcissus." [t, harp]. London: Faber.

14. Buck, Percy. 1936. "Dead Upon the Tree, My Saviour." *Hymn Book* [voice, org.]. Oxford: Clarendon.

15. Burkinshaw, Sydney. undated. "The Hollow Men." [t, c-t, bar. soli, SATB, sax., cl. vla., db., perc., mrmb.].

16. ———. undated. "A Song of Simeon." [ms solo, fl., piano, perc.].

17. ———. undated. "Phlebas." [bar. solo and piano].

18. Burritt, Lloyd. 1970. *Acid Mass* [work for theatre: 12 v. SATB, dancers, tapes, slides, films].

19. ———. 1966. *Landscapes* [cycle: s, a soli, tape].

20. Burt, George J. 1967. "New Hampshire: Children's Voices in the Orchard." [double chorus of female voices, a cap.]. New York: Continuo.

21. Christou, Jani. 1959. *Six Songs for Mezzo-soprano and Orchestra* . Wiesbaden: Impero Verlag.

22. ———. 1953. *Symphony No. 1*. Rome: DeSantis.

23. Clarke, F. R. C. 1951. *Two Songs from "The Hollow Men'"* [voice and piano].

24. Cone, Edward T. undated. "The Hippopotamus." [t solo, men's chorus, ww. ensemble].

25. ———. undated. "La Figlia che Piange." [t solo and ch. ensemble]. New York: E. B. Marks.

26. Crawford, John Charlton. 1971. "Ash-Wednesday." [oratorio: SATB, s and bar. soli, narr., orch.]. New York: Oxford University Press.

27. Dalby, Martin. undated. "Whisper Music." [ch. orch.]. London: Novello.

28. Dankworth, John. undated. "Sweeny Agonistes." [melodrama: two female voices, five male voices, jazz band of cls., tpt., ob., piano, drums]. London: Faber.

29. Diamond, David. 1951. "For an Old Man." [voice and piano]. New York: Southen Music Publishing.

30. Dickenson, Peter. 1958. "Meditation on *Murder in the Cathedral.*" [org. solo].

31. Elkus, Jonathan. 1966. *Three Medieval Places* [incidental music for org. solo]. Bryn Mawr, PA: Beekman.

32. Elston, Arnold. undated. "Sweeny Agonistes." [opera: s, bar. soli, SATB, ch. orch. (or piano)].

33. Engel, Lehman. 1954. [incidental music on *Murder in the Cathedral*].
34. Fortner, Wolfgang. 1951. "Aria." [solo voice, fl., vla. ch. orch.]. Mainz: B. Schott.
35. ———. 1973. "Versuch Eines Agon." [opera]. Mainz: B. Schott.
36. Frith, Michael. 1976. "The River Flows, the Seasons Turn." [anthem: SATB, s solo, org.]. London: Oxford University Press.
37. Gruen, John. 1959. *Two Eliot Poems for Voice* [voice]. New York: not published.
38. Gubaidulina, Sof'ia Asgatovna. 1989. "Offertorium: Hommage a T. S. Eliot." [sound recording]. Hamburg: Deutsche Grammophone.
39. Hanson, Howard. 1976. *New Land, New Covenant* [SATB, opt. children's chorus, s and bar. soli, narr., org., small orch.]. New York: C. Fischer.
40. Harvey, Jonathan. 1975. "The Dove Descending." [anthem: SATB, org.]. London: Novello.
41. ———. 1979. "Inner Light (2)." [SATB chorus with twelve instruments]. London: Faber Music.
42. Healey, Derek. 1961. *Six American Songs* [s or t solo, piano].
43. Holloway, Robin. 1964. [incidental music on *Sweeny Agonistes* for speakers and six musicians].
44. ———. 1973. *The Death of God* . London: Oxford University Press.
45. ———. 1976. *Five Madrigals* [SATB a cap]. London: Oxford University Press.
46. Howell, Dorothy. 1953. "The Song of the Jellicles." [part song: 2-pt. voices, piano]. London: Edward Arnold.
47. Jones, Kenneth. undated. "O Light Invisible." [s solo, mixed chorus, ch. orch.]. London: J. & W. Chester.
48. Joyce, Mary Ann. 1970. *The Passion, Death, and Resurrection of Jesus Christ* [SATB, orch.]. St. Louis: Washington University Press.
49. Keats, Donald. 1976. "The Hollow Men." [mixed chorus]. New York: Boosey & Hawkes.
50. ———. 1962. "The Naming of Cats." [SATB and piano]. New York: Boosey & Hawkes.
51. Kellam, Ian. 1972. [incidental music on *Murder in the Cathedral*].
52. Lajtha, Laszlo. undated. [incidental music on *Murder in the Cathedral*].

53. Leighton, Kenneth. 1958. *The Light Invisible* [SATB, t solo, orch.]. London: Novello.
54. Lloyd Webber, Andrew. 1981. *Cats* [musical: some lyrics by Eliot]. London: Faber.
55. Lourié, Arthur. 1949. "The Dove." *The Third Hour 4* [voice and piano]. New York: unpublished.
56. ———. 1993. *A Little Chamber Music.* ("Little Gidding") [sound recording]. Hamburg: Deutsche Grammophon.
57. MacInnis, Donald. 1956. "Death by Water." [men's chorus]. Hollywood: Camero Music.
58. Matuszczak, Bernadetta. 1968. *A Chamber Drama* [bar. solo, reciting voice, b. cl., cello, db., perc., tape]. Warsaw: Przedstawicielstwo.
59. McCabe, John. 1958. *Five Elegies* [cycle: s solo, ch. orch.]. London: Oxford University Press (unpublished).
60. Milhaud, Darius. 1939. [incidental music on *Murder in the Cathedral*].
61. Parris, Robert. undated. "The Hippopotamus." [men's chorus, ch. ensemble].
62. Paynter, John. 1972. *Landscapes* [choral suite: SATB a cap., opt. ob.]. London: Oxford University Press.
63. Persichetti, Vincent. 1947. "Dust in Sunlight and Memory in Corners." *Poems for Piano (Vol. II)* [piano solo]. Philadelphia: Elkan-Vogel.
64. ———. 1948. *"The Hollow Men" for Trumpet and String Orchestra.* Philadelphia: Elkan-Vogel.
65. Peterson, Wayne. 1954. "Prelude I." [cycle: s or t solo, piano].
66. Pizzetti, Ildebrando. 1958. "Assassinio nella cattedrale; tragedia musicale in due atti e un intermezzo." [opera: s, a, two t, two b soli., orch.]. Milano: Ricordi.
67. Polin, Claire. 1973. *Infinito* [requiem: SATB, s solo, narr., a sax]. New York: Seesaw Music.
68. Porter, Quincy. undated. [incidental music on *Sweeny Agonistes*].
69. Price, Beryl. 1972. *A Cycle of Cats* [cycle: ssa and piano]. London: Oxford University Press.
70. Purser, J. W. R. 1963. *Five Landscapes* [s, t soli, piano].
71. Rathaus, Karol. 1959. *Three Songs* [SATB a cap.]. Bryn Mawr, PA: Thomas Presser.
72. Rautavaara, Einojuhani. 1967. *Two Preludes* [TTBB a cap.]. Helsinki: Ylioppilaskunnan.

73. Rawsthorne, Alan. 1954. *Practical Cats* [speaker and orch.]. London: Oxford University Press (unpublished).
74. Reif, Paul. 1957. "Five-Finger Exercises." [cycle: bar. and piano]. New York: Leslie Productions.
75. ———. 1957. "La Figlia che Piange." [bar. and piano]. New York: General Music.
76. Searle, Humphrey. 1956. *Two Practical Cats* [spkr., fl., pic., gtr., cello]. London: Oxford University Press.
77. Shaw, Martin. undated. [incidental music on *The Rock*]. London: J. B. Cramer.
78. ———. 1934. "The Builders: Song from *The Rock*." [unison chorus with piano or orch.]. London: J. B. Cramer.
79. ———. 1966. "The Greater Light." [anthem: t solo, double choir, org.]. New York: G. Schirmer.
80. Smith, Gregg. 1962. *Landscapes* [SATB a cap.]. New York: G. Schirmer.
81. Souster, Tim. undated. *Waste Land Music* [electronic music]. London: ODB Editions.
82. Stevens, James. 1969. "The Family Reunion." [incidental music for TV prod., ch. orch.].
83. Stravinsky, Igor. 1962. "The Dove Descending." [anthem: SATB a cap.]. London: Boosey & Hawkes.
84. ———. 1965. "Introitus: T. S. Eliot in memoriam." [six male voices, ch. ensemble]. London: Boosey & Hawkes.
85. Swanson, Howard. 1952. *Four Preludes* [voice and piano]. New York: Weintraub.
86. Taverner, John. 1994. *Sections from T. S. Eliot's "Four Quartets."* [voice and piano].
87. Thomas, Alan. 1957. *Five Landscapes* [cycle: voice and piano]. Bryn Mawr, PA: Theodore Presser.
88. Tippett, Michael. 1944. *A Child of Our Time* [oratorio: s, a, t, b soli, SATB, orch.]. London: B. Schott.
89. Togni, Camillo. 1962. "Assasinio Nella Cattedrale." [mixed chorus a cap.]. Milano: Edizioni Suvini Zerboni.
90. ———. 1962. "Coro di T. S. Eliot." [mixed chorus a cap.]. Milano: Edizioni Suvini Zerboni.
91. Tremain, Ronald. undated. [incidental music for radio: male v., a cap.].
92. van Baaren, Kees. 1949. "The Hollow Men." [cantata: SATB, s and bar. soli, small orch.]. Amsterdam: Donemus.

93. Ware, John. 1966. "Essay for Orchestra on T. S. Eliot's *Murder in the Cathedral*." [orch. only].

94. Whear, Paul W. undated. "Burnt Norton." [spkr., ch. ensemble]. Cleveland: Ludwig.

95. Whettam, Graham. 1960. "The Wounded Surgeon Plies the Steel." [anthem: SATB a cap.]. London: Boosey & Hawkes.

96. Wildberger, Jacques. 1965. "In my end is my beginning." [duet for s and t with ch. orch.]. Koln: H. Gerig.

97. Willan, Healey. 1936. [incidental music adapt. from plainsong sources and the composer's publ. works].

98. Williams, Bryn. 1972. "The Hollow Men." [chorus, ch. orch.].

99. Wills, Arthur. 1976. "The Light Invisible." [double chorus, perc., harp, org.]. London: J. Weinberger.

100. Young, Douglas. undated. *Landscapes and Absences* [cycle: t solo, Eng. hn., with interludes for Eng. hn., str. trio]. London: Faber.

Contributors

John Adames teaches English at the British Columbia Institute of Technology. He has published widely in the area of modern poetry including major articles on W. H. Auden (*The Modern Language Review*), Seamus Heaney (*Irish University Review*), and A. R. Ammons (*Twentieth-Century Literature*).

David Banks was born in Newcastle in north-east England in 1943, but has been living abroad since 1975. He is at present Professor of English Linguistics at the Université de Bretagne Occidentale at Brest, France, and his main research interest is the analysis of scientific text. He is also a practicing poet and an amateur musician.

David Barndollar is in the Department of English at the University of Texas, Austin. He is finishing a dissertation on the recursive long poems of the postromantic periods, including poems by Tennyson, Browning, Eliot, Merrill, and Walcott. He is also Assistant Director of the Computer Writing and Research Lab at Texas.

J. Robert Browning's research is mainly on seventeenth-century culture. He has written on music and the poetry of John Donne and is completing a dissertation at Indiana University, Bloomington, on the relationship between sensational art forms and public sphere discourse during the Interregnum.

Brad Bucknell is Associate Professor of English at the University of Manitoba in Winnipeg. His interest in music and literature is obsessive

and ongoing. His book, *Musical Aesthetics and Literary Modernism: Pater, Pound, Joyce, and Stein,* will be published by Cambridge University Press in 2000. His recent research involves the collaboration of Kurt Weill and Langston Hughes.

David Chinitz, Associate Professor of English at Loyola University, Chicago, is the author of "T. S. Eliot and the Cultural Divide" (*PMLA* 1995), "Rejuvenation through Joy: Langston Hughes, Primitivism, and Jazz" (*American Literary History* 1997), and other articles. He is now completing a book on Eliot and popular culture, from which the present essay is extracted.

John Xiros Cooper, Associate Professor of English at the University of British Columbia, has published two books on T. S. Eliot (1987, 1995) and is completing a book on modernism titled *Modernism, Modernization, and the Market.* He has also published articles on a variety of authors and topics.

Margaret E. Dana retired recently after a distinguished career as a Professor of English at California Baptist University.

Jonathan Gill teaches literature at Columbia University and is working on a book about the relationship between blacks and Jews in America. He has lectured and published widely on modernist poetry and American music.

Jonna Mackin is an Instructor of English at the University of Pennsylvania. She works in the area of modernism and postmodernism. She has written on Charlie Chaplin and James Joyce and is engaged in research on the politics of humor and ethnicity in American novels after World War II.

Kevin McNeilly, Assistant Professor of English, University of British Columbia, teaches cultural studies and critical theory. He has published articles on jazz and literature, including work on Charles Mingus, John Zorn, and Robert Creeley, as well as papers on W. B. Yeats, Theodor Adorno, and Franz Boas.

C. F. Pond is currently writing a book on operatic adaptations of *A Midsummer Night's Dream.* She received her Ph.D. at the University of Leeds, with a dissertation on Benjamin Britten's vocal music in its historical and cultural contexts. She lives in Cambridge, England.

Suzanne Robinson is a Lecturer in the Faculty of Music at the University of Melbourne in Australia. She has published widely in a variety of music journals on British and Australian musical traditions and on women in music. She is also an editor of musical texts, most recently a full vocal score of G. W. L. Marshall-Hall's one-act opera, *Stella*.

Andrew Shenton, Department of Music, Harvard University, is completing a study of Western religious music.

Jayme Stayer is Assistant Chair of the Department of Communications and Humanities at Owens College in Toledo, Ohio. He teaches courses in literature and music. His research interests include the works of Igor Stravinsky, T. S. Eliot, and opera.

Brent E. Whitted is in the English Department at the University of British Columbia and is finishing a study on law and literature in the Inns of Court in the age of Shakespeare. His article, "Locating the Anomalous: Gesualdo, Blake, and Seurat," appears in *Mosaic* (March 1998).

Index